Looking After Heritage Places

Judith Anderson.

Looking After Heritage Places

*The Basics of Heritage Planning
for Managers, Landowners
and Administrators*

Michael Pearson &
Sharon Sullivan

MELBOURNE UNIVERSITY PRESS
1995

First published 1995

Typeset by Melbourne University Press in 10 pt Baskerville
Printed in Malaysia by
SRM Production Services Sdn Bhd for
Melbourne University Press, Carlton, Victoria 3053

National Library of Australia Cataloguing-in-Publication entry

Pearson, Michael, 1951– .
 Looking after heritage places: the basics of heritage
 planning for managers, landowners and administrators.
 Bibliography.
 Includes index.
 ISBN 0 522 84554 1.

 1. Historic sites—Australia—Management. 2. Historic
 sites—Australia—Conservation and restoration.
 3. Cultural property, Protection of—Australia. 4. Sacred
 sites (Australian Aboriginal)—Management. 5. Aborigines,
 Australian—Antiquities—Collection and preservation.
 I. Sullivan, Sharon, 1944– . II. Title.

363.690994

Contents

Illustrations

Acknowledgements

This book has had a long gestation, and many have assisted directly in its production, and indirectly through discussion of many of the ideas and concepts incorporated in it.

The Riverina College of Advanced Education (now Charles Sturt University) prompted the work by giving us the opportunity to write a component of a course for park rangers on the principles of cultural resource management. Terry de Lacy facilitated that process, and the NSW National Parks and Wildlife Service supported our work on it. Subsequently, the Australian Heritage Commission supported the conversion of that course into the first draft of this book.

During the course of drafting and redrafting, the staff of both the Service and the Australian Heritage Commission have provided great assistance and encouragement. Much encouragement has also come from our colleagues and friends in Australia ICOMOS, and we have benefited from the many individual and group discussions we have had with them. We have leant heavily on the ICOMOS framework for conservation planning, and on the extension of it by Jim Kerr, and we gratefully acknowledge that intellectual underpinning.

Caroline Rola-Wojciechowski did much work for us in the initial phase, seeking out bibliographic references, which became the basis for an Australian Heritage Commission bibliography referred to elsewhere in the book.

Simon Molesworth provided valuable comment on an earlier draft, which helped maintain our resolve to carry on. Carol Miegel struggled with our writing and computer-disc-juggling over a long period, and retained her good nature throughout.

The Getty Conservation Institute, Los Angeles, provided an opportunity, and funding, to develop some aspects of this book further.

Our partners, Rosalie Pearson and Malin Blazejowski, have been patient, loving and encouraging, and Rosie also undertook the indexing. Isabel McBryde is ultimately responsible, in the sense that she taught us both and inspired our interest in the past.

Our thanks go to all of those mentioned, and the many others who have provided input, knowingly or unwittingly, to the development of this book.

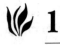 **1**

Looking After the Past

An Introduction to the Management of Heritage Places

What this book is about

This book shows how to plan for and carry out the identification, investigation, assessment, conservation and management of places associated with human history, and which are of value to our society for cultural reasons—heritage places. The book is written for a number of audiences. It is aimed at the manager, students and practitioners in heritage fields, and at all those actively involved in heritage issues. The manager (the person who has to look after and/or make decisions concerning the short- and long-term management of areas of land containing heritage places) might be the owner, ranger, historic house or museum manager, reserve warden, forester, caretaker, or any other person responsible for the day-to-day on-the-ground control of places. The manager might also be the administrator in a company or at whatever level in local, state or federal government, responsible in some way for decision making affecting that place, either directly or through the development of policy for the particular management body, or even of some authority not directly responsible for the place but making decisions that will directly affect it.

Others actively involved in heritage issues might include those who have a part in the running of local museums or heritage

activist groups—people who need to understand the context for their activities, and who need to be able to judge if others are conforming to established heritage standards.

Students of, and practitioners within, the various specialist fields involved in heritage management, such as architecture, archaeology, history, geography, anthropology, engineering and many more, have an equal need for access to the processes described in this book.

Heritage studies now exists as an academic discipline in itself in Australia, one devoted not only to teaching good practice but to questioning, testing and exploring the underlying assumptions of our common heritage conservation practice through a critical examination of the discourse.[1] The present writers have contributed to this examination.[2]

Increasingly too, practitioners themselves are aware of the complexities and sometimes contradictions embodied in their roles, and are self-conscious about the cultural biases and assumptions that of necessity influence their heritage practice.

This book is not primarily a critique of the discipline, however. Its major aim is to describe the processes of current, best heritage management for the practitioner, and to draw attention, where relevant, to some of the key current issues and problems that will impact on their considerations and activities. Students of heritage studies will wish to go more deeply into many of these issues, and indeed to question some of the basic assumptions of this book. We hope that by describing current good practice, we will provide a realistic and comprehensible background for their pursuit of such investigations.

The structure of the book follows the sequence of events that usually faces a manager in identifying, assessing, and conserving a heritage place. In some cases the manager, say, will come into the process part of the way through. For example, the place may be already identified, and the hence the survey chapters of the book will be redundant. The manager in that case may simply need to check that every feature of the place with potential heritage value has been properly identified, and then read on from the next relevant section.

The structure generally follows a sequence in which the building blocks of a good conservation and management solution are founded upon what goes before: first find the place and describe it, then assess what is important about it and why, then decide

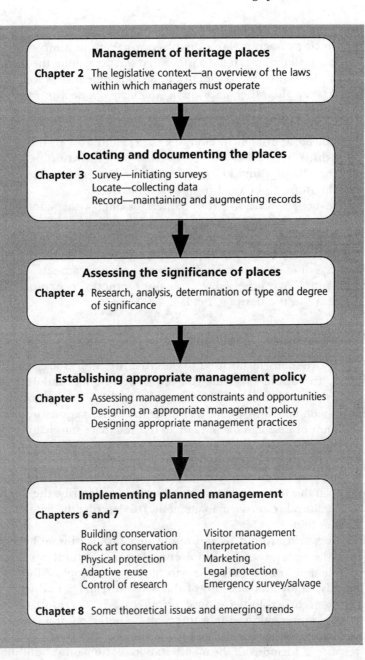

Management of heritage places

Chapter 2 The legislative context—an overview of the laws within which managers must operate

Locating and documenting the places

Chapter 3 Survey—initiating surveys
Locate—collecting data
Record—maintaining and augmenting records

Assessing the significance of places

Chapter 4 Research, analysis, determination of type and degree of significance

Establishing appropriate management policy

Chapter 5 Assessing management constraints and opportunities
Designing an appropriate management policy
Designing appropriate management practices

Implementing planned management

Chapters 6 and 7

Building conservation Visitor management
Rock art conservation Interpretation
Physical protection Marketing
Adaptive reuse Legal protection
Control of research Emergency survey/salvage

Chapter 8 Some theoretical issues and emerging trends

Figure 1.1 Sequence of chapters outlining the management process

how best to protect those values and manage all the other things that need managing about the place. You cannot jump straight to the last step of making decisions that will determine the future of the place with any confidence in the outcome unless you have undertaken the other steps upon which such a decision should be based.

Because we have followed this structure, it imposes a compartmentalized approach to complex issues, and as a result it has been difficult at times to present issues in a fully rounded way. This handbook should be referred to for guidance, rather than as a discourse to be read from cover to cover.

The book's division into chapters dealing with major components of the management process in a logical sequence is outlined in Figure 1.1.

The notes provide both specific references for material used, and a guide to other readings on particular aspects of the discussion.[3] We urge you to use the footnotes to explore the literature in the heritage field.

What are heritage places?

There are many terms used to describe the subject area of this book. In various contexts the terms 'Aboriginal and historic places', 'prehistoric and historic sites' and 'cultural resources' have been in favour when describing the conservation and management of heritage places, but all of these have implications in their wording that are seen by some either to exclude important places or to encompass more than is intended.

One pair of terms in common use encompassing the field we cover in this book are 'cultural resources' (to describe the items) and 'cultural resource management' (to describe the act of conserving them).

The world around us can be divided (arbitrarily we accept) into the natural and cultural environment. Natural resources are elements of the natural environment that people value, use, modify, enjoy and because of this seek to manage and to conserve, or to exploit. Cultural resources are the result of humanity's interaction with or intervention in the natural world or its natural resources. In its broadest sense, the term 'cultural resources' includes all the manifestations of humanity: buildings, landscapes, artefacts, literature, language, art, music, folkways and cultural institutions are all cultural resources.

The term 'cultural resources' has usually been used to refer to only those parts of the cultural heritage, those manifestations of humanity, physically represented in the landscape by 'places' (that is, cultural resources which occur on, or are an integral part of, land or landscape). The term 'cultural resource management' is used in the United States of America, and to some degree in Australia, to describe the process of looking after those cultural resources that occur in the landscape.[4] These terms, however, are only readily understood when this specialist definition is applied. In general they could be interpreted in such a broad way as to be meaningless. Additionally, they do not reflect the common usage of ordinary people, or indeed of many professionals. We therefore prefer to use the term 'cultural or heritage place' in this book—but even with this definition there are problems.

In Australia the whole landscape is a cultural place, in that it is an artefact of humanity; people have been modifying or giving human meaning to the landscape for at least 60 000 years, and most of Australia has been affected by this.

When we conserve items of the 'natural heritage' (even wilderness areas) we are really preserving an ecosystem often profoundly affected by Aboriginal environmental manipulation, including especially the use of fire.[5] In the last 200 years the impact of humanity on the land has been even more dramatic.

Within this cultural landscape there are generally *areas* where human activity is more manifest than in the rest of the landscape. We define a *place* as a site, area or region of land that represents a particular focus of past human activity, or that represents a concentration of *in situ* cultural material. A place includes any structures, building or works upon or integral with the land, and any artefacts or other physical relic associated with the land, or it may have no visible evidence of human activity, being rather the site of a past event of importance or the embodiment of a particular belief or legend.

Examples might be an Aboriginal ceremonial ground, a pioneer's house and contents, a shop, the remains of an early whaling site or a recent fish farm, Captain Cook's landing-place, a 40 000-year-old Aboriginal campsite or a 1990s brick-veneer house, a shipwreck, an industrial or mining landscape, a bus-stop, a Macassan trepanger campsite or the Surfers Paradise Caravan Park, a garbage dump, the local war memorial, a garden, an Aboriginal rock painting, a band rotunda.

We will examine later, in more detail, ways of defining and sorting this potentially huge resource of places, and of assessing which parts of it are of importance, to whom, and what to do about it. Many places are not important, or significant, and do not require conservation. On the other hand, a proportion of places will have characteristics that might indicate that they are or may be culturally significant, of importance to the Australian community, and therefore need to be investigated further. Often this indication of potential significance has been used as the basis for conservation.

The commonest reason for valuing a place is that it has acquired a patina of age that gives it some often ill-defined importance: hence a nineteenth-century bottle-dump may be considered 'historic', 'important', 'worth preserving', but one dumped on your lawn last week by an overflow crowd from the local pub will be considered as something else entirely. For various reasons, we tend to value and conserve places that appear to be old, and are readily recognized by the majority of people as part of the Australian past.

These obvious indicators of potential significance give the manager one way of distinguishing which cultural places might be worth investigating more thoroughly. However, there are other reasons, not immediately discernible, why a place may be important. A rock outcrop or a tree may have immense importance, now, as a sacred site to Australian Aboriginal people; but this significance will be discernible only to the small group of custodians for whom the natural feature is an incarnation of an ancestor hero. None the less, this is a true and important value.

> In the intimate link existing between Aborigines and their territory, topographical features, plants and animals were an unquestioned, integral part of existence. Like themselves, they were endowed with life essence in the dreamtime by creation heroes. These totemic ancestors were transformed into natural features—rocks, cavities—but retained their life essence. Around such totemic features appropriate ceremonies were performed. C. P. Mountford has demonstrated that almost every topographical feature on Ayers Rock possesses deep mythological reality. From a knowledge of the living people, therefore, a prehistorian realises that rocks did not require human 'arrangement' before they played an intimate role in ceremonial life; yet, unless human agency was involved in erecting them, he cannot identify them archaeologically.[6]

Similarly, an archaeological deposit may contain information whose importance is, in the first investigation, only discernible to scientists but which in the long run reveals, for instance, the site of the Eureka Stockade or the first Government House.

The manager must be aware of all the ways in which cultural places may prove to be of significance, and to be able to identify those places potentially worthy of conservation. Such assessment is by definition value laden and many faceted. Part of the role of the manager is to apply intellectual rigour to process.

Despite the complexities of determining the significance of particular places it is necessary, if we are to manage cultural places so as to conserve them, to make a distinction between the almost infinite number of 'cultural places' in the world, and those with *some* degree of heritage value or significance for people today or in the future. This value can be initially defined as the capacity or potential of the place to demonstrate or symbolize, or contribute to our understanding of, or appreciation of, the human story.

It is sometimes defined as aesthetic, historic, scientific, or social value for past, present, or future generations (see Australia ICOMOS's Burra Charter[7]). We call this value, in its broadest sense, heritage value, or cultural value or significance, and we define the subject of this book as *the management of cultural places that have this value or potential.*

For convenience, we will call the places having this value *heritage places*, with the understanding (stressed again because of its importance) that this definition encompasses all cultural places with any *potential* present or future value as defined above. Later in this chapter we will discuss further the question of defining significance. An essential first step in the process of management is elucidating that value or significance.

What is management?

In the world in which we live today just about every piece of land and every object on it is owned by, occupied by, or is the responsibility of, some individual, group or government. The way in which those responsible for the land choose to use it, exploit it or conserve it constitutes the 'management' of that land. Decisions may be consciously planned or may be unconscious responses to a variety of pressures, and the resulting management may be good, bad, or indifferent.

Judgement about the quality of the management will be based on the management aim, on whether it has been successful, and (increasingly) on whether it is deemed to have been an appropriate aim. For instance, some say that the forest industry's management of Australian native forests has been successful, since it has provided industry with the timber it needs and Australia with export earnings; others say that it has been unsuccessful in that it has failed to conserve various vegetation and wildlife communities. Some say the building of the Argyle Dam in Western Australia was a wise and far-sighted plan to bring water to arid Australia; others say that the Aboriginal dreaming places that were inundated were far more important, and that the chosen land use was totally inappropriate.

The aim of this book is to provide managers (those responsible for making decisions about the management of land and the heritage places upon it) with an outline of the philosophy and principles that can be applied to make better decisions concerning culturally important places. One aspect of management is the assessment of heritage places, resulting in a decision about which places should be conserved and which places, in certain circumstances, can be destroyed, modified or simply left alone. This decision is probably the most difficult one that a manager will be called upon to make. It is often irreversible, and from it all subsequent action plans will flow. If conservation of a heritage place is appropriate, a series of established principles can guide planning and works to ensure that the place involved is looked after so as to retain its cultural significance. If destruction or modification is necessary, there is a process to follow that involves the least loss of significance and of information concerning past lifeways, history, prehistory or cultural identity. Retention of this information is as much the responsibility of the manager as is the management of the land itself.

Effective management of heritage places involves four steps:

1　Location, identification and documentation of the resource, that is, the heritage place or places within a defined area of land

2　Assessment of the value or significance of the place to the community or sections of the community

3　Planning and decision making, weighing the values of the heritage place with a range of other opportunities and con-

straints that the manager must consider to produce a management policy aimed at conserving cultural significance

4 Implementation of decisions covering the future use and management of the place—ranging from active conservation to recording and disposal.

Figure 1.2 illustrates the planning process for achieving this; we will return to this throughout this book. Chapters 5 and 6 deal with conservation in some detail, but it is important to briefly define it here. *Conservation* is here defined as all those processes of looking after a place so as to retain its cultural significance. It includes maintenance, and may, according to circumstance, include preservation, restoration, reconstruction and adaptation, and will be commonly a combination of more than one of these (see Australia ICOMOS Burra Charter). Conservation is not a simple issue. We can see clearly that the physical destruction of a place would not usually conserve its cultural significance, and that its sympathetic restoration and/or reuse, probably would: but what if a building were moved and re-erected elsewhere? What if a sacred Aboriginal place were opened to tourists? Are these examples of conservation? We will return to a discussion of these matters in Chapter 6.

The conservation of as wide a range of heritage places as possible will be a primary aim of sympathetic management. However, the conservation of all heritage places in a given area is not often achieved. This is because society has other important and sometimes conflicting aims for the land, or other needs for the resources required for conservation, or even because, in some cases, the destruction of the fabric of a place is necessary to gain important information from it. The balancing of these factors is, in the first instance, the job of the land manager. Hence we cannot always equate management with conservation.

When the natural gas pipeline was built from Moomba in South Australia to Sydney, it was inevitable that Aboriginal sites would be in its path, and would be destroyed. Moving the pipeline every time an Aboriginal campsite was discovered was clearly impractical, because of the number of sites involved. In those circumstances, the management of the sites rested heavily on decisions about assessment of the importance of sites, including the views of Aboriginal groups, as to which ones were important enough to cause a major and expensive diversion, and on the

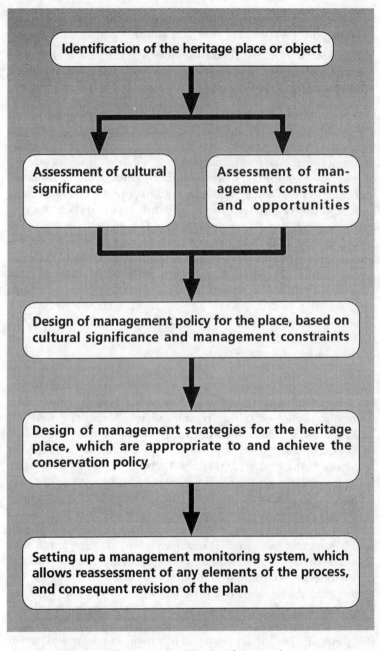

Figure 1.2 Heritage conservation planning framework

recovery of as much information as possible from those sites that could not be saved. Management has both a technical and a political dimension. The manager needs access to first-rate and unarguable technical data, but also needs realistic data on the commercial and political situation, and often must possess negotiation and liaison skills of a high order. In fact, the manager needs to be able to practise or co-ordinate a wide range of skills. Above all, good heritage place management relies on the manager having good general management skills. Specialized conservation skills alone will not make up for inadequacy in this area.

The aims of management of heritage places may be summarized as follows:

- the elucidation of all the values of heritage places
- the setting in place of strategies for long-term preservation of at least a sample of such places through legal and physical protection and conservation
- the implementation of management practices that minimize the necessity for destruction of the values of such places and maximize the opportunities of mitigating the effects of the unavoidable destruction of places or their components
- to the extent appropriate, the presentation of the values of the place to the public through access and interpretation.

Why do we conserve heritage places?

So far we have dealt with definitions. Before we proceed to look in more detail at the various steps that constitute heritage place management, it is necessary to look at one basic assumption that this book makes, and which is, in fact, its *raison d'être*. This is the assumption that heritage places are valuable, scarce and non-renewable. If they were not truly valuable to society or if they were infinitely available and renewable, management for their conservation would be unimportant or unnecessary.

Heritage places are scarce and non-renewable. There are only a certain number of Aboriginal engravings or nineteenth-century colonial mansions and public buildings, there is only one Captain Cook's first landing-place or one Goanna dreaming site. These places, once destroyed, cannot be regenerated, reintroduced, or duplicated. In some cases copies can be made, presupposing

that we have exact details of the originals, but these copies do not have the same cultural value. These cultural remains are decaying at a steady rate, sometimes accelerated by human activity. The resource will be added to—the bottle-dump in your front yard, if it survives, may become a valuable record of twentieth-century technology in the twenty-second and twenty-third centuries—but such new sites will commemorate a different period, will have a different significance, and will not duplicate the values, meaning or information content of earlier places. Heritage places are, comparatively speaking, a scarce resource.

There is considerable evidence that our society values these heritage places. National and state legislation protects them, and there is funding, reservation of places, public education campaigns, a very large voluntary conservation movement, and a booming 'heritage publication' press.

Valuing our past seems in its simplest form, to be a natural human inclination.[8] We can trace in many cultures a respect for, and an active use and conservation of past material remains, over many centuries. An outstanding example of this is the traditional Chinese regard for the ancient, and its ongoing relevance in Chinese society.[9] However, the elements of this tradition of respect for the past clearly vary greatly from culture to culture, and over time.

The present interest in heritage in Australia is part of a long tradition of treasuring the past in Western civilization. The Romans venerated, protected and copied the heritage of ancient Greece. The Crusaders had as part of their mission the management of the heritage sites in the Holy Land. The European enlightenment was a movement that looked back for its inspiration to the ancient world and led, more generally, to an appreciation of the material remains of the past and their ability to influence and inspire the present. In the modern world the first heritage legislation was enacted in 1666 in Sweden, when a royal proclamation forbade the breaking up or interference with 'monuments' on Crown land or private property. This legislation was administered in the field by priests and their assistants, making them perhaps the first modern heritage managers.[10]

The advancing tide of the industrial revolution and the great twentieth-century upheavals of war and post-industrial development turned a general sense of appreciation and admiration into a fear of loss. This fear has increased the value of those

elements of our past that we previously took for granted. The speed and scale with which change has occurred in the twentieth century is unparalleled. It is no accident that it has been in the twentieth century that we have developed the most powerful and well-supported national and international conservation conventions and supporting administrative systems, and have begun to articulate clearly a justification for protecting the past, in the face of its imminent disappearance.

The 1974 report of the Committee of Enquiry into the National Estate quoted from the eloquent UNESCO recommendation concerning the protection of cultural property:

> Cultural property is the product and witness of the different traditions and of the spiritual achievements of the past, and is thus an essential element in the personality of the peoples of the world. It is the duty of government to ensure the protection and the preservation of the cultural heritage of mankind, as much as to promote social and economic development.[11]

In Australia today many reasons for valuing our heritage have been advanced. Here is a list of the values of some different strands of our heritage put forward by the first Chairman of the Australian Heritage Commission, David Yencken:

- The most ancient archaeological sites provide vital evidence of the emergence of modern man and of his colonisation of this continent at a date earlier than 40,000 years ago.
- Archaeological sites emphasise the richness of early Aboriginal society in Australia and its significance compared to other centres of early human development, such as the Middle East.
- Aboriginal rock engravings and painting supply fascinating evidence of Aboriginal cultural values and creativity. They provide records of Aboriginal perceptions of foreign contact, including Macassan praus and European colonists. They record environmental data which are of great interest to science (an example is the paintings of Tasmanian tigers [thylacines] in Arnhem Land in the Northern Territory).
- Contact sites where Aboriginal and white man met are of great historical interest. Some, such as the massacre sites, are of special religious significance to Aborigines.

- Many Aboriginal places where traditional life has persisted have sacred or other symbolic significance to Aborigines.

- Historic era, European and Asian places provide evidence not always available in documentary form, of the process of settlement of Australia by other cultures in the last 200–300 years.

- Historic places provide us with tangible evidence of Australia's immediate past. They are the cultural roots of today's society.

- Historic places include both the artistic efforts of other eras and examples of structures and sites which are typical of regional life and work in Australia over the last 200 years.

- Historic buildings and areas from other eras provide us with a diversity of building forms which give character and charm to our cities and countryside. Once destroyed, they can never be replaced.[12]

Increasingly, evidence is accumulating that conservation of the cultural heritage has demonstrable social and economic benefits. There is a straightforward economic argument that relates to the built environment:

> In these times, one valid case for preservation is economic. Can we afford to rebuild the environment every generation? With the doubling of construction costs in the last five years, new construction is pricing itself out of many markets, making recycling not a sentimental exercise but a necessity.
>
> Another case for preservation is energy: important in the decision to recycle instead of rebuild. The residual value of energy built into old cities is enormous, packed into streets, utilities, and buildings: 1) time energy—manifold individual decisions over a period of development and use; 2) natural and human energy invested in materials and artisanship; 3) kinetic energy of construction and the fuel required.
>
> This is the energy content of a city. Energy is wasted when any old building is pulled down.[13]

The stock of our built heritage represents an enormous investment of natural resources. Continued use, reuse, or recycling of this stock is surely just as important for ecologically sustainable development as other more commonly promoted resource recycling.

The cultural landscape generally also appears to be important to a society's health and well-being. A 'sense of place'—an identity—is something all communities need, and indeed it can be argued, as in the case of many modern alienated communities, that a principal cause of alienation, crime and dysfunction is the loss of this sense of identity. Community identity is very dependent on elements to which our cultural heritage contributes—the symbolic qualities that define a country, the spiritual or traditional connection between the past and the present, collective memory and meaning, a human scale, a familiar landscape, and special and shared attachments that relate to longevity of use or to events that have had a profound effect on the community.

In brief, Australia's heritage places are the manifestation of a heritage that is rich, varied and unique, and which stretches back at least 60 000 years. This heritage is increasingly cherished and valued by modern Australians and by the rest of the world. Heritage places are valued because:

- they are the product and witness of the different traditions and of the spiritual achievements of the past, and are thus an essential element in the personality of the people of Australia
- they illustrate, enliven and symbolize Australia's unique 60 000-year history
- they include examples of high artistic and creative achievement
- they are an inseparable part of the cultural landscape that provides Australians with an essential emotional and physical link with their past
- they have the potential to provide information of great value in many areas of research
- they are irreplaceable, but properly conserved and cared for are a usable and sustainable resource of great economic and prestige value for Australia, through tourism and adaptive use
- they have the capacity to significantly improve the quality of life for Australians, by providing a link for them with their past, by providing recreation and community use opportunities, and by their economic potential.

Ultimately, 'the supreme justification for conservation of the National Estate is the deep feeling of most Australians that their

descendants have the right to at least as many options in the cultural and national environment as they have themselves'.[14]

In our time the pressures of expansion and technological development have continued to threaten the common heritage of traditional buildings. A belief in development, often for its own sake, and in the virtues of profit as a measure of social benefit, has increasingly affected the stability of both the natural and the man-made environment. At the same time there is in the community an increasing sense of deprivation and dissatisfaction. There is an awareness that modern urban conditions, despite their provision of sophisticated amenities, often fail to satisfy some of the real and basic needs of life.

The disappearance of familiar landmarks and rapid changes in our surroundings can lead to a sense of insecurity. A 'built' environment should give a feeling of continuity and maintain a balance between the old and the new. A living community must possess visible reminders of the past as a stable and relevant backdrop to the activities of the present.

The growing interest in the preservation of old buildings is largely based on such foundations.[15]

≈

The women sat among the doomed things, turning them over and looking past them and back . . . How can we live without our lives? How will we know it's us without our past?[16]

≈

This personal testimony serves to illumine aspects of Aboriginal art. The site itself must be comprehended as frequently more meaningful than the art which covered it. For the appropriate social group, it was the locality which possessed life essence or totemic and mythological reality. The drawings on significant sites were simply the medium through which ancestral creation beings continued to influence every-day life.[17]

The nature of significance

General agreement in the community that heritage places have value is a prerequisite for their effective conservation: but more

than general agreement of their value is required for their management. For management purposes, it is necessary to assess in detail the particular value of individual heritage places. This task is not as easy as it first appears, and is the subject of Chapter 4, but here we will look briefly at the framework currently used to better define the value of places.

The term 'significance' is used in heritage conservation to mean the degree to which a place possesses a certain valued attribute, and is often used synonymously with the term 'value'.

The degree and type of value of a place will be different for various groups and individuals. All places are not equally significant or important, and consequently are not equally worthy of conservation and management. One of the roles of a manager is that of assessing the significance of heritage places, or understanding and weighing that assessment if it is carried out by specialists.

When it has been decided that a place is of considerable value, it is then necessary for the manager of this place to know and to act on the specific reasons *why* the place is of value; because these reasons should form the basis for management decisions. These different elements of significance have important implications for managers. If, for instance, the manager has evidence that a major value of a house is its setting in a historic landscape, the manager will probably advise against shrinking the curtilage and subdividing the landscape. To assist in the precise definition of significance in particular cases, the general category 'heritage value' or 'cultural significance' is more closely defined by workers in the field. There are many ways of doing this. Below are some of the subdivisions in common use, and which we find useful.

Community heritage values—historic, aesthetic or social

It must always be borne in mind that ultimately there can only be one valid reason for conserving heritage places: they are valued by elements of a community, by a whole community or by our society as a whole. The exercise of finding out why a place is important is necessary in order to arrive at a way of looking after the place so as to conserve that value for society. 'Public value' or 'community heritage value' are terms sometimes used to refer

to those elements of significance of heritage places that are most generally valued by communities—their historic, aesthetic and social attributes. The community, of course, doesn't necessarily use these terms when explaining why a place is valued: more often the values are interwoven into feelings of reverence for the age of the place, its place in the community's heart as a symbol or shrine for some past event or period, or its value as a landmark or familiar visual element creating for people a sense of place, or providing, in Helen Proudfoot's words, 'a trigger to the historic imagination'.[18]

Most people want to know about their past, and to see and hear about the evidence of it. They want to learn about past history, and some places are particularly suited to achieving this. Conservation of such places is important to national or local self-identity. These places commemorate or illustrate important achievements in architecture, in industry, in technology, or are associated with important historic figures or events. Many are also pleasing as works of art or craft: a well-designed building, a landscape or garden, an Aboriginal art site. All these elements contribute to the reasons why people value such places.

An example of a place with public value is Sydney Harbour Bridge—valued because its massive bulk has dominated the Sydney landscape for most of this present generation, and has come to symbolize the sense of place for most Sydneysiders. Many appreciate its aesthetic value. The bridge also has major historical value due to its role in the history of engineering and in the development of the largest city in Australia, but these are not necessarily central to why the community might value it.

The role of the manager is to recognize that what the community values may be made up of a number of different aspects of the place, and to understand how to identify and assess, and eventually manage the place to conserve those sometimes disparate aspects of significance. As the bridge between the community and the professions involved in the detail of conservation, the manager has to be able to understand and speak the languages of both groups.

Value to minority groups

Part of the value of cultural places is their special value to minority groups in the community. This may include people

from ethnic minorities, who have a particular interest in their own history. Value to minority groups is a very important part of the social value of sites. It is given a separate heading here precisely because it is a value often disregarded or downplayed by the majority culture. This point is further discussed in Chapter 4.

The most numerous places in Australia in this category are Aboriginal places of particular significance to Aborigines. All Aboriginal places have a general importance to Aborigines; they provide important evidence of Aboriginal history before 1788, and they play an important part in Aboriginal identity and cultural survival. Aboriginal significance may be:

- *traditional:* the place may be a sacred, or important religious site; for example, a place that has an important association with a cultural hero, or a place where a ceremony is or was held

- *historic:* the place may be important in post-European Aboriginal history—it may tell the story of Aboriginal contact with Europeans, or their subsequent history—a massacre site like Myall Creek (NSW) or a cemetery or an Aboriginal mission may be such a place[19]

- *contemporary:* the place may be a site with no traditional associations—it may be an archaeological site unknown to present Aborigines; but it may, when discovered, acquire importance to Aborigines because of what it symbolizes, and because it tells them about their past; for instance, sites at Lake Mungo (NSW), among the earliest known human occupation sites in Australia, are obviously of importance to Aborigines, though discovered and interpreted by archaeologists.[20]

In some areas of Australia there are many traditional Aboriginal and Torres Strait Islander places—in fact, whole landscapes—in other areas not many traditional places remain, but there are many sites of historic or contemporary significance to Aborigines. The nature of some places—their sacredness or significance to present Aboriginal people—has a fundamental effect on how they are defined or managed. Such places are more than heritage places to the Aboriginal community; and it is sometimes inappropriate to manage them in accordance with normal conservation practice. We discuss this in more detail later.

Some places have important values for other minority groups in Australia. In Queensland and northern New South Wales there are places of significance to Pacific Islanders, who are descendants of those transported to Australia during the infamous 'Kanaka' trade. Some of these places have historic and other contemporary significance for Islander groups.

Throughout Australia there are Chinese communities descended from Chinese who came to Australia during the gold rush and later. Places of significance to these communities include temples, cemeteries, ceremonial structures such as ovens, and now or in the future may include places where early Chinese activity occurred—for example, the goldfields (Lambing Flat, Palmer River), garden areas (Atherton Tablelands) and urban areas ('Chinatowns').

Other examples of places of significance to ethnic groups include the German settlement areas in South Australia, the Japanese sites in north-western Australia associated with pearl fishing, Greek sites in Melbourne and Sydney, the nineteenth-century Italian settlement area at 'New Italy' in northern New South Wales, and German, Italian and Japanese prisoner-of-war and internment camps, and migrant hostels. The meaning and significance of many of these places to particular groups in the community is only now being considered. In the past, such places have often had significance attributed to them by the dominant cultural group, without reference to the ethnic group that gave rise to them.

Different cultures have different traditions about the past and its proper treatment. Our rather formalized and categorizing systems for heritage management (of which this book is part, for example) may not be the most appropriate way of dealing with the places of minority cultures. Clearly their significance in their traditional culture, rather than in that of the dominant culture, will be of paramount importance in their management.

Scientific or research value

Many places contain information of great value. They reveal information about earlier technology, architecture and environments, and sometimes about otherwise unknown past occurrences. They are therefore important for historic, prehistoric and environmental research. Often this information is extracted by archaeological techniques.

Aboriginal occupation sites or campsites, for example, tell us about the Aboriginal occupation of Australia. Research at these sites provides scientific and archaeological evidence about Aboriginal culture and physical anthropology For example, at Kuta-Kina Cave on the Franklin River in Tasmania, the 20 000-year-old remains of numerous wallabies tells us that they lived here in great numbers during the ice age; and that Tasmanian people lived and hunted them on the edge of the southern glaciation, both important facts previously unknown. Such places are important not only for the history of Aborigines but for the history of human evolution, and of life on earth.

Historic places may also tell us about Australian history; or about past events, technology or social life. For example, one of the fields of interest of both prehistorians and historians is how a culture copes with changes in environment, and what patterns of adaptations can be observed.

Significance and society

There are many ways to divide, assess, analyse and determine significance. The divisions given above are not exhaustive or proscriptive. They also overlap; these are not hard or quantifiable values. Some places, indeed most, will have more than one value. For example, an architecturally significant building (an important example of, say, a regional architectural form) may also be historically important (as, say, the long-time residence of a nationally important figure). Each element of the value of the place must be identified, and considered in depth when management decisions are being made.

The significance of a place to a local community may not be as easy to define as some of the types of significance discussed so far. One of the key social values places may have is their role in establishing and maintaining a community's sense of place and of belonging.

In the final analysis, heritage places are not significant by their nature; they are given value by human beings. Their value rests in their perception by the community. Significance is wholly a human artefact or concept; as such it is as fluid, complex and dynamic as society's multilayered and changing value system.

This has a number of implications for managers. They must recognize and respond to society's perceptions and expectations about the value of heritage places, but at the same time they

must be aware of the forces and values shaping these perceptions, and maintain, in so far as it is possible, a balanced view about the nature of the particular significance of a place.

This is necessary because, especially in the short term, there may be a mismatch between society's perception of the significance of a heritage place, and the factual information available to us. This may arise through ignorance, through prejudice, or through deliberate manipulation. The ruins of a building at Bittangabee, on the south coast of New South Wales are undoubtedly associated with the early settlers and developers, the Imlay brothers. Yet popular tradition has it that they are the remains of sixteenth-century Portuguese settlement. The manager's role is to sort out and disseminate the facts, while acknowledging the strength of popular belief.

Similarly nineteenth-century colonial history, and heritage places associated with it is often sanitized by the descendants of pioneers, and whole elements—the Aborigines, the servant classes, the role of women—are omitted or marginalized. Here the manager's role is to ensure that the whole story—all the elements of significance—are revealed and considered.

The 'catch 22' is that the manager is part of society, and subject to the same range of influences and prejudices as anyone else. This is what makes the manager able to appreciate and incorporate society's views. At the same time it necessitates the rigour and objectivity of the processes of significance assessment (see Chapter 4).

The range of heritage places in Australia

What is the range of heritage places in need of management? What is the resource we are trying to identify and protect in the process? As outlined earlier in this chapter, a heritage place may be any physical manifestation of human activity associated with a particular locality. It may be a site plus its buildings, Aboriginal artefacts, or other human works. It may also be an area of land with no physical remains of human activity, but one which has instead strong associations with some historical event or cultural sentiment lending the place cultural importance. It may be a landscape with strong aesthetic or historic value. Examples might be a tree or mountain important in Aboriginal tradition, an explorer's first landfall or campsite of critical importance in

inland exploration, or the place where some event of national significance occurred.

We are dealing with *places* and the management of them in the context of land management. A critical element of place is that the conjunction of location and human action or association be retained. An artefact, a piece of equipment, or a whole building, removed from the site with which it is historically associated, may lose much of its cultural value, or at least its value to society changes. It becomes an *object* rather than a component of a place, and the ground rules for its conservation and management change dramatically in many cases, and may be beyond the scope of this book. This distinction tends to become vague around the edges: there are buildings that were traditionally moved around the countryside, and there are engineering works (trains, for example) that are by nature mobile, but are an integral part of a place (that is, the railway). As a rule of thumb, if the current association of building or work *and* its present site is of cultural significance, then it is a heritage place. If the building or work is not associated with its traditional location, but is significant because of its own intrinsic interest, then it could be considered to be a museum or art object, and its conservation planned without reference to the consideration of place.

A factor that can strongly influence the management of cultural places, but not often referred to in publications on the subject, is the location of the place in an urban or non-urban environment. The vast majority of conservation literature is oriented, explicitly or implicitly, to urban contexts, or to the techniques of building conservation that can be applied, to some extent, anywhere. To a degree this orientation is to be expected, considering that the emphasis in conservation publications has been on the built environment, and that the vast bulk of the built environment exists in urban contexts. Land managers, however, are concerned with non-urban as well as urban areas, and to date have had to try to adapt approaches designed for the city to a rural or bush context. In this book we have tried to use both urban and non-urban examples to illustrate the principles and processes of conservation.

Heritage places are both widespread and numerous. Aborigines have occupied Australia for at least 60 000 years and have lived in every environment and in every extreme of climate, past

and present. The places where they lived, and the evidence of their occupation such as campsites, and stone tool or shell scatters, are innumerable. Even art sites are extremely common in some areas. For example, more than 3000 rock engraving sites have been located in Sydney sandstone, many within urban areas. Some of these sites are of great importance, others minor; the point is simply that heritage places, and their management problems, are everywhere.

At the same time, many sorts of heritage places are difficult to recognize without specialist training or assistance. Most people cannot tell a piece of rock from a stone tool and would have little chance, unaided, of recognizing an archaeological site. Anne Bickford and Helen Proudfoot found one of the most important historical sites in Australia—the archaeological remains of the first Government House, under the tarmac and cement of a vacant city block—through a process of historical research and test excavations. To the passer-by it was just another car park.[21]

There is no substitute to training and experience in the recognition, location and assessment of heritage places. A comprehensive description of site types and their characteristics would be another book. What follows is simply a broad résumé of the range and variety of heritage places.

There have been many approaches developed to index the range of places making up the humanly modified environment. The National Trusts have such checklists, as do most of the government agencies involved in conservation. However, there is not, as yet, any generally accepted classificatory system for cultural places, and such classificatory systems have their own dangers. What is outlined here, therefore, is simply designed to indicate the wide-ranging nature of activities that have contributed to the resource.[22]

Perhaps the most numerous of cultural places are the places where people have lived. Everyone who ever lived has resided somewhere, and a large number of *residential places* have survived long enough to be of value to us. They reflect how people in the past lived, and they add diversity to the areas where we now live.

Contrary to popular belief, Aboriginal people did not wander aimlessly and endlessly across the landscape. They followed seasonal patterns of movement and often lived in semi-permanent

Houses are
> the commonest of all historic artefacts and the most numerous item in the built environment. The starting point is the belief, expressed a century ago by John Ruskin, that buildings are 'documents embedded in time'. Houses especially, being intimately and intensely used by people are among the most authentic and interesting of heritage documents.
>
> While people are often not aware of the historical significance of houses, they are for most of us inescapable parts of our physical environment. We work, play, eat, sleep and die in them, and so they teach us profoundly. They shape our cities and towns, over suburbia and our streets, affecting the whole of our environment. In the words of Winston Churchill: 'We mould our buildings and then our buildings mould us'.[23]

∼

> Further down, near Menindee, Mitchell found a native village, in which the huts were of a very strong and permanent construction. One group was in ruins, but the more modern had been recently thatched with dry grass. Each formed a semi-circle, the huts facing inwards, or to the centre, and the open side of the curve being towards the east. On the side of the hill of tombs, there was one unusually capacious hut, capable of containing twelve or fifteen persons, and of a very substantial construction, as well as commodious plan, especially in the situation for the fire, which without any of the smoke being enclosed, was accessible from every part of the hut.[24]

locations. In some cases generations of Aborigines returned to the same rock shelter or location for more than 20 000 years. These living places have immense value and potential for information. Many Aboriginal occupation sites contain or are associated with ancient and spectacular paintings and engravings.

In some areas traditional Aboriginal dwellings (gunyahs) still exist, as do their more recent adaptations. Miners' humpies, rural homesteads, stockmen's huts, inner urban terraces, suburban bungalows, and housing commission apartment blocks, are all familiar elements of the environment in which we live. All are not worthy of conservation and management, but a proportion

of them, a sample representing that range of residences, should be kept to exemplify the diversity of lifestyles in Australia's past.

The next most numerous type of cultural place is related to *commercial and trade activity*. In the case of Aboriginal sites, the exchange of raw materials and manufactured goods between Aboriginal groups is being increasingly studied, and places relevant to this exchange system have been identified. These include traditional trading areas such as the big campsites on the inland rivers, near stone fishtraps or other food sources.

In the historic era commercial buildings and sites of all sorts are very common: shops, markets, warehouses, commercial office blocks, department stores, hotels, restaurants, etc.

Industrial places are as old as human occupation. Aboriginal 'workshop' sites fall into this category, places where stone tools, nets, etc., were manufactured. Axe-grinding grooves are a very common example of this type of place.

Scarred trees show evidence of the removal of bark or wood for canoes, dwellings and tools. Many Aboriginal places of this sort are associated with *subsistence activity* such as food preparation: seed grinding patches, ovens for steaming food, and animal butchering sites, for instance. Stone fishtraps are common on the coast and on inland rivers.

The immediate image of modern industrial sites is of steel mills, factories, foundries, engineering works and the like, but it also includes a wide range of other industrial processes. The manufacture of building materials (brickworks, cement works, extraction and milling of timber, pipeworks, paint manufacture, etc.), foodstuff (canneries, factories, abattoirs, bakeries, bottle production, breweries etc.), clothing (tanneries, woollen and cotton mills), extractive or exploitive industries (whaling, forestry, fishing, sealing), all may be significant. Engineering services such as sewerage, electricity, and water supply must also be considered.

Mining and quarrying have had a major impact on the development of Australia, and while goldmining has been well recognized as an industry worth commemorating by conserving places, other mining has not been so well represented. Extraction of stone and ochre by Aborigines is well attested but little known to the public, and the protection of such sites is of extreme importance. Silver, copper, coal, lead, zinc, molybdenum, opal, talc, marble, building stone, lime and many more types of mining

It cannot be said too loudly that Australia's heritage of industrial remains is of international significance. Because so many extractive industries were situated in the bush, because of the spaciousness of the country, and because of economic stagnation in many country towns since 1911 or so, many old industrial buildings remain much as they were; they have not been recycled or destroyed. Moreover, a significant amount of heavy machinery also remains on sites, often after being moved from another location; the 'tyranny of distance' has saved remarkable things from the scrap-metal dealer. It never fails, for example, to excite the visiting British archaeologist that so many stamper batteries survive, more or less complete, some still in working order, standing near their mine-heads: in all the length and breadth of Britain only one stamper battery survives, at Tolgus in Cornwall.[25]

and quarrying are as yet poorly represented by conserved examples. Mining sites also tend to be under particular threat, as the fluctuating metals market creates a cycle of reworking, which often leads to the destruction of the evidence of earlier extraction methods. The famous goldfields of Victoria and Western Australia, for example, are rapidly being transformed through the use of modern mining techniques, and old headframes, crushing works, smelters and workings are disappearing at an alarming rate. Aborigines mined ochre for art and decoration, and stone for tools such as grinding stones and hatchets, and these sites are also numerous.

Similarly under threat are many kinds of *agricultural places*. Pastoral remains (woolsheds, stockyards, wool scours, dips, shearer's quarters, homesteads, fencing, etc.), farming places (dairies, barns, oast houses, granaries, vineyards, silos, orchards, field systems, etc.) and associated industrial activities such as flour-milling and winemaking, are all under pressure from new technologies that are rapidly changing the face of the agricultural landscape. It is worth considering that government reserved land, such as national parks, may well be the only places where the remains of, say, large-scale pastoralism of the nineteenth century, may be able to be seen in the twenty-first century. It is therefore essential that managers of these reserved lands consider the value of these resources before deciding on action that might lead to their destruction.

Wilgie Mia—Aboriginal quarry, Western Australia

Western Australia boasts the immense ochre mine at Wilgie Mia. A hillside is virtually an open cut, varying between fifty and a hundred feet in width into the hill. The excavation represents the removal of several thousand tons of rock, and there is ethnographic evidence that wooden scaffolds were propped against the rock to assist quarrying operations. Heavy stones were used as mauls for battering the rock, while wooden wedges up to eighteen inches in length were driven in to prise out the thick red or yellow ochre seams. The cavity floor is stratified in places to a depth of almost six metres, and fortunately local conditions have preserved the wedges throughout the deposit.[26]

~

Sons of Gwalia Mine—European mine, Western Australia

The Sons of Gwalia Gold Mine near Leonora, commenced large-scale operation in 1897. The town of Gwalia grew up around the mine as the mine prospered. A massive headframe was erected over the main shaft, much of it under the supervision of the then mine manager, Herbert Hoover, later to be President of the United States of America. The mine, its headframe, and the village of Gwalia survived into the 1980s, while other early relics of the Western Australian goldfields around it were disappearing as a result of massive remining by open-cut methods.

At the request of the Western Australian Heritage Committee, the South Australian Department of Environment and Planning's Heritage and Conservation Branch sent expert researchers to record and assess the mine and village. Funding was obtained for conservation works through the Commonwealth's Community Employment Programme. Despite all this activity and support, the mining company leasing the site could not forego the mineral trapped beneath the mine area. In the absence of any state heritage legislation the mine and headframe were disassembled and the site open cut. The intention was to re-erect the headframe away from the gold lease area. However, the 'mine', the original 'place', is now lost forever.

Places associated with government and community services are prolific. Into this category fall parliament houses, official government residences, public service offices, post offices, police stations, court houses, prisons, schools, hospitals, military sites (barracks, fortifications, bases), customs buildings and municipal buildings and services (town halls, libraries, museums, galleries). Aboriginal sites relating to the recent past are often associated with government or community service activity. Mission and government settlements, in particular, are numerous and important.

Transportation is another source of a wide variety of cultural places. Along the inland rivers are to be found great river red gums, with huge scars showing the removal of bark for canoes. Bark canoes were developed by Aborigines, and later used by early European settlers.

Later water transport has associated wharfs, docks, shipyards, harbour facilities such as breakwaters, and navigation facilities such as beacons and lighthouses. Railways in the age of steam required water towers, coal-loaders, stations, round houses, workshops, bridges, tunnels, tracks, signal systems and trains. All of these are threatened by the demise of steam and the upgrading of rail systems by modern technology and modes of operation. Road transport has left bridges, roadways, massive earthworks and cuttings, culverts, toll-houses, weighbridges, coaching stables, horse troughs, petrol stations and garages. Less common land transport remains include tramways, pack routes, cableways and

Tathra Wharf, New South Wales

The wharf at Tathra, near Bega on the NSW South Coast, started life as a jetty in 1861. The wharf was added to progressively, reaching its heyday as a major deep-water wharf in the period 1908–13, at which time it had sub-deck landing stages, cattle yards and loading ramp, storage sheds, a crane, and spring buffers to prevent ships crushing the wharf in heavy swells. The wharf has survived, while others of its kind have been demolished since the cessation of the coastal shipping trade in the 1950s.

The National Trust of Australia (NSW) has struggled long and hard to achieve the conservation of the wharf, and largely by means of commercial sponsorship is now achieving this.[27]

foot-tracks. Places associated with air transport have received
little conservation attention, but Australia possesses a range of
quite early aircraft hangers, airfields and support structures
which deserve consideration by the managers of those areas.

Shipwrecks ring our extensive coast, evidence of the dangers
facing our travelling forebears, and a wonderful source of cul-
tural information. The earliest known shipwreck in Australian
waters was that of the English ship *Trial* (1622). Better known is
the Dutch ship *Batavia*, which went aground, with almost un-
believably bizarre and gruesome results for those shipwrecked,
on the Abrolhos Islands in 1629.

Historic shipwrecks of all ages are protected around Australia,
under the Commonwealth's *Historic Shipwrecks Act* 1976.

Sites of religious or spiritual importance are also widespread.
Ceremonial rings and other places, of earth or stone, with
associated carved trees or paintings and engravings, are spread
throughout Australia. Features of the landscape—trees, rocks,
mountains, rivers—are sacred; as are places embodying or com-
memorating ancestral hero figures. These places, and places
where initiation or other ceremonies are or were held, are often
known only to their custodians and traditional owners. Churches,
and Chinese and Indian temples, also fall into this category.
These places often have heritage value; but they are, pre-
eminently, part of a living religious system, and their manage-
ment must recognize this.

Aboriginal art sites are widespread, numerous and diverse.
Engravings and paintings are often associated with living and
ceremonial sites. The tradition dates back at least 20 000 years,
and Australia has the greatest and finest corpus of such sites in
the world.

Cemeteries and burial grounds are also numerous. Aboriginal
burial sites include the oldest known ritual cremation in the
world, cemeteries of 300–400 individuals, tree burials, mummifi-
cation and elaborate memorials and tombs. Early European
cemeteries are also numerous. They are a source of endless
fascination and contemplation, as well as containing valuable
genealogical and other information, and representing a major
element of art in masonry.

Many *historic sites* are valued by society, despite having no
physical remains associated with the historic event or association
being commemorated. Common examples are explorers' camp-

The *Batavia* wreck

The Dutch East India ship *Batavia* was wrecked on the Houtman Abrolhos Islands off the Western Australian coast while on her maiden voyage from Amsterdam to Batavia (Djakarta in Indonesia) in 1629. When the ship struck a reef, more than 250 of the people aboard managed to reach a small group of islands, but 40 drowned in the attempt. A senior company official, Pelsaert, and Captain Jacobsz, sailed off to Batavia for help in a boat with 49 crew. Meanwhile the supercargo, Jeronimus Cornelisz, assumed command of the survivors. Having earlier plotted to mutiny and seize the ship, Cornelisz now decided to carry out his plan when the rescuers arrived back at the island. This necessitated getting rid of the crew members not loyal to him. With his followers he murdered 125 men and women, but a party of men under Wiebbe Hayes held out against Cornelisz on another island. Hayes succeeded in capturing Cornelisz, and when Pelsaert returned in the rescue ship *Sardam* he captured the remaining mutineers, executing some on the islands, marooning two on the mainland of Western Australia and returning the rest for punishment in Batavia.

The ship *Batavia* lay on the sea-bed until rediscovered in 1963. The wreck was excavated by the Western Australian Maritime Museum's archaeologists between 1974 and 1976, and a large section of the ship's hull is now being put on display in the Museum, together with a large collection of objects raised from the site, including an entire stone gateway intended for the entrance to the port of Batavia.[28]

～

The *William Salthouse* wreck

The brig *William Salthouse* was wrecked in Port Phillip Bay (near Melbourne) in 1841, at the end of a voyage from Canada bringing a cargo of salted pork, beef, fish, barrels of flour, wine and hardware to the colony. The wreck was test-excavated by the Victorian Archaeological Survey in 1983, and a largely intact cargo of barrels was located. It is this cargo that is the real value of the wreck, as even after minimal test excavation it has already revealed much about nineteenth-century cargo regulations and their flaunting, and raises questions about the nature of the goods being imported into Victoria at this early date.[29]

sites, landing-places or routes, the sites of Aboriginal massacres, and 'first' settlements by Europeans in the various colonies.

Other types of heritage places are numerous, including *scientific research establishments, telecommunications stations* (for example, space communications bases), places of *recreation and entertainment* (for example, racecourses, funfairs, theatres, etc.), and *monuments and memorials* reflecting past events and cultural attitudes towards them.

Cultural landscapes are an important part of our heritage. They can present a cumulative record of human activity and land use in the landscape, and as such can offer insights into the values, ideals and philosophies of the communities forming them, and of their relationship to the place. The study of cultural landscapes can suggest the feelings of the community towards its environment, and indicate the social networks developed by the community. Cultural landscapes have a strong role in providing the distinguishing character of a locale, a character that might have varying degrees of aesthetic quality, but, regardless, is considered to be important in establishing the communities' sense of place.

Though for the purposes of this book, we speak of the identification and conservation of places, and must define their boundaries, it is important, always, to consider them in their context. Aboriginal people hold particular places to be sacred, as an apotheosis of their ancestral beings. But these particular places are merely pinpoints, or markers in a sacred landscape, and derive their value and significance from the context, the resonance, and the significance of the landscape itself, which was made by the ancestor, and is part of that ancestor's dreaming track. In the same way other heritage places cannot be cut off from their cultural context—the wider, local regional and national story—of which they are a manifestation. When they are not seen in their context they lose a great deal of their significance, richness and depth of meaning. In short, if we consider that heritage sites are manifestations of our national story, we must keep that wider story before us, in all its multi-faceted complexity, when we study them.

It should also be remembered that the artefacts and equipment associated with a place may contribute greatly to the significance of that place. A nineteenth-century flour-mill with its machinery intact is likely to be much more important than a similar mill

that has lost its machinery. A house of a particular style may be of much greater value if it contains original furnishings and finishes, a situation every house-museum curator dreams of. A shipwreck site, or dry-land archaeological site, may be of value solely because of the collection of artefacts it contains. The manager of cultural places must therefore be alert to the way in which artefact and place interrelate, in order to make rational management decisions to preserve that association.

Heritage and its inheritors

Probably the most important thing to remember about heritage places is that they belong to the society that values them. Heritage is for people: it is of no use and no interest otherwise. It is easy for a manager or heritage expert to create an elite and precious atmosphere about cultural conservation that removes cultural places from their proper place in society. It is important for heritage managers, by every means in their power, to stay close to the 'grass roots', where history is made, and remade.

At the same time, by being aware of the wide range of heritage places, and their novelty, it is possible for managers to bring to the attention of the community the existence of a place they believe to be of value to it: to make available for public access places not previously known or appreciated. Examples are in the First Government House site in Sydney, the ice-age Aboriginal sites in Tasmania, and the Dutch shipwrecks of Western Australia.

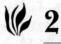 **2**

The Legislative and Administrative Framework

The management of heritage places, at whatever level, takes place within a legal and administrative framework established by governments. Australia has a great range of heritage legislation, of varying degrees of effectiveness. This effectiveness depends on the quality and comprehensiveness of the legislation, the zeal and wisdom with which it is implemented, and the adequacy of the administrative and technical systems and financial resources supporting it.

Though there is no doubt that from the point of view of heritage place management much legislation is deficient, or difficult to use, it is still a crucial tool. It can also be a constraint upon the actions of managers. It is therefore essential for the manager to know what the legislation is, how it can be used, what its limits are, and how it affects the management of Aboriginal and historic places. The relevance of the legislation in different states to heritage place management will vary according to circumstances. It may be that there is little relevant specific legislation in a particular state, or that cultural places under the manager's control are protected by virtue of their specific land status, for example, in a national park, or as a historic house or bank owned by a local council. However, in most circumstances, the legislation will say something of the government's intentions, and act as a tool to assist in the management of the resource.

The range of legislation, the sometimes complex interaction between the administration of different Acts, and the myriad of details about the operation of each bit of legislation, dictates that this chapter concentrates on giving just the outline of the legal situation in each state and territory, without going into details. Each manager will have to find those parts of the legislation that impact on particular management circumstances, and it is up to the manager to seek out the details necessary to successfully use the law to help conserve the heritage place.

Effective legislation

Some of the characteristics of effective heritage legislation are as follows:

- It is closely linked to and provides for an effective administrative structure, and ongoing financial support, by way of a special fund or legislatively provided income.
- It acknowledges those groups particularly and traditionally linked to the heritage it protects, and provides specific custodial and consultation rights for those groups.
- It places emphasis on positive and enabling provisions—for example, tax incentives, and other benefits, education provisions, listings of significant places.
- It protects classes of places or objects, without the necessity for their particular listing (though the particular listing of significant places is also desirable). For instance, the NSW *National Parks and Wildlife Act 1974* legally protects all Aboriginal sites ('relics'), regardless of whether they have been formally registered.
- It has the minimum deterrent clauses necessary for its effectiveness, concentrating on those major issues that are enforceable.
- It provides penalty clauses that are real deterrents (for example, loss of development rights).
- It provides specifically for public involvement and public education.
- It recognizes and balances the right of both the individual and of society in cultural property.
- It provides for an effective field management component (for example, rangers, field officers, provision of expertise, etc.).

- It is closely linked to or embodies land planning, environmental impact assessment and land management provisions.
- It is administratively as simple as possible, with as little red tape and as few approval processes as possible.

In reality, few individual pieces of legislation will incorporate all of these considerations, but some states achieve many of them though a range of more or less related bits of legislation that address the separate aspects.

Legislation and politics

Regardless of its quality, legislation is an expression of the will of the people. It exists as an acknowledgement of society's concern. This is a very important, often symbolic, value that attaches to legislation: it can be used by the manager as a powerful basis for arguing for the protection of a particular place, or for general conservation promotion. This may be the case even when the law lacks specific protective powers. For instance, the statement that a place is 'on the World Heritage List' or 'on the Register of the National Estate' may have a powerful effect on decision makers, even though this may not mean that the place is protected by law, from a particular intended action. The message the decision maker gets, in this case, is that society has considered the place important enough to invoke a legislative measure—its formal recognition and listing as an item of heritage significance.

Conversely, because it is an expression of political will, effective legislation is not always an ironclad guarantee of protection. If a government finds a particular element of a piece of legislation politically inconvenient at a point in time, it can usually find a way around it, even when the legislation is strong. Governments, for instance, have had recourse to special Acts of Parliament to exempt particular areas or developments from the provision of planning or heritage Acts; or, more simply, have declined to list on relevant registers areas of undoubted significance, to save the bother and protest associated with overriding such listings to allow development. In such cases the original legislation remains intact, but is ineffective in protecting the place that has been the subject of a land-use conflict, and of course is correspondingly weakened.

Legislation and management

Even at its most effective, however, legislation should be seen by the manager not as a solution to management problems but as a framework within which to work. Much of the heritage place manager's efforts and actions will have no direct legislative base. For instance, the erection of signs, the maintenance of a local site register, the provision of interpretive information, or the physical conservation of a place, while being desirable and necessary steps in certain circumstances for successful management of a place, need not be (and indeed usually are not) specifically directed or required by law.

Anyone who takes the law as a bible, and as the limit of involvement in the management of heritage places, will not carry out much active management, and indeed will be guilty of damage caused by neglect. This would be true even if the law were perfect. It is not designed to give detailed instructions concerning desirable practices or to prohibit detailed lists of sins against cultural resources. Legislation is not a recipe for heritage place management; it is an expression of the community's wish for such management, and, if properly written or used, is a useful tool.

Types of legislation

There are four types of legislation in Australia bearing to varying degrees on the management of heritage places:

1 Aboriginal and historic sites protection Acts

These usually specifically protect either Aboriginal or historic places, seldom both. Often all Aboriginal sites are protected *as a class*. In most cases, to be legally protected, historic places have to be individually identified and listed in some way. These Acts are called 'relics' or 'heritage' or 'sites' Acts, or 'historic conservation Acts'. They usually contain two types of clauses:

- prohibitive, which make it illegal to do certain things to places,

- affirmative, which encourage active conservation provision for reserves, for advisers, for funding, or for research.

Sometimes these Acts include protection for elements of the natural environment as part of the heritage (for example, the *NSW Heritage Act 1977*).

All states and territories now have some form of protection for Aboriginal sites, and all states and territories except Tasmania have legislation protecting the historic heritage.

2 Notification Acts

A small group of Acts, namely the National Trust Acts and the *Australian Heritage Commission Act 1975*, establish as their primary function the compilation of registers of Aboriginal and historic places. The registers have no direct legal effect (except, in the case of Commonwealth actions, the National Estate Register), but act as early warning systems to notify the government and the public of the existence and value of heritage places, and offer authoritative comment if these places are threatened in any way.

Some other Acts, such as the *South Australian Heritage Act 1978*, the *Victorian Historic Buildings Act 1981*, the *Queensland Heritage Act 1992*, the *Western Australian Heritage Act 1990* and various Aboriginal sites protection Acts, also establish registers, which can act in the same way. However, these registers have additional legal sanctions attached to them, which place them in the first category of Acts described above.

3 Land or site management Acts

These establish government and statutory level conservation and management services, such as the legislation establishing National Parks and Wildlife Services, Forestry Commissions and Historic House Trusts or History Trusts. They often incorporate provisions to protect Aboriginal and historic places occurring in the areas of land being managed by that authority. In some cases there is also provision for the gazettal of additional land solely for the purpose of protecting and managing heritage places. In the case of historic places, the powers of these authorities are usually limited to the land that they administer or acquire. In the case of Aboriginal sites, the powers of some of these statutory authorities are extensive enough to put them into category of protection Acts described above.

In the interests of effective management of government-owned heritage places, it would be desirable for more government

departments to be made responsible for the conservation and management of heritage places lying on lands that they administer. In most cases this responsibility is currently perceived as applying to 'important' buildings only, some governments requiring their departments to fund works on such buildings through the respective public works departments. In New South Wales and Victoria, at least, government departments are being pressured by the state heritage bodies to identify heritage places under their control.

4 Planning legislation

These include a range of environmental planning Acts, Crown Lands Acts, and local government Acts, incorporate provisions that establish specific planning measures to ensure preservation of heritage places, or allow the reservation of land for conservation purposes, including heritage place conservation. Such Acts often refer only very briefly to such matters, but can be very important. The primary heritage reserves protection Acts in some states (discussed above), sometimes operate to a large extent through the specific provisions of the planning Acts.

The effectiveness of planning legislation for the purposes of heritage protection varies from state to state. In states such as New South Wales and South Australia where it is linked to the heritage Acts, planning legislation can provide a process for implementing heritage protection regulations and controls. In some states, such as Queensland, clauses allowing for such things as compensation for 'injuriously affecting' private property can effectively ensure that the planning Act is seldom, if ever, used specifically for heritage protection. Where planning legislation is closely linked to heritage protection, it is referred to in the state and territory sections below.

International conventions and recommendations

Australia is a signatory to, or a supporter of, several conventions and recommendations promulgated by UNESCO. While these will be of little direct relevance to most heritage place managers, they do put the current philosophies and practices of heritage

place management followed in Australia into an international context. In a discussion of these international conventions and recommendations, David Yencken has pointed out that

> while Australia has met most of its obligations under the Conventions it has ratified, it has been slow in some instances to take follow up action . . . There are other Conventions it should ratify . . . and . . . Australia falls far short of the standards set down by many of the international recommendations.[1]

International agreements have political and moral weight and important implications for the actions of national governments, as was shown in the case involving south-western Tasmania. The major convention affecting cultural places is the *Convention of the Protection of the World Cultural and Natural Heritage 1972* (the World Heritage Convention). Ratified by Australia in 1974, the convention requires signatories to adopt general policies, establish appropriate organizations and services, and develop suitable legal, technical scientific and financial measures for the protection, conservation and presentation of the cultural and natural heritage, and to submit an inventory of properties suitable for inclusion on the World Heritage List. The Australian government is a keen supporter of the World Heritage List concept. To ensure protection, and for reasons of prestige, Australia and other countries are eager to have places listed by the World Heritage Committee. By 1993 the Great Barrier Reef (Qld), the Willandra Lakes Region (NSW), Kakadu National Park (NT), Western Tasmania Wilderness Parks (Tas.), Lord Howe Island Group (NSW), Uluru National Park (NT), Wet Tropics of Queensland (Qld), East Coast temperate and subtropical rainforest parks (NSW), and Shark Bay (WA), had been listed. All of these areas have significant natural environmental values, and Kakadu, Willandra Lakes, Uluru and south-west Tasmania have equally important cultural values. This cultural value is based in the important Aboriginal sites in these areas. For example, the Willandra Lakes were considered to have cultural value as being the (then) earliest known Australian human settlement site.

The Australian government, in asking to have these places listed, had to show that the places would be appropriately managed as items of world heritage importance.

The criteria applied by the World Heritage Committee in evaluating nominations for the World Heritage List for cultural reasons (as revised in March 1992) are that the place must:

i represent a unique artistic achievement, a masterpiece of the creative genius; or

ii have exerted great influence, over a span of time or within a cultural area of the world, on developments in architecture, monumental arts, or town-planning and landscape design; or

iii bear a unique or at least exceptional testimony to a civilization or cultural tradition that has disappeared; or

iv be an outstanding example of a type of building or architectural ensemble or landscape that illustrates (a) significant stage(s) in human history; or

v be an outstanding example of a traditional human settlement or land use that is representative of a culture (or cultures), especially when it has become vulnerable under the impact of irreversible changes; or

vi be directly or tangibly associated with events or living traditions, with ideas, or with beliefs, with artistic and literary works of outstanding universal significance (the Committee considers that this criterion should justify inclusion in the list only in exceptional circumstances or in conjunction with other criteria);

and

i meet the test of authenticity in design, material, workmanship or setting and in the case of cultural landscapes their distinctive character and components (the Committee stressed that reconstruction is only acceptable if it is carried out on the basis of complete and detailed documentation on the original and no extent on conjecture);

ii have adequate legal and/or traditional protection and management mechanisms to ensure the conservation of the nominated cultural property or cultural landscapes. The existence of protective legislation at the national, provincial or municipal level or well-established traditional protection and/or adequate management mechanisms is therefore

essential and must be stated clearly on the nomination form. Assurances of the effective implementation of these laws and/or management mechanisms are also expected. Furthermore, in order to preserve the integrity of cultural sites, particularly those open to large numbers of visitors, the State Party concerned should be able to provide evidence of suitable administrative arrangements to cover the management of the property, its conservation and its accessibility to the public.

Cultural heritage properties listed on the World Heritage List to date have tended to reflect a Eurocentric view of what constitutes cultural heritage values. They tend to be monumental works of scale and grandeur, and to relate to pre-industrial civilizations. Neither the sophisticated and subtle Aboriginal places that 'touch the earth lightly' or the recent colonial remains of European settlement in Australia are seen by many European experts, at first glance, as possessing the necessary characteristics for listing. This both provides a challenge to which Australia is rising, and provokes interesting and challenging debates about the nature of heritage.

The Australian government has not yet achieved the listing of a place solely on the basis of its cultural value. Presently it is proposing the listing of the Sydney Opera House, and is investigating a nomination covering major convict places, and one or more for significant Aboriginal places (for instance, the cave paintings of Cape York or the Kimberley). Aboriginal groups are enthusiastic about a relisting of some World Heritage places to more clearly articulate their cultural value. Uluru is such a place.

In 1983 the Australian government passed the *World Heritage Properties Act*, and successfully defended it in the High Court, enabling the government through its external affairs powers to prevent Tasmania from building a dam in a World Heritage area. The government was able to argue successfully that it had powers and obligations in this area because it was a signatory to the World Heritage Convention. The provisions of the Act have more recently been brought to bear on the protection of the Queensland wet tropical rainforests area.[2]

Briefly, this Act provides that on any property submitted by the Australian government and declared a World Heritage Property, it is unlawful for a person, foreign corporation, or trading corporation to carry out excavation works, mining exploration

or works, erect buildings, damage standing buildings, damage or kill trees, construct roads, use explosives, or carry out any other specified act without the minister's consent, where a proclamation under the Act has been made. Such proclamations can be made where:

- the property has been nominated for World Heritage Listing at a state's request
- protection of the property is a matter of international obligation, treaty, or international concern, where failure to act would prejudice international relations
- the place is part of the heritage distinctive to the Australian nation by reason of its aesthetic, historic, scientific or social significance, or its international or national renown.

Some sections of the Act protecting Aboriginal places were held to be invalid by the High Court, and have subsequently been amended.

Under the Act any interested party or the Attorney-General can seek an injunction through the High Court or federal court to stop any action mentioned in the Act.

This situation—the passing by the Australian government of legislation enforcing World Heritage protection provisions in Australia—was necessary to allow the listing and the protection of places that state governments wished to develop (for instance, by hydroelectric schemes, and logging). This is, in turn, a result of the Australian federal system, which traditionally assigns land-use decisions to the states.

The result of federal action, both to list and protect areas, has caused a degree of backlash among state governments and some local interests. Because of this history, proposals for World Heritage Listing can cause concern and opposition in some quarters, far in excess of most overseas experience. On the other hand, there is strong support from the community in general, the conservation movement and the tourism industry. (A recent detailed survey of the people of Cairns showed that 80 per cent now approve of World Heritage Listing of the Wet Tropics and management for conservation, though there was a vociferous campaign against it.)

Australia is a supporter of many UNESCO recommendations relating to the management of heritage places. These are too lengthy to discuss fully here, but a useful summary of the most

important recommendations is given in David Yencken's review *Australia's National Estate: The Role of the Commonwealth.*[3] The recommendations include:

* Recommendation on International Principles Applicable to Archaeological Excavations, 1956
* Recommendation Concerning the Safeguarding of the Beauty and Character of Landscapes and Sites, 1962
* Recommendation Concerning the Preservation of Cultural Property Endangered by Public or Private Works, 1968
* Recommendation on Participation by the People at Large in Cultural Life and their Contribution to It, 1976.

There are also other international conventions and recommendations dealing with museums and movable objects, the latter being recognized by the Australian government by the passing of the *Protection of Movable Cultural Heritage Act 1986.*

Perhaps of more direct concern to heritage place managers are the guidelines for conservation developed by ICOMOS (International Council for Monuments and Sites). ICOMOS is a UNESCO-sponsored organization, of which Australia is a member country. ICOMOS promotes good conservation and management practice throughout the world.

The Burra Charter is the instrument embodying Australian standards in this area. It is an adaptation by Australia ICOMOS of the older ICOMOS Venice Charter, and lays down the basis for conservation practice. It is an obligatory standard for conservation agencies receiving federal funding in Australia, and is the basis for the principles embodied in this book. Its requirements regarding conservation practice are given in Chapter 6. The heritage authorities of the Australian and many state governments have adopted its standards, and make adherence to them a prerequisite for many of the conservation and management works they control, either directly or through grants.[4]

The Burra Charter is given in full in Appendix 1.

National legislation

The most relevant Commonwealth legislation are the *Australian Heritage Commission Act 1975* and the *Aboriginal and Torres Strait Islanders Heritage Protection Act 1984.*

The Australian Heritage Commission Act established the Australian Heritage Commission as a Commonwealth statutory body. The Commission maintains the Register of the National Estate, an inventory of the places in Australia with 'aesthetic, historic, scientific, or social significance or other special value' for present and future generations. This includes important elements of the natural or cultural environment, including places of significance to Aboriginal, European and Asian cultures in Australia.

Criteria were developed for the assessment of nominations to the Register of the National Estate and incorporated into the Act in 1990. Each criterion can be applied to the natural, Aboriginal and historic elements of the National Estate, the particular way in which each element relates to the criterion being detailed within sub-criteria that expand on the central theme. The criteria (in full) are as follows:

Criterion A:
Its importance in the course, or pattern, of Australia's natural or cultural history

A.1 Importance in the evolution of Australian flora, fauna, landscapes or climate.

A.2 Importance in maintaining existing processes or natural systems at the regional or national scale.

A.3 Importance in exhibiting unusual richness or diversity of flora, fauna, landscapes or cultural features.

A.4 Importance for their association with events, developments or cultural phases which have had a significant role in the human occupation and evolution of the nation, state, region or community

Criterion B:
Its possession of uncommon, rare or endangered aspects of Australia's natural or cultural history

B.1 Importance for rare endangered or uncommon flora, fauna, communities, ecosystems, natural landscapes or phenomena, or as a wilderness.

B.2 Importance in demonstrating a distinctive way of life, custom, process, land-use, function or design no longer practised, in danger of being lost or of exceptional interest.

Criterion C:

Its potential to yield information that will contribute to an understanding of Australia's natural or cultural history

C.1 Importance for information contributing to a wider understanding of Australia's natural history, by virtue of its use as a research site, teaching site, type locality, reference or benchmark site.

C.2 Importance for information contributing to a wider understanding of the history of human occupation of Australia.

Criterion D:

Its importance in demonstrating the principal characteristics of:

 (i) **A class of Australia's natural or cultural places; or**
 (ii) **A class of Australia's natural or cultural environments**

D.1 Importance in demonstrating the principal characteristics of the range of landscape, environments or ecosystems, the attributes of which identify them as being characteristic of their class.

D.2 Importance in demonstrating the principal characteristics of the range of human activities in the Australian environment (including way of life custom, process, land-use, function, design or technique).

Criterion E:

Its importance in exhibiting particular aesthetic characteristics valued by a community or cultural group

E.1 Importance for a community for aesthetic characteristics held in high esteem or otherwise valued by the community.

Criterion F:

Its importance in demonstrating a high degree of creative or technical achievement at a particular period

F.1 Importance for their technical, creative, design or artistic excellence, innovation or achievement.

Criterion G:

Its strong or special associations with a particular community or cultural group for social, cultural or spiritual reasons

G.1 Importance as places highly valued by a community for reasons of religious, spiritual, cultural, educational or social associations.

Criterion H:

Its special association with the life or works of a person, or group of persons, of importance in Australia's natural or cultural history

H.1 Importance for their close association with individuals whose activities have been significant within the history of the nation, state or region.

Guidelines to the application of these criteria are available from the Australian Heritage Commission.[5] These or similar criteria are in common use in many parts of Australia.

The listings are published in the *Commonwealth Gazette*, and all listings to 1981 were published and illustrated in *The Heritage of Australia*. Revised state editions of this book have been published from time to time.[6] Up-to-date information can be obtained from the Australian Heritage Commission.

Any person may nominate a place for the Register, nominations being submitted on forms that are issued by the Commission, together with instructions for their completion. In the case of both Aboriginal and historic environment places the nominations are assessed by Commission staff, often with advice from external expert groups or contracted individuals, and in the case of Aboriginal place nominations with liaison with the Aboriginal community body from the relevant area. Increasingly, the Commission is attempting to carry out assessments in a thematic or regional context, by gathering similar nominations or undertaking special surveys to provide a more appropriate basis for comparative assessment.

If, after considering the evaluation, the Commission decides that the nominated place is worthy of entry on the Register, it is required under its Act to advertise its intention in the *Commonwealth Gazette* and by public notice in the press, and to invite comments or objections.

Objections must be lodged within three months, though extensions for detailing of objects is granted when it seems reasonable. When an objection is received, the Commission assesses the nature of the objection. If the objection does not question the National Estate significance of the place, it might be considered by the Commission without further assessment. If National Estate values are questioned, the minister (since amendments to the Act in 1990) appoints an assessor or panel of assessors to consider the objection. The Commission then gives full consideration to the objections, taking into account the assessor's comments, staff views, and the objector's comments, and decides whether or not the place will proceed to be entered in the Register or not. When the Commission is considering a place for the Register (and any objections to it) it is making an assessment of 'aesthetic, historic, scientific, or social significance, or other special heritage value' of the place only. The listing is therefore recognition of the place, and not an attempt to determine in any way what should be its ownership, use or management.

The implications of listing

The Register of the National Estate has a direct protective role *only* in relation to actions proposed by the Australian government that might adversely affect the National Estate.

There are no direct legal constraints on owners of private property, or on state or local governments, caused by the entry of that property in the Register of the National Estate. Thus the Commission has no power to direct private owners or state or local governments with respect to their actions that might affect a place in the Register, and does not acquire property entered in the Register. The entry of a place in the Register does not have the effect of granting public access to it. While there are no direct effects for such owners, it is possible that there may be indirect consequences if the Australian government plans an action that may affect their property. If the proposed action is a significant one in national estate terms, the government would be required to observe the protective provisions of the Australian Heritage Commission Act (see below).

The general purpose of the Register is to alert and educate all Australians to the existence of places of National Estate signifi-

cance, and to provide an essential reference and a working tool for balancing conservation and development decisions. The Commission is required to provide information on the significant of registered places to any inquirer.

As a protective inventory, the effects of registration relate only to actions by the Australian government. The duties of ministers, departments and authorities are set out in Section 30 of the Act. In summary, Section 30 requires that:

1 Ministers ensure that their own actions and those of their departments and authorities do not adversely affect the National Estate values of places in the Register unless there are no feasible and prudent alternatives and, if there are no such alternatives, unless all reasonable measures are taken to minimize the effect. The minister's actions to achieve these ends must be consistent with any relevant laws.

2 Authorities of the Commonwealth, in relation to their own actions, take similar steps to those described in (1).

3 Before a Minister, department or authority takes any action that might significantly affect the National Estate value of a place in the Register, they must inform the Australian Heritage Commission and give it a reasonable opportunity to consider and comment on the proposed action. The statement of significance for each place in the Register provides the basis for the Commission's conservation advice to Commonwealth ministers and bodies.

The Commission's functions as listed in the Act, and the provisions of Section 30 of the Act, make it quite clear that the Commission's only decision-making powers relate to the entry of places in the Register of the National Estate. Its other functions are advisory, educational and research oriented. Decisions on whether Commonwealth actions that might adversely affect a place in the Register proceed, are modified or do not proceed, remain with the Commonwealth proponent of the action. The Commission's role is to ensure, as far as it is able, that such decisions are taken with an awareness of the National Estate significance of the place involved.

Perhaps the most important overall effect of listing is the prestige it gives a site or area. This has often halted local or state government action, not by any legislative power but by forcing,

through popular pressure, the proper consideration of the value of the item to the community.

The Commission also advises the Australian government on issues related to the National Estate, runs excellent education information programmes, and administers the government's National Estate Grants Program. This is a programme of funding to 'approved bodies' for the protection of the National Estate. It is usually administered through state heritage agencies and by the Commission directly. Grants are not given to individuals, but any non-profit incorporated group, organization or authority can apply for a grant if it relates to the identification, conservation or presentation of an item of the National Estate.

Many state- or publicly-owned or protected sites are listed on the Register of the National Estate, as well as privately-owned places. In the past, the majority of the nominations for historic places have come from the National Trust lists, and are hence biased to some degree towards those types of places that have preoccupied the Trusts. The Commission is attempting to redress this imbalance by funding surveys and studies of types of places less well represented in the Register. The aim is to develop a truly comprehensive Register that is representative of the physical aspects of Australia's cultural heritage.

Commonwealth protection for Aboriginal places

The Australian Heritage Commission Act provides some recognition for Aboriginal sites, but the Australian government, by the enactment of the Aboriginal and Torres Strait Islanders Heritage Protection Act, sought to acknowledge a special relationship between Aborigines and the Aboriginal Heritage of Australia, and to guarantee a role for Aborigines in decisions about the management of Aboriginal places of significance to them.

This action was necessary because the question of Aboriginal custodianship (the control and management of Aboriginal places by Aborigines) is still at issue in Australia. Most of the state Acts that protect the Aboriginal heritage do not adequately acknowledge the special significance of Aboriginal places to present-day Aborigines, or provide any statutory role for Aborigines in Aboriginal place management.

The Aboriginal position has been clearly articulated by Ros Langford.[7] Aborigines feel that they have a legal and moral right to have a deciding voice in Aboriginal place management. Legal issues relating to Aboriginal place custodianship are bound up with arguments about the ownership of Australia, and consequently, land rights.

The European colonizers of Australia have in the past maintained that Australia, prior to European settlement, was to all intents and purposes unsettled (unowned), or at least unused or unmodified in any significant way. But Aboriginal places are tangible proof of substantial Aboriginal occupation of Australia, and provide convincing evidence for their modification of the landscape. It has been argued in international law that proof of occupation, and therefore prior ownership of a country, rests on proof of a material impact on that country. The evidence of and from Aboriginal places destroys the legal fiction that Australia was essentially unoccupied at the time Europeans arrived. The High Court ruling on Native Title—the Mabo Case—has now given case-law precedent to that view.

The fact remains, however, that Australia was taken from the Aborigines by force, without any agreement, treaty or acknowledgement of prior ownership or occupation. No complete resolution of the situation has yet been reached. Therefore the assertion of custodianship over Aboriginal places by the legislative action of state governments by white Australians, has no legal basis, as far as Aborigines are concerned, and could be regarded as part of the ongoing illegal occupation of Australia. Where the places concerned are of sacred or religious significance, the questions of freedom of religion and racial or religious determination also arise, when such places are threatened or Aboriginal access is restricted. Australia has relevant laws in this area, and is also a signatory to various relevant United Nations agreements.

Aborigines are also concerned about the European 'majority's cultural hegemony, and their interpretation and use of the evidence from Aboriginal places. On the one hand, this has provided very valuable evidence about the long-term occupation of Australia by Aborigines, and hence has provided a basis for land rights arguments. On the other hand, in the past the Europeans have used poor, biased and incorrect data to justify a version of social domination.

When this country was invaded by Europeans, the dispossession of the Aborigines and the acts of often violent aggression by which this was accomplished, were justified, in part, by the assertion that the Aborigines were primitive, or sub-human, a lower link in the evolutionary chain, destined in the view of most nineteenth-century scientists to be displaced by a higher order.[8] Europeans from this self-serving early interpretation of Aborigines have developed a more sophisticated and disinterested view of the history and nature of Aboriginal society; but the key fact is that Europeans still control much Aboriginal cultural history with expertise, funding, and control of information. Though anthropologists now deride the concept of the Australian Aborigines as 'primitive savages', the ordinary person's view of the Aborigines derives from earlier scientific theories and teachings, such as those outlined above. Additionally, anthropologists have frequently published information regarded by Aboriginal groups as secret or sacred. Aborigines therefore also seek some control over the interpretation of anthropological or archaeological evidence researched by scientists; a matter that, in itself, raises complex issues of research ethics, censorship, and freedom of speech.

The assertion of custodianship rights by Aborigines is strongly contested in some quarters. Developers and some governments see such claims as an unwarranted restriction on development and economic growth, and as an attack on private properties. Many argue that such views are divisive and usurp the authority of the state. Some academics and heritage administrators, who seek to preserve Aboriginal places for their research or heritage value, feel that their universal value and the search for truth and knowledge as expressed in research must be greater than their value to an particular group. Recently the Australian Archaeological Association has recognized the issue of Aboriginal custodianship in its endorsed code of ethics, given in full in Appendix 2.

This debate is the background to the gazettal of the Aboriginal and Torres Strait Islander Heritage Protection Act, and colours and influences legislation policies and procedures relating to Aboriginal place management throughout Australia.

The *Aboriginal and Torres Strait Islander Heritage Protection Amendment Act 1987* is administered by the Aboriginal and Torres Strait Islander Commission. The Act is a federal Act, in an area where, due to the 1966 referendum, the Commonwealth has jurisdiction.

This means that in certain circumstances it overrides relevant state and territory provisions, or can be implemented in circumstances where state or territory provisions are lacking or are not enforced. The Act was passed to provide protection for the Aboriginal heritage, in circumstances when it was demonstrated that such protection was not available at a state level. The Act has actually been in force since 1984 as the *Aboriginal and Torres Strait Islander Heritage (Interim Protection) Act 1984*. It has been amended by the removal of a previous sunset clause (that is, a clause that would automatically cease to apply after a stated date) and the insertion of part IIA, Victorian Aboriginal Cultural Heritage, which applies only in Victoria and provides, at federal level, for an Act to protect the Victorian cultural heritage.

The Act must be invoked by or on behalf of an Aboriginal or Torres Strait Islander or organization. Its provisions have been used quite frequently to negotiate the protection of Aboriginal sites threatened by development, especially where such sites are sacred or significant sites, important to local Aboriginal groups but not clearly recognized or protected by state law. The Act also protects movable cultural property (sacred objects, artefacts, etc.) and enables the more effective prevention of interstate trade in illegally or immorally acquired objects. It also provides specifically for the protection of Aboriginal skeletal material in certain circumstances.

The major stated purpose of the Act is to preserve and protect from injury or desecration areas and objects of significance to Aborigines and Islanders. The Act enables immediate and direct action for protection of threatened areas and objects by a declaration from the Commonwealth minister or authorized officers, including emergency declarations (effective for thirty days).

These provisions are in cases where state and territory laws do not provide adequate protection, either through absence of legislation or unwillingness to enforce legislative provisions. Longer term, or permanent declarations of areas (Section 10) have similar criteria to those for emergency declarations, but the minister may require a report to consider representations and to describe the area and detail protective provisions. Similar provisions relate the declarations of significant Aboriginal objects. A declaration is reviewable by parliament where the operation of the Act or provisions of a declaration result in the acquisition of property; there are provisions for compensation

and legal assistance. The effect of a declaration is to prevent action that may damage or desecrate a place or object. The minister is required to consult with the states and territories concerning such declarations.

Substantial penalties are invoked for offences against the Act: $10 000 and/or five years' imprisonment; and corporate body offences of up to $50 000.

A register to summarize declarations is maintained. This register is not open for inspection, except by prescribed persons or circumstances.

Aboriginal involvement is essential for the operation of this Act, which provides for Aboriginal people throughout Australia to take the initiative in protecting sites and objects of significance to them. Aboriginal involvement is specified in matters requiring consultation, such as physical research activities, and in regard to the appropriate section concerning skeletal remains.

Under the provisions of the Act a request for declaration of a significant area could be made to prevent or stop archaeological research activities if they are perceived as a threat.[9]

The Act, like the World Heritage Properties Act, reflects the tension inherent in a federal system. It enables any Aboriginal person or group to invoke Australian government intervention at any stage of a state's negotiations, under its own Act, with developers and Aboriginal groups. This can render the agreements reached at a state level, and perhaps negotiated with the state and Council, invalid. This is often especially where Aboriginal concerns have been disregarded, but it tends to weaken the state authority's negotiating credentials, especially in the view of developers or land-use agents, who, for planning purposes, require a decision that will stick. This, in turn, can have the effect of making states less, rather than more, responsible in these matters. However, in practice, the government has been circumspect and cautious in its use of overriding provisions, and has tended to seek a solution at the state level.

In most cases it has not been necessary to formally invoke the Act, since the possibility of Commonwealth government intervention has had the effect of facilitating a negotiated settlement. However, in at least one case, with state government concurrence, this Act has completely overruled state legislation. In Victoria a Victorian Act, rejected by the Victorian Upper House as too protective of Aboriginal heritage, was inserted in the Aboriginal

and Torres Strait Islander Heritage Protection Act, and hence became law in Victoria. This is an extreme action, and can be viewed as desirable only as a last resort. It has achieved its purpose, but has also led to administrative and jurisdictional problems.

The Act does not have a strong administrative or operational framework to back up its provisions. It is very effective in preventing or mitigating short-term dramatic damage or destruction, but it does not effectively provide for the ongoing, on-the-ground management of heritage places, since it is difficult for the Commonwealth government to exercise such ongoing jurisdiction in the states and territories.

Historic Shipwrecks Act 1976

Heritage place management does not necessarily stop at the water's edge. The *Historic Shipwrecks Act 1976* is a Commonwealth Act for the protection of designated historic shipwrecks in coastal waters. The Act was applied, state by state, after agreement has been reached between the state concerned and the federal government. A body, usually a state body, is made responsible for administering the Act, and individual wrecks are protected under the Act when their significance has been proven. The provisions of the Act protect gazetted wrecks in Commonwealth waters from disturbance by salvagers and casual divers. This includes the artefacts found in wrecks. A system of rewards is established to recompense the discoverer of historic wrecks for the profits that would otherwise be made from salvage.[10]

In April 1993 Section 4A(2) of the Act was implemented, which extends historic shipwreck status to all shipwrecks older than seventy-five years in Australian waters, whether they have been located as yet or not. There is therefore now a blanket protection for all old wrecks. An amnesty was announced at the same date, which extended for a year, to allow members of the public to declare artefacts in their possession that had been recovered from Historic Wrecks, as now defined, without fear of prosecution. This was very successful, perhaps the largest collection declared in this amnesty consisting of many hundreds of artefacts from the wreck of the *Dunbar*, which sank after hitting the Gap at Sydney Harbour's South Head in 1857.

In most states historic shipwrecks in state waters may be protected by mirroring state shipwreck legislation, or may come within the terms of the state's broader heritage legislation.

State and Territory legislation

The Australian government's power and role in heritage place management is strictly limited. Except in the case of Aboriginal place protection and World Heritage, it does not impinge upon state powers, cannot usually stop states from destroying places, and cannot legislate to actively protect them. The essential protective legislation is state- or territory-generated. An inevitable result of this is a great discrepancy between states in the intent and extent of the jurisdiction of their legislation.

Listed here are specific pieces of heritage legislation, state by state, followed by a general discussion of other state Acts that can have a peripheral bearing on heritage place management. This analysis draws largely on the work of Gerry Bates, and the more recent work of Peter James.[11]

Australian Capital Territory

The *Land (Planning and Environment) Act 1991* and the *Heritage Objects Act 1991* operate together to provide protection for the historic heritage in the ACT. They are, to a large degree, complex and obscure pieces of legislation.

Protection of places is primarily under the Land Act, and is based on the operation of the Heritage Places Register. Both Aboriginal and historic places are included in the Register, as are natural places. Criteria comparable with the National Estate criteria are specified in the schedules of the Act. Registration is instigated by any person, by the Heritage Council established under the Act, or by the minister, and public consultation and notification are required. Following any objections being dealt with by the Heritage Council, the intention to register is submitted by the heritage Council to the ACT Planning Authority, where it goes through a process of variation of the Territory Plan (the key planning instrument). Any person during this period may apply to the Administrative Appeals Tribunal for a review of the Heritage Council's decision.

The minister may apply stop work orders to 'controlled' activities. To undertake any 'controlled' activity on a registered place without prior approval is an offence.

Parts of the *Land (Planning and Environment) Act 1991* relate specifically to Aboriginal heritage. The Act protects places significant to Aboriginal tradition, and requires notification of the location of any such places. There are compensation rights if the interim registration of a place causes loss or damage to an individual. The minister may also make orders in respect of unregistered Aboriginal places.

When it is considering registering an Aboriginal place, the Heritage Council is required to consult with a relevant Aboriginal organization about the effect of the registration on Aboriginal tradition.

New South Wales

The *Heritage Act 1977* (with amendments in 1987) is the primary legislation protecting the historical heritage in New South Wales. The Act aims to conserve the 'environmental heritage' of the state, which is defined as the 'buildings, works, relics, or places of historic, scientific, cultural, social, archaeological, architectural, natural, or aesthetic significance for the state'. The Heritage Council is established to protect these items, being empowered to make recommendations to the minister in relation to the conservation and display of, access to, and information about items of the environmental heritage, and to conduct research and organize conferences. The Council also advises on the allocation of National Estate funds in New South Wales, advises on nominations to the World Heritage List, and keeps a register of places subject to conservation instruments or other orders served under the Act.

The major powers under the Act relate to the protection of items of the environmental heritage offered through

- stop work orders (Section 136), which give 40 days' protection from destruction

- Section 130 orders, which give notice to owners that a place may have heritage significance, and requiring prior notice be given to the Heritage Council before any action that might

'harm' the place is taken. 'Harm' is defined in the Act, and Section 130 orders last for twelve months

- Interim and Permanent Conservation Orders.

Interim Conservation Orders may be placed on an item with no prior warning, and are valid for a period of up to one year, in which time the item can be thoroughly investigated, and a Permanent Conservation Order enacted or an environmental planning instrument (under the *Environmental Planning and Assessment Act 1979*) applied to the item, or the decision made that the place is not an item of the environmental heritage that requires such protection, or the minister for some other reason decides to revoke the order. There is a system of objection and review on various grounds that may require an inquiry before a Permanent Conservation Order is placed. If the owner or lessee objects on certain grounds to the making of a Permanent Order, the Minister has to appoint a Commission of Inquiry to look into the matter.

If a conservation order is current for a place, an order can be issued to the owner to effect repairs to the place if it is falling into disrepair.

The Act also requires that an individual must have a permit from the Heritage Council to excavate land with the intent to discover, expose or move a relic, a relic being any deposit, object or material evidence relating to the settlement of New South Wales that is more than fifty years old, but not including Aboriginal settlement. This applies to all lands in New South Wales, not just those covered by conservation orders. Most of the other protective mechanisms of the Act were extended to include relics in the 1987 amendments. This section of the Act also applies to shipwrecks within state waters, as a complement to the Commonwealth's Historic Shipwrecks Act.

To ensure the protection of the item that is subject to a conservation order, the Heritage Council may impose restrictions on the use and development of the land on which the item is found. However, this potentially strong deterrent has never been imposed by a court. The Council can also acquire lands and personal property with money from the Heritage Conservation Fund, but this is not a usual procedure in the protection of the environmental heritage. Places subject to Permanent Conservation Orders may receive rating and land tax relief.

While the Heritage Council has these extensive powers under the Act, they are seen only as a last resort, the majority of the time of the Council and its support body, the Heritage and Conservation Branch of the Department of Planning, being spent in achieving the aims of the Act by negotiation rather than by direct legal action, and in achieving protection through environmental planning instruments under Local Environmental Plans, under the Environmental Planning and Assessment Act.[12] The Heritage Act is primarily aimed at the protection of the environmental heritage, and not at its long-term management beyond the extent to which a conservation order may enable recommendations as to use and development can be made. The Heritage Council therefore has no wing involved in the day-to-day management of heritage places.

One of the innovative developments in New South Wales has been the setting up of a capital fund of $20 million, the interest from which funds a state Heritage Assistance Program of grants and loans administered by the Heritage Council. This fund was provided from the proceeds of the sale of the development rights over the First Government House site, which has been conserved intact. The Heritage Council and the Department of Planning are also trying to establish a register system to alert planners and the public to the existence of the state's heritage *not* protected by conservation orders.

A Heritage System Review, looking at a number of issues relating to the operations of the Heritage Act and the Department of Planning, had not been completed at the time of writing (1994).

The *Historic Houses Act 1980* is directed solely at the management of houses of historical and architectural interest, as house museums. The Historic Houses Trust is established under the Act to provide central administration of the historic houses, and to provide educational and cultural services in order to increase public knowledge and enjoyment of these buildings and their place in the heritage of the state. The powers of the Trust are limited to maintenance, exhibition, education and related matters. The minister may authorize alterations to a house, and land may be divested from public authorities and vested in the Trust by proclamation of the governor. Gifts of private property may also be accepted

The Trust's role to date has been limited to the management of a small number of properties. The Trust cannot be seen as

potential manager for a wide range of publicly-owned historic buildings, as its aims are limited by its Act, and its acquisitions have been primarily due to historical accident. However, the Trust has implemented some innovative approaches to historic house management, and has established a reference collection of interior decoration materials that may be very useful to other managers. Its public interpretation and promotional activities set precedents that others may wish to emulate.

In addition to responsibilities for Aboriginal sites, the *National Parks and Wildlife Act 1974* also identifies the gazettal of 'Historic Sites' for the conservation of non-Aboriginal places as a role for the National Parks and Wildlife Service. This is in addition to the responsibility to identify and conserve historic places lying within national parks and nature reserves. Places suitable for gazettal as historic sites are 'areas that are the sites of buildings, objects, monuments, or events of national significance'. Obviously, a vast number of places in New South Wales would fall into this broad definition, and the Service, while attempting to establish an acquisition policy based on the principle of sampling the potential resource within a framework of historic themes,[13] in fact early in its existence acquired sites by conscious choice only. As a result, no historic site has been proclaimed in the last decade.

While the number of gazetted historic sites remains small, increasing numbers of major historic places are being added to or gazetted within national parks, such as the Quarantine Station, Sydney Harbour National Park, the Newnes shale-oil refinery, Wollemi National Park and the Great North Road, Dharug National Park. The National Parks and Wildlife Service is the only New South Wales government agency with an acknowledged broad-based responsibility for the management of historic resources in the state, but unlike its role in Aboriginal site protection, it has no protective powers over historic places outside the areas of lands that it administers (that is, national parks, nature reserves, historic sites, etc.). The Service has been through several phases of embracing or reluctantly accepting its role as historic site heritage manager, a role it appears to feel sits uneasily with its nature conservation role.

The *National Parks and Wildlife Act 1974* also protects all Aboriginal relics that originate in New South Wales, regardless of their legal status. It is illegal to destroy, deface or damage

such relics. A relic is defined as material evidence of Aboriginal occupation, and therefore does not apply to mythological places or natural features of significance.

Aboriginal places may be acquired by the Crown and declared as historic sites or 'Aboriginal Areas', or incorporated in national parks or nature reserves. An 'Aboriginal Place' may be gazetted over land of any status that is, or was, in the opinion of the minister, of significance to Aboriginal culture. It then acquires the same protection status as a relic. The minister may place an interim protection order over an endangered site or relic pending its investigation.

The Director of National Parks is empowered to conduct research, and to carry out educational or conservation work with respect to Aboriginal culture.

The Director's consent (appealable to the minister) is required for the destruction of or damage to any relic. People collecting relics are obliged to report their existence to the Service. There is no legal requirement for Aboriginal involvement in Aboriginal place management. A permit is required by anyone wishing to collect artefacts or to disturb or excavate land for the purpose of discovering a relic.

The *National Parks and Wildlife Act 1975–84* and the *Forestry Act 1959–71* allows national parks to be declared on Crown lands considered to be of scenic, scientific or historic interest, and parts of national parks can be specifically reserved for a variety of purposes including 'Historic Areas', for the preservation of areas of historical significance to the state. The *Fisheries Act 1976* allows the creation of marine reserves and parks, a category of which is 'Historic Area', set aside for the preservation of areas of historic and cultural significance to the state, which might include shipwrecks and cultural places.

Northern Territory

The *Heritage Conservation Act 1991* is the primary piece of historic heritage legislation in the territory. The Act encompasses natural and Aboriginal heritage, as well as historic, and establishes criteria for their assessment reflecting those in the Commonwealth's *Australian Heritage Commission Act 1975*.

The minister declares heritage places or objects on the recommendation of the Heritage Council, and the Council must

keep a register of such places. Interim Conservation Orders may be made by the minister. These run for ninety days, or until the place or object is declared as a heritage place or object. Following notification of its intentions, the Heritage Council considers any comments and objections to declaration of places, and advises the minister of these matters, after which the minister has ninety days to make a determination as to whether to declare the place or object, or not.

Works affecting declared places or objects must be in compliance with a conservation management plan, as described in the Act. Such conservation plans are prepared by the Heritage Council, and are subject to public comment and decision (and amendment) by the Administrator of the Northern Territory. The plan is then placed before the Legislative Assembly, and is adopted if the Assembly does not resolve to the contrary. If the plan is rejected by the Assembly, the Heritage Council has to prepare another plan, which goes through the same process. Any amendments to adopted conservation plans must go through the same process. It is not clear from the Act what the offence may be if an action is taken at a declared place before a conservation plan is approved.

Heritage Agreements are specified in the Act, but their effectiveness is limited by Section 37, which describes them only as covenants that run with the land.[14]

Sections of some other Acts relate to a limited degree to European and Asian places. The *Territory Parks and Wildlife Conservation Ordinance 1976* is administered through the Conservation Commission (*Conservation Commission Act 1980*), among other things, to manage parks, reserves and protected areas. These reserves include historical reserves, numbering fourteen in 1979. Management plans for other parks and reserves must have regard for the protection of special features, including objects or sites of archaeological or historical interest. The *Native and Historical Objects and Areas Preservation Act 1955* prevents the removal from the Northern Territory of, among other things, 'an object relating to the Territory which is of archaeological or historical interest or value'.

The *Aboriginal Sacred Sites Act 1989* has the same definition of 'sacred site' as does the earlier Commonwealth *Aboriginal Land Rights (Northern Territory) Act 1976*. The Act protects a site that is 'sacred to Aboriginals or is otherwise of significance according

to Aboriginal tradition, and includes any land that, under law of the Northern Territory, is declared to be sacred to Aboriginals or of significance according to Aboriginal tradition'.

It is an offence under the Act to carry out work or to enter or remain upon a sacred site without approval, unless the person is Aboriginal and has right of access through Aboriginal tradition. The Act sets up an Aboriginal Areas Protection Authority, predominantly nominated by Aboriginal Land Councils. The Act sets out procedures for registering sacred sites, including secrecy of information in accordance with Aboriginal tradition.

The Commonwealth's *Aboriginal Land Rights (Northern Territory) Act 1976* aims at the granting of traditional Aboriginal land for the benefit of Aboriginals, and establishes Aboriginal Land Trusts, Land Councils and Land Commissioners. This Act is superior to territory legislation, but acts in parallel with it where the two are not in conflict.

Complementary legislation to this Act is the Commonwealth ordinance of 1957, the *Native and Historical Objects Preservation Act 1955*, which is administered by the Museums and Art Galleries of the Northern Territory.

The objectives of this Act are to preserve objects and areas via gazettal to prevent removal from the territory, and to control the sale of and/or permit copies of objects to be made. The minister may acquire or purchase an object on behalf of the territory. It is an offence to conceal, remove, destroy, deface or damage prescribed objects, and they may be seized. Under the *Crown Land Ordinance 1931* an area may be declared a prescribed or prohibited area. Thus these areas may only be declared on Crown land or on reserves, and 'must be surveyed, exactly described and gazetted for public information'.[15] Unauthorized entry of these areas is an offence, as is any interference with ancient or human remains, or a ceremonial, burial or initiation ground.

Queensland

The *Queensland Heritage Act 1992* replaced the *Heritage Buildings Protection Act 1990*, which was interim legislation to protect the cultural heritage while more comprehensive legislation was drafted. Its application is limited to the historic environment.

The Act covers places and objects, including submerged relics and objects forming part of Queensland's heritage, which is defined in the same form of words as the National Estate in the *Australian Heritage Commission Act 1975*. A Heritage Council is created, and criteria specified to guide it in the creation of a Heritage Register. Again, the criteria reflect those in the Australian Heritage Commission Act. However, a place may not be entered in the Register if it can be shown that there is no prospect of the cultural heritage significance or the place being conserved. As Peter James has pointed out: 'this is a difficult provision in that it confuses the two issues of assessment of significance and future management of the place and consequently has the potential to substantially complicate registration procedure'.[16] Owners may also appeal to a court against the decision of a heritage authority on heritage issues.

Archaeological remains and sites are able to be protected by an order by the Governor in Council.

Any person may nominate a place to the Heritage Register. The Heritage Council may invite written submissions on the nomination, must notify the owner and local authority of the Council's intentions if it considers the place to be worthy of registration, and any objections are dealt with by an assessor chosen from a panel by the minister. If the Council proceeds after consideration of the assessor's report, the owners are again notified, and may take up their objection through appeal to the Planning and Environment Court, but only on the basis of arguing that the place does not have the heritage values claimed by the Council. In effect, the court has the opportunity to reassess the heritage value of the nominated place, the only case of this power in Australia.

No development (as widely defined) can occur on a registered place without the approval of the Heritage Council, which is notified through the local authority application process, or, in the case of that authority itself or other Crown bodies, the Heritage Council must be notified directly. Decisions on lands other than those owned by the local authority can be delegated to that local authority by the Heritage Council. If a proposal is to destroy or substantially reduce the heritage significance of a registered place, the Heritage Council can only recommend it proceed if there is no feasible and prudent alternative to the development. In the case of Crown developments, the minister

concerned makes the final decision, and must only consider the Council's advice.

Stop work orders may be issued by the minister on any place if the minister believes it may have heritage significance. Heritage Agreements are provided for in the Act, but mechanisms to provide support for the owner other than through rates and land tax relief are lacking.

Penalties for breaches to the Act include fines and the power to prohibit development on the site for up to ten years.

The *Local Government (Planning and Environment) Act 1990* provides a code for the local authorities or the minister to develop planning schemes for areas. They include, among other things, provision for the cultural aspects of the environment. The Act also provides for compensation to owners able to demonstrate that their property has been 'injuriously affected' by a planning scheme, a provision that is likely to limit the extent to which the Act will be used to protect heritage places where there is not prior agreement with the owner.

In the case of the Aboriginal heritage, the primary legislation is the *Cultural Record (Landscapes Queensland and Queensland Estate) Act 1987*, which is an unsatisfactory protection and has been largely superseded in most of its application in the historic heritage area by the Queensland Heritage Act. The Queensland government has indicated its intention to draft new legislation to better protect Aboriginal heritage. The Cultural Record Act gives the Governor in Council power to declare any area a Designated Landscape Area, being areas with features or landscapes used, altered or affected by people, and that are significant as a result. Provision is included to recognize indigenous ownership or access to certain parts of the Queensland Estate. Before any such declaration can be made, the minister administering the *Mining Act 1968* must be notified, and a report provided by the minister on the mineral-bearing potential of the area.

South Australia

The *South Australian Heritage Act 1978* aims at the preservation, protection and enhancement of the physical, social and cultural heritage of South Australia. The Act is intended to link directly into the *Planning and Development Act 1966*, which was already in

existence, and administered by the Department of Environment and Planning. The Act establishes a Heritage Committee, which advises the minister on entries to a Register of State Heritage Items, on financial assistance for conservation purposes, and on matters relating to the heritage of the state.

The key element of the Act is the Register of State Heritage Items, which can include land, buildings, and structures, and shipwrecks (under the South Australian *Historic Shipwrecks Act 1981*) in state territorial waters. Items are entered into an interim list for a twelve-month period to allow public comment and objections before being placed on the Register. Large areas, such as historic towns, streetscapes or natural areas, can be designated State Heritage Areas. However, these are not entered in the Register, and hence have only limited planning protection.[17] Amendments in 1985 enable the minister in emergency situations to issue conservation orders to protect places of potential significance.

Alteration or demolition of registered items requires the consent of the relevant planning authority, being variously the State Planning Authority or the local council (under the *Planning Act 1982*), but this does not bind the Crown, a defence against prosecution for breaching the Act being that the action was required by another law of the state. The relevant planning authority is required to inform the minister administering the Heritage Act of any applications for work on registered properties, and to receive a recommendation from that minister. The Heritage Act does not cover the City of Adelaide, where heritage items are protected by the *City of Adelaide Development Control Act 1976*.

The minister may enter into agreement with the owners of an item on the Register, or other items in certain circumstances, which may restrict the use of the item, require works to it, permit inspection, etc. These Heritage Agreements are binding on future owners of an item, and damages may be awarded if agreements are breached.

A new Heritage Bill has been drafted, but had not been to parliament at the time of writing. This Bill creates a body with greater powers than the existing Heritage Committee; establishes criteria for identifying 'places of heritage value'; introduces an extended objection process, which includes appeals to the courts; allows owners to apply for a Certificate of Exclusion, which, if granted, prevents entry of the place on the Register for five

years; requires permits for archaeological work; and continues with the Heritage Agreement system.

The *History Trust Act 1981* has the objects of setting up a trust to carry out and promote research relating to the history of the state, accumulating and caring for objects of historic interest, and maintaining a register of such objects. Premises or land may be placed under the care and control of the trust to achieve those ends.

The Aboriginal heritage is protected by the *Aboriginal Heritage Act 1988*, administered by the Aboriginal Heritage Branch, Department of Environment and Planning, Adelaide. The Act establishes an Aboriginal Heritage Committee, consisting of Aboriginal persons representing their people throughout the state, to advise the minister. The Act recognizes the need to protect objects and sites that are 'significant according to Aboriginal tradition', or which are significant to Aboriginal archaeology, anthropology or history. The Act provides blanket protection for all Aboriginal sites and Aboriginal objects of significance within the state. This avoids specific sites or objects having to be registered for legal protection, though a register is also established. Certain powers can be granted to traditional owners under the Act. The minister can restrict or prohibit access to a site, and the minister may acquire and care for sites, objects and records.

The Aboriginal Heritage Act requires notification of Aboriginal sites if they are located, and requires permission to excavate an Aboriginal site, or to damage or interfere with an Aboriginal site of object in any way. A Register of Aboriginal Sites and Objects is created. Section 35 prohibits the divulgence of information that would contravene Aboriginal tradition, and information entered into the archives is confidential. The minister may grant permission for Aboriginal persons to enter any land for the purpose of gaining access to an Aboriginal site, object or remains. A fund is set up for acquisitions, grants, loans and research related to the protection of the Aboriginal heritage.

Tasmania

Tasmania is now the only state without heritage legislation protecting historic places, and the Aboriginal heritage legislation

is now out of date. Heritage legislation has been promised for 1993, but nothing had occurred at the time of writing.

The *National Parks and Wildlife Act 1970* enables reserves to be set up to protect important historic and Aboriginal sites. Fifteen historic sites have been gazetted, ranging from the Port Arthur penal settlement (now managed by a separate statutory authority, under the *Port Arthur Historic Site Management Authority Act 1987*) to individual monuments to explorers. Some of these sites are leased out to private commercial management.

The *Local Government Act 1962* allows local government to identify and protect or acquire historic places, which are common powers in many local government Acts. However, the Act also allows owners affected by preservation orders under the Act to seek compensation for any expenditure made worthless, or any increased cost of maintenance of the place caused by the order. If financial hardship can be shown, the owner may obtain a magistrate's order that the local authority purchase the property.

Aboriginal sites are protected under the *Aboriginal Relics Act 1975*, administered by the Department of Lands, Parks and Wildlife, Tasmania.

The essence of the Act is as follows.

A 'relic' is defined as:

(a) any artefact, painting, carving, engraving, arrangement of stones, midden, or other object made or created by any of the original inhabitants of Australia or the descendants of any such inhabitants;

(b) any object, site, or place that bears signs of the activities of any such original inhabitants or their descendants; or

(c) the remains of the body of such an original inhabitant or of a descendant of such an inhabitant who died before the year 1876.

In addition to relics, the Act allows for any land containing a relic to be declared a 'Protected Site' in order to protect that relic. An area of land that is not Crown land cannot be made a protected site unless the owner or occupier gives consent in writing, and compensation may be claimed. It is the responsibility of the Department to manage all protected sites. A 'relic' must have been made or created before 1876 (the year of the death of Truganini, believed to have been the last full-blood Tasmanian Aboriginal).

Anyone who finds a relic, whether it is on the property of the Crown or not, must report the discovery to the Secretary, as soon as practicable, unless the person has reason to believe that the Department already knows of its existence and location. It is illegal to disturb, damage, deface or destroy a relic, or to remove a relic from the place where it is found without a permit granted by the minister. Anyone wishing to collect or disturb relics, or excavate or in any way disturb land to discover relics, must obtain a permit from the minister. This applies whether the land is freehold or Crown land.

Members of the public may become wardens or honorary wardens with powers to police the provisions of the Act protecting Aboriginal relics.

Other legislation, besides the Aboriginal Relics Act, may be relevant to Aboriginal sites in Tasmania. For example, under the National Parks and Wildlife Act action may be taken to reserve and protect sites.

The Aboriginal Relics Act is outdated in many respects, and provides only limited protection for Aboriginal heritage. Tasmanian Aboriginal people have long been disillusioned with its provisions. Though staff of the administrative authority have made efforts to more effectively involve the Aboriginal people in the protection of their heritage, the Act does not provide for any such involvement.

Aboriginal involvement in the provisions of the Act is limited to the specification that a person of Aboriginal descent is to be represented on the Advisory Committee.

Victoria

The *Historic Buildings Act 1981* (amended in 1983) relates to the protection and preservation of buildings, and works and related objects of historic or architectural importance or interest. A Historic Buildings Council is set up under the Act to advise the minister regarding the listing of suitable buildings on the Historic Buildings Register and Register of Government Buildings. Entry in or removal from the Historic Buildings Register is made by the Governor in Council, on the recommendation of the minister, who may in turn act upon the recommendation of the Historic Buildings Council. Applications to have buildings listed under the Act can be made by anyone, and the owner has the

opportunity to object to listing. The Historic Buildings Council may make an examination as to whether a building should be added to or removed from the Register, and that takes the form of a public hearing, at which anyone may appear and give evidence.

The effect of registration is to make it an offence for any person to remove, demolish, or otherwise damage a building or carry out development in relation to land on which the building is situated, or to subdivide that land, without a permit being issued by the Council. Applications for such permits for works that will detrimentally effect a place are publicly advertised, and a process for consideration of the application is specified in the Act. Objections to decisions by the Council can be submitted to the minister, and heard by the Administrative Appeals Tribunal if the minister thinks fit.

It is an offence for a person to allow a registered building to fall into disrepair in order to enable demolition or development to occur, and the Council may order repairs to be carried out within a given period (though this provision has never been exercised).

The Council can issue Interim Preservation Orders in situations where a threatened building is being investigated for possible inclusion on the Historic Buildings Register. Such orders lapse after fourteen days. Council can recommend compulsory purchase of items, and recommend grants be made to assist in the upkeep of buildings.

The Historic Buildings Act includes amendments to the *Local Government Act 1958* to require referral of and permission for certain actions by local government to the Historic Buildings Council, and for valuation and rates relief for listed property. The *Planning Environment Act 1987* makes it obligatory for local government to take action through planning schemes to protect registered places.

Covenants can be entered into by either the minister or the National Trust with owners to restrict use and development of sites.

The major problem with this Act is that it applies (or is applied) only in relation to buildings, with no wider application to the historic conservation field as a whole.

An extremely useful programme, not instigated under this Act, but developed by the Victorian government, is the conser-

vation-architect advisory service to historic towns. An expert consultant is made available in each of twelve historic towns to assist local councils and government departments make recommendations to local restoration fund committees on the distribution of loans and grants, and to give free advice to local owners on the conservation of historic buildings. This programme has subsequently been taken up in other states, often with the assistance of National Estate Grants Program funds.

The *Historic Shipwrecks Act 1981* broadly mimics the Commonwealth legislation, for the purposes of protecting wrecks in state waters.

The *National Parks Act 1975* allows for the gazettal of national parks as well as 'other parks', which include state parks, coastal parks, historic parks and wilderness parks.

The *Victorian Conservation Trust Act 1972* establishes a trust of government appointees given powers to protect property with certain heritage values (primarily natural). Its function is very like that of the National Trusts (see below).

In 1982 government legal opinion held that the powers of the *Archaeological and Aboriginal Relics Preservation Act 1972* extended to archaeological relics on historic sites, and from that date until 1992 the Victorian Archaeological Survey administered the Act and was involved in limited historical archaeological projects. While the Act as it relates to Aboriginal archaeological sites deals with the study and reservation of such sites, the role in the case of historical archaeological sites has been limited to the study of sites of major importance or causing major problems, and only with the approval of the owner of the site involved, and results will not be published without the owner's permission. In December 1992 the Aboriginal and historical functions of the Survey were split, responsibility for them being given to the Department of Aboriginal Affairs and the proposed Heritage Victoria, respectively.

The *Aboriginal and Torres Strait Islander Heritage Protection Amendment Act 1987* is a Commonwealth Act, currently administered in Victoria by the Victoria Archaeology Survey, Ministry for Aboriginal Affairs. The explanation for this unusual arrangement is given above in the section on Commonwealth legislation.

This Act amends the principal Act (*Aboriginal and Torres Strait Islander Heritage Protection Act 1984*, No. 79) by adding Part IIA, which applies only in Victoria and repeals the *Archaeological and*

Aboriginal Relics Preservation Act 1972. The inserted amendment to the Commonwealth Act, applicable only to Victoria, provides comprehensive protection for Aboriginal cultural heritage. Aboriginal cultural property may be a place, or object of folklore, either privately or publicly owned. Declarations under the provisions of the Act state what can and cannot be done to Aboriginal cultural property.

Emergency declaration of an Aboriginal place or object immediately threatened may be made by an inspector or the minister on application by anyone, or through a magistrate by a local Aboriginal community, and is in force for 30–44 days. This declaration may be revoked or replaced by a temporary declaration (60–120 days) or a permanent declaration of preservation.

A permanent declaration of preservation is made in relation to a place or object the local Aboriginal community considers significant. The minister must seek representation from people affected before making a declaration. If the minister refuses to make, or revokes, a declaration, the local Aboriginal community may request appointment of an arbitrator to review the minister's decision. Compulsory acquisition of Aboriginal cultural property is vested with the minister on the advice of local Aboriginal communities, or other persons, that the property is significant and irreplaceable.

The minister is responsible for the keeping of a register containing a summary of particulars of declarations of preservation. Access is restricted to prescribed persons or circumstances. Honorary keepers or a warden are required to maintain a record of Aboriginal cultural property held by an Aboriginal community.

No special fund or grant is specified for the operation of the Act.

Aboriginal people are actively involved with the provisions of the Act. Representatives may make recommendations to the minister for the review or amendment of Part IIA. Property acquired under the Act is vested in the local community, and Aboriginal people are consulted for appropriate action concerning skeletal material. They have free access and use of places and objects if sanctioned by Aboriginal tradition, and may enter into an Aboriginal Cultural Heritage Agreement with a person who possesses any cultural property in Victoria.

Requests for permits to excavate or conduct research on Aboriginal objects in a community area must be made to the

local Aboriginal community, or to the minister if there is no community. Discovery of Aboriginal skeletal remains must be reported to the minister.

Western Australia

The *Heritage of Western Australia Act 1990* was the first specific historic heritage legislation to have effect in Western Australia. The Act established the Heritage Council of Western Australia, and defines criteria for its deliberations in establishing a Register of Heritage Places, and in considering other protective mechanisms in the Act.

Heritage Agreements are stressed in the Act as the principal protective measure.

The Register of Heritage Places is compiled and maintained by the Heritage Council, but it may only enter a place in the Register at the minister's direction. The Council considers places, advertises its intent and gathers submissions on the proposed entry, considers submissions, then advises the minister of these matters so that the minister may make direction one way or the other. Interim protection exists for the place once the minister accepts the Council's initial advice. The minister may also direct the Council that a place shall not be entered in the Register. A similar public submission process is undergone by the Council before advising the minister so the minister can take a final decision. Similar provisions exist for the removal of places from the Register.

Conservation orders may be issued for a place by the minister, regardless of whether it is registered or not. Such orders can be placed with the agreement of the owner ('consent orders'), or by giving written notice to the landowner, publicly advertising the intention and seeking submissions, and then advising the minister. Clearly the usefulness of this mechanism in an emergency is limited. However, stop work orders, which last for 42 days, can be issued by the minister.

Appeals against the decision of the minister can be made by any person to the Town Planning Appeal Tribunal. Where registration proceedings have commenced, but been formally withdrawn or allowed to lapse, the Heritage Council may not reactivate the process for a period of five years without leave of the Supreme Court.

Ministers and public authorities (including local authorities) may take no action to adversely affect a registered place unless there is no feasible and prudent alternative to the taking of that action.

Proposals for development affecting a registered place under the *Metropolitan Region Town Planning Scheme Act 1959*, the *Town Planning and Development Act 1928*, the *Local Government Act 1960* or the *Strata Titles Act 1985* must be referred to the Heritage Council, and its advice received before the matter proceeds further. Final decisions still lie with the consent authority or minister.

The minister has the power to declare that a law does not apply to a registered place. No other specific protection is afforded to registered places by the Heritage Council, other than through its role in giving advice on any development applications under the various planning Acts referred to above. Penalties do apply to breaches of conservation orders or stop work orders: these may include fines and imprisonment, and freezing of development approval for up to ten years. Owners have the power to seek compensation or purchase of the property in some circumstances where reasonable beneficial use has been prevented.

The Act is to be reviewed after three years of operation (1994), so these details may change in coming years.

The *Maritime Archaeology Act 1973* was the first such Act in Australia. It now serves as protection for shipwrecks in state waters, in parallel with the Commonwealth's *Historic Shipwrecks Act 1981*.

The *Lands Act 1933* allows for the proclamation of three classes of reservation of Crown lands: A class, which is a perpetual dedication for specific purposes; B class, which is reserved from alienation until the governor might repeal it; and C class, which relates to lands vested in other authorities, such as national parks. The reservation of lands under this Act 'for a public purpose' can include reservation for the protection of historic places and precincts.

The *Aboriginal Heritage Act 1972* is administered by the Department of Aboriginal Sites of the Western Australian Museum. Under the provisions of the Act all known and unknown Aboriginal and archaeological sites and cultural material are the property of the state. The Western Australian Museum Trustees are

responsible for the proper care and protection of places and objects under the Act. However, the minister's authority is not bound by the Trustees or their advisory body's recommendations regarding the protection and preservation of Aboriginal or archaeological sites. Offences against the Act include excavating, destroying, damaging, concealing or altering an Aboriginal site or dealing with an object in a manner not sanctioned by relevant Aboriginal custom without the consent of the Trustees or the minister. The governor may declare an object or class of objects as 'Aboriginal Cultural material' for their legal protection.

A protected area may be declared by the governor on the recommendations of the minister, and after objections have been sought, encompassing any site of special status regardless of land ownership. Crown land may be reserved, and the governor may purchase or compulsorily resume land as a protected area under the *Public Works Act 1902*. Protected areas may be revoked or varied through recommendations of the minister. Sites are protected within these areas by regulating or prohibiting entry. Temporarily protected areas may be declared to prevent or control entry into a locality for the preservation and protection of that locality and object(s) within it. The temporary status is effective for six months, and it can be revoked or varied at any time. Covenants may be entered into between the Trustees and the owner of the land, and covenants may be registered on the title to the land.

The Registrar of Aboriginal Sites is required to maintain a register of protected areas, Aboriginal cultural material and a register of all other places and objects. G. K. Ward, however, states that, because the clauses involving objects have never been invoked, no register of objects is currently maintained.[18]

The Aboriginal Material Preservation Fund is used for all expenditure incurred by the Trustees for the effective implementation of the Act.

The Act protects the right of Aboriginal people over sites and objects that are significant to them. People of Aboriginal descent and traditional custodians are actively involved in decisions directly affecting their traditional culture and providing scope to further protect places and objects not registered under the Act.

The right to excavate is reserved to the Trustees. They may authorize the entry and excavation of an Aboriginal site, and

the examination or removal of things from the site. No other permits are specified.

Other relevant legislation

The *National Trust of Australia Act (N.S.W.) 1960* (replaced in 1991), *National Trust of Australia Act (South Australia) 1955*; *National Trust of Australia Act (Western Australia) 1964*; *National Trust of Australia Act (Tasmania) 1975*, and the *National Trust of Queensland Act 1963*, are all enabling Acts establishing National Trusts in each state. The National Trusts in Victoria and the Australian Capital Territory differ in being companies, rather than being set up by Act of Parliament. The trusts are independent of government control, and have the common aims of encouraging and assisting in the preservation of areas of natural or historical interest or beauty, for public, scientific and educational purposes. The trusts may purchase property, borrow, lend and invest money, accept gifts of land exempt from a range of duties, and some trusts may enter into covenants with owners of properties to restrict use and development of the land, with land rate and land tax advantages for the owners. The most influential activity of the National Trusts to date has been in the compilation of registers of important sites and buildings, landscapes, streetscapes and complexes for each state. These registers have no legal status, but they do bring these sites to the attention of the public and stimulate considerable moral pressure on governments and would-be developers to take heritage values into consideration. In the state context, the role of the trust registers is similar to that of the National Estate Register, which, in fact, largely consists of places nominated by the National Trusts from their own state registers.

Trusts also raise money, and in some cases administer funds made available, for various surveys of cultural places and conservation programmes. They also provide a focus for public pressure on governments to enact adequate conservation legislation.

The activities of the trusts, and the services they offer, can be of considerable value to cultural place managers, especially in states with inadequate or no historic preservation legislation.

In some states there is some provision for the protection or reservation of buildings and land within the planning control

legislation and local government legislation. For instance, the New South Wales *Local Government Act 1920* allows local government to acquire, protect, preserve and maintain places of historic or scientific interest, as well as natural scenery. Quite a few councils take advantage of this clause to preserve local buildings or to erect monuments at key points on, for example, explorers' routes or sites of importance in local settlement. These Acts provide an often-overlooked avenue for people to achieve conservation of cultural places, at a local level, and to have a direct involvement in their management.

The various Building Control Acts throughout Australia often have influence on the conservation planning for historic buildings, by virtue of building codes and standards, especially since the adoption in 1990 of a uniform Building Code of Australia, which applies to all states and territories. Some Acts have clauses that can be applied to exempt historic buildings from the regulations. Managers of historic buildings should make themselves aware of the existence of these clauses and the ease of difficulty of having them applied in their particular circumstances.

Environmental and general Planning Acts often contain important auxiliary provisions, allowing specific planning measures to ensure, among other things, the reservation of important items and areas of the cultural heritage. Such Acts sometimes only refer very briefly to such matters, but can be very important. Provisions for regional and local plans, for instance, can be used to get local authorities to consider historic values, and to incorporate cultural resource inventories in their planning process. Similarly, a general provision for environmental impact statements can be used to encourage surveys and assessment of cultural resources.

A number of states, as indicated above, implement their Heritage Acts through the Planning Act for the state. Indeed this trend is continuing to grow, the reasoning being that heritage considerations should be part of the broader planning process and not imposed in isolation from it. As a result, it is argued, the local authority should be given powers to consider heritage issues in the local planning context, and to seek state Heritage Council advice on specifically registered places only. In most cases, where a planning scheme is developed with heritage as a component, the state heritage body is involved through legislative requirement.

The close nexus between heritage legislation and planning legislation is particularly important for managers of heritage places in urban areas, where the place is often not specifically identified in a state Heritage Register, but where it may be identified in a local environmental plan or planning scheme. It may be possible, indeed essential, for the manager of, say, a house museum in a suburb or country town to become involved to ensure that the heritage values of the place are recognized, and that the control mechanisms help rather than hinder conservation and management of the place.

In the above discussion mention was made of the provisions of several Acts, such as those controlling national parks and forestry activities, which form the basis for the operations of state government departments or authorities. Other such Acts (for example, those establishing public works departments or Crown lands offices) exist, containing provisions whereby the departments concerned may protect cultural places on the lands they administer. By-laws and regulations of such departments often contain useful provisions that can be used to achieve the effective management of cultural places on government land without recourse to the primary heritage legislation of the state concerned.

Using legal measures for active conservation

Secure land tenure and appropriate land-use rules, or zoning, are an essential prerequisite to effective long-term site planning, otherwise extensive conservation and promotion measures may be wasted in the longer term. For instance, the local Aboriginal Land Council, the historical society, the local council and the landowner might combine to open a rock art site to the public. Development might include a road, picnic facilities, brochures, protective and interpretive work. Everyone may be happy with the outcome, until the property owner retires and the son or daughter takes over, decides that tourism is more trouble than it is worth, and closes the area. Similarly, the management and conservation of a historic building in a city or town can have an uncertain future if the objectives of conservation are not in some way formally recognized as an objective of the ownership of the building, such as through the deeding of the property to

a trust for the purposes of conservation, or the settlement of a Heritage Agreement between the owner and the state Heritage Council or minister.

The surest form of tenure is, of course, ownership of the land. However, this is not always necessary or possible, and does not always, of itself, protect all aspects of the place's significance, since it may not prevent inappropriate neighbouring use. The following are some legal measures for long-term individual place protection, one or more of which will be available under the relevant state or territory legislation.

Gazettal of a place under a special provision, or placement of a conservation order does not change the status of the land, but it does impose certain specified restrictions and protection (for example, a prohibited area, a permanent conservation order or an Aboriginal place declaration). As an extreme example, the placing of south-west Tasmania and the wet tropical rainforests of Queensland on the World Heritage List provided certain types of protection of the area under Commonwealth law without changing land status. The main problem with such declarations or gazettals is that while they usually prevent outright destruction or damage to a place, they do not always compel the owner or relevant authority to take active conservation measures, hence the well-known expression 'demolition by neglect'.

Zoning or inclusion as part of a local or regional planning scheme imposes certain land-use restrictions that may assist in protection. It is possible, for instance, to zone an area within a municipality 'for historic preservation', and to restrict inappropriate use accordingly.

Placing of covenants usually requires an owner's consent, but can assist in protection in certain circumstances (for example, placing of covenants is often a condition of financial aid from the state to a private owner to assist in the upkeep or restoration of a historic property). The covenant usually prevents interference with the feature or features of significance. In some states covenants, once made, run with the title of the property: in other states such agreements have to be made with each successive owner.

A Heritage Agreement is an agreement between the Heritage Council, other government authority or minister and a private owner, whereby the government provides financial compensation, or other incentives (assistance in kind, for example) to

ensure the preservation of a place of significance. For instance, a house-owner may gain rates and land-tax relief and grants or low-interest loans, or a grazier might be compensated for fencing cattle out of an area containing an Aboriginal surface campsite, so that stone artefacts are not damaged or destroyed by them. Such agreements now exist in several states, and are usually more flexible to operate than covenants, which often come with a body of arcane and outmoded legal interpretations.

Lists of important sites are maintained by the Australian Heritage Commission, various state and territory authorities, and National Trusts. These lists have varying legal force—ranging from very little to substantial—but they do bestow prestige, and in this way assist in protection.

The administrative framework

The successful conservation of particular places depends on an adequate administrative framework. The well-managed site is like the tip of an iceberg: it floats because it is supported by nine times the resources apparent on site, including finances, team-work, planning, infrastructure, policy, research, public support, expertise and legislation. Hence, effective administration is essential for effective place management. In particular, specific place conservation needs to be based on a sound set of policies and procedures, an effective administrative structure, and good state, regional and local land-use planning.

How to get a place added to a heritage register

If you want a place you are managing added to a state or national register, the process, while differing in detail, is very similar across Australia. In most states where registers exist, anyone can nominate a place for consideration by the heritage listing body.

You must obtain a copy of the application form from the state Heritage Council or its equivalent, or from the Australian Heritage Commission in the case of the Register of the National Estate. The heritage agencies are gradually standardizing their processes and terminology, so that eventually the information provided to support, say, a nomination to the Register of the

National Estate, will also be able to be used without change for a nomination to the state register. The nomination forms seek basically similar information:

- name and address of the person or body proposing the nomination,
- particulars about the location of the place, and often ownership and title details
- a description of the place, its components, boundaries, its current condition, and any other information that might be relevant to the assessment of the place
- a statement of why the place has heritage significance.

This information is then used as the basis for an assessment by the professional staff of the heritage body, and eventually by the Heritage Council itself. During the assessment other information is usually sought by the heritage body, to thoroughly assess the history and other aspects of significance of the place, and to compare it with other similar places. In this way the Heritage Council can determine the 'threshold' level of significance appropriate to that place, and judge whether the place crosses that threshold. The threshold is the degree to which the place possesses a particular value sufficient to justify listing as a heritage item, and it will vary with each different type of value being assessed (as outlined in Chapter 4).

Often the threshold can only be determined through comparative analysis, and if there has not been sufficient research into a particular type of place the assessment may be deferred until such study can be carried out. There is, therefore, sometimes a considerable delay between the nomination being made and its final assessment by the Heritage Council, so it is important in the nomination to highlight any threats to the place that might require an urgent assessment.

 3

Documenting the Resource

Finding and Recording Aboriginal and Historic Places

Location, identification and documentation of heritage places are essential first steps in their management. To be able to manage the place, you must know it exists, and know where and what it is.

Documentation is the process of describing in a written, permanent form, all or some of the place's attributes. It includes the gathering and integration of all relevant written and graphic information about the place. The completion of a place (site) recording form, with location, ownership, description of place, photographs, and references to relevant written records, is the most common and effective approach to place documentation. The documentation of a place may be part of a survey report, heritage study or research report.

The manager needs this information before assessing the place, or making decisions about its future. While for the purposes of this book, we have separated the processes of identification and documentation from those of assessment of significance and management decisions, in reality they are often closely linked. We could go so far as to say that the best documentation procedures contain an essential element of assessment—comparative description. The descriptions of most places sought in place recording forms includes comparative attributes: 'an outstanding example of the Federation style', 'a typical Sydney

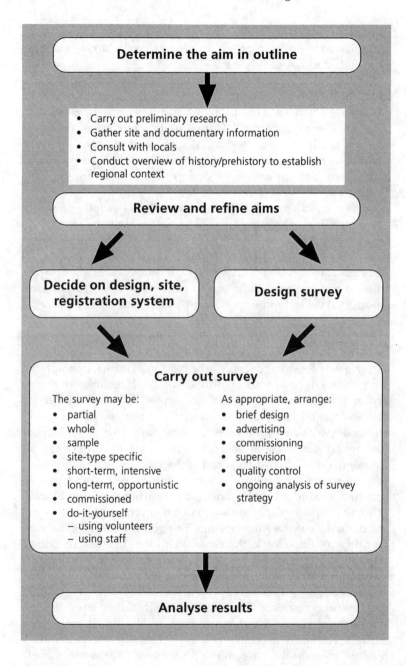

Figure 3.1 Survey procedures for locating heritage places

sandstone engraving site', 'the best preserved and most intact stonemasonry works in Southern Queensland', 'a rare example of a shell midden of this size'.

Because of this it is difficult to separate the process of documentation from assessment, and, indeed, in the real world such separation often leads to problems. This is because investigation, location, identification and documentation of cultural resources is rarely carried out for its own sake: more often it is part of the process of management, or of research. In either case, a clearly articulated aim, and a survey design that suits it, are essential first steps.

Surveys conducted without this intellectual discipline may put 'dots on the map' where none were before, but the results will be no more than this. They will certainly not supply the information needed for assessment or management. Hence a survey of Aboriginal places that merely pinpoints and lists the place types, without an understanding of the prehistory of the area, local Aboriginal views, land tenure, comparison with other areas, etc., will be of little use either for research or for management.[1]

The process of identification and documentation can be undertaken at a variety of scales, from the state- or nation-wide surveys of the government agencies or the National Trusts, through the area survey necessary to identify cultural places in a local government area, a suburb, or a national park or state forest, down to the detailed inventory necessary to document the extent of cultural evidence present on a single large historic place or Aboriginal place (such as Port Arthur, Carnarvon Gorge or Centennial Park in Sydney), and at the smallest scale to identify, say, the range and nature of outbuildings, works and garden planting around a historic house on an urban building block.

Some heritage places are well known and documented. If you are in charge of the Alice Springs Telegraph Station or the cave paintings of Cape York, the process of identification and documentation of the major elements of the place will already have taken place. More work may well be needed to fill out the picture, and to enable proper management, but the initial recognition of a cultural resource has been achieved. Other sites, though not perhaps reserved as historic sites or Aboriginal places, are easily recognized as being of cultural value—for example, a historic court-house or hotel, a 120-year-old woolshed, a well-preserved Aboriginal carved tree or ceremonial ground. This type of place may have state, federal, local or National Trust

recognition, by being listed or noted in some way. Most of the heritage places of Australia, however, have not been located or protected. This is because for many areas systematic surveys have not been conducted, and because many heritage places are not immediately obvious to untrained eyes, or, if they are, their value is not readily identifiable.

The inevitable process of decay means that places are often not in a complete state, and archaeological skills are often required to retrieve information about the processes involved in the creation and decay of the place. For example, to determine whether a rock shelter has been occupied by Aborigines, researchers have to assess factors such as the colour of the floor, the presence or absence of occupation debris (stone flakes, shells, animal bones) and sometimes, if there is no visible surface evidence, conduct a test excavation. The remains of an old mining area or a nineteenth-century industrial complex might be obvious to the casual observer, but often the meaning of the place, its age, exact identity, use and layout may need to be determined by historic research, careful recording and archaeological work, geological analysis or any number of other investigative processes. A wide variety of past land uses and industrial processes may result in remains that are visible but indecipherable without quite specialized knowledge of the processes that created them.

Whole landscapes may be historical artefacts that only reveal themselves after careful survey. Sacred sites or landscapes, or other areas of significance to Aborigines, can only be revealed by their traditional owners. Such sites often have no special meaning to Europeans, or may be totally misinterpreted by them—one person's 'wilderness' might be another person's 'dreaming'. Even within the bounds of one's own cultural heritage it may be impossible without research to understand the meanings hidden in the landscape. The origins and meaning of a century-old agricultural landscape, for example, with its hedges and dry-stone walls relating to the earliest European settlement patterns, may not be understood as an historical document to those who presently live in it, and may require a search of written documents and maps, and oral research with the oldest former inhabitants, before it can be understood and interpreted. Sandy Blair and Anne Claoué-Long recently commented:

> The evidence of convict occupation of rural Australia, in particular, is often subtle (for example, ruined buildings, and archaeological sites, or patterns of land use) and so is

easily overlooked, or even destroyed out of ignorance of its cultural significance. Such places have sometimes also remained unrecognised because the experiences of the convict era have been too close or painful for communities to deal with: in the 1930s, for example, much of the convict heritage of Port Macquarie was deliberately destroyed to remove the 'hated stain' of the convict past.[2]

Even in cases where the identification of the place is obvious, such as with an intact building identified in the literature as being built at a certain time, it is often a specialized job to sort out the sequence of additions, alterations and demolition of parts of the single building. This might be the role of an architect, architectural historian or archaeologist, or the manager supported by specialists, depending on the circumstances, and might be crucial in firmly identifying the building as the one referred to in the literature, or as wholly or partly a later construction.

Many areas in Australia have never been surveyed in any systematic fashion to locate the cultural places they contain. This is as true for suburban areas as it is for the most remote rural areas. Often the background research into the history or prehistory, which provides an essential context for such a survey, is also lacking. Yet such information, followed by further assessment and study, using architectural, historical, archaeological and anthropological techniques, is an essential tool for the manager. Land and building managers are not necessarily trained in these areas, nor is it always necessary or possible to carry out detailed studies of the very numerous places some managers control, but it is essential that they know of the existence of such places and of their potential importance. The means by which such an understanding of the resource may be achieved, through its initial recording, is the subject of this chapter.

Documentation and management

Even at places with readily recognizable cultural resources— Hill End Historic Place (NSW), Port Arthur (Tas.), Wilgie Mia Aboriginal Ochre Mine (WA)—the managers do not usually know the whole resource. For instance, many of the remains of places such as the remote village of Cossack in Western Australia, or the original garden layout in the grounds of Vaucluse House

in suburban Sydney, are not immediately recognizable, and without archaeological survey could be accidentally damaged.

Survey for sites is often necessary, therefore, even in well-known areas that are reserved for the specific purpose of conserving cultural places. Most land, however, is not managed or reserved primarily for this purpose. The land might be a national park, a state forest, a water catchment, an Aboriginal reserve, a recreation area, a municipality or an industrial complex. In these cases, usually there is no documentation of cultural places, and almost certainly no survey or inventory has been made to locate them. Since there is no part of Australia without some cultural remains, chances are high that most areas of land will contain some traces of past human history worth recording and possibly conserving (though note that location and recording of a place does not necessarily mean that it can, should or will be conserved).

When managers are ignorant of cultural remains, management plans ignore their existence, make no provision for their protection, and in some cases propose practices that are gravely and directly detrimental to them. For example, a major group of Tasmanian land managers, the Tasmanian Hydro-Electric Commission, commissioned an assessment of the environmental effect of dams on the Franklin and Gordon Rivers in the late 1970s. A one-line entry in the environmental impact statement stated that no Aboriginal sites were known to exist in the area, and that it was believed to have been uninhabited by Aborigines (no evidence was supplied to support this conclusion; no survey for sites was conducted). The conclusion was that no consideration need be given to this aspect of management in plans to flood the area. Subsequently, a brief archaeological reconnaissance revealed a major place, over 20 000 years old, of considerable scientific importance (and, as it subsequently emerged, of great value to the Tasmanian Aboriginal community).[3] Other sites were subsequently located. These sites were an important reason for listing the area as a World Heritage property.

Another example was when the New South Wales government proposed to lease a downtown Sydney block for the construction of a multistorey building. No consideration prior to this decision was given to whether the place had heritage significance, despite the fact that it was known to be the location of the first Government House in 1788. Subsequent investigation revealed, however, that footings of the building, and associated significant

archaeological deposits relating to the earliest history of Sydney were still *in situ*. This rather changed the plans for development of the place.[4] The development rights were subsequently transferred to the adjacent block, the profits from this sale were used to conserve and present the First Government House site, and $20 million was used to set up an operating fund to finance heritage grants and loans elsewhere in the state.

These examples are perhaps extreme. Usually the sites located do not jeopardize the present or proposed land use; or they necessitate some adaptation rather than land-use change. Often they actually give added monetary or social value to the area. However, until knowing what the cultural resources are, the manager does not have all the relevant information required for good land management. Some managers are recognizing this need. The Forestry Commissions of New South Wales and Tasmania, for example, have commissioned surveys of their cultural places, and have adapted management practices to conserve significant sites.[5]

In several states, legislative or administrative directives have been instituted to require government land administration bodies to identify and assess heritage places under their control, so that management can take into account the existence of these places when making decisions that might affect them. A good example is the Western Australian Heritage Act, which requires municipalities and shires to conduct heritage studies within a set period of time.

Aims and strategies

The first step in producing a heritage place inventory is to clearly define the aims of the exercise. Why is it being done? What is to be achieved? How will this achievement be measured? The more clearly articulated the aim of the undertaking, the more chance the manager has of achieving results and, of course, the results, will vary according to the aims.

The local Aboriginal Lands Council, a manager or an archaeologist may wish to conduct research into the history of Aboriginal occupation of an area or an aspect of it. The aim of the researchers would then be to locate well-preserved substantial archaeological deposits, in order to excavate one or more to test their construction of local prehistory. The survey strategy would

therefore target those areas where it is anticipated such deposits will be found: for example, an area of sandstone outcropping in a major valley with open flats and permanent water, or the remnant bushland areas or water-edge reserves in a built-up urban area. The survey will probably not locate all the Aboriginal sites in the area (though as a by-product it may find a number of sites to notify to the relevant authority). Such a survey, though it may be very important in elucidating the cultural history of the area, will not take the place of a comprehensive survey, or a stratified random sample survey.

At another time, the aim may be a survey before a planned development to mitigate the effects of the development on heritage places. A survey of archaeological remains on an old goldfield through which a new highway is passing, or of an old industrial area being converted to a housing estate, would be good examples. The strategy would be firstly to gain an overview of the general history of the area and the activities that have taken place there, so that sites encountered could be correctly identified and interpreted; then to conduct a limited survey in the area of direct and indirect impact, intensifying the survey where evidence of past activities is most numerous.

When a local council commissions a heritage study of the local government area, it wants, as a result, sufficient information about the council area's cultural places to enable the integration of conservation measures (zoning, community use, restoration) for significant heritage properties and landscapes into planning schemes for the area. The survey strategy will therefore be aimed at producing an overview of important historic themes for the council area, and at locating, on the ground, the locally or regionally significant places and landscapes reflecting these themes. The survey should involve shire officers (especially works staff and supervisors) as well as the community, with the object of making them allies in the conservation of their heritage, and from the survey should stem a plan for action by council officers.

The State Planning Department in most states can provide published guidelines to the heritage study processes in that state. Some current examples are referred to in the notes, and a model brief as used in Victoria is provided in Appendix 4.[6]

So the aim will dictate the type of results expected of the survey. However, it is not usually realistic for the manager to produce a refined set of objectives and a detailed survey strategy

without some background research. The working out of a set of
general objectives should be followed by research into back-
ground information.

Good background information on the rationale and methodol-
ogy of site recording is available to managers.[7]

Gathering background information

The first step in producing a heritage place inventory is to
assemble all known information on the heritage places of the
area under study. This can include previous recordings of places,
all documentary evidence, and local knowledge including oral
tradition.

Registers

Heritage registers were referred to in Chapter 2. The main
registers you should consult are:

- the Register of the National Estate, which lists important or
 representative places throughout Australia, but which, while
 including about 11 000 places in 1993, is not comprehensive

- the State Aboriginal Sites Registers, which exist in each state
 and territory and which document in varying degrees of
 completeness Aboriginal places throughout the states. Access
 to information may be restricted unless the manager can
 demonstrate a valid reason for asking for the information

- the state Historic Heritage Registers kept by most state gov-
 ernment heritage authorities, and the National Trust Registers
 in each state. In some states the National Trust also has lists
 of places not included in the registers, such as the Industrial
 Archaeology Inventory of the New South Wales Trust (refer
 to Chapter 6).

Each of the bodies maintaining registers also issue recording
forms and other associated information on places of use to
managers. For instance, most Aboriginal place authorities have
free brochures in which are described the range of sites occurring
in that state; many local councils who have active planning
schemes put out brochures describing the protection of heritage
places within the scheme, and often even publish guidelines to

owners on appropriate alterations and maintenance that will conserve the heritage values of buildings.

The Australian Heritage Commission and state historic heritage bodies, supported by a decision of state heritage ministers, is moving towards the development of a national inventory to incorporate or provide seamless computer access to all historic heritage registers. This would allow an enquirer to access the Register of the National Estate, the state heritage register, and eventually even local government register data, through one computer access point. When this finally occurs it will greatly speed up the gathering of existing information. It is already having the effect of stimulating the formulation of consistent standards for recording information about places.

The information in place registers will usually only tell you what has been recorded. In most cases, the places recorded in place registers are the result of chance discovery, or a series of uncoordinated research programmes, rather than being a systematic inventory. However, in some instances, systematic surveys have been conducted, and general background information on the heritage places of an area is sometimes available. In many states, local governments are now producing local heritage surveys, and, while few can be regarded as being comprehensive, they may provide a good starting point for other surveys.

It is necessary to find out whether a survey of heritage places has been conducted for the area or specific place under study, and whether any other research results or background information are available from the relevant authority. Some state authorities collate details of surveys conducted, and areas covered, and some organizations like the National Trust have conducted regional studies and overviews. For instance, the Aboriginal sites register in New South Wales provides information on areas over which previous surveys have been conducted, and the NSW National Parks and Wildlife Service maintains a catalogue of these surveys.

This type of information is often not well organized nor easily located, however. In many cases the manager of an area or place will be conducting pioneering research. Actually finding out what is available often takes time and patience, but staff at the Australian Heritage Commission, or the state or local authority, are usually knowledgable and helpful, and can at least suggest useful leads. Often someone at a regional college or university

(in a history, prehistory or architecture department) is conducting relevant research, and may have been that route before.

The relevant land management authority's own archives, or those of a government department or authority that may have been associated with the place in the past, may require some investigation. A past owner or manager may have begun an inventory or a history, and misfiled it in the filing system. Other government department files and archives may be relevant to sites within the management area. Examples are Department of Mines records, Defence Department records, Public Works Department records, or local land-rates books.

A new and potentially very powerful tool for this research is HERA, the computerized bibliography from which hard copy printouts are produced and published regularly by the Australian Heritage Commission. HERA lists and annotates all known material relating to conservation studies, including surveys and inventories. All the backlog accessioning is not yet complete, but HERA has a very effective cross-referencing system, and is available for researchers' use. In the first instance, contact the Librarian at the Australian Heritage Commission.

Local histories

The production of an inventory is somewhat meaningless, and the assessment of places is often impossible, if it does not have the context of an overview of the area's prehistory (however basic), an ethnographic picture of Aboriginal society at European contact, or of the area's historical pattern of settlement and land use.

This information occurs in many guises: in the context of heritage place inventories, it is usually referred to as documentary evidence to distinguish it from the physical evidence of the place itself, but this general category can also include oral history, photographs, film, and other forms of documentation. The review of this evidence can produce many levels of information:

- a local or regional history (for example, W. K. Hancock's *Discovering Monaro*, or Bobby Hardy's *West of the Darling*), which integrates and synthesizes what is known of the story of the area[8]

- a range of research papers dealing with aspects of the area's history (for example, Betty Meehan's monograph, *Shell Bed to*

Shell Midden, which covers the subsistence economy of the Anbara people of the Northern Territory[9]

- specific references to places, either contemporary historical references or references by later chroniclers or researchers
- 'contextual' information, such as ethnographic observations of Aboriginal society, descriptions of nineteenth-century European land use and settlement, or nineteenth-century information that puts the places located into a historic or prehistoric social context.

The Australian Institute of Aboriginal and Torres Strait Islander Studies maintains a cross-referenced bibliography of all printed and much manuscript material on the Australian Aborigines. It is organized by geographical area. The bibliographer will send enquirers a list of major references for the subject area.

Local, regional or state historical societies often have extensive relevant information, especially on early European settlement and associated places. Local councils also sometimes have such information. A valuable source of information is often the various local histories written for an area. These may be books commissioned by local historical societies, or published by individuals, or pamphlets published for council or school centenaries or other historical events. (The Cook Bicentenary celebrations in 1970 produced many of them; the 1988 Bicentenary produced even more.[10]) These histories will either pinpoint actual places, or provide an overview of the various land uses that have affected the area since European settlement, and the types of historic places that these land uses produced. Similarly, local newspaper offices are sometimes useful.

The State Libraries and Archives Offices, apart from holding copies of most published local historical information, also have large collections of manuscript documents (such as diaries, letterbooks, journals, reminiscences, station records, government department correspondence and records, photographs and maps) that may be relevant. These collections are sometimes difficult to work on, and such work is inevitably time consuming. If the manager cannot do such work, it may be possible to commission a review of this material by a professional historian or archivist: most libraries and archives offices offer limited free searching of records for people who write in requesting it. There are several directories available that list other places where manuscript or photographic collections are kept in each state.

A number of books provide guidance on sources and techniques of historical research.[11]

Local contacts

Often local historical societies, or long-time local residents, are a valuable source of personal and family knowledge of places, and folklore concerning them. The local museum is often a good place to start, containing as it does donated artefacts, photographs, and yellowing newspaper clippings.

The assembling and sorting out of documentary evidence to provide an initial picture of the history or prehistory of the area is like assembling a jigsaw puzzle, except that, as an added complication, many of the pieces are hidden, some of them may be missing, and you don't have the box lid to copy.

So the process has many moments of achievement and of frustration. At this stage, if not before, it is essential to consult the experts. We refer not to the professor of history or prehistory at a university (though, as indicated above, this may be a very useful source of information and guidance) but to the people whose history and places are being studied. It is extremely important that relevant local people are involved and consulted early in the process.

Such local contacts can be most useful allies in heritage place recording, or can be very obstructive. There is often a feeling of possessiveness about local history. Managers can be considered meddling outsiders if they do not consult, or if they disregard local advice or knowledge. On the other hand, they can have a very fruitful relationship, and be given a great deal of assistance and voluntary work, if they go about the liaison tactfully and with respect for the locals' specialized knowledge and their special relationships to the places being studied. (For examples of the value of oral history and local contacts in developing inventories and context building, see Klaus Hueneke's and Matthew Higgins's works,[12] about the huts and sites in the alpine country, which were partly based on oral history and place surveys.) Where there is a local Aboriginal community it is *imperative* that the manager fully consults the community about the areas to be surveyed. There may be places of importance in the area, which should not be disturbed or interfered with, and the local Aboriginal community may know of mythological sites

that no surveyor could find unaided; alternatively, they may have no knowledge but a general interest in their own culture, which should be respected.[13] In some circumstances it may be totally inappropriate to record Aboriginal sites, or to seek information about them, as this may cause serious offence. More and more Aboriginal communities are asserting their right to record and protect their own sites, or to commission their own surveys by anthropologists. On the other hand, they may welcome assistance and consultation by the land manager. The role of the manager is to seek effective management of heritage places, and this may require direct involvement of the Aboriginal community to achieve this for sensitive sites.

There are also other similar groups with particular links or interests, such as the local timber-getters and their descendants who may have a particular interest in a state forest, or the descendants of a pastoralist whose property is now a national park, or the school or religious group who once used a house that is now a museum, and who feel a deep commitment to conserving the place. Likewise, it is important to liaise closely with the local land-use authorities.

Close local involvement in the survey design, and in its execution has another very important advantage. Heritage places are significant because of the way people regard them. Some heritage places—the Willandra Lakes, Port Arthur, the 'Dig' Tree—are of national importance and have national recognition, but most have their value in the first instance for reasons of regional or local significance. Their significance to the local community is crucial to their value and their conservation. The manager cannot really create a relevant and comprehensive inventory of cultural places without this input, and certainly cannot assess significance, or make effective management decisions, in a vacuum. Unless the inventory is 'owned' by the community, and unless it reflects, among other things, their views on the nature of their heritage, it is not a good or true inventory.

There are many ways of gaining such involvement. Press releases and newspaper articles, requests for information, a formal or informal steering committee, field days, recruitment of volunteer surveyors and researchers, lectures and local displays, can all help. Increasingly the community will be actively involved at all stages of the work, especially where heritage studies are commissioned.

Refining aims of the inventory

Earlier in this chapter we gave a broad idea of some of the survey options available to managers of different types of areas, depending on their needs. Once the various sources of information just discussed have been consulted, managers may be in a far better position to decide an appropriate strategy for locating and documenting the cultural places in their area. In many, if not in most, cases the review of register material, local histories/ ethnographies, past management records and local sources will at least give an overview of the human history of the area, and at best will give a preliminary inventory of major known Aboriginal and historic places that can be used to stimulate ideas for survey design, and point out areas where knowledge of the resource is weakest. The background research can pinpoint those areas most intensively settled or utilized, and enable the most concentrated survey effort to be made in those areas.

The manager must now ask, in the light of available information, what the specific aim of the inventory is, how will it be used, and what data is necessary to fulfil this aim. Put another way, the decision has to be made as to what will be looked for and why, and what details of each individual place located will need to be recorded. The manager of a small site (say, a single building on a suburban block) will have very different needs from a manager trying to get a cultural heritage overview of a local government area or a national park.

A place register

For the manager of an area that may contain a number of heritage places, the next step may be to create a place register or inventory.

It may be that the initial research provides the manager with at least an overview of the range and density of heritage places in the subject area, and that what needs to happen next is not a more detailed survey but the setting up of a place register and documentation archive, which systematically stores the information known to date, and provides a system for accessing future data. This register needs to be accessible, well organized, simple to add information to and to use. It needs to be integrated into

the systems of the relevant office, so that its use and upkeep are mandatory and automatic.

The manager should plan a suitable method of storing and filing records. Key factors are accessibility, security and usefulness. It is necessary to decide, for example, whether to file records in alphabetical order, in map-grid reference order, or place-type order; how to use and store maps and aerial photos; what to do with photos and other information; who should have access to the register; how it can be integrated with state and national registers; and whether it will be on a computer or paper-based. If possible, advice on all these points should be obtained from the state authority or from other available experts—for example, the National Trust. All existing systems need modification for different situations, but if there is a system available at a local or state level, there are important advantages in using it.[14]

Registers usually need a site form, which can be used for a variety of places and which allow for a range of descriptions. The site forms used by the state authorities are usually appropriate.

Computerized geographic information systems are developing rapidly at a national level (ERIN[15]) and in most states, usually managed by the major land management authorities. These geographic information systems are essentially a layout of the landscape and environment in computerized graphic form, with digitized information on a range of collected information about environmental parameters. Often the regional or state site registers are already overlain on these systems, or can be readily integrated into them. This integration has immense potential. It allows the surveyor to compare heritage place occurrence and type with landscape, vegetation, other evidence of settlement patterns, etc. It effectively puts heritage places back in their environment, and hence gives them a range of new meanings and interpretations. The approach can also be used to manipulate historical data, and has great potential for urban heritage investigations.[16]

Choosing a survey method

In most cases, the initial research will indicate an incomplete data set, and, apart from setting up a system to make it usable and able to be added to, the manager may feel the need to do more work. Briefly, the options for further work are as follows:

- progressive inventory of places over time, as information comes to hand
- a total survey of the cultural places of an area or part of an area
- a survey of sample areas to allow predictive modelling
- a specific place-type survey
- further detailed research to elucidate particular aspects of the cultural resource
- a survey aimed at locating the most important or significant sites.

In each land management situation the needs of the manager, and hence the aims of the inventory, vary. Some examples of types of inventory and survey techniques are outlined below.

A manager may need to establish an inventory of places covering a large area of land. This may be a large management area, such as a major park or forest, or it may extend to an even larger land unit such as a shire, a region or even a state. With very large land areas it is often beyond the financial resources of the manager to undertake a one-off survey with any hope of arriving at a complete or even representative inventory of heritage places. Many keepers of state registers of Aboriginal and historic places are in this position, and rely on opportunistic random site recording, collation of inventory information from incidental surveys within the state (for example, environmental impact assessments), and place-type survey (such as the mining remains of a region). In this situation, a system of long-term planning, as described earlier, is necessary to establish a framework within which small inputs can be built up into a more complete picture over time.

On smaller areas of land, such as a national park, state forest, industrial estate or municipality, such problems may still exist, but the scale of the problem is usually more easily managed. Inventories in this situation can be aimed at gaining an overview of the total cultural resource in the area being managed, or at selective inventories of place types.

If a management area is small, it may be possible to conduct a complete ground survey to located all or the majority of visible Aboriginal or historic places within it, or even all of the elements making up a single heritage place.

At historic sites like Port Arthur, a protected township, or a dense complex of Aboriginal art sites, it may be necessary to

undertake a very intensive survey to locate all of the heritage places requiring management. Such management areas are often more intensively developed for visitor use and interpretation than larger areas of land, and the location of all heritage places is necessary to minimize damage during development and to fully define the resource available for interpretation to visitors. Because the land area involved is small, intensive on-ground survey of all of it is possible, and a complete and in-depth inventory can be developed.

Boydtown, on the south coast of New South Wales, was recognized as a historic area some time ago. It contains the inn built by Benjamin Boyd, a colourful nineteenth-century entrepreneur, who specialized in whale oil. Restoration of the inn itself and plans for tourist exploitation of the site threatened other cultural elements. A detailed survey of a very small area (about 15 hectares) resulted in the local recording and protection of a complex of important archaeological sites associated with the whaling and pastoral industries.[17]

This is the ideal survey situation. If all heritage places have been located, identified, recorded and assessed, planning for their management is comparatively simple. Safeguards and management strategies can be built into ongoing management of the area.

Total surveys are also conducted for particular research aims: for instance, if an archaeologist is doing a detailed study of the relationship between Aboriginal living patterns and the environment, an in-depth survey of all sites in a particular environment or series of environments might be necessary.

Another common reason for a total survey is for environmental assessment purposes. If a proposed land use will adversely affect heritage places, then the places must be located and assessed as part of the overall environmental assessment process. In this case, expertise in the location and assessment of a wide range of places—from nineteenth-century engineering works to 20 000-year-old rock engravings—may be required.

Full site surveys often provide us with the first information in a region of site densities and interrelatedness, and of the relationship of sites to the environment. Enough data of this type may allow the manager to assess site occurrence in a particular environmental zone, and predict the occurrence of sites in similar areas.

In larger areas, where an overview of site occurrence is required, a sampling strategy is often employed. In Australia this is most commonly used to locate prehistoric Aboriginal sites. The type of sampling strategy employed is usually stratified random sampling. The area to be surveyed is divided up into different environmental zones or landform units. Within these zones or units, blocks of the same size are chosen at random and surveyed in detail, with a record of all site occurrences and, in some cases, a record also of locations where sites do not occur but could be expected to (for instance, suitable rock shelters with no sign of habitation).

The results of such surveys are analysed, and used as a model to predict the likely presence and density of similar sites in similar environmental zones elsewhere in the area under study. The model is then tested by further surveys of other randomly chosen blocks. Often only 10 per cent of the total area is surveyed, but the results of such work can be extremely accurate. The accuracy is dependent on the care and skill with which the survey is designed, and on its validity as a predictive model. Land managers, such as foresters and national park rangers, have proved to be particularly skilled at this type of survey, because of their detailed knowledge of the characteristics of land they manage.

Predictive modelling doesn't tell the manager exactly how many sites there are or exactly where individual sites are, nor does it predict the unusual, rare, or particularly important place, but it gives a good indication of likely type, occurrence, density, and location, which is invaluable for assessment of the importance of the area as a whole and for forward planning for development or visitor use. It can be extremely accurate. Brian Egloff and Dennis Byrne, working in the coastal forests of southern New South Wales were able by stratified random sample to construct a model of Aboriginal occupation, and hence of site occurrence in similar terrain, which when tested proved very accurate.[18]

The use of predictive models is more relevant to Aboriginal place survey that it is to historic place survey. It is usually far easier to get a total inventory of historic places, since they are not as numerous as Aboriginal sites, and they do not occur with such regularity as to make predictive modelling very effective in a limited land area.

Sometimes prehistoric settlement patterns and site occurrence are predicted without ground survey by a review of previous surveys, of records in site registers, of ethnography, and other relevant information such as Aboriginal and other local informants. This is usually done when the area is large, and finance is limited. In some areas where the general distribution and nature of the resource is well known because of previous surveys this works quite well. It is now possible for an experienced archaeologist to broadly predict site occurrence around Sydney in Hawkesbury sandstone, for instance. This is usually the first step in a local council planning study. Such an initial predictive assessment can be useful in indicating areas that should be zoned as sensitive, and should be the subject of on-the-ground surveys prior to any significant land-use change. Such a process is a preliminary measure only, however, and cannot take the place of a ground survey.

Sometimes, and especially in the case of historic places, it may be possible to attract funding for a large-scale inventory project. This can be structured so that historical documentary research is carried out first, which, backed up by local knowledge and previous recordings of places, can lead to the identification of a number of places or establish a land-use history that might suggest profitable areas for intensive on-ground survey. Such a survey can then take place, using volunteer or paid recording teams directed to areas highlighted by the previous research.

Full surveys of larger areas are rarely achieved. The more normal situation is one in which the inventory is built up of places identified by local informants, opportunistic discovery, research projects, and places located during smaller-scale surveys undertaken to locate the cultural places as a preliminary to specific management practices or developments.

In one state, South Australia, the Heritage Branch of the Department of the Environment conducted a systematic state-wide survey for significant historic places. The first step was to commission a report that analysed the history of the state chronologically, and on a thematic basis, established a series of key themes and periods. Following this, the regions were established on a geographic basis, and regional surveys were commissioned to provide an understanding of the history and the heritage resources of each of these regions. So far, more than half the regions have been surveyed in this way, resulting in reports

providing a general statement of the important historic themes of the regions, a list of places of significance, and associated documentation-description, photographs, etc.[19]

These surveys are not aimed at locating all cultural places, rather the more significant ones—but they provide a framework and a context within which local land managers and authorities can conduct further, more detailed local surveys and inventories. Inventories, especially over large areas, or across a series of areas managed by one body (such as national parks, forestry areas, and reserves of various types), can be guided by various checklists of place types. Such thematic checklists have been in and out of fashion for decades,[20] and are once again, in the 1990s, being used to help guide survey work in some states. They act as a useful reference to the types of places that potentially exist in any area, and can stimulate the search for places that otherwise might be overlooked. Some checklist headings are unlikely to occur in some localities, and it may be useful for the manager to modify one of the existing lists, or to develop a new list, to suit particular environments or circumstances. The new list might be more specific in its reference to place types, especially if it is drawn up in the light of extensive documentary research and a survey of existing registers.

The Department of Planning in New South Wales has produced, as part of its State Heritage Inventory Program, a list of historic themes intended to be used as a guide or checklist for those conducting heritage studies. It has been given a mixed reception. Many historians tend to think that it limits and fossilizes our interpretation of history, and that likewise it limits types of places having heritage value. However, such a list is only ever intended as a guide, not as a rule book. The Australian Heritage Commission is refining its approach to historic themes, and the draft list of themes being tested is given in Appendix 3.

Survey by specific types of place might be appropriate in some situations, especially as one type of input into an accumulative inventory. In a coastal reserve, for example, there might be pressing management planning reasons for undertaking a survey of Aboriginal shell middens. Similarly, in Kosciusko National Park specific surveys have been undertaken for miners' and stockmen's huts, and for mining sites. In the case of the inventory of huts, a primary motivation was to enable proper assessment of recreation use of the huts throughout the park, and to provide a

basis for recreation planning in the future. The identification of the cultural values of the huts was a spin-off not fully appreciated by many until the survey was completed, but which has led to the gradual development of a maintenance programme based primarily on cultural significance rather than recreation use.

Such surveys can often be profitably pursued outside the boundaries of the area being managed, in order to locate and study similar places. These similar places can be compared with the place being managed, and assist in its assessment and conservation. Thus the comparison of, say, coastal defence fortifications in several states may enable the manager to accurately assess the relative significance of the fort being managed, and also provide information on design details and fittings that may be missing from the site but which may be reconstructed based on the interstate examples. In some instances, such a state- or nation-wide survey is required before an assessment of significance of a particular place can be made. The assessment of quarantine stations is an example; usually there is only one in each state, all of which came under centralized federal control early this century, so it is difficult to assess any one in isolation from the rest.

As can be seen, the reasons for wanting an inventory of cultural places, and the methods designed to produce the inventory, can vary greatly, and include a lot of other approaches not listed in the examples given here. However, there are certain essential elements common to the planning of all types of surveys.

The heritage place and its context

All of these survey methods are aimed at an inventory of one sort or another, and to be successful and meaningful all have one common requirement—the placing of the cultural place in its context. Heritage places exist in two contexts: they are part of the physical landscape, and they relate very closely to it. This is obvious with most Aboriginal places—shell mounds exist because of nearby beaches and rock platforms; paintings or engravings are located on suitable rock surfaces; occupation sites are most numerous near permanent water. But it also holds true for European places. Factors such as transport, arable land, access to natural resources (water, timber, metal, etc.) are important in the placement and pattern of early settlement. A prerequisite for

a meaningful survey is a general understanding of this physical landscape and the relationship of the places to it.

Heritage places are also part of the culture and history of the region or the country. If we isolate them from it and try to deal with them without this context, they then lose their significance and their interrelatedness, and become only 'dots on the map'. It is difficult to overstress this point, which we will return to when we are discussing significance assessment. What this means, in effect, is that it is really impossible to carry out a proper and useful inventory without some information about the history of the area, to explicate and elucidate the located physical remains. The more developed the research into local or regional history or prehistory, the better any heritage-place inventory will be. This is also a spiralling process; such an inventory itself feeds into the local story, enriches it, and provides new insights.

The South Australian regional heritage surveys described earlier were preceded by a historic study that outlined the major themes in the state's history, and their regional manifestations. The surveys were able to correlate places with the historical context provided by the historical thematic study, and hence to interpret, assess and compare them. A stimulating overview study was carried out in New South Wales, but little subsequent survey work has been carried out to reinforce it, though that state is now developing a State Heritage Inventory Program, which may eventually take up the challenge.[21]

In the case of Aboriginal sites, the sites themselves are the most important evidence for much of the prehistory of the area since written evidence is lacking. Even in this case, a theoretical framework or hypothesis, based on earlier research and reflecting what is generally known of the prehistory of the region, will provide a much better basis for place inventory work than an aimless survey with no such theoretical framework.

Many of the examples discussed above are of surveys with one-dimensional purpose, to some extent. The law, the division of expertise and the bureaucratic process, all tend to split and divide aspects of our environment—Aboriginal and European, natural and cultural, object and place, history and folklore.

Increasingly, local communities tend not to do so. They have a holistic view of the elements in their environment that they value, and they can clearly articulate the contemporary relevance and significance of these elements.

There are encouraging signs that communities are taking charge of their heritage, and are commissioning or carrying out studies that integrate different elements of heritage: history, place, object, document, social value, and the values of the natural environment. This results in an outcome that is more than simply the sum of its parts—it provides the community with an integrated picture of their heritage—and an enduring 'sense of place' that enables them to actively and effectively conserve those elements of their environment making up a sense of place. Such broad-brush surveys will have a very different purpose and methodology to the more specialist and specialized ones described above. They will have implications for the range of expertise required, and for the management of the project.

The Australian Heritage Commission has been carrying out regional surveys and assessments, aimed at establishing all the National Estate values of specific regions.

Places of National Estate significance are places of aesthetic, historic, scientific, social or other special value. In this work, therefore, both natural and cultural values are considered, and the end result is a network of significant natural and cultural landscapes, and individual places. A range of survey techniques has been used. At one end of the scale, predictive surveys aimed at establishing prehistoric occupation patterns have been carried out. This has been linked with consultation with the Aboriginal community to identify places of contemporary significance. In the same way, identification of historic themes (for example, nineteenth-century rural industrial activity—mining, forestry, etc.) have been coupled with community workshops, in which locals identify and describe places and landscapes of significance to them.

These workshops have demonstrated a number of things with considerable bearing on the more traditional survey techniques. Firstly, there is a wealth of information and interest in the community about places significant to them, and which would simply not be located by a traditional 'expert' survey. This is because the value of the place resides in its social and contemporary value to the present community. Secondly, the community does not distinguish between 'natural' and 'cultural', 'place' and 'object', etc., but displays a much more integrated 'sense of place'. Thirdly, even with respect to places identified in more traditional surveys—public buildings, old mine sites, etc.—the

community often has an additional or different view of the reasons why these places are significant to that presented by the expert. Furthermore, the community is very keen to learn more about its heritage, and to absorb and incorporate the results of expert studies.

This trend is exciting and challenging. It does not mean that the rigour of traditional surveys should be abandoned. Rather it means that there is an increasing possibility of linking these results with those of community involvement, creating a multi-dimensional and enriched view of our heritage and sense of identity.

Choices for action

So far, we have identified three essential requirements for any survey method: a clear understanding of the aims of the survey, of the physical characteristics of the area, and of what is known about its history or prehistory.

It is also necessary to have sufficient expertise to be able to recognize, locate and record heritage places.

A major decision that has to be made at this stage is whether the surveys will be undertaken by the manager and the staff of the area being managed, by the relevant state authority, or by commissioned consultants. Many factors have to be considered. The primary one in most instances is funding and staff availability. Special funding may be available from a variety of sources, or the state authority may be able to arrange such funding. It is possible that a research institution (university or college) may be able to offer assistance in surveys by making it part of a student programme. Other factors include the area of land involved, the intensiveness of survey required, the time-scale allowed, and the degree of specialist expertise required. Two alternative approaches are commissioning a survey, and planning your own inventory.

Commissioning a survey

Before taking steps to engage a consultant, the manager should double-check that the survey objectives have been sorted out.

The best way to do this is to write down succinctly and clearly what is required. This can be done in the form of a draft brief. As an end-product the manager should also get some preliminary ideas about likely costs. As a rule, someone in the office of the relevant state authority can provide an estimate of likely costs, if there is a good preliminary brief to work from.

At this stage, it may be useful to set up a small steering committee to run the project. This could include interested local people, an independent expert, and an officer from the relevant heritage authority. This committee can revise the brief, and in consultation with the manager prepare a more detailed one. It can also be used to select the successful tenderer, and to review stages in the contract.

The manager will then be in a position either to approach one or more relevant specialists or firms for a quote or to advertise more widely. In most cases the relevant expert will be an historical archaeologist, an architect, a historian, a prehistorian or a heritage planner. Often, of course, the ideal will be a team with a range of expertise, and indeed, increasingly, teams of experts tender for such surveys. Guidelines for reputable consultants, rates and procedures are available from professional associations such as the Australian Association of Consultant Archaeologists, the Institute of Architects, the Professional Historians' Association or the relevant state authority. Useful general advice will be given by the state authorities or the National Trust, which may also help with planning the survey.

A commissioned survey should be based on the detailed brief, which outlines what the manager requires the consultant to produce. In some cases it may be necessary to involve the consultant in some aspects of the writing of the final version of the brief, as the specialist being employed may know more about the possibilities and limitations of the survey technique being proposed than does the manager.

Planning an in-house inventory

The chances are that most of the work in setting up an inventory will be done by the local management, since funding from any source is limited. In any case, all managers of heritage places need to know something about basic procedures, even if only to

direct the professional staff they employ, and to assess and use the results. Once the manager has decided the questions raised at the beginning of this section, it is possible to set up an inventory system to suit these aims. To do this, the manager should select priority *areas* or *places* for recording—depending on the need, and the presumed importance or vulnerability of the resource.

The manager will again need to develop a brief to work to, and go through the same processes described above, of selecting or developing recording forms, checking other registers, etc.

Practical advice for survey, place recording and documentation

Many land managers have some of the skills required for surveys, and by field work with experienced surveyors or by attending relevant courses run by state authorities can pick up enough information to conduct preliminary surveys.

This book is not the place for detailed instruction in survey techniques, surveying, or other place-recording techniques. These matters are dealt with adequately by a number of publications.[22] However, there are aspects of survey, place recording and documentation where advice can be offered of particular relevance to the manager. As a first step, a manager planning heritage place survey work should arrange for some preliminary training of relevant staff in survey techniques and site recognition and documentation.

Survey

It is worth reiterating the advice of the last section, that managers fully consider the purpose of the survey, and choose the survey design most appropriate to that purpose. It is also essential that, whatever system is used, the information about places is transferred to a well-maintained register as soon as possible. The easiest way of doing this is to ensure that all recording is done on the chosen register forms in the first place. To have to transfer information from one survey format to a different

register format is time consuming, and a major factor in the delay in getting information into a form where it is available to managers.

Place recording and surveying

A good recording of a place consists of three basic elements, a plan of the place, a description of the various elements making up the place, and information that puts the place into geographical, social, historic, prehistoric or environmental context.

Descriptions of surveying techniques available in textbooks often dwell on the use of complex equipment to achieve degrees of accuracy not necessarily required for first-order site recording for inventory purposes. Certainly such techniques tend to be inappropriate in the context in which much recording is undertaken by the land manager. Often the first recording of a place occurs while the manager/site recorder is engaged in other duties associated with land management, such as back-country patrol of a national park, or weed control in an urban park. In such circumstances the manager may have to record a place with little more than a compass and feet (to pace distance) and perhaps a tape measure, and may have to complete the recording in a short space of time. Such a recording may form the only record of that place in the register of sites and the place might not be more intensively surveyed, or even visited by management staff for years to come.

The first prerequisite is accurate map-reading, whether it be of the Sydney *Gregory's* or of a 1:250 000 map sheet of somewhere in the east of Western Australia. Often maps are poor, or on a very small scale, and the manager will need skills in drawing meaningful sketch maps to enable places to be located later.

Once the location of the place is accurately recorded, the following quick and simple survey techniques are needed for inventory purposes. It is stressed that these methods, which use only compass, tape or pacing, will result in plans of varying accuracy, depending on the time and care taken, and the complexity of the place, or the irregularity of the topography recorded. The plan may be suitable for site register purposes, but may be quite inadequate for, say, conservation planning purposes, at which stage a more accurate and professionally executed survey plan may be required.

Simple surveying principles and methods

Scale

The scale to which the plan of a place will be drawn depends on the type, complexity and extent of the place being recorded. An overall site plan should be scaled so that it fits on one sheet of paper, while details may be planned at a different scale on separate sheets. In most cases in the field, however, site-plan information would be recorded in a notebook or on a clipboard rather than on graph paper or a larger plane-table, so initial recording of survey information is often not to a set scale at all. In such cases enough information has to be noted down to allow a roughly scaled plan to be produced back in the office.

Methods

There are three main methods by which plans can be produced using the most basic equipment. These are triangulation (and its synonym 'intersection', and the related technique 'trilateration'), radiation and traversing. These methods can be used independently, or more commonly in combination.

Triangulation is the establishment of a point in relation to two other known points. The two known points can be two ends of an artificially laid-out datum line, or two ends of a building, two fence posts or two trees; in fact, any two points the distance between which is measured (and recorded) and the compass bearing of the line joining the two is noted.

From these two points (A and B), any third (C) point can be located by two methods:

1 Take compass bearings from points A and B to point C (which, when later plotted on paper, will intersect, giving the position of C (Figure 3.2).

2 Measure the distances (by tape or pacing) from points A and B to point C (Figure 3.3).

In both cases a triangle is formed, which can later be reproduced to give accurate locations of all points on a plan.

This technique requires that all points which are to be measured in relation to the baseline (AB) must be visible from both base points. However, once several other points are recorded, these can be used as new ends of baselines and the process repeated. For example, in Figure 3.3, point C could be used to

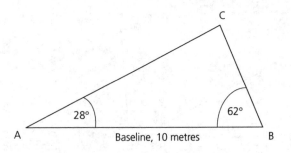

Figure 3.2 Triangulation by baseline and angles

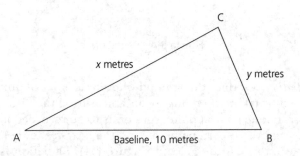

Figure 3.3 Triangulation by baseline and measurement

form a new baseline with point A, and another feature D (which might not be visible from B) recorded onto the plan from that new baseline. All features on a site can be located by a series of triangles in this way.

Of the two approaches to triangulation, that using measurement is probably more accurate than that using angles, as there are many complications and errors that can creep into the use of magnetic compasses (proximity to iron-clad buildings, overhead wires and wire fences, and simple mathematical error, being but a few), but both have their applications. For example, angles are better used if the point to be fixed is across a river, or the other side of a blackberry bush, where measuring the distance would be difficult or unpleasant!

Figure 3.4 Radiation

Radiation describes the method whereby a series of points are recorded by taking their angles, and measuring the distances to them from one central point. All points to be recorded must be visible from the recording point, and the distance to them must be measurable on the ground (Figure 3.4). Radiation is often effectively used in combination with triangulation; for example, in recording a cluster of features around one point located on a larger survey by triangulation.

The angle and distance is measured in turn from A to B, C, D, E and F.

Traversing can be used to plan features that are widely scattered, or that are obscured by intervening vegetation or landforms. It can also be used to produce a 'frame' within which other features are located by triangulation or radiation from points on the traverse. A traverse is simply linking together a series of points by a sequence of compass angles and measurements of distance between the points (Figure 3.5).

The compass bearing, A to B, is recorded; then the distance measured; then angle B to C recorded, and distance measured; and so on—C to D, D to E, E to F, and F back to A. Accuracy can be increased (or errors identified) by taking back-bearings along the traverse (for example, B back to A), and taking cross-bearings where possible (for example, D to A).

Figure 3.5 Traversing

These three simple methods, used in combination, should enable the manager to produce a plan of just about any site with a fair degree of accuracy in a relatively short time. Remember that it is easier and more accurate to record from the whole down to the part, establishing the extremities of the site and working inwards. The methods described do not include the recording of height or slope, so if these are significant on the site they must be referred to on the plan in some way.

When the field notes are finally plotted onto a single sheet, and the plan of the place produced, some obvious points have to be remembered. These are:

1 Include a north point (saying whether it is true or magnetic north).

2 Include a scale: a bar scale, divided into metres or stated multiples of metres is preferable to a ratio scale (for example 1:100), as the latter will be meaningless if the plan is reduced or expanded, which can happen in photocopying and is almost certain to happen if the plan is reproduced for publication.

3 Include a title identifying the place, and note in one corner of the plan the date recorded and the name of the recorder.

It is also very useful for future reference to number any photographs taken of the place, and indicate these with a corresponding number on the plan at the location of the photographer, with an arrow showing the direction of the view.

Other aspects of place recording

Place recorders often become so absorbed in the place being recorded that they omit putting it into its geographical context, which can be important in assessment and management. It is necessary to identify and record the relationship between the place and its setting, the place and other places nearby, or culturally similar, or historically linked with it; the elements that make up the place (for example, sites, buildings, fences, rock shelters and open campsites). Recording of these relationships should be by written description, plans, maps and, where relevant, photographs.

Place plans and descriptions, no matter what surveying technique is used, should include all elements that go to make up the place. They should demonstrate the extent of the place, its aspect, topography, and relation to natural features, and describe the major features of the place. In the case of historic place descriptions, all buildings, other structures such as wells, mineshafts, fences and equipment should be described and mapped. Identifiable marks such as makers' names on machinery, or pottery marks and other artefact makers' names should be recorded, as these can be most useful in dating places and activities, and establishing relationships between places. Where verbal evidence relates directly to a place it should be recorded and related to the physical evidence. This may be the case, for example, if a former landowner or a worker at a now-defunct industrial place accompanies the recorder to the place or is interviewed later.

Where the place is small (say, a house and its grounds, or a flour-mill), it is important for the early site recording to identify the detail of items and features that can easily disappear or be relocated elsewhere during management 'clean-up' or conservation works. Features worth recording include such things as old plantings in gardens (this information can be used to reconstruct the garden at a later date), the location of machinery and other artefacts and any makers' details on them, evidence of former

buildings, fencelines, wells, earthworks, any of which might be visible now but may be destroyed or hidden by subsequent activity on the site. Sometimes outbuildings contain 'rubbish' or bits of building fabric from the main building, removed during an earlier renovation. This can be very useful in reconstructing former details of the building, and all such evidence should be recorded, and the material made safe for future reference.

Establishing the location of the place being recorded can be achieved in a number of ways. The best way is to locate the place on a large-scale topographic map (1:25 000 or 1:50 000 where they exist), and give its map grid reference in the recording form. In some areas the best map scale available is the 1:250 000 series, a scale that makes place location very difficult at times. Because of this, it is always wise to back up the grid reference with a sketch map relating the place to recognizable landmarks, such as roads, creeks, homesteads or fences. In some cases, reference to a cadastral map (that is, showing parishes and portions) can be useful, but should never be used alone without other locational information. As pointed out earlier, accurate map-reading or sketch-map-drawing are essential to a good survey. An incorrect grid reference, or a sketch-map north arrow that points east, can be disastrous.

In many situations managers work in land areas that are poorly mapped, or where map interpretation on the ground is difficult. In these situations annotated aerial photographs are useful. An alternative approach now within the reach of some managers is the use of a global positioning system (GPS), which is a hand-held instrument giving extremely accurate latitude/longitude positions by accessing data beamed from satellites. These systems are no more expensive than a medium-priced camera, and are useful for survey work, especially in poorly mapped areas, or areas where map positioning is difficult, such as in flat country, arid landscapes, or heavily dissected mountainous country.

Photography is an important part of recording a place. Overall views of a place, and photographs of details (such as buildings, fences, and machinery) or, on Aboriginal sites, groups of axe grooves, rock art or shelters, should be taken, with a scale in the photograph where this will be useful (for example, detailed shots). Black-and-white photography is probably the best for place recording, and likely to survive much longer than colour prints or slides, but is very expensive these days. Taking both

black and white and colour is best of all, but few of us arrive at a place with two cameras or can afford doubling the processing costs.

It is essential that all photographs are labelled as soon as possible with the description of what they show, where they were taken, the photographer's name, and the date of the photograph. It is also highly desirable to include a sketch map with the filed photographs, showing the viewpoint from which each photo was taken of the place. This will be useful to subsequent managers or other users of the register.

In summary, the following minimum information is usually required about a heritage place, for initial inventory and management purposes.

Location of the place

Descriptions of the location of a place, if possible, should include the following information.

1 A written description of how to reach the place, with details of the distance from known points and the direction. While you are doing this, try to imagine yourself following your own directions to locate the place again. The manager is indeed lucky if the place they manage is a street address!

2 A sketch map with distances and with as many recognizable fixed points as possible: road (labelled), fencelines, natural landmarks, watercourses, and vegetation changes, for instance, can all help a future worker. Compass bearings are often useful.

3 Landowner/status: if you know this, put it in, it is most useful information for place managers.

4 Map reference: if you are using a topographic or other map, you should be able to give a map reference. Topographic maps usually have instructions actually printed on them. But a map reference is not as important as a good location sketch. If the sketch is detailed and accurate, a map reference can be derived from it; this is often not the case in reverse, that is, it is often difficult on a 1:250 000 map (5 km to 2 cm), because the scale is too small. The most detailed map available should be used. In many parts of the country excellent 1:25 000 maps are now available. You should check for maps with the local

or national mapping authority. In poorly mapped areas or in difficult terrain the use of a global positioning system can give accurate latitude/longitude locations, which can then be translated into map references.

5 Cadastral information: if, by any chance, you have a cadastral map (one showing administrative land divisions, for example, parish, portion, etc.) you can provide this information. Some of the 1:25 000 maps have a cadastral overlay giving this information.

Description of the place

In the place description include, if possible, the following details.

1 A clear description of what the place is, and its major features. For example, if it is an Aboriginal art site, the colour and types of painting; if it is a wool scour the layout, size, extent, machinery, etc.; if a commercial or residential building, the nature of the building, any outbuildings and other features.

2 The extent of the place; for example, the length, depth and height of a rock shelter, or a woolshed, or the extent of the block and any critical relationship to other places (for example, it is one of a terrace group).

3 An estimate or count of features; for example, 6 axe grinding grooves, 12 hearths, more than 20 paintings.

4 A sketch of the place and/or its main features, if appropriate; for example, a sketch of the pattern of a convict stockade.

5 Local position in relation to surrounding geography; for example, a campsite adjacent to a permanent water-hole, or the relationship of a bottle-dump to a standing building, or the relationship of a homestead to encroaching suburban housing.

6 A brief description of the surrounding environment; for example, forest, woodland, open plain, industrial estate, etc.

7 A description of the condition of the place, and whether it is endangered in any way; for example, by weathering, stock, vandalism, development.

8 Photographs illustrating significant features.

If it is possible, you should note these things while you are at the place. Relying on memory is often inaccurate. If you have a place form, fill in as much of it as possible *on site*.

What not to do at a heritage place

An inventory of heritage places is not an excuse for interfering with the fabric of the place, by digging, collecting artefacts, or otherwise disturbing it. There are exceptional circumstances where one would collect artefacts or samples from the place— when it is in immediate danger of destruction, for example. But, in general, collecting is unnecessary and harmful; it destroys the integrity of the place, and makes further study of it more difficult. It also means more work back in the office to record and store the object in a responsible way. An unusual or diagnostic artefact or feature should be sketched, described or photographed, but left *in situ*.

Some operational difficulties

Place definition

A carved tree, a rubbing groove, a mill-race or a bottle-dump are heritage places, but do we call a ground scatter of three stone flakes or two bricks a place? They are undoubtedly a focus of human activity, but is it useful or necessary to pinpoint or record them?

In many parts of Australia where there is little ground cover, it is impossible to step out of a vehicle without treading on a stone flake. Recording every occurrence is impossible, and would have little significance, except in some very specialized research.

In another situation, however, the flakes might be significant. Three flakes in the drip-line of a rock shelter might indicate substantial occupation deposit. Similarly, a car body in the middle of the bush may be just dumped and not constitute a place, while one adjacent to a mining place may be part of that place and an important indicator of the operational or transport technology and dating of the mine.

A problem arises in defining the limits of a place, and in determining whether it is one place or more than one. Levels of

detail in recording will depend on the aim of the exercise; the most important step is to clearly state these aims and associated methods.

Visibility
Heritage places are often difficult to see. In large areas of Australia, ground-cover is such that the chance of finding the less obvious heritage places are slim. Some rock shelters that appear sterile on the surface have sizeable occupation deposits; the remains of some nineteenth-century agricultural or other pursuits are similarly obscured. Surveyors use a variety of techniques to gauge the value of hidden sites. They study sections exposed by erosion or construction, they carry out auger transects or test excavations, they survey when ground-cover is minimal. However, even with these techniques many cultural places (especially Aboriginal sites, which tend to be less obvious, less visible and, because older, are sometimes obscured by the processes of ageing or soil movement) are not located by even the most careful survey.

At historic places the problem is more often one of the visibility of early remains being masked by later human activity. The remains of an old building or mine, for example, can be incorporated into the fabric of much later developments, and may not be obvious on a casual inspection. Investigation of these matters should be left to a relevant professional, and investigation entailing disturbance of the place should not be undertaken by anyone untrained.

The existence and location of some heritage places is only known through the study of documents or by information from local informants.

Documentation of the place
Documentation of the place requires the location of all material relevant to the place, for example, histories, archaeological reports, measured drawings of buildings, oral information, photographs (old and new), or prior recordings. All of this information does not necessarily have to be filed with the place recording in the place register system, but it must be referred to so that it can be found by those interested in the place.

A common problem in place documentation, particularly in the recording of historic places, is the failure to properly refer-

ence old information. It may appear to be a small point, but the assessment of a place's significance and its future management and conservation, may depend on just one or two pieces of background information. To record whether that information was provided by the nineteenth-century journal of the builder of the place, by an unreferenced 1960s local history, or by local oral legend, may be crucial in judging its validity and hence the assessment and future of the place. So, whenever information is collected or filed, the source of the information (and in the case of oral information, the recorder's judgement of the speaker's sources, accuracy or memory) must also be recorded.

In the case of old photographs, it is important to try and find out from the donor, or source of the photo, when it was taken, why it was taken (for example, family picnic, official departmental photo, etc.), what it shows (and who), and who took it. All of this information should be written on the back of the photo, or kept in some other way so that the photo can be easily identified. Failure to record this information can lead to serious misinterpretation of the place, especially if modern copies of old photos in good condition are mixed up with other recent photos of the place. It may be difficult in this circumstance to distinguish a 1920s or 1930s photo from recent shots, especially if time indicators such as people are not shown.

In the case of any old documents, be they photographs, paintings, maps or manuscripts, it is usually better for the long-term survival of the evidence if the manager takes a copy and lodges the original in a local, regional or state library or archives collection (that is, if the owner doesn't want them back!). In rare cases the manager may have access to adequate storage facilities, or may use such material for display purposes. Many managers cannot distinguish between management and collection, but few have the skills to do both well, and in a way that clearly relates the collected material to the understanding and conservation of the heritage place. Managers would be well advised to leave the collecting to professionals in the field or to get professional advice on how to do it responsibly.

Specialist recording: the use and assessment of specialist recorders and programmes
A number of specialist recording and analysis techniques can be applied to Aboriginal and historic places that could be beyond

the ability of most managers to undertake alone. These techniques are discussed here because managers should be aware of them, so that they can call in relevant specialists as required, and be in a position to assess their work at a basic level.

In some instances the recording and documentation of a place cannot be considered to be complete without this specialist input. The level of documentation, as pointed out above, will depend on the aims of the exercise. If we merely wish to know where heritage places are so as not to accidentally destroy them, then a survey may suffice. But if we need to know the significance of the place, or to plan its active conservation interpretation, then a much greater degree of documentation may be needed. For example, it is often necessary to excavate part of a place to determine its age, its associations, and its importance in contributing to new information not obtainable from other sources.

Architectural analysis of a building will provide information about the construction of the building, its type and style, finishes and services, and provide an assessment of its physical condition. It will also attempt to establish the history of constructional changes by documenting additions and modifications that occurred over time. This type of work is best done by architects, architectural historians, and some other conservation specialists who defy strict definition but might be called 'building analysts'. Architectural analysis might include the production of measured drawings. A number of sources give an overview of this recording approach.[23]

Architectural draughting and measured drawings may be the best way to record structures, especially if conservation programmes are likely to be carried out on them. Commissioning measured drawings is often an expensive exercise, and for many buildings may not be necessary. For simple buildings, photographic and basic measuring and sketching of details, with a floor plan, may be sufficient record for most purposes. In some cases, it may be possible to interest architecture faculties from universities in a recording programme as part of their undergraduate or postgraduate training courses. Measured drawings can give accurate ground plans, together with accurate elevations of each wall of a building, both inside and outside, if required. If a manager wants the drawings to represent the current condition of a building, it may be necessary to stress this to the draughter/architect, as often deflections and minor irregularities in buildings can be

overlooked in the final drawing. The recording of very irregular buildings, such as a partly collapsed or decaying slab cottage, may present real difficulties to the draughter if the present condition of the building is to be represented. Over the past few years, much better results have been achieved, for this type of building particularly, using photogrammetry.

Photogrammetry, or more accurately, terrestrial photogrammetry, is a process whereby a highly accurate, two-dimensional elevation of a building can be made using stereoscopic pairs of photographs and a special plotting machine. The technique has been used to some extent in Australia on Aboriginal sites, particularly art sites, and on large and elaborate building facades, and more recently on vernacular buildings with highly irregular shapes.

The success of photogrammetry relies on an accurate, detailed and precisely controlled photographic record being made, and on the skill of the plotter who draws up the final drawings, and the degree of understanding and interpretation that person puts into the final product.

The initial recording is highly technical, and requires specialized equipment and a skilled operator to achieve good results. Plotting machines are rare, and initially, at least, it is desirable for the place recorder to work with the skilled plotter to describe what is needed in the final drawing. Otherwise, the plotter will simply draw what is seen, and that may not be the detail of importance to the place recorder or manager. A spin-off of the technique is that you also get photographs of high resolution, which can be used in conjunction with drawings or independently.

The experience of the National Parks Service in New South Wales has been that it is as cheap, if not cheaper, to employ a university surveying team, using photogrammetry to record vernacular buildings, than to use architectural draughting to produce traditional measured drawings, and the results are far more accurate. What is more, the photographs can be replotted or plots redraughted to give more detailed or simpler drawings, as required.

A number of sources describe the photogrammetric process.[24]

Other photographic techniques can be used, such as rectified photography and reverse perspective analysis of old photographs. Rectified photographs can be produced as a spin-off from photo-

grammetric recording, and in some circumstances can be used directly without the expense of having plotting carried out. While a manager may be able to arrange this recording, it is usually most effectively overseen by an architect or archaeologist who understands both the place and the recording technique.

Engineering recording might be applied to a range of historic places (such as bridges, wharfs, large mine headframes) and places with extensive machinery (such as mills). Like architectural measured drawings, the recording of engineering relics is a specialized skill, and the Institutions of Engineers throughout Australia have established committees or semi-autonomous groups to study engineering heritage. The South Australian Department of the Environment some years ago undertook recording of some of the engineering relics in that state, and some of their recordings have been published.[25]

A manager with a large engineering relic to record should contact the relevant state chapter of the Institution of Engineers to find out if a local engineering heritage branch exists, for assistance or advice.

Geological and soils analysis can be applied to a variety of sites as part of the recording and research phase. The analysis of a mining place, and samples taken from it by a geologist, might help to firmly identify a place or its mining process, while petrological analysis of Aboriginal stone artefacts has been applied to some sites as a highly specialized research technique to identify the nature of stone from particular quarry sources. Soils analysis can be useful at a wide variety of sites, both Aboriginal and historic, but is usually best applied by archaeologists rather than by the manager.[26]

Botanical analysis can be applicable to both Aboriginal and historic places in particular circumstances. The identification of plant species around a former dwelling can be an aid in the reconstruction of gardens, for example, while the analysis of plant remains from archaeological deposits can aid in the reconstruction of food patterns or other uses of plant material. While managers are often competent in the identification of plant species, the identification of nineteenth-century varieties may require specialist knowledge, and analysis of archaeological plant specimens is highly specialized. A useful reference for the analysis of historical garden features has been published by the Australian Heritage Commission.[27] An understanding of the

general vegetation around a place can help when trying to establish the biogeographical context for its human use and operation.

Archaeological excavation is a specialized field, and should not be attempted by the manager. Indeed, in most states the excavation of Aboriginal sites, and in some states the excavation of historic sites, is controlled by legislation (see Chapter 2). While archaeological excavation would not be regarded as a normal recording process in the context of this chapter, it is often a necessary step before full assessment of the place can be arrived at (that is, place documentation). In other cases, where recording might be in response to an immediate threat to the place, excavation might be one of the techniques used to salvage as much information from a place as possible before its destruction.

The manager should rely heavily on the advice of archaeologists when establishing whether or not excavation is required. At the same time the manager must be able to assess all of the various factors that go to make up a site's significance, and protect the place from archaeological disturbance if that seems appropriate. In the case of Aboriginal places, consultation with the Aboriginal custodians is essential. Managers are the guardians of the places under their care, and in some respects archaeological excavation will destroy those places. The manager must weigh up whether the information gained by excavation will outweigh the loss of that archaeological deposit for future research, and whether excavation will detract from other important values of the place.

Archaeological recording can be carried out without excavation, and in many places it might be appropriate to call in archaeologists to record industrial remains, buildings, unidentified ruins, modified landscapes, or complex Aboriginal sites such as rock-art sites or extensive open campsites, without disturbing the ground at all.

Rock-art recording is a specialized field. An accurate recording of an engraving or painting, which does not damage the place, requires a host of specialized techniques, as well as skill and practice. Often a place has many complex layers of art (called super-positioning), which are difficult to untangle and put in chronological order; sometimes the art is faded or indistinct. Recorders use complex photography, photogrammetry, tracing with polythene sheets, and oblique and varied lighting. See John

Clegg's article for an excellent rundown of techniques.[28] Additionally rock-art specialists use complex techniques to interpret art, to work out its relationship to other sites, and to use it as a cultural marker to tell us more about prehistory generally.[29]

Anthropologists also work with Aborigines to record and explicate the significance of sacred sites and story places. This requires a range of skills and knowledge, including skills in the study of culture and society, and understanding of Aboriginal religion and culture, and linguistic and communication skills.

Aboriginal consultants work with other specialists to explicate the meaning and value of places within Aboriginal culture.

In all cases of specialist recording, it might be difficult to find the relevant specialists in some states, and sometimes the 'next best thing' is the best that the manager can get. If the manager has a good idea of what results can be expected from various techniques, then appropriate questions can be asked of the specialists being considered for recording jobs, and their experience or knowledge assessed. In some cases there will be no substitute for the experienced specialists, who may have to be brought in from interstate. It is therefore important that the manager decides, based on whatever advice is locally available, exactly what, if any, specialist recording methods would be useful for the area, and not be carried away with ideas of 'gee-whiz' recording technology if it is inappropriate.

For the heritage place manager, place documentation is an ongoing process, never really concluded.

 4

Assessing the Value of Heritage Places

Ultimately cultural places depend for their value on the recognition society affords them. The manager needs to understand in detail the nature of the significance of the place to society, so that appropriate management can occur to conserve those values. If adequate assessment is not undertaken, it is possible that management decisions will be made that inadvertently destroy or diminish important aspects of the place's significance.

The process of determining the value of a heritage place is usually known as *the assessment of cultural significance.* This assessment process has two interrelated and interdependent elements. The first is the determination of the elements that made the place significant, and the type or types of significance that it manifests. The second is the determination of the degree of value that the place holds for society. Assessment is an exciting and absorbing undertaking, which almost invariably reveals new information and gives new insights into the cultural place or places being assessed.

What is cultural significance?

The Burra Charter defines it as meaning 'aesthetic, historic, scientific, or social value for past, present, or future generations'. These aspects of significance were briefly discussed in Chapter 1. Later in this chapter we will look at the process of significance assessment and the manager's role in it.

Why is it necessary to assess significance?

Most of the examples of the heritage places we discussed in Chapter 1, and described in the documentation in Chapter 3, are recognized as having some cultural significance. An Aboriginal axe-grinding groove or the remains of an early weatherboard hut may not be on the Register of the National Estate, but they do have some historic or social value. Why then is it necessary to assess and define this value further? There are two reasons.

It is clear that there is a vast degree of difference between the value of various heritage places. One axe-grinding groove is not as important, or as valuable, to the Aboriginal community or to the general public as the wonderful rock painting at Ubir in Kakadu National Park. The old weatherboard hut does not attract the degree of interest or evoke the strength of feelings of the Roundhouse, the earliest surviving government building in Western Australia, or Port Essington, the abandoned Northern Territory settlement.

In this sense, people are making decisions every day about the degree of significance, in their reaction to heritage places, and in their management of them. The manager, in particular, has to make a range of decisions about places being managed, and these decisions will depend not only on knowing what the resource is but also on knowing to what degree and in what way the place is important.

The management alternatives for a heritage place or heritage places on a particular area of land can be summarized as follows:

- To make conservation of the heritage place the main aim of management by gazetting it at as a recognized historic site (such as Wonthaggi Coal Mines, Vic.) or by appropriate zoning for part of a municipality, park, or state forest. We would do this if the heritage place had great significance.

- To incorporate the aim of conservation of the place with other aims as a high priority in area management (for example, to preserve a large commercial building or cultural remains within a nature reserve, and manage the area so as to preserve a balance between the two aims, with minimal detriment to either resource). We would do this if the place were of some significance, at least comparable with the natural values of the managed area, or in the case of a place where

the cost of conservation and presentation was impossible to meet without giving it a new commercially viable use. For example, the handsome old warehouses of the nineteenth-century industrial suburbs of our cities are often successfully converted to offices or apartments.

- To passively manage the heritage place or places, undertaking only minimum conservation measures, while allowing no activity that would directly damage them. We would do this if the places were of moderate or low significance, worth conserving as a sample, or where the place was of a type not normally requiring many conservation resources (for example, some historic sites without structures, some earthworks or mining remains, and various types of Aboriginal sites).

- To allow or recommend destruction of the place or places by some form of conflicting land use—for example, inundation of the land and places by the development of a hydroelectric scheme. This is not often the choice of the heritage manager. However, if the places were of minor value only, and/or if the proposed land use was considered to be of greater value or significance society may make this choice.

The real-life situation is more complex than this and presents more alternatives that are not always so clear-cut. However, it can be seen that, in essence, from the manager's point of view such decisions depend on two things: an assessment of the degree and type of value that the heritage place has, and the appreciation of this heritage value compared with other values or needs that society might have. This then is the first reason why an assessment of significance is necessary: to allow decisions about the appropriate management of the site to be made with full knowledge of the relevant facts.

If the manager has a clear appreciation of the value of the cultural resources being managed, management decisions can be implemented in accordance with this appreciation. Where there is a threat of an alternative, conflicting land use, the manager is in a position to assess these conflicting claims, or at least to present the information about the value of the heritage place for proper consideration by the development proponent or authority.

If the manager does not know the significance of sites on the area of land, the only responsible alternative is to assume such significance, and to take no action that would jeopardize them until their value has been assessed. This is because cultural resources are scarce, non-renewable, and potentially valuable. As we will see, this is the usual (and proper) stance taken by managers faced by development proposals for areas containing places of unknown value; but it is, of course, not an ideal situation. One is often faced with hurried assessment in an atmosphere of tension, generated by the existence of a potentially conflicting land-use proposal, or by some other threat.

A more common situation, and one that is equally undesirable, is that in which a manager is actively managing land for some purpose (say as a national park, or to comply with a local planning scheme) and is making numerous daily decisions that may affect heritage places of unknown value. The manager needs not only information on the existence and nature of places under control but also a clear perception of their importance and relative value.

A second reason for site assessment is that the role of good management is to conserve as much of the cultural significance of the place as possible. We need to know in what aspects of the place this significance resides in order to conserve it. We may know, for instance, that Lake Mungo is a very important place— it is on the World Heritage List—but for our management decisions about conserving it we need more detail. It has public value—many people want to visit it—but it also has immense scientific value that could be jeopardized by public visitation. We need to be aware of the nature of both values in sufficient detail to conserve them. Additionally, it has special significance to Aborigines who might object to some types of research or visitor activity. In this case we may have to sacrifice some public access to conserve scientific value, and some types of research to conserve and respect its significance to Aborigines and direct visitors to less-sensitive parts of the place. This is all part of the process of conserving cultural significance: we need an objective and professional statement of *all* the reasons a place is important, to enable management policies to be developed that will safeguard its total value. This is most crucial for the very important and significant sites, which tend to have the most interventionist management.

Our discussion to date shows that there is a tendency for various aspects of significance to require different management strategies, and that there is sometimes, therefore, the possibility that management aims will come into conflict. The final management decision depends on judging precisely what is the most significant aspect of the place, and what makes up other aspects of its significance. We will discuss this later. Firstly, it is important to review some aspects of significance in more detail.

The degree of detail and the formality of the process will depend very much on circumstances. The most detailed and thorough level of assessment espoused by Australia ICOMOS, is as part of a *conservation plan*. A conservation plan is a plan for the active conservation of a heritage place, and has three main elements: a statement of significance, a conservation policy, and a strategy for implementation. It is usually prepared by professionals, and is the prelude to often quite extensive conservation work.

In the context of a conservation plan, a statement of significance is defined as a succinct summary of the reasons why the place is of value, and is supported by sufficient description of the assessment process used and the data upon which the assessment was based, to demonstrate that the statement of significance was justified.

The formal *statement of significance* can only be produced when all the information relevant to the assessment of cultural significance that it is feasible and possible to collect has been collected and assessed. Part of the process of assessment is the identification of relevant information that cannot be collected at this time.

This requires employment of the appropriate expertise—the relevant archaeological, architectural or historic studies, etc. It requires the placing of the site in its historic and social context, and relevant consultation/discussion with the community in which the place exists or for which it is particularly significant. It requires comparative assessment of the site, an assessment of its value as an outstanding example or a representative sample compared with other places of the same type or that illustrate the same major theme in Australian history. It requires the identification of those elements giving a place special value not shared by other places.

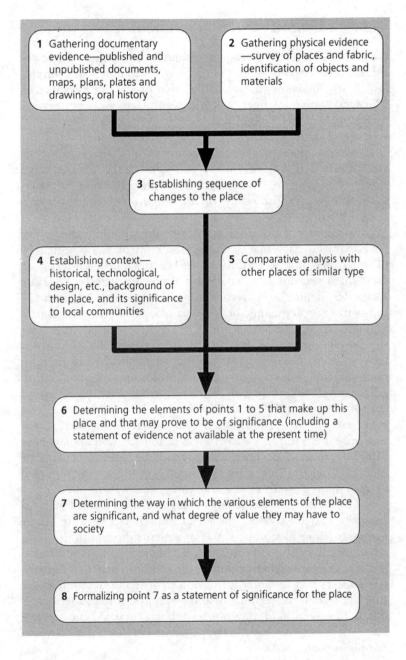

Figure 4.1 Process of assessment of significance

Levels of significance assessment

Later we will look at the steps required to achieve this degree of significance assessment and the manager's role in it. It is important firstly, however, to put this formal process in perspective. The fact is that relatively few heritage places will ever have a formal statement of significance, a conservation policy and a strategy of implementation prepared for them. Such complete conservation plans are usually commissioned only for places already assumed to be of considerable significance, and for which some action is planned that might affect the cultural significance, such as conservation works, or a change of use or disruptive developments.

Land managers are often faced with the situation where they have many heritage places under their control, the significance of which may not be established or be only poorly understood, and which are not affected by any direct management action. Examples include Kosciusko National Park, which has over 100 huts within its area, and the Victorian Department of Conservation and Natural Resources, which has control over (among other things) 600 cemeteries. It is unrealistic to expect the manager to have access to the resources required to gather the information necessary for a formal statement of significance and conservation policy developed to ICOMOS standards for each place under control, nor does the need exist for such a level of planning in every case. In fact, the situation is more likely to be that at any one time there will be varying levels of information available for different places in any area, and there will be a variety of management policies in place, ranging from a simple set of generalized management guidelines to a complete conservation plan.

For example, in a particular management area an Aboriginal campsite may have been studied in some detail because of the proposal (since abandoned) to put a picnic ground in the area, a nineteenth-century mining area may have a conservation plan because it is being interpreted to the public; a series of Aboriginal art sites may be known, but not recorded in detail, because they are well protected, stable and not under threat; some areas of the managed land may not have been surveyed for cultural places at all, or only have been the subject of a stratified random sample survey.

Conversely, it is important to realize that assessment of significance at some level is essential for any heritage place man-

agement, even if that management takes the form of passive protection. Essentially, the processes that we go through should be the same in all instances, though the degree of formality and detail will vary.

It is beginning to be understood that *any* management of a place over time, will affect the significance of the place. Because of this, managers are increasingly controlling management practices through the use of management plans for larger areas in which heritage places are located. These planning controls often establish procedures whereby basic assessment and policy development will automatically occur should any increased level of activity affect a place. On a more general level, they establish basic management guidelines for the protection of all heritage places in the wider area.

What varies according to need is the appropriate level of detailed information required on any place or group of places, and the level of refinement and expertise required in the assessment process. If we are doing an environmental impact study of an area of land that may contain heritage places, we need to assess significance to the degree necessary to determine whether the site should be conserved, or whether, if necessary, it can be destroyed. If we are doing a regional heritage study, our aim might be to identify significant places, and to leave their detailed assessment to the stage when (and if) an individual management plan for each place is considered necessary.

The greater the likelihood of human intervention or decay affecting the place, the greater the need for additional assessment of significance, and the development of an appropriate management strategy. One of the skills of the manager lies in determining the actual level of threats to heritage places, and hence the level of significance assessment for the manager's needs, within realistic human resource and financial cost.

Regardless, however, of the level of significance assessment required, it is necessary for the manager to have an understanding of the elements of cultural significance and of the process of assessment of this significance (Figure 4.1, steps 6 and 7).

Elements of significance

There are many ways of defining types of significance. Different practitioners and authorities have their own systems. They all

have merit. However, there does seem to be a distinct advantage for everyone in using a set of criteria already widely accepted. The Burra Charter provides a process for significance assessment, for heritage practitioners. The approach taken by Jim Kerr to apply the Burra principles is often seen as an exemplar of the process. More recently Australia ICOMOS has produced *The Illustrated Burra Charter*, which similarly illustrates significance assessment.[1] Though the full development of a conservation plan espoused by the Burra Charter is not always appropriate, the Charter and its terms and processes are well established and accepted in Australia, and are basic to good conservation practice. It is therefore helpful, where appropriate, to use the terms and processes laid down there, and they form the basis for the following discussion.

The guidelines to the Charter comment:

> Cultural significance is a concept which helps in estimating the value of places. The places that are likely to be of significance are those which help an understanding of the past, or enrich the present, and which will be of value to future generations.
>
> Although there are a variety of adjectives used in definitions of cultural significance in Australia, the adjectives 'aesthetic', 'historic', 'scientific' and 'social' given alphabetically in the Burra Charter, can encompass all other values . . .
>
> It should be noted that they are not mutually exclusive, for example architectural style has both historic and aesthetic aspects.[2]

Aesthetic significance

> Aesthetic value includes aspects of sensory perception for which criteria can and should be stated. Such criteria may include consideration of the form, scale, colour texture and materials of the fabric; the smells and sounds associated with the place and its use.[3]

This statement really does not explain this value very clearly. Yet it indisputably exists. The reason why so much Georgian architecture is prized and preserved is not just because of its historic value: it has a pleasing simplicity and balance that is the essence of great design almost universally admired. Similarly,

the great pieces of Aboriginal rock art—the Wandjina figures of the Kimberley, or the paintings of the great master of 'x-ray style', Najombolmi (Barramundi Charley), in Arnhem Land—have an aesthetic value transcending their scientific or historic importance, though these may also be important attributes.

Referring to the built environment, Jim Kerr poses the following three questions to assist in assessment of aesthetic significance:

- What degree of unity has the place in scale, form materials, texture and colour?
- To what degree has the place a relationship between its parts and the setting which reinforces the quality of both?
- To what degree are contrasting elements intrusive and disruptive or agreeably surprising?[4]

But there are other, less architecturally derived concepts that contribute to this value. The concept and symbolism of old things, and the evidence of the accretions of time, have a strong effect on many Australians. When this is combined with a pleasing aesthetic experience, it creates a powerful emotional effect. Many heritage places, not of particular significance otherwise, may have these qualities, and may have acquired them through accretion over time. Aesthetic value, in these cases, may have grown with the changes to the place that have been wrought by time, and may have little relationship to the original object. An ivy-covered colonial cottage sells postcards, and enhances the neighbourhood; a ruined mansion or the stone remains of a nineteenth-century industrial site have a similar quality. The concept of the 'romance of ruins' is an ancient one. Eighteenth-century English nobility did the 'grand tour' of Europe to add polish to their French and Italian, and to gaze at, and be edified by, the ancient ruins and picturesque remains of earlier civilizations. So do we today. In fact, the image of the ivy cottage or the ancient ruin has become so hackneyed as to be a sort of cliché in itself, and hence the reality is sometimes an experience in kitsch.[5]

A place may also have aesthetic value because it expresses an aesthetic ideal, such as a place that epitomizes the design principles of an architectural style or a landscape concept. In this case it is not necessary for the assessor to admire the particular style; its aesthetic value rests in its being a type of site exemplifying a

particular design ideal. Hence the assessor might have such refined sensitivities as to actually turn green at the sight of a nineteenth-century neo-gothic pile such as Greycliffe House in Sydney, but should still note that it has aesthetic value.

Landscapes, in particular, tend by their nature to have strong aesthetic elements. The 'beauty and the terror' of Dorothea Mackellar is easily recognizable in our experience of large-scale natural landscapes—much described as part of the 'wilderness experience'. The cultural landscapes of nineteenth-century pastoralism can have a different, but equally strong, effect. Here, it is often the pleasing juxtaposition of order and wilderness, or European culture and Australian environment, that is effective. A Georgian, convict-built, sandstone mansion, with its ordered fields and hedges, set against the backdrop of a towering Tasmanian mountain forest—as can be seen in the heartland of Tasmania—has a powerful aesthetic appeal.

Aesthetic value, then, is a complex matter, and requires the clear articulation of criteria in particular cases. On the one hand, it resides in part in the instinctive reaction of the majority of society to the elements that comprise beauty in design, association, mood. On the other hand, it can relate to the demonstration, in a place, of a particular design or style, or to an objective attempt to quantify design or landscape elements.

In its regional assessment work, the Australian Heritage Commission has attempted to devise criteria for assessing the aesthetic value of landscapes, using methodological developments to date, while freely admitting that aesthetic assessment is poorly developed and still presents some problems.

In its preliminary paper the Commission defines aesthetic value as 'a certain quality of a place which provides a sensory experience to a person participating in or viewing a landscape, of such strength that it has a positive impact on human thought'.[6]

The qualities sought in the landscapes of East Gippsland (and which could be applied to heritage places more generally) are as follows.

Abstract qualities
The presence of particularly vivid, distinguished, uncommon or rare features or combinations of features derived from the landscape's abstract attributes. This aspect is also described as scenic or visual quality.

Evocative responses
The ability of the landscape area to evoke particularly strong responses in the public, and in expert assessors.

Meanings
The existence of long-standing special meaning of the landscape to the public, and the ability of the landscape to convey special meanings to viewers, visitors, or community. This aspect may also be shared with social, historic, and at times, scientific values.

Landmark quality
The landscape unit or feature within it stands out and is recognized by the broader community. It may be a source of identification of a locality. The feature may be physical, such as a distinctive hill, or may have seasonal features, such as a place regularly visited by humpback whales.

Landscape integrity
A strong consistency of natural and or cultural character of a landscape or place with little degradation of this character is a aesthetic quality that has importance to people.

The study team used a mixture of landscape assessment techniques, historical research, market research, and community workshops to establish areas with these qualities.

Sometimes the aesthetic qualities of a place may have potential to conflict with other values, especially if the management of the place is designed solely to enhance them. The Georgian mansion we referred earlier is a good example. It is possible to enhance its aesthetic value by restoring it as an architectural gem, which fully embodies and manifests the grace and beauty of Georgian architecture. But before we persuade the relevant minister to provide the necessary $3 million special grant to do so, we must consider whether any other values will be compromised. What is the history of the place? Are later additions (which may detract from its potential aesthetic value) of historic or social importance? Is the family which lived in the house, and the aesthetically unpleasing signs of their occupation, of more importance than its architectural qualities? Are there, for instance, late nineteenth-century plumbing upgrades of technological and historical importance?

In Western society, with its strong emphasis on measured time, the concept and symbolism of ancient things and the evidence of time's accretion has, in itself, a strong effect on the visitor. This feeling, along with the concept of 'alienness' or 'otherness' is often strong at Aboriginal sites, such as art sites. The motifs, the evidence of a different way of life, the remoteness from civilization all touch the visitor. These effects combine with and add to the innate beauty of the art and its setting to produce a powerful aesthetic and emotional experience. This is often in contrast to the traditional Aboriginal view. Time past yesterday is the 'Dreamtime' for Aborigines - a time that is both static (immeasurable) and dynamic, because it is the time of creation, which is ongoing. Most art belongs to this period, and so is seen through very different eyes. Aesthetic value, especially when it arises from cultural traditions that vary from those of the original owners, can come into conflict with other values. For the traditional owners the art may be secondary (like stained-glass windows in a church), temporary, or disregarded because of its history. Alternatively, it may, in their view, be faded and 'dying', and may need repainting or removal. We later describe an instance of this conflict at an art site in the Kimberley.

The assessment of aesthetic significance, and its weighting relative to other types of significance, usually needs guidance by a professional, or more often by a group of professionals. None the less, the manager should be aware of the issues, and be satisfied that the balancing of values has been done properly.

Architectural value

Architectural value of a building (real or assumed) was once the principal determinant in conserving it—in the 1960s a 'historic building' often really meant simply 'an architecturally beautiful building'. With the growth in the conservation movement over the last few decades, and a better concept of the many aspects of historic significance, this simplistic view is much less prevalent today. Times have also become more litigious, so if you make a claim about a building's architecture or style, getting it right has become much more important.

The discipline of architectural history underpins the assessment of architectural significance, and hence a building's architectural value is usually dealt with as a *part* of the building's

historical significance. It is usually a taxonomic approach to history, dealing with the way the building fits into the characteristics that define a style, or how it is evaluated among the works of a particular architect, or how it utilized design or materials to achieve an innovative solution to a particular problem facing the architect.

Architectural historians have been active in researching and debating the development of architecture in Australia, and, as a result, a number of useful publications assist the manager in understanding the major architectural styles as they developed here. Selected publications are listed in the notes, but you will be able to find a publication dealing with just about every type of building a manager might be faced with, and many site types as well.[7]

Historic value

> A place may have historic value because it has influenced, or has been influenced by, an historic figure, event, phase or activity. It may also have historic value as the site of an important event. For any given place the significance will be greater where evidence of the association or event survives *in situ*, or where the settings are substantially intact, than where it has been changed or evidence does not survive. However, some events or associations may be so important that the place retains significance regardless of subsequent treatment.[8]

In one sense, all heritage places have some historic value. As we noted earlier, placing a site in its historical context is an essential first step in assessing its significance. Because of this, the role of the historian or prehistorian, or the gathering of data professionally prepared by them, is a crucial one that cannot be dispensed with; we will discuss it in more detail later. 'Historical value' is an often over-used phrase encompassing a range of other assessments. Graeme Davison has discussed the different ways in which the historical value (as distinct from the architectural value) of a building is seen: the building being valued as an antique, as a shrine, or as a document.[9]

There has been much debate in Australia about the respective roles of historians and architects in the assessment of significance, and the nature of historical assessment.[10] The central

theme of that debate was about the resolution of the different traditional approaches taken by architects and historians in their analysis of the past: architects have traditionally been concerned with designed buildings as static objects frozen in time—concrete statements relying only on their physical fabric for their meaning —while historians have traditionally been concerned with the dynamics of change, reasons for events, and the broad contexts within which things happen. Within Australia, at least, the study of physical object and place has not been a part of that concern.

> In the course of the past twenty years or so, architectural historians have developed clear and widely-accepted criteria for determining the *architectural* importance of a building. Is it the work of an eminent architect? Does it embody an innovative or skilful design solution? Is it an outstanding or typical example of an important style? Does it exhibit an important use of new materials or building technology? The underlying assumptions of the architectural historian's approach are similar to those of an art historian or literary critic. The individual building is placed, like a picture or a poem, within a taxonomic framework of authorship, style, period and so on, and then ranked according to its relative importance. Connoisseurs will sometimes differ in their ranking of individual buildings, but everyone accepts the assumption that such a ranking is, or ought to be, possible. But no such consensus has yet developed for the critical assessment of historic significance . . .
>
> When architects appraise buildings, it was suggested, they implicitly adopt the standpoint of a connoisseur, grading buildings according to a scale of relative excellence. But when historians say a building is historically important they are not giving it a rank amidst a range of other possible candidates, but making a judgement of its significance in relation to a wider context of social, political or intellectual history. The architect's method of assessment is primarily intrinsic and comparative, relating to the specific qualities of the building or structure itself; the historian's is primarily contextual, relating to the society of which the building is a physical relic. When architects wish to argue for the significance of a building they are inclined to locate it in a taxonomy of styles—Georgian, Victorian, Federation, etc. When historians argue for its significance they are included to tell its human story or to locate it in its past social and geographical context.[11]

The easiest historic values to identify are those where a particular event is associated with a place. The room in which William Wentworth wrote the first colonial government constitution, the site of the Eureka Stockade or the Barcaldine shearers' strike camp, or the first road to cross the Blue Mountains, are examples. More subtle are the ways in which individual places, or places collectively, are associated with and reflect more general patterns representing particular trends in the settlement, growth, land use, or social values and attitudes in the past. To understand and explain these trends is the job of the historian, prehistorian, historical geographer, architectural historian, archaeologist, and the like. The interpretation of such trends can change over time; the discussion of, say, the relationships between labour and capital or between land policy and land settlement practice grow and develop as new information is found and as ways of looking at the past change. Such changes often say as much about contemporary Australian social, economic and political attitudes as they do about what happened in history. For example, war histories written after World War I, compared with those written now, reflect changing perceptions of war, imperialism and the world generally over sixty years. The presentation to the public of the changing interpretation of the past can in itself be a valuable device.

Very often places are claimed to be significant because they demonstrate particularly well the characteristics of class or type of place. This is particularly true of buildings of a certain architectural style or some industrial or engineering work that demonstrates a particular technological innovation or phase. In such cases, the assessment of significance can only be based on comparative analysis with places of like type. While many studies provide such contexts for individual types of places, there is still a vast amount of research to be done before definitive comparisons can be made for the majority of such assessments. The manager must accept that the assessment can only be as good as the comparative data available at the time, and that future research may strengthen or diminish the comparative significance of the place being conserved. This is discussed further later in this chapter.

Another aspect of historical significance often not given the attention it deserves is the potential that many places have to explicate a long sequence of history in one locality. Some build-

ings, industrial places, and Aboriginal places have a long period of continuous human use reflected in their fabric. This history might be represented by an identifiable sequence of developments and modifications to the place, such as building extensions or overlaid rock-art paintings, or it might simply be that the place has an unmistakable patina of age. It is this sense of accumulation of age, the continuity that can carry the visitor's mind back into the past and produce a feeling of having roots there, that is the most potent 'trigger to the historical imagination'.[12] It can be the key to why the place is valued, but it is often hard to define and quantify (and it is very easy to destroy). Because of this it is sometimes ignored as an aspect of significance in favour of some finite event or historical association, and in developing the conservation policy on the basis of this narrower significance the broader historical meaning of the place is jeopardized. The assessment process must balance the relative values of a place as, say, the home of a minor explorer (which might suggest the removal of additions to reveal the view from the study where he planned his explorations), and as the place where generations of the explorer's family have lived and worked for 150 years. The answer will often be in the fabric of the place and what it has to say about its own past: 'It is the greatest error to suppose that history must be something written down; for it may just as well be something built up; and churches, houses, bridges . . . can tell their story as plainly as print for those who have eyes to read.'[13]

Often, too, people are not aware of the historic value of less dramatic, more ordinary sites. It is understandable that the great nineteen-century colonial mansions will attract more interest than a humble slab cottage, but the cottage is more representative of the life of our ancestors than the mansion, and can be used to illustrate this fact.

In industrial sites the same distortion of history exists. For example, there are numerous historic places and tourist parks presenting goldmining to the public, but few presenting coal-mining or lime-burning, which have played a less romantic, but important role in our nation's development.

Themes in history
To overcome these problems, and to put historic assessment of sites into a framework, thematic lists have been devised. These

lists outline the major themes in history (or prehistory) and allow the manager to consider where a particular site fits into the system, or, on a broader—regional or state—basis, can be

Campbell Springs homestead was in use around the turn of the century until about 1915. It was an outstation of Wave Hill station and was located on what is now Limbunya station. Conventionally, a European homestead is a site of European historical significance. In actuality, this is a site of significance to Aboriginal people because they have the memories and knowledge which give life to the place.

The site is not shown on any current maps. Archaeological techniques would enable a comprehensive understanding of how the place was used. We visited the place with Aboriginal people who knew it intimately because their forebears had worked there. At sites which have been in use more recently, or by larger groups of people, we have walked through the ruins with the Aboriginal people who were teaching us. They showed us the remains of posts which had once been the horse yard and the stone foundation of what had once been the meat house. They pointed out the distant hills where the bones of Aboriginal people who had been massacred nearby had been placed. They walked us through and explained to us the layout and former use of the whole camp, telling stories of incidents which had occurred in the area.

Too often white history is constructed around sites which are deemed to be European without recognising that Aboriginal people's history is also located in these sites. Sites like Campbell Springs are not monuments of white history; they are monuments of Australian history. Assuredly they have a somewhat different significance to the Aboriginal and the European people whose lives were enmeshed at these sites. Few white people now hold the information relevant to these sites. The locations of many such sites are known only to the Aboriginal people. And yet, for both white and black, these are places where they worked and suffered as well as where they laughed and enjoyed life. Many of these places are sites where people died and other people were born, where women and men lived out the daily drama of human life. To identify the history of such places as either black or white is to miss their vital significance as sites of shared life.[15]

used to indicate whether any major themes have been neglected in site management or interpretation.[14]

Thematic lists, however, are only a tool. They don't guard against misinterpretation of the past, and they are themselves based on particular views of what happened in the past, views that change over time, and dealing with issues on which there is often more than one interpretation.

The uncritical use of themes can lead to an embarrassing simplification of history. For the manager to 'play God' can have disastrous effects, especially if irreversible management decisions are made in the absence of accurate historical information. An example is the series of events following the decision by National Parks in New South Wales to conserve a goldmining village back in the late 1960s. The decision was made to acquire the town of Hill End, gazette it as a Historic Site and present it to the public as the Service's one example of goldmining history. The unfortunate aspect of the decision, from a heritage point of view, was that it was felt that, as Hill End was being acquired, there was no point in maintaining another goldmining town at Kiandra in the Kosciusko National Park. After all, it was argued, all mining towns were the same, and to keep one was to adequately 'sample' the population. Unfortunately, that assumption was wrong, for in terms of their history and mining technology, Hill End and Kiandra were like chalk and cheese, and both in their own ways were irreplaceable. The decision to remove most of Kiandra's buildings and remains was based on extremely simplistic management grounds, with no assessment of the relative significance of the two places.

Thematic approaches in most cases do not help in making decisions about how to manage a place, but such surveys can mean that decisions are made in the light of known heritage resources rather than in blinkered ignorance.

Spurious significance

We should also touch on the problem of spurious significance. There is a tendency for spurious stories to grow concerning the origin and importance of a place. Armed with no convincing evidence, indeed despite information to the contrary, many people believe, for instance, that the ruins at Bittangabee (Ben Boyd National Park, NSW) are sixteenth-century Portuguese in origin. These hardy, adventurous, and industrious seafarers are

also believed by some to have been responsible for the Sydney rock engravings, and the Wandjina paintings of Western Australia; though another school of thought attributes Aboriginal art to the influence of space travellers. Clearly, these serious misconceptions must be dealt with, though it is often not easy to change these erroneous, but strongly held, beliefs.

In a less dramatic way, spurious history, or in some cases unsubstantiated history, is common across the country. Bushrangers' caves and explorers' campsites crop up in areas where the associated bushrangers or explorers never travelled; there must be twenty woolsheds claimed to be the first to introduce mechanical shearing into Australia; somewhere in Australia there is what is claimed to be the earliest or largest example in the Southern Hemisphere of just about everything. In assessing significance, the manager or the relevant practitioner has to either substantiate or disprove such claims, as a conservation policy based on dubious significance is a very dangerous basis for management. The manager should always ensure that the evidence supporting any claim to significance is provided and would be accepted by an impartial informed observer.

History, the public and the manager
While we have expressed the view that heritage places only have significance because of their value to society, you must be aware that, as in the above examples, the manager has a role in forming or guiding the public's awareness of its past, and hence may actually mould the way in which society values heritage places. Selection of sites by gauging public interest will not result in a full coverage of sites of significance. Some areas of our history are neglected, some are positively misrepresented or romanticized. In many situations, truly significant places of great symbolic value to minority groups, or places potentially of such value to the wider community, can only be saved and protected by research to locate them, followed by a strong effort by managers to ensure that they are given due consideration.

The manager has to be aware also of the continuous evolution of historical interpretations of the past. There is a growing involvement of academic and public historians and archaeologists in the discussion of new approaches to the past, and the ways in which the meaning of events, trends or movements (and associated places) can be reinterpreted by each generation in

historical hindsight, and can be interpreted in different ways if new perspectives are embraced. The integration of different approaches to the study of the history, by drawing on the concepts used in the analysis of the theories of culture, in anthropology, in gender studies, in the visual arts, are all enriching the scope of those trying to study the past. New journals, such as the *Public History Review* (published by the Professional Historians' Association of New South Wales), and established ones, such as the US journal *The Public Historian*, contain contributions that are adding to this exciting development.

While not expected to be able to (or need to) reassess and reinterpret historic places to keep up with the thinking at the cutting edge of the new approaches, the manager should be aware of what is going on in a general way, and, when reanalysis of the place and its conservation and presentation takes place, to ensure that those undertaking the work are aware of the most recent thinking, and can incorporate what is relevant and thereby enrich the understanding and presentation of the place. The manager must also know enough to be able to avoid having the place interpreted in the light of some historical fad that will fade and date the interpretation very quickly.

Integrity of a place

Many aspects of assessment, historical significance included, can be lessened by the loss of integrity or completeness of the place. To assess any particular claim for significance, the manager must look carefully at the integrity of the place to see if it still adequately demonstrates or represents the claimed significance.

The room where Burke and Wills stayed at the Menindee Hotel on the Darling River in New South Wales, during their epic and fatal overland expedition, once looked out onto the banks of the river. Over recent years a cold room was built, which largely blocked off this view, and in the room itself an entire wall was knocked out to absorb it into a large pool-room and bar space. The fabric, which had remained largely intact from Burke and Wills's day until the 1970s, and which was evocative of their last 'civilized' living, is now destroyed, and with that destruction the place's significance has been diminished by having the historical associations made less tangible.

In the case of Captain Cook's landing-place at Kurnell in Sydney, however, the subsequent ravages of multiplying me-

morials, Sunday picnic hordes, and a nearby suburb and massive oil refinery, have not diminished the historical significance of the place, since the event is regarded as being a culturally seminal point of history by many Australians. The significance rests less on fabric (as in the case of Burke and Wills's room) and more on symbolism, and as a result can withstand more disruptive treatment of the fabric (not that the manager should encourage disruption!).

Significance of function and use
An aspect of cultural significance often poorly dealt with in assessments is the importance or otherwise of the continuing traditional function or use of the place. We argue below that the function of Aboriginal places in living Aboriginal traditional life is a value that might override other established values.

Similarly, the manager needs to ensure that the assessment process deals effectively with the question of function. In the case of historic places (for example, a working sawmill, or blacksmith's shop, or an operating shop or post office, or an occupied residence), they may owe substantial aspects of their significance to the continuation of that traditional function or use. If this is the case, it must be clearly stated in the statement of significance, as it will have major implications when the manager comes to consider the development of management policy for the place.

Scientific value

> The scientific or research value of a place will depend upon the importance of the data involved or its rarity, quality or representativeness and on the degree to which the place may contribute further substantial information.[16]

> A site or a resource is said to be scientifically significant when its further study may be expected to help answer current research questions. That is, scientific significance is defined as research potential.[17]

Some heritage places have as a prime value their potential for providing information about past human culture, the environment, or human behaviour generally. This value is variously called scientific, archaeological, research or informational value.

Research value of Aboriginal places

Aboriginal sites with this value include sites with occupation deposit—places where people have lived or worked and left evidence of their presence (for example, stone and other artefacts, food remains, and charcoal). Other type of sites, art sites for example, also have research value; the art is an artefact reflecting cultural traits over time and space, and can be used to elucidate the Aboriginal past. In fact, Aboriginal sites often have considerable significance for the natural sciences—from them we are able to learn a great deal about Australia's past natural history. For instance, Aboriginal sites are often an invaluable repository of information about Australia's past climate and environmental changes. At Lake Mungo, in the Willandra Lakes, clay balls moulded by Aborigines for fire-stones can tell us about Pleistocene variations in the Earth's magnetic field; in Kakadu the depiction of animal species in art sites can indicate local variations in environmental conditions over time.

Clearly, then, these sites have scientific value. So has Kutakina Cave on the Franklin River, Tasmania. In both cases the significance of the sites has been described in terms of their capacity to provide very significant new information that will answer important questions about the Aboriginal past in Australia, and about the past environmental history of Australia.[18]

Here is how John Mulvaney described for *Bulletin* readers the potential of the deposit in the Franklin River caves in Tasmania:

> The limestone and dampness have combined to preserve evidence in these caves in a remarkable manner. The degree of preservation and the sheer quantity of material places these caves in the forefront of Pacific region sites. However, most inferences depend upon a square metre of excavated deposit.
>
> Vivid layers of sediment and charcoal are sealed beneath a capping of flowstone. The charcoal provides a time scale through radiocarbon dating. Microscopic pollen grains embedded in the strata offer prospects of tracing the vegetational sequence, from the grasslands which supported the marsupials to the advent of the rainforest which choked off man and beast. Bones of animals abound, enabling detailed study of human diet and changing animal populations as the climate warmed and the humid rains converted the region to the wettest in Australia.
>
> There are incredible quantities of stone flakes and tools— more than 75,000 of them in the area excavated. Around

18,000 years ago, natural glass was being utilised, carried here from the Darwin meteorite impact some 25 km away. The presence of ochre is a clue that non-material aspects of culture also figured. All this data allows detailed studies of climatic fluctuations and reconstruction of economic life in detail unsurpassed overseas.

While such sites may be excavated in salvage operations, these can only treat the deposits, not the caves. Archaeology is a rapidly changing discipline, as are related laboratory techniques. Excavations conducted today will seek answers and use the apparatus of today. In Europe, cave sites have been excavated and re-excavated for more than a century.[19]

In Australia, prehistoric places in general have more research or scientific potential than places relating to recent European settlement. This is because they are the major source of information about Aboriginal prehistory, and since this prehistory has such a great time depth, the sites have potential for answering important questions about natural history and human evolution and adaptation.

European historic places and research significance
European places also have this value. In particular, European sites with archaeological deposit, or which consist entirely of archaeological deposit, have research potential as a major value. They may tell us about Australian history, or about past events, technology or social life. For example, one of the fields of interest of both prehistorians and historians is how a culture copes with changes in environment, and what patterns of adaptation can be observed. Australia is one of the classic 'frontier' countries, where people with a culture developed under one set of conditions (in this case predominantly of Great Britain) had to adapt rapidly to an entirely different environment and new set of demands on their cultural 'tool kit'. Study of 'frontier' settlement sites in the United States is uncovering evidence about the process of cultural adaptation that goes beyond the evidence presented in the written documents of the period. It is highly likely that, similarly, new evidence will be found in Australian frontier sites that is of great anthropological, as well as historical, interest.

Another example is the case of Irrawang Pottery, a pottery and vineyard in the Hunter Valley (NSW), which operated from the mid-1830s to the 1850s. Here archaeology has produced evidence of the range of pottery produced in early New South

Wales, has traced the origin of the designs, identified local adaptation due to available materials and isolation from technological advances in Europe, and local requirements, and has given a new insight into the scale and complexity of an early colonial industry. Most of the evidence is valuable in terms of expanding our knowledge of New South Wales history, but some of it is of wider relevance in the history of nineteenth-century technology world-wide.[20]

Historic places may have substantial research values in other fields besides archaeology. Buildings and engineering features contain evidence of stylistic or technological innovation requiring study, and nineteenth-century gardens may contain plants or plant remains of historical and horticultural research potential. As an example, using a combination of physical evidence, historical descriptions and graphical material, and comparisons with international examples, Brian Rogers has been able to unravel and explain local adoption, adaptation and invention in the Australian salt industry.[21]

Sites with archaeological research potential have a number of common characteristics. The original 'fabric' of the site—the walls, the wind-breaks, the original furnishings—have often largely disappeared. The significant 'fabric' is often the contents, the debris, the discarded and broken by-products of past living, ironically often more intact and valuable if the site has been abandoned than if it has been continually restored and refurbished over a long period. Standing buildings and other structures may have more accessible evidence in their construction, finishes and furnishings, which may be of research significance.

Assessing research significance

There has been much discussion in the literature about assessment of research significance. Bowdler and others provide a good coverage that puts the subject in an Australian perspective.[22] In Australia, Peter Coutts has devised a numerical system for prehistoric sites, based on factors such as site age, type, preservation, rarity, representativeness and research potential.[23]

The sites are scored on this system and ranked. For a small, well-defined region, where the potential of all places is known, this system can work well as a short-term measure. Many workers, however, oppose this system on several grounds. It seems to

them to give a misleading impression of objectivity to what is actually a very subjective process. Such a numerical system also tends to fossilize the value of the place. But significance is always relative, and it can change for many reasons—further research and new discoveries may dramatically change the scientific value of a site, or a group of sites.

In general terms, the assessment of research significance must be based on the researcher's knowledge of the subject, and on what is presently seen as the potential for solving current, important research problems. Very many sites contain potential information; and judging them to be important just on this basis—that is, their capacity to supply data—is not a sufficiently selective process, and leads to mindless data collection, while not necessarily increasing our real knowledge. For example, a nineteenth-century bottle-dump may contain a great deal of information about nineteenth-century bottles, but we must ask whether the information will add *substantially* and *significantly* to our knowledge of nineteenth-century life in Australia, or of bottle-making technology. Thus Sandra Bowdler and Anne Bickford suggest that the relative *scientific* or *research* value of a place can be judged by answering the following questions:

> Can the site contribute knowledge which no other resource can? That is, can it provide information not available from documents or oral history, for example?
>
> Can the site contribute knowledge which no other such site can?
>
> Is this knowledge relevant to general questions about human history or other substantive subjects?[24]

Answers in the affirmative, in descending order (with supporting statements), will demonstrate the research value of a site. The most significant sites would be (in terms of scientific significance) those to which all three answers could be made in the affirmative. There are, as always, problems of application. We can confidently assert, on this basis, that the Willandra Lakes or Kutakina Cave have research value; but this is in part because we have little information about the whole resource. Systematic site survey in south-west Tasmania may greatly increase the number of caves with research potential, lessening the value of Kutakina Cave in particular.

Research significance will change through time; particularly in Australia, where comparatively little is known about the resource. Preliminary research, sufficient to indicate the un-doubted potential of the area or site establishes the research value of a place and often leads, in time, to public or historic value for the site. Sites at Lake Mungo have research value; but Mungo is also now famous for past important and exciting discoveries, and hence is an area with public and social value to both Aborigines and whites. This process results from the reali-zation of research potential by the carrying out of significant research.

Another aspect of this problem is that sites with *potential* to solve research questions in the future may not be assessed as significant using this system. For example, before the discovery of radio-carbon-dating techniques, using charcoal from ancient Aboriginal hearths, one major research use of such sites was unknown. Therefore, in judging the research value of sites, professionals also employ the concept of *representativeness*—they attempt to 'store' representative examples for future use—a very valid conservation strategy. The heritage places in national parks and other permanently reserved areas are often in this category. However, this concept also has problems in Australia, where in most areas presently not enough work has been done to enable us to identify 'representative ' sites. Assessing the comparative significance of individual places within these areas is difficult, and the results can be at best tentative and temporary.[25]

In one sense 'representativeness' is an illusionary concept. It is not possible to conserve a representative sample of places for future research, when we do not know the nature, technological possibilities or aim of the research. 'Representativeness' to us, now, is inevitably based on our view of current research ques-tions, and our understanding of the sites features constituting representativeness. So while representativeness is an important concept in place conservation, because it does provide a level of objectivity, it cannot totally overcome the problems of planning, in the present, for the unknown research needs of the future. This is why the conservation of as much as possible of our scarce, non-renewable resources is important. To overcome this prob-lem, some practitioners have suggested the conservation of a totally random sample.

It follows that research values have direct implications for the investigative techniques, and the actual professional skills of the practitioners employed in the preparation of a statement of significance. Archaeological and/or other expert inputs are crucial for the production of a proper statement of significance in the cases we have discussed. As discussed later, destructive research (excavation) into the fabric may also be necessary to elucidate the place's significance.

A manager may be in a position, however, to make initial assessments of such significance before a specialist is called in. This is particularly the case where the manager has been involved with specialists in previous recording and assessment projects. For example, at Port Arthur (Tasmania), where a framework for assessment and management practice has been established, it would be within the capability of many managers to evaluate new sites against what is already known, and to make initial judgements about management. The background knowledge of resources, in such a situation, puts the manager in a better position to make urgent decisions, and to brief relevant specialists rapidly, should this be necessary.

This value also has clear implications for management. Scientific or research potential dictates that this value be preserved, often by restricting visitors or carefully controlling their access. Recent developments in the theory of scientific method have also raised some problems for the manager. For example, the 'new archaeology' of the 1970s and 1980s tended to use sites as testing grounds for universal laws 'explaining' human behaviour. Creating regional stories or culture histories became unfashionable with many theorists.[26] This somewhat rigid and artificial 'scientific' use of places has the capacity to be in direct conflict with values that the community may see in the same heritage.

Social value

> Social value embraces the qualities for which a place has become a focus of spiritual, political, national, or other cultural sentiment to a majority or minority group.[27]

Those places with social value have often acquired it because of their historic, aesthetic, educational or scientific significance. Some such sites tend to be obvious, especially when their social

significance relates to the majority culture. Rottnest Island in Western Australia, Victoria and Constitution Docks in Hobart, the GPO in Sydney, and the Old Parliament House in Canberra, are all examples of sites with this social value.

However, though the significance of places does depend ultimately on the value society places on them, selection of places simply by gauging short-term public interest, or popularity, will not give a true reflection of significance. Society sometimes indicates the real significance of a place by trying to ignore it or make it disappear, because it represents the darker side of our history or society, which it is more comfortable to ignore. The Myall Creek Massacre Site (NSW) is a good example.[28] Here, in 1838, twenty-eight Aborigines were massacred by white stockmen. For the first time in Australian history, the perpetrators of the deed were tried, and seven were executed, amid public uproar and divisive debate on the matter. Many present-day Australians would rather not be reminded of such happenings—they prefer a rosier view of early colonial life, and, in fact, attempts have been made, locally, to make the place 'disappear'.

In some situations, social values of one sort can lead to other values being wilfully hidden. Because of the recent debate about conservation and logging values of native forests, both conservation groups and foresters tended to forget or to ignore historic remains of significant early forestry activities and to downplay their significance. The manager must be aware of the political nature of history, and of special interest groups who seek to push a particular view of the past. However, the manager may need more experience or specialist assistance to recognize the biases existing in the public's view of cultural resources, and so develop management initiatives to overcome them.

Sites with symbolic value for Australians may be important just because they are 'there', not because people necessarily see them. Indeed, for one reason or another, most people don't see some of these sites—none the less, they are important. For example, the discussion of the future of Mawson's hut in Antarctica has created much public interest; the result to date has been that the responsible authority decided to adopt a policy to preserve the hut in the Antarctic rather than dismantle it and return it to Australia as had been suggested. The symbolism of the hut's existence, *in situ*, even though most people will never see it, is very powerful.[29]

Social significance to local communities
One aspect of significance poorly represented in conservation thinking in the past has been the value of places to local communities. Perhaps this has been because the definition and evaluation of such community value is far more difficult than many other aspects of significance assessment. Many places valued by communities are unknown to the wider society. These special places often contribute to the community's sense of place by reflecting the historic, scenic, recreational or social experiences common to that community and which distinguish that community and that locality from other communities and localities. Only rarely will the community feel the need to state its strong feelings for such places; often the realization of the value of the place only comes when the places are threatened.

The assessment of the significance of places to a community is made difficult because it is hard to distinguish between simple conservatism and more deeply rooted social ties. Indeed, it may be impossible (and unnecessary) to separate the two, as it may be the case that some forms of social significance come through growing community attachment to places kept by an earlier generation through conservatism alone. At its simplest level, the community may value a place because it represents one of the few remaining links with that community's past. Better examples may exist elsewhere, but they are not accessible to that community and are not part of the sense of place that the community may be striving to retain (although it is not often put in these terms). It is therefore dangerous for the manager of a heritage place to assume that because the place is not an outstanding example of its type, or has no known important historical associations, that the place has no cultural significance. Just as the interests of minority ethnic groups have to be taken into account when assessing significance, so too should the interests of the most common minority group, the local community.

Some examples of special significance to communities are:

- Mother's Memorial, Toowoomba, Queensland—This World War I memorial was located at a major crossroads where the mothers of the town gathered funds for the war effort, and subsequently erected the memorial to the dead. The intention of the local council to move the memorial in the interests of better traffic flow brought out the strongest local feeling for

the place. Unfortunately, the lack of time available for the marshalling of arguments, and the absence at the time of any state legislation that could be triggered to delay the decision, meant that the removal of the memorial proceeded without a proper assessment of the social value of the place.

* Carnarvon Lightkeeper's Quarters, Western Australia—The local community has gathered funding from a variety of sources to conserve the Lightkeeper's Quarters because it is symbolic to the community of its links with the maritime trade, upon which the town was founded, and with which most families had direct ties. The place in itself is a relatively unexceptional example of its type: its value lies in its symbolism of the community's shared past.

The concept of social value is both slippery and challenging. Chris Johnston's discussion paper, *What Is Social Value?*, puts a number of these issues well, and moves towards the difficult realm of assessment of such values.[30] We have already discussed in Chapter 3 the growing moves within communities to themselves recognize and assess the social values inherent in their environment. We increasingly recognize, therefore, that the views of practitioners and the community about heritage value often differ in significant ways.

The Australian Heritage Commission's study of Queanbeyan (NSW) illustrates this. Meredith Walker conducted a heritage study of the town, and then assisted Australian Heritage Commission staff in running a community study to ascertain independently the community's views on their heritage.[31] Practitioner and public agreed, by and large, about the significance elements of the town's heritage, but there were some significant variations. People tended to value places not so much for their architecture, or their public history value, as for their part in the ongoing life of the town, and as reminders of significant events in their own lives. The river running through the town was not listed as an official heritage item, since it was to some extent 'natural'; but it was of central heritage value to the citizens who played, courted and strolled by it, and for whom it was the centre or *raison d'être* of the town.

The Commission is developing criteria for defining places valued by the community for religious or social reasons.

Within these criteria, types of specific values considered include:

- community landmark or signature
- strong symbolic qualities defining a community
- spiritual or traditional connection between past and present
- represents/embodies important collective (community) meanings
- association with events having a profound effect on a community
- symbolically represents the past in the present
- represents attitudes, beliefs, behaviours fundamental to community identity
- essential community function leading to a special attachment
- longevity of use or association, including continuity to the present.

The Australian Heritage Commission's regional work with the community in East Gippsland and the Central Highlands of Victoria has revealed many places of local, social value that would not necessarily occur to the heritage planner, architect or archaeologist. Places identified included the fire bell, the highest flood mark on the oldest building, and sites of drama and disaster associated with nineteenth-century industrial pursuits—forestry, mining and road-building.

Social significance and minorities
In this context we need to particularly consider the question of places of social importance to minority groups. Such places often have a range of values. They may be of historic, scientific or aesthetic value to the whole community. White Australians, with an interest in heritage issues and in conservation have generally accepted Aboriginal sites as part of this heritage. They have made laws to protect them, and have sought to integrate them into planning schemes by laying claim to the Aboriginal past as part of the heritage of all Australians. Aboriginal sites, rather than European ones to date, have been recognized as being of world importance and are considered by the World Heritage Committee to be some of the most important such places in Australia. Other places, such as the Chinese goldfields or the Cowra (NSW) Japanese prisoner-of-war camp also have such values for all Australians.

On the other hand, some places of value to a minority group may generate little general interest, especially in the short term,

but may still be worthy of recognition. It is difficult for the majority culture to deal appropriately with these places. There is a tendency either to incorporate them in the mainstream (if they have general importance) without regard to their special status for one group; or, if they are not of significance to the majority culture, to ignore them or belittle their value.

Recognition of this problem has led American practitioners to suggest another type of significance: a subset of social significance that describes the value of a site to a discrete, minority group or culture within the community or majority culture. They have called it (perhaps regrettably) ethnic or minority significance. It is defined thus: 'A site which has religious, mythological, social or other special importance for a discrete population is said to be ethnically significant'.[32] This concept is as applicable in Australia as in the United States. Both nations, the product of recent colonization by an overwhelming alien culture, have to find ways of coming to terms with the indigenous cultures that they almost obliterated, and of recognizing the diverse cultural origins of the recent colonizers themselves. Discussion in the American literature about ethnic significance indicates the relevance of this concept to Australia. The following passage refers specially to archaeological resources, but it can be seen to have general application.

> By this definition, of course, ethnic significance overlaps somewhat with historical significance, but that is of little concern. Ethnic significance has been overlooked in much of previous conservation archaeology; today, however, the heightened awareness of many groups to their cultural heritage as revealed in archaeological sites, the investigator ignores ethnic significance only at great peril. Determination of ethnic significance requires consultation with groups who occupied a site, descendants of such groups and also groups who presently own or live near the sites under consideration. The latter criterion should be taken seriously; sometimes an archaeological site is an appreciable source of pride for a nearby community (Bell and Gettys n.d.). A potential problem is that archaeologists might not have the ability to define what is ethnically significant, and the suggestion they do smacks of some ethnocentrism.[33]

Aboriginal sites are by far the largest single category of places with 'ethnic' or 'minority', as well as general, significance in

Australia. We will therefore examine this significance in some detail, before returning to a general discussion of minority sites.

The significance of Aboriginal sites to Aboriginal people

Aboriginal places, like other heritage places, may be significant in a number of ways. As we have seen, to the general community they may have immense scientific or social significance. This is one important reason why Kakadu, the Willandra Lakes, and south-west Tasmania are on the World Heritage List.

Aboriginal places, additionally, have a special significance for Australian Aboriginal people. Australian Aborigines have a very ancient and distinct traditional culture, which is still very much alive. At the same time, in Australian society today they constitute a visibly oppressed and disadvantaged minority. These two elements give their heritage and history a special significance, and pose fundamental questions for Aboriginal place managers. Aboriginal places may be important to Aboriginal people in a number of ways.

Many publications and commentators refer ignorantly to 'sacred sites' as being synonymous with the whole range of Aboriginal sites. Yet 'sacred sites', though very important, comprise only a small percentage of Aboriginal heritage places. Aboriginal people themselves traditionally did not designate 'sacred sites' as Europeans do, and their spiritual beliefs about such places are not readily translatable. At one level, the landscape and all it contains have a sacred element to traditional Aborigines in line with an essentially religious explanation of the origins of the cosmos, and the Aboriginal people. Hence, 'sacred sites' are in one sense markers or foci within this general sacredness. They may be places or tracks, sometimes over hundreds of miles where ancestral Dreamtime heroes travelled, or performed various actions. They may commemorate where they were taken into the sky (in Eastern Australia), or in other parts of Australia may represent the metamorphosed ancestor itself, in the form of a rock or mountain. They may be places where initiation or totemic or increase ceremonies were or are held. Some of these places, or events associated with them, are 'secret sacred': certain levels of knowledge about them, or even their existence is known only to designated people within the tribe or group. Some may be very dangerous and life-threatening. Others are known to the whole community, and are part of everyday

life. Different places have different degrees and types of sacred-
ness or significance for their community. Such places are only
found in their pre-European context and environment in the
north of Australia—areas where traditional cultural and Aborigi-
nal landscape have been relatively unchanged—but they still
exist in many parts of Australia, often in forms that demonstrate
that they are part of a living culture that has adapted and changed
over 200 years of European impact.[34]

This very brief and superficial discussion of sacred sites indi-
cates that they have a number of characteristics of concern to
the heritage manager. Such places may have other values—for
example, they may contain important rock art, or occupation
deposit, and may be ideal for educating the public. However, it
is clear that where a place has important sacred or religious
significance, this is a social value that will tend to outweigh
other considerations relating to the heritage value of the place
from a European perspective, such as public, research or aes-
thetic value.

In the areas of Australia last settled by Europeans, in the
Northern Territory for example, this paramount value is acknowl-
edged. The Northern Territory Aboriginal Areas Protection
Authority, controlled by Aborigines, has been set up to protect
and manage traditional sites in accordance with Aboriginal
wishes. In these circumstances, it is the Aboriginal owners, or
their employees acting on their behalf, who have control of site
management and who can apply the European-based heritage
conservation guidelines if they see them as appropriate. Sacred
sites, part of a living religious tradition, have paramount values
other than as heritage items, which may dictate actions and
practices that are contrary to the ideals of the conservation
movement.

In settled Australia, this value is sometimes distorted, masked,
or hidden by 200 years of colonization. Yet it often exists, and it
must be taken into account by managers assessing significance.
Clearly the 'experts' in this case are the Aboriginal community.
However, the information often needs to be sought, and trans-
lated and interpreted for the manager by specialized staff.
Elements of religious or traditional belief often also permeate
Aboriginal attitudes to sites not specifically identified as tradi-
tionally sacred. In south-eastern Australia, Aborigines assessing
the sacredness or significance of newly discovered prehistoric

places have to rely on traditions that are still very real, but which have become rather vague and generalized over 200 years, with the disruption and loss of continuity that is a by-product of colonization.

Aboriginal places may also be important to Aborigines because of their historic significance. Many places are associated with recent (the last 200 years) Aboriginal history. These include places such as massacre sites, mission stations, and nineteenth-century welfare settlements and reserves. Many of these places are significant only to Aborigines. Others (for instance, the site of the Myall Creek massacre) are generally recognized as representing an event of importance in the history of Australia.

Some sites of great importance to white Australians have a very different significance for Aborigines. The site of the first Government House in Sydney is significant to white Australians as a symbol of the establishment of the first seat of government, order, law and a promise of expansion and growth: for Aborigines it is the first tangible symbol of conquest. The Alice Springs Overland Telegraph Line Repeater Station is significant to Europeans because of what it means in terms of the conquest of distance and isolation, and because of the achievement of establishing complex remote settlement; Aborigines remember it bitterly as a place where Aboriginal children were taken from their parents.

The controversy in the 1980s over the repainting of the Wandjina paintings in the Kimberley by the traditional owners is a good example of some of these points. There has been some dispute about who the traditional owners are, but the key point is that the paintings traditionally have been repainted. They have not been repainted for some time, however, and the most recent versions have become internationally famous for their aesthetic qualities, and have been studied and analysed for their meaning. Therefore, the local people's decision to repaint them on a Commonwealth Employment Scheme grant, and thus obliterate the original figures, caused some violent and genuine reactions from art lovers and scholars; but it can be argued that it was a traditional and legitimate action.[35]

The places we have been describing to date, sacred sites, and sites of specific historic or social significance to particular Aboriginal communities, make up a minority of known Aboriginal heritage places in Australia. In southern Australia the vast

majority of sites are prehistoric. They relate to evidence of Aboriginal occupation of the continent over 60 000 years, but they have no specific traditional significance to any particular group. They are usually as unknown to Aborigines as to others until located and identified by archaeological survey or other research. The originally very close ties that Aborigines have with the land have been interrupted or destroyed by 200 years of white settlement. However, Aboriginal society is undergoing a renaissance, a cultural revival. Aborigines in southern Australia are asserting their Aboriginality as a matter of pride for the first time since Europeans came. There is an immense interest by Aborigines in their own past and their own places of great symbolic value, and as these are seen are a means of achieving political power sites such as middens, engravings, quarries and occupation deposits are very important to Aborigines.

Such sites are the main source of information about the Aboriginal past. Their existence has important legal implications for land claims and for assertions of prior occupation of Australia. Since in many areas effective land rights for Aborigines have never been granted, Aboriginal sites take on added value and importance to the landless Aboriginal community. Aborigines therefore seek custodianship of sites—all sites—not just those of particular sacredness or significance. By custodianship they generally mean control, at a policy level, of site assessment, management, research and interpretation. We have discussed the arguments for this view, and its implications for legislation and management, in Chapter 2. The issue here lies in the problem of assessment of such sites. For Europeans such sites are often of great scientific importance. Aboriginal sites illustrate Aboriginal history over 60 000 years. Ironically, it is this very important value that is often the subject of conflict between researchers and Aborigines, and leads to disputes about the significance of such sites. In other instances their assessment and interpretation by Europeans has often led to, or actually been used to justify, a racist view of Aboriginal life and culture.

Fay Gale's study of bus operators at Uluru (Northern Territory) found that they were making a feature of the local rock art.[36] However, their interpretation of it to visitors was simplistic, wrong and racist. This had a direct impact on how the visitors appreciated the art, but, more importantly, on how they viewed the

traditional owners who now own the Park, and who are trying to establish respect and economic viability in the local community.

Some sites, though prehistoric, have religious or symbolic meaning, which sometimes makes their study, or assessment or research into them, inappropriate. A good example of the complexity of this issue is the case of Aboriginal burials. Such burials are common, in situations where conditions for bone preservation are favourable, and many are extremely ancient. The largest ancient group of the remains of *Homo sapiens* is found in Australia, at Lake Mungo (NSW), and these remains have an immense capacity to teach us about the human past. They can provide answers to major research questions about Aboriginal life in Australia over 60 000 years, about Aboriginal origins, human development, adaptation and change, and past environments in Australia.

Aboriginal burials are also of great importance to Aboriginal people. Many Aboriginal people feel a strong relationship to their ancestors, however remote, and are offended by their unauthorized excavation and study. Many Aboriginal people hold strong religious beliefs, which the disturbance of the graves of their ancestors deeply offends. Aborigines recognize the strong informational value of skeletal material, but they are sceptical of the interpretation of it by scientists. There has been an almost total white Australian monopoly in this area, and the published results of their research has had an effect on the way the Australian community has perceived Aborigines, who in the past have been described in terms of anthropological stereotypes.

In the past, Aboriginal burials have been treated with the greatest and most shocking disrespect in the name of science. This has made the question of the value of Aboriginal remains doubly important to Aborigines, for whom any research into burials has become symbolic of Aboriginal oppression and power-lessness. This means that Aboriginal burials have a very important political symbolic value to Aborigines.

Hence, Aboriginal burial places are very important heritage places, and the remains they contain even more so. This multi-faceted significance, however, has led to much conflict and heated debate. Aborigines have reburied or cremated some remains. Scientists and museum curators have refused to return others.

Because the guidelines for the recording, assessment and research into burial sites and other Aboriginal sites were designed by the majority culture, researchers have assumed, until recently, that the main value of a site will be its value to that majority culture, and that the assessor will be of that culture. This very concept is offensive to many Aborigines, no matter how impeccable the end result. For all the reasons outlined above, Aborigines demand a full say in the assessment of their sites, and on principle will not accept less. At Mootwingee Historic Site in western NSW, Aborigines barricaded the site, and allowed no visitors. They were protesting about their lack of management involvement in a site famous for its rock engravings and paintings.[37]

The argument is a politically charged one. While scientific findings have given a time depth to the Aboriginal occupation of Australia, and have disposed of the more offensive racial origins arguments, both of which findings are valuable ammunition in the Aboriginal fight for political, social and site custodial justice, scientific value in itself is often seen by Aborigines as having little relevance to arguments about Aboriginal cultural identity and the control of Aboriginal heritage.

These characteristics of Aboriginal sites—their significance (and political importance) to a distinct minority group in the community—has important consequences for the investigative and evaluative processes determining the cultural significance of Aboriginal sites as a basis for conservation policy.

In most cases, the white Australian practitioner can have no way of really assessing the value of a site, except in European terms, unless there is a process of real consultation, and a genuine attempt to accept as equally valid the views of another culture.

These days there is close co-operation between Aborigines, archaeologists and anthropologists in assessing the significance of Aboriginal places. All are enriched by this process, and all the values of Aboriginal places are fully explored and articulated. See, for instance, Colin Pardoe's account of his work with skeletal material and burial sites, in co-operation with the Aboriginal communities of the Murray–Darling.[38]

In summary: because of the very important role that sacred sites play in Aboriginal religion, and because of the political importance of Aboriginal sites in general to Aborigines, a consequence of the absence of treaties, agreements or land rights

legislation for Aborigines, Aboriginal concerns and interests in our opinion are relevant to every Aboriginal place—sacred, historic, or prehistoric—and should feature in every statement of significance and conservation plan dealing with such sites.

Minorities and heritage place assessment
The above discussion about Aboriginal sites has implications for the assessment of all minority sites. What we learn from these experiences is that the assessment, interpretation and use of sites can have a significant social influence on communities or groups, and that there is often an explicit or hidden conflict in significance assessment. Because of the complexity of the issue, it is necessary to clarify the problems that arise with such places, in the context of the planning process.

There are two main problems. The first one is that all aspects of the significance are not being documented and assessed for all such places. The element most commonly left out of the assessment is the social significance of the place to the minority group as a whole, or to traditional custodians or local minority communities in particular. This often means that the management policy, based on inadequate assessment of significance, is flawed, and is not acceptable or is offensive to the minority community who have a special interest in the place.

Second, consultation and involvement is mandatory. If the relevant minority group cannot be located, or is not interested, the social significance to a minority group cannot be established (though other forms of significance may). The concerned group will be central to a decision about significance and, hence, about subsequent management decisions. This is not always simple.

Sometimes it is difficult to gain information about the site at all, until it is threatened in some way. This may be because the people concerned fear ridicule or simply consider it dangerous to draw attention to themselves. In the 1930s and 1940s adult Aborigines were still 'protected' (that is, under the will of a settlement manager of 'the welfare'), and Aboriginal children were still being taken from their parents throughout Australia. The children of that era are now the elders of the Aboriginal community.

It may be that the place is sacred, or dangerous, or that it represents something that the dominant culture has not yet 'taken over'. The manager must be sensitive to this problem,

and must make efforts to overcome it in co-operation with the place's custodians. In some cases, also, the group concerned object strongly to 'expert' assessment, on the grounds that they themselves are the best judge of significance. This is especially the case when the sites are traditional Aboriginal sacred or significant sites.

In these cases, an assertion of significance by the particular group is an essential first step, in recognition of their site's value. Often the people concerned also have a firm view of the comparative significance of such sites. This view may be geographically limited, and not encompass all such places, or the idea of custodianship might mean that control, and hence information relating to comparative assessment, is fragmented throughout various sections of a minority group. Comparative value would have to be weighed with that fragmentation of knowledge in mind. However, since the significance of the site is of the group's own making, it follows that their view of its comparative significance within their own cultural domain (if this is an acceptable concept to them) will prevail.

In other cases, especially in the southern states, the details regarding the significance of Aboriginal sites has been lost by cultural attrition. Similarly, details regarding nineteenth-century Chinese sites may also be lost. This does not mean that such sites are not significant. Many such places are of importance to Europeans, but have totally spurious or hopelessly romantic versions of their history attached to them. In such cases, expert research, in co-operation with the concerned group, might firm up and clarify the evidence for significance, and, overall, strengthen the case and explicate it for the majority culture. This process, of stating the significance in terms that the majority culture can comprehend, and we hope, respect, is particularly important when a land-use conflict is pending. For a good example of this process, see the work of Brian Egloff.[39]

It may not be appropriate for the manager or for specialists to attribute 'ethnic' or minority significance to sites. However, it is the job of the manager to consult with local groups if it is felt that a site has been located that might be of significance to them. For example, a manager may locate an early Italian settlement area, identified from documentary sources. This source may not be known to those people of Italian descent

living in the region, but considerable interest may be shown once the knowledge is made available to them. Even if such a site is of no interest to the relevant ethnic group, its significance in the other categories should be investigated. For example, such an early Italian site might prove to be historically rare, and of great scientific interest.

The second common problem is that a thorough assessment of significance, taking all the elements raised above into account, may often result in a real conflict of values, which must be resolved in the conservation management policy for the site.

Conflict may arise because significance other than social value to Aborigines, for example, is given pre-eminence, and the resulting management policy and practices are not acceptable to the Aboriginal community, or because social value to Aborigines is given pre-eminence and the resulting management policy and practices are not acceptable to some other group in society (often a commercial interest such as mining or forestry). In most cases the resolution of an appropriate policy is made more difficult by the presence of another major constraint, especially a political interest.

It is our contention that if a planning process such as that outlined in this book were applied consistently to Aboriginal and other minority places an appropriate solution would be found in most cases. Some degree of conflict with the interests of one or other party involved in the process might still be expected, but this would at least be clearly identified and recognized as a part of the process, and hence would have some chance of resolution or compromise. Key points in the application of this process to these types of places is that Aboriginal and other minority groups must be involved in the full assessment process, because of their expertise, as traditional custodians, or cultural inheritors of these places. If, as we have argued, local Anglo-Saxon communities should be involved directly in the assessment process because of their close association with places for two or three generations, how much more necessary it must be to involve communities of Aboriginal people who may have been associated with places for 200 or 2000 generations. The fact that questions of Aboriginal control over Aboriginal sites and of multiculturalization are now on the political agenda simply adds weight to the argument.

The nature of cultural significance

There are some characteristics of cultural significance that run as a thread through these discussions of types of significance, and must be kept in mind in significance assessment.

The most important point to reiterate is that there is no such thing as an objective assessment of significance, though people often behave as if there were; as though a 'true' interpretation of the past were possible. The past does not exist, except in our present understanding of it, and this understanding is rooted in our ideology and culture. Hence, 'We cannot speak of significance as an inherent attribute of cultural properties, waiting only to be discerned. Significance, rather, is a quality that we assign to a cultural resource based on the theoretical [or ideological] framework within which we happen to be thinking.'[40]

This attribute of significance is an inevitable result of the nature of heritage places. The only significance they have is given to them by humanity. It is important to recognize this fact, and to minimize the more obvious forms of unconscious bias and over-simplification by a careful and systematic assessment of various aspects of significance. Otherwise it is fatally easy to overlook or ignore important aspects of cultural value that do not fit in with a particular mind set, or to distort the evidence to produce a comfortable myth. In the past, for instance, architects assessing heritage places have paid little attention to the social or historic value of nineteenth-century houses, choosing to concentrate purely on their architectural value.

On the other hand, it is very easy for a local community group or a tourist venture to use a spurious or exaggerated view of the historic or social significance of a place or feature to push a particular barrow. Their real aim is nature conservation or urban amenity or the invention of a colourful past, rather than the conservation of cultural significance.

Hence, we need a careful, intellectually rigorous process of significance assessment that ensures, as far as it is possible, that all aspects of value are duly considered and that none are exaggerated.

While for these reasons a professional approach to significance assessment is crucial, narrowly based empiricist approaches to significance focusing on external forms, or on esoteric and narrow assessment procedures, without adequately setting the

place in its historical or social context will destroy 'the love of place' that is the basis of the heritage movement, and will effectively remove heritage from its rightful owners—the people. The task is one of empathetically interpreting the different structures of meaning associated with places, and of developing a broadly framed understanding of the significance of environment in people's lives in the present and the past. This necessitates public participation, ongoing and at many levels. In fact, appropriate public participation is as crucial a factor in significance assessment as are the application of appropriate expertise and intellectual rigour.[41]

It will also be clear that significance is almost always multi-faceted. We have just examined various 'types' of significance, but almost any place one can think of will have more than one type of significance. This has implications, as we shall see below, for the range of expertise needed to carry out the assessment. To ensure that all aspects of a site are being considered, a wide-enough range of expertise must be involved in its assessment.

Significance is almost always comparative. Unless a cultural place is unique, then it is necessary to assess it in a comparative context, which matches it with other places of the same type, and with other places exemplifying the same historic theme. In fact, often until we have a range of information about other places of the same sort, we cannot reach a conclusion about the value of any particular one. For instance, are the features exemplified at the Fremantle Gaol unique or representative? How many other examples of a gaol of this period, and built for this use, are there? Or—is this New England red ochre painting typical of the New England style? Does it have any significant differences? How comparatively well-preserved is it?

So the value of a site may depend in one instance on its rarity and in another on its representativeness.

Assessment of comparative value requires two things. Firstly, it is necessary that comparative data exists, ideally some sort of national or regional overview study of the place type—for instance, David Bell's study of all known examples of carved trees in New South Wales, or the various studies of Australian lighthouses.[42] Secondly, the assessor needs the technical expertise to carry out a comparative assessment. Often the manager will find that neither the information nor the expertise is available, that steps 4 and 5 in Figure 4.1 are impossible to complete, and that

decisions have to be made on what limited information can be gathered to support the assessment.

The significance of a place is not static, nor is it susceptible to formula or 'recipe' type treatment. All the types of significance outlined in this chapter are dynamic, and will change in time and space. A site may be significant locally, but not nationally (or vice versa) or its significance may depend on current understanding of context, and may decline or grow in the future. For instance, a site may cease to be scientifically important when the information it provided has been incorporated in the literature; or it may become important because of a new discovery or research technique.

Fifty years ago Australia's convict past was not celebrated, nor were the sites associated with it. The name 'Port Arthur' was actually expunged in the late nineteenth century, and the town was renamed Carnarvon in the hope that its convict past would similarly disappear. Similarly attempts were made to expunge the convict 'stain' at Port Macquarie in the 1930s.[43] Today 90 per cent of tourists to Tasmania visit Port Arthur, and the Australian government is considering the nomination of convict sites for World Heritage Listing. Who can say what aspects of Australia's past will next fire the public imagination? There seems no doubt that Australia's increasingly multicultural population will influence our view of history and hence of the relative value of various historic sites. Because significance is a dynamic concept, assessment and reassessment is an ongoing process. This is as it should be, as long as assessors keep in mind the pitfalls and problems discussed here. The need to assess sites now, and the inability to predict what particular sites might be significant in times to come leads managers to use a twofold strategy—assessing as significant not only the sites of obvious importance to this generation but also linking the concept of representativeness to significance; that is, designating as significant (and managing appropriately) a representative sample of sites for future use and reference. For a discussion of many of the concepts covered above, see the references listed in the notes.[44]

Finally, the heritage place manager must be aware that cultural significance is not the only value that a place may have, and that it sometimes has other, more important attributes.

An example of this point was the discussion of a paper on the conservation of urban areas that occurred some years ago within

Australia ICOMOS. The discussion did not resolve itself in the adoption of urban conservation guidelines, as some thought it might, largely due to the realization that those features constituting urban areas may have radically different values for different socio-economic groups in our society. In particular, it was suggested that conservation-related trends such as 'gentrification' of urban areas could have significant social and economic influence on communities. Conservation was seen as being akin to social engineering, and the concept of significance as a part of a 'logical' process in arriving at conservation policy was seen to be very closely tied to the personal political/social/economic attitudes of the assessor. ICOMOS wisely decided that, as social engineering was not among the skills of its members, the solution of urban conservation problems should be viewed as not just a heritage issue, but as one that involved many facets of society's value system.

Carrying out significance assessment

The guidelines to the Burra Charter outline the processes of significance assessment.[45] As discussed above, these guidelines are for the preparation of a professionally researched, formal statement of significance. They apply, however, to a greater or lesser degree to all significance assessment, and they provide a very useful checklist for the manager.

> In establishing the cultural significance of a place it is necessary to assess all the information relevant to an understanding of the place and its fabric. The task includes a report comprising written material and graphic material. The contents of the report . . . will generally be in two sections: first the assessment of cultural significance, and second, the statement of cultural significance.[46]

What follows is an outline of the process. It is very well covered in a booklet by Jim Kerr; refer to it for a full and useful coverage of the process of conservation planning.[47] Dr Kerr has also published a number of concise and easily-read heritage assessments and conservation plans for buildings and groups, all very useful reading for a manager undertaking a planning exercise.[48] The process being followed is outlined in Figure 4.1, which can

be used as a rough guide to the sequence of steps that need to be taken.

Research and collection of information

The first task is to collect all the relevant information. This requires research on and off site. The evidence may be documentary, physical, or oral (Figure 4.1, steps 1 and 2).

Documentary evidence, discussed to some extent in Chapter 3, is written or graphic evidence relating to the place. It may include published material, reports, correspondence, sketches, paintings, photographs and maps.

In the first instance, the researcher is looking for information directly about the place. Some of this material may be of doubtful authenticity or may be contradictory. Special skills in archival research and in document interpretation are often helpful. It was with these skills that Jack McIlroy deduced, from the documentary evidence, the probable location and orientation of Bathers Bay whaling station site in Fremantle.[49]

Physical evidence is evidence that derives from the place itself. It may be the fabric of a building, which tells its changing use; or it may be that the shells and charcoal in an Aboriginal midden reveal its date, and the type of subsistence economy it represents: 'Physical evidence tells the story of what actually happened, rather than what someone intended should happen, or believed did happen. It provides data on the sequence of changes and intimate information on human usage and habit.'[50]

Article 24 of the Burra Charter stresses that the archaeological evidence that forms a part of many heritage places should be disturbed only to gather information necessary for the place's conservation, and that any other disturbance, say for scientific research purposes, should be subject to a conservation plan. This is a good principle for many places, especially historic and building sites, but in our view ignores the problem facing many managers of whether or not to approve research excavations at places (particularly Aboriginal sites) without a conservation plan, and where the research is not specifically aimed at developing such a plan.

The dilemma not addressed by the Burra Charter is that in some archaeological sites the overwhelming cultural significance rests in the evidence contained in the deposit—yet to excavate

the deposit to reveal and interpret the evidence actually destroys the site. In an ideal world with unlimited resources of time and money, a conservation plan would be developed that identifies that research potential is the only value, and legitimizes a management process that destroys the site to retrieve the evidence. More commonly, the manager has to decide without benefit of an exhaustive conservation analysis and policy whether there is greater benefit in providing increased knowledge to the community as a whole, and to the special-interest communities in particular (such as the local Aboriginal community, and the academic community) by allowing excavation to occur, or in preserving the site intact. Some common approaches to reduce the potential impacts of making a wrong decision are to limit the proportion of a particular site that can be disturbed, and to limit the proportion of similar sites in an area or district that can be investigated through excavation.

The Willandra Lakes are on the World Heritage List. One very important reason for their listing is their immense research importance. Yet this could not have been known without investigation of the fabric (that is, excavation), which was the basis for the discovery of the place's significance. Excavation established the site's antiquity, and its cultural sequences, and demonstrated the antiquity of the Aboriginal presence in Australia. Even in these circumstances, however, it is important to keep such investigation to the absolute minimum required to establish significance, and to conduct future research in accordance with a conservation policy.

Oral evidence could take the form of reminiscences and stories about the place and its associations. It can (and should) also include local information and opinion on the value of the place, and the reasons why it is considered to have significance.

The guidelines to the Burra Charter suggest that information relevant to the following should be collected:[51]

(a) the developmental sequence of the place and its relationship to the surviving fabric;

(b) the existence and nature of lost or obliterated fabric;

(c) the rarity or technical interest of all or any part of the place;

(d) the functions of the place and its parts;

(e) the relationship of the place and its parts with its setting;

(f) the cultural influences that have affected the form and fabric of the place;

(g) the significance of the place to people who use or have used the place, or descendants of such people;

(h) the historical content of the place with particular reference to the ways in which its fabric has been influenced by historical forces or has itself influenced the course of history;

(i) the scientific or research potential of the place;

(j) the relationship of the place to other places, for example in respect of design, technology, use, locality or origin;

(k) any other factor relevant to an understanding of the place.

These guidelines cover aspects included in the steps of Figure 4.1.

The site in its context

At this stage it may be necessary to carry out further research (as suggested in the list above) that relates to the place's historic or social context, or to gather comparative information about places of a similar type. A regional history outlining dominant historic themes, or a work describing all the known buildings of a particular famous architect, may give the assessment of significance the necessary context and depth, and will ensure that the place is assessed in the physical and cultural landscape that it elucidates, and in which it can best be understood and appreciated.

The gathering of comparative information about the type or class of places similar to that being assessed can be of critical importance in arriving at a valid statement of significance. One use of comparative assessment applies to places thought to be outstanding examples or developmental landmarks of their type. Through the gathering of comparative data it might be possible to define with some exactitude the physical characteristics of the 'type', its history and geographical spread. With this information available, the importance of the place being assessed can be quite clearly stated. Another use of this comparative information is to enable places that are truly representative of the type of place and its range of variations to be located.

An example of the establishment of a profile of a type of place useful for comparative purposes is Professor Colin O'Connor's work on bridges. O'Connor identified a series of bridges that

were landmarks in the history of bridge construction in Australia. All types of bridge construction were covered, and the end result is a database against which other bridges can be compared and assessed for their significance to the history of engineering.[52] Another example of a type profile useful for comparative purposes and establishment of context is Jim Kerr's excellent work on convict establishments.[53] A third example is Josephine McDonald's work on rock engravings of the Hawkesbury.[54]

The manager must be prepared, however, to accept that in many situations there has not been sufficient work done yet to establish good comparative data for a wide range of place types. In some cases, assessments of cultural significance may have to be radically rethought when such data eventually becomes available. In many cases, the best that can be achieved now is an informed assessment based on the best available information.

Analysing and synthesizing the evidence

The evidence must be critically analysed, and from it a synthesis of the history and development of the place should emerge. At this point missing evidence should be identified, along with extra work that might be required and to explicate significance further. The crucial evidence, on which an assessment is based, should be presented or cited.

Earlier in this chapter we discussed one set of headings that could be used for thinking through the major elements of significance a place may have. Practitioners who have to assess numerous places tend to use more detailed checklists within these headings, such as the criteria and sub-criteria for listing on the Register of the National Estate provided in Chapter 2. A quick glance at these will show that they can be very useful in focusing the mind on particular characteristics that can be used to test the claims for significance. The degree to which the place meets these criteria is one way of establishing its degree of significance. Guidelines for using these criteria are available from the Australian Heritage Commission.

Assessment of the level of significance (Figure 4.1, step 7)
We have already discussed the criteria for assessment that the Burra Charter provides. Jim Kerr gives a further breakdown of

these elements and discusses the criteria he has used success-fully for the built environment.[55] It is, of course, necessary to determine the degree of significance, as well as the type(s). This is often a question of comparison. It is very difficult to properly assess significance if we do not have some idea of the full range of similar places, as discussed above.

The statement of significance (Figure 4.1, step 8)
The statement of significance itself should be a brief, pithy but comprehensive statement of all the ways in which the place is significant. It should not just be a list of every conceivable rea-son for significance that the assessor can think up, however. It must state clearly and unequivocally the major reasons why the place is important. It must be supported by the presentation of sufficient evidence to justify the assessment judgement. Jim Kerr suggests some useful ways of dealing with complex places with many elements which required separate assessment and state-ment of value.[56]

We do not consider that a scoring system for significance is appropriate in a statement of significance. Quantification of some type is often necessary, since after all it is essential to judge between elements of varying significance; but assigning values such as on a score of one to five tends to give a misleading impression of objectivity to what is actually a very subjective process. Such a numerical system tends to fossilize the value of a place and its comparative value. But significance is always relative, and is not a fixed property. Unresolved aspects of significance should be identified; hypotheses should not be presented as established fact.

Significance and management
The statement of significance is a summation of the cultural significance of the place. It does not take into account other values or needs of society, or management problems and realities. For instance, a statement of significance for the Golden Mile in Kalgoorlie, may assess it as being of considerable significance as illustrating important themes in nineteenth-century Australian history. This may be indisputable. However, current economics may dictate that open-cut mining is the only viable gold-recovery technique available to present-day miners, and this may necessi-tate the wholesale destruction of earlier mining remains.

In another example, a group of huts in a national park may have some significance in demonstrating or commemorating a past way of life. Their present illegal and substandard occupation by squatters on public land, however, may be an unacceptable management problem, necessitating eviction, and subsequent problems in conserving the huts. In neither of these cases does the fact that an assessment has been done, and a statement of significance produced, prevent the manager or planner from taking unavoidable action, even if it is deleterious to significance. In the final analysis the manager has to weigh cultural significance against other management factors. This is the manager's legitimate role.

The consideration of these conflicting demands should take place, however, during development of management policy, after the establishment of cultural significance. The implications of the statement of cultural significance then becomes one of the various sets of constraints and requirements that the manager has to weigh up in developing the final management policy.

The relevant point is that the manager needs all the information before making a decision—including objective information about significance. In the real world this is sometimes not possible, but it is an important objective. One of the ongoing areas of debate in heritage management arises from attempts by decision makers to elide the concepts of significance and management. That is, decision makers seem to have a strong natural tendency to downplay or simply not recognize the significance of a place, if its ongoing conservation is a problem for some reason. Hence, there is very often strenuous resistance to listing an area on the National Estate register though it is undoubtedly important, because though this has little legal weight it confirms its value and forces some public consideration of it. However, significance assessment should never be undertaken or amended solely to justify management decisions that have already been made. It is far better to have a real assessment of heritage value, and document the reasons for taking damaging action, than to falsify the assessment of significance. Quite apart from intellectual integrity, one reason for this open approach is that there is often a time delay between making a decision and acting upon it. Sometimes circumstances change during that period allowing a reassessment of the management requirements and constraints, but if the assessment of significance is faulty there may be no

basis upon which to develop a management policy less damaging to the values of the place.

Aboriginal sites often do not have a formal statement of significance based on the Burra Charter model, but they usually do have a similar archaeological or anthropological assessment and a summary of their importance in that context.

The next step in the process, in line with the Burra Charter, is the preparation of a conservation policy or management policies, which takes the statement of significance and puts it together logically with other management constraints and opportunities, to come up with a strategy or plan for the management of the place. We will discuss this in the next chapter.

The role of the manager

The manager's role in the assessment of cultural significance is crucial, as will have been deduced from this chapter. The degree of direct involvement of the manager in the process of establishing the significance of a heritage place will vary, both with personal expertise, and with the level of assessment and the type of management planning being undertaken.

The manager's role can be summarized as follows:

- recognition of the need for assessment of significance
- provision for significance assessment as a part of the management planning process
- assessment of resources, expertise and staff input required
- commissioning and/or undertaking significance assessment
- assessment of the adequacy of the assessment and statement of significance.

The manager, in recognizing the need for significance assessment, and providing for it, is ensuring good future management. The employment of appropriate professional assistance is necessary in most cases, especially when the assessment will form the basis for action affecting the place. In these cases the role of the manager is in commissioning the research, overseeing the work, providing local input and expertise, especially with respect to management issues, and in assessing the adequacy of the product.

In real life the manager is often likely to have to adapt the process to suit available resources, management needs, and access to data. Also, managers often have access to a lot of information needed for significance assessment, and through their own or their staff's past work or experience, or through past relevant commissioned research, are actually much more familiar with the elements of significance than any consultant and have insights and knowledge the consultant does not. These in-house resources need to be carefully assessed before paying a consultant to produce what the manager may already have, and may previously have paid for!

For instance, at the Quarantine Station in Sydney Harbour National Park, a great deal of information now exists about the general historic context of the place. It is therefore quite possible for the manager to make intelligent significance assessments about particular parts of the complex, as required for day-to-day management, although the particular building or precinct may not have had a specific statement of significance written about it.

In another case, the general regional distribution, age, research potential of significance of a particular type of archaeological site may be known from previous archaeological field studies. The place in question may be one of fifty hand-stencils sites in a 50-kilometre sandstone escarpment and, from initial inspection, may fall well within the range of the known sites on all the criteria considered in previous studies. In this instance it is relatively simple to produce in-house at least a preliminary significance assessment and statement.

A common situation is for a 'context' to have been established for one type of place in an area being managed (that is, step 4 of Figure 4.1 is developed first). An example may be 'all mining in area A is of historic and research interest due to the presence of a high degree of unusual local technological innovation'. Hence, any place that is a mining site in area A can be automatically judged significant for this reason, without establishing steps 1–3 of the process. If such a place is subsequently threatened by decay or development, steps 1–3 are undertaken to establish if the assumption implicit in the generalized 'contextual' assessment in fact are true for that place. That is, the level of assessment is intensified on an as-needs basis.

Thus, where the general cultural context is known, where past research has been carried out, and/or where the management

staff have a good range of experience, in-house assessment is perfectly reasonable.

Even in circumstances where crucial data is missing and where technical expertise (for example, archaeological or architectural investigation) is required and unavailable, a great deal can often be achieved, in its absence, by the manager and staff carefully undertaking the process laid out above. At the very least it is often possible, cheap and useful to assemble basic data or data sources prior to the employment of a consultant, and such an exercise will also indicate exactly where expertise is required and will eliminate the necessity for paying for unnecessary work. Another alternative is to carry out an in-house study, and to employ a suitable consultant on a retainer to advise and assist.

The more the manager knows about the heritage place, prior to using outside expertise, the more explicit and limited the brief can be, and the more exact and usable the product.

There are many instances of managers finding that the report of the consultants is inferior to that which their own staff could have produced, given time and encouragement, or that only sections of it provide technical data not available in-house. While some areas do need expertise, a lot of significance assessment is common sense and intellectual rigour; both qualities that good managers possess in abundance.

The manager then, in estimating the degree and level of work required for significance assessment of a particular place, should:

- assess the level of assessment required for the management proposed
- review the existing information on the place (data available, past studies, work on referral context, etc.)
- review the experience, expertise and general ability of available staff
- review special technical requirements (for example, archaeological, architectural investigation)

and decide, on this basis, on the appropriate option, which might be:

- small-scale in-house assessment based on review of previous work
- initial research/data collection by the manager and staff, followed by the employment of carefully targeted expertise

- undertaking of the whole process in-house with the employment of an expert adviser on retainer
- employment of consultants for whole process, with relevant supervision and support from the manager.

Finally, whether the assessment is in-house or carried out by consultants, it is important that the manager ensure its adequacy, as a summation of the place's significance.

Asking the following questions might help the manager decide this.

- Was the expertise employed appropriate and sufficient? For example, a nineteenth-century industrial site might need input from a historian—to study archival information and establish historical context—as well as an archaeologist—to study the physical remains. It may be inappropriate for the historian to assess the physical remains or the archaeologist to do the history if they lack the skills.
- Is there evidence of sufficient research to establish significance? Can you find any obvious gaps? The manager of a building, for example, might decide to get an architect to assess in detail changes to the building over time, and the integrity of internal finishes and detailing, recognizing that these elements are not always obvious to the untrained eye, and are vulnerable to damage during conservation works.
- Has the site been considered in a comparative context at a regional, state, or national level, if this is possible and appropriate? For example, an assessment of an Aboriginal rock-engraving site should provide data on other similar sites, their assessed significance, and the resultant comparative significance of this particular site.
- What is the underlying philosophy or assumption employed in the judgement of significance? For example, if a site is assessed as being of archaeological (scientific) significance, on what is this based? Is it based on a good understanding of the place's relevance to important research questions or perhaps on the simplistic criteria that it is a large and well-preserved site? In the case of a building, such as a local post office, has the assessment been based purely on architectural values, or has it included an assessment of local community feeling for the place?

- Have other values, besides the major identified one, been taken into account? For instance, the Alice Springs Telegraph Station (NT) might be assessed as being of importance in the history of the development of communications systems in remote Australia; it may also be important, however, in the recent history of Aborigines in the area, because of the way it affected their lifestyle.

- Does the statement suggest to the manager the implications for management of the site? This question forms the link between assessing significance and determining conservation policy.

Conclusion

It should be clear from this chapter that the adequate assessment of cultural significance of a place is the single most important step in the management planning process, in the sense that if it is not done well the subsequent management decisions may well be inappropriate and destroy the heritage place. It is therefore in the manager's best interest to be totally involved in the assessment process, either as a relevant expert or as an overseer of the work of others. If it is done well, the manager will be confident to move on to the development of management policy, which is the subject of the next chapter.

Some examples of statements of significance

Statements of significance for register citations are usually based on less research than those used as the basis for conservation plans, and as a result are more abbreviated, as the following examples show.

The first two examples are statements of significance for places entered in the Register of the National Estate (RNE statements include reference to the specific criteria under which the place is assessed; these are listed in Chapter 4).

Dawn Fraser Swimming Pool, Balmain, New South Wales:

> The Dawn Fraser Swimming Pool is important for its historic associations with the development of recreational and competitive swimming and water polo in Australia. (Criterion A.4)

It has had particular associations since 1884 with the Balmain Amateur Swimming and Life-Saving Club, the oldest active swimming club in Australia. The pool's name honours the club's most famous member, a winner of gold medals in three Olympic Games, whose swimming career was established at the pool. (Criterion H.1)

This is one of the few surviving tidal public baths which were once common in Sydney Harbour, and it is the only one complete with most of its buildings. These 1904/24 buildings are important for the way they demonstrate the characteristics of early 20th Century public baths. (Criteria B.2 & F.1)

The pool is also of considerable social value as a venue which has been used for sport and recreation by the Balmain community from 1883 to the present. (Criterion G.1)

Arkaya Dreaming—Ilyira-arakata:

This citation, from the Register of the National Estate listing, is for one of a series of fifteen culturally linked but geographically separate places that are part of the Arkaya Dreaming in Central Australia:

The Place forms part of Arkaya, the Kestrel Dreaming. Arkaya is one of the major dreaming tracks of the Lake Eyre Basin. It tells how Kirrki, the Kestrel, hunts down and kills the two Kanmarri, the Rainbow Serpents. It describes how the pursuit of the snakes by the Kestrel forms the geographic landscape of the region. Arkaya, like other Dreamings not only tells of how landscape elements were created, but also sets down for Aboriginal communities the important elements of religious and social life which need to be followed by Aboriginal people.

Ilyira-arakata means 'sand in the mouth' and is the place where the two Kanmarri Snakes got sand in their mouth from travelling underground. Two river red gums, which have now gone, represent the Rainbow Snakes. Despite the fact that these gums are no longer at the place, the locality remains important to Aboriginal people. It has this significance because it forms an important part of Arkaya and thus has social and religious significance to the Aboriginal communities of northern South Australia and the southern Northern Territory. (Criterion G.1)

The Kestrel History links many sites and places to each other and in turn these connected places form what is for the Aboriginal people of the region, a cultural landscape. The telling of how a natural landscape was formed, and in this process transformed into a cultural relationship to the other connected places and to the landscape of which all of these places form a

part, thus tells us about an important feature of the Aboriginal occupation of the region. (Criterion A.4)

The next two statements are from conservation plans.

Woodlands homestead, Victoria

Statement of significance formulated for a conservation plan:

> The essential importance of the homestead building at *Woodlands* is that it is a rare and possibly unique example of a very large portable house imported into Victoria in 1842. Although relatively unsophisticated in terms of its structural system, the house has elements which predominate in later prefabricated building. In terms of social conditions, the house reflects the needs of settlers in the new colony, in which resources were still scarce to be able to build efficiently and cheaply.
>
> The hand painted internal wall decoration of the west wing is unusually rich, and extremely rare if not unique in Victoria.
>
> In terms of setting the homestead is important for its surviving courtyard garden with the earliest recorded European plantings (*Magnolia grandiflora*) and for retaining its rural woodland setting over 150 years.
>
> The homestead is important because of its association with the Greene family, one of the early pioneering families of the Port Phillip District, and with William Croker (1888–1917) and Ben Chaffey (1917–1937) who were both prominent in horse racing and pastoral circles in Victoria. It is unusual in being so well chronicled by Lady Stawell (née Mary Elizabeth Greene) and to a lesser extent by Rolf Boldrewood. [57]

The management policy for this place is presented in Chapter 5.

Laura Aboriginal art and archaeological sites, Queensland:

Significance assessment from a management plan:

> *Social and religious significance for Aboriginal people of the area:*
> * Sites represent a visible link with the past.
> * Sites have been handed down by their ancestors.
> * Sites contain information and provide knowledge about the pre-European past.
> * Sites contain information and provide knowledge about the post-European [historic] past.
> * Sites are of religious and spiritual importance.

* Sites are inseparably tied to the land for which the Aboriginal people feel deep associations both through blood affiliations to country and through custodial responsibility as a result of residence.
* Sites provide a rich and exciting illustration of Aboriginal culture.
* The sites are important to Aboriginal people because they provide a way to present Aboriginal culture to Australian and international visitors.
* Sites are important as a source of income to the people; however, this is secondary to their religious and cultural significance, and the community is very clear about the limits it places upon this aspect.
* Some sites have been identified as being of 'special significance'.

Scientific and research significance:
The art and archaeological sites in the Laura area are important in scientific terms because of:
* the uniqueness of the art,
* the fact that the body of sites forms a discrete concentration of an art style,
* the stylistic variations within the body of art,
* the density of site numbers in comparison to other bodies of art,
* the association of art sites and archaeological sites,
* the antiquity of art and archaeological sites,
* the potential of the art to illuminate the overall prehistory of the area and the potential of the art sites to be interrogated archaeologically,
* the potential for the art to be part of a holistic and multi-disciplinary research approach as demonstrated by Morwood.

The aesthetic significance:
The art offers aesthetic benefit through:
* location of the pictures in the landscape;
* location of the pictures on the rock—the play of form and colour related to rock shape;
* insight into the moment of painting in the very different past;
* insights into Aboriginal culture and belief, stories and myths;
* providing triggers to the imagination about the past;
* appearances in international publications.

It ranks as the most interesting, unusual, dramatic and profoundly beautiful body of rock art in the world.

The significance of the sites to the wider community:
The sites are important as an expression of local Aboriginal cultural identity which can be perceived by the wider community [national and international]. The sites facilitate interaction between the wider community and the Aboriginal community. The sites provide a window onto Aboriginal culture.[58]

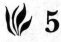 5

Planning for Heritage Place Management

Introduction

Why management plans?

In previous chapters we have looked at the legal framework for the conservation of places and at the principles and practices of location, documentation and assessment of these resources, which are the crucial steps in the management of the places. This chapter will be concerned with the third element of heritage place management: planning for appropriate management policies and practices. The difference between 'management plans' and 'conservation plans' is one of emphasis and extent. The management plan for a heritage place should incorporate what might otherwise be called the conservation plan, but it usually would cover other aspects of the management of the place, especially if it were a large area, that the conservation plan might not. The intention of this book is to enable managers to better understand the nature of heritage value and its conservation, so that conservation is seen as a primary objective of management and is integrated with management planning.

'Management' in this context consists of identifying the range of options available for each heritage place in accordance with its assessed significance, balancing these options with other

considerations, such as the availability of funding and human resources and the potential conflict with other management aims for the same or adjacent land, and then choosing the most appropriate option and pursuing it as management policy. The identification and adoption of such a process is 'management planning', and its elaboration on paper is a 'management plan'. Where conservation is the principal aspect of management of the place, the resulting plan is often called a 'conservation plan'.

Proper management planning is the keystone of effective heritage place management, in that adequate inventory, assessment, and where appropriate, conservation of the resource will not consistently take place without it. The management of cultural resources differs from the management of natural resources, in that cultural resources deteriorate over time, and are not self-regenerating like most elements of natural systems. Hence, management by the exclusion of incompatible uses and the protection from outside damaging influences, which might allow a natural resource to sustain itself, or to regenerate, will not necessarily achieve the conservation of a wide range of cultural resources. They usually require far more positive and active management programmes than a manager might be used to applying to a natural resource.

In the previous chapter, when considering the question of significance assessment we made three points crucial to our consideration of heritage place management.

Firstly, assessment of significance must precede management decisions. We must know the degree and type of cultural significance of the place, or places we are considering before we can make decisions affecting the conservation of a heritage place. The more detailed our assessment of significance, the more confident and detailed our management decisions can be.

Secondly, assessment of significance must be separate from management considerations, which should not influence the results of the assessment process. That is, our knowledge of severe management problems in the conservation of it should not mean that we discount or minimize its significance. The significance of the place should be objectively assessed. This value will then become one of the factors (and hopefully a primary factor) considered in management planning for the place.

Thirdly, and conversely, significance assessment alone does not, and cannot dictate management decisions, which are constrained by a whole range of factors, such as conflicting land-use options, financial considerations, technical conservation problems, or legislative or social concerns. The manager has a clear responsibility to objectively assess significance. Equally, there is a clear responsibility to take other real constraints and considerations into account, and to balance the heritage value of a place with society's other needs. The better the values of the place are understood, however, the greater may be the manager's chances of finding convincing reasons for overcoming management problems in order to achieve conservation.

The designing of a conservation or management policy that considers both the significance of the place and its management constraints is the next step.

In cases where the assessment process outlined in the previous chapter demonstrates a place to be significant, and where it is possible to actively conserve it, a conservation policy will be appropriate. The ICOMOS definition of Conservation Policy states that 'The conservation policy should identify the most appropriate way of caring for the fabric and setting of the place arising out of the statement of significance and other constraints'.[1]

The policy is sometimes called a *management policy,* especially where full conservation of the place is not possible or appropriate, or when conservation is only one of a number of aims in the specific land-management situation. Some potential heritage places may be shown by assessment to have little or no significance. Some places may have considerable significance, but other overriding factors (constraints) may make it impossible to actively conserve them, because, for instance, they may be in the path of a conflicting land use of overwhelming value. In such cases a management policy will need to specify methods of minimizing damage to the place and loss of significance, and ways of salvaging any relevant information that may be lost.

Regardless of whether the full conservation policy approach or some other management policy approach is found to be appropriate, it is essential that the processes outlined in the Burra Charter and its guidelines, and expanded on in Jim Kerr's *Conservation Plan,* are consistently applied to management planning;[2] that is, the separation and sequencing of the three stages—

significance assessment, development of policy, and implementation of a strategy and specific appropriate management practices.

This process, as it applies to heritage place management (that is, where the place is identified as significant and where active conservation is planned), is shown in the idealized flow chart in Figure 5.1.

Levels of management

It will readily be seen that there is a whole range of appropriate management policies, flowing from an assessment of significance and of constraints. The manager is faced with what we might call a management-policy continuum.

At one end of the continuum, we might have a situation in which a place of relatively small or even of considerable significance is located within a proposed inundation area, or an area proposed for a new inner city development. Its conservation is not possible without jeopardizing the proposed land use, which is of considerable importance to the community. The requirement for the proposed land use is judged to outweigh the value to society of the significant place. In this case the appropriate policy might be a full recording and salvage, followed by inundation or removal.

For many heritage places, passive management, at times at the level of almost, but not quite, benign neglect, is all that is required to ensure conservation. Many heritage places of significance may have no above-ground evidence, or that evidence might be of a very robust nature; and even if they might have archaeological deposits (and not all do), there may be little that a manager can do to aid their conservation except ensure that physical damage through erosion, vandalism or disturbing development does not occur. On the other hand, management options can include more active involvement even on those 'featureless' sites, so that while minimal management input is required for conservation of the place, major input might be required for physical protection of the resource, for interpretation, or for the control of leases over the land and conflicting land uses.

An important heritage place, in secure tenure, might deserve elaborate and complex physical conservation and management for public use and enjoyment. A good example is the Aboriginal

Figure 5.1 The planning process

rock art at West Head, in Ku-ring-gai Chase National Park, north of Sydney, which receives many visitors. In such cases, preparation of a formal conservation plan would be appropriate. A place might be so significant that its value would outweigh any proposed competing land use, and indeed the need for active conservation and presentation to the public of such great significance might became a positive requirement placed on management. In some cases it will be the reason a management structure was instigated in the first place.

The range of management options along this continuum is almost infinite. Here are some examples of options commonly in use:

- direct management and conservation by a public authority
- adaptation for management or commercial use
- commercial lease for use and/or conservation
- residential lease for use and/or conservation
- non-disturbance and protection or controlled research of archaeological resources
- stabilization of structures as ruins
- minimal necessary preservation of remote sites
- visitor control (or exclusion)
- management involvement of special interest groups
- abandonment to benign neglect
- active removal of all or part of the fabric of a place.

The selection of the appropriate management option or options within the planning process, as will be seen in what follows, should be based on factors such as the purpose of the dedication and use of the area involved; the appropriate level of conservation entailed, based on the assessment of the significance of the place and assessment of other constraints; the amount and kind of public use; the feasibility of leasing or other uses; and the costs of conservation.

On the whole, the bias in the information and examples given here is towards the most common management situation, where the conservation of the heritage place has to occur on land that also has other values, for nature conservation, scenic protection, forestry or water catchment, as a museum or accommodation for other items of community value, municipal use, recreation, defence-related activities, and so on.

Local practice and styles of management vary so widely in Australia that to offer a definitive recipe would be pointless, so what follows is rather a checklist of factors to consider in management planning for heritage places. You should be wary of applying 'recipes' for management or conservation planning before seriously assessing the relevance of that recipe to your own situation. The mechanisms for undertaking each step in the management planning process, and the format of the final plan, will vary considerably, there being no 'right' approach to suit all circumstances. However, the elements suggested here, and the basic sequence of investigation, assessment and statement of significance, definition of management objectives and constraints, statement of conservation policy and the specification of management practices to be followed, should be incorporated into each management plan for a heritage place, or area containing heritage places. This process can be used to provide management guidelines for an environmental assessment document, or for a conservation plan. In the former case, some heritage places may ultimately be destroyed; in the latter, full-scale active conservation may be the management aim. The process of decision making and planning is the same.

When some of the key steps are not followed, or when they get out of sequence (for example, when a permit to destroy a place is issued prior to the assessment of significance, or to the exploration of other options), poor decision making will result. We emphasize again that it is not possible, or desirable, to save or conserve all heritage places; but because they are scarce and valuable, the manager's concern must be to maximize conservation opportunities, and to mitigate the effects of unavoidable destruction or damage. The management planning process is designed to assist in this aim.

Levels of planning

When we examined significance assessment, we made the point that the context of the heritage place was an important element to be considered. Its place in the physical and cultural landscape must be known before its significance can be fully assessed. The relationship of the place to major historic themes, to regional and local history, and to other places of the same type, need to

be researched, contemplated and understood to enable the explication of the particular place's value.

In part, the confidence with which the manager can devise an appropriate management policy and implement subsequent detailed management decisions depends on the quality and definitiveness of the statement of significance, which, in turn, depends to a considerable extent on the degree to which the historic and regional context is known.

A good example of the provision of a helpful regional context for managers is some work carried out in New South Wales. The National Parks and Wildlife Service (NSW) has undertaken a regional study of rock art, to provide a basic regional context for assessment and management.

The Sydney metropolis contains the largest population concentration in Australia. It also contains more than 3000 recorded engraving and painting sites, and a large area of land dedicated as national parks and other Crown reserves. Those parks containing many of the engravings and paintings are also subject to very high visitation rates.

The Service has undertaken a study of the art of the region, using current data. The aims of the study are to:

- establish the level of data available and its usefulness
- target the areas or sites requiring more detailed analysis
- identify a representative sample of art sites, and determine whether those contained in permanent reserves constitute such a sample
- target other big sites or site complexes for reservation or other legal protection
- identify further research questions
- document information about the significance of sites to Aboriginal communities
- analyse the range and distribution of sites open to the public
- identify a network of sites for display to the public (especially schools) that will provide an accessible and representative interpretive tool.

The work to date has established that the material in the site register (collected over 100 years) is very variable, but with a computer analysis it can be used to deduce a range of basic data to provide some baseline information or representativeness. The

1 Heritage is not just the past, but the present interacting with the
past in the ongoing growth of cultural tradition. The reburial of ancient
Aboriginal skeletal material is part of the present Aboriginal communi-
ty's way of maintaining the traditional respect for the dead, by returning
those who have been disturbed to dignity through burial in a sacred
location in a landscape with spiritual significance. South Coast (NSW)
tribal elders Guboo Ted Thomas and Jack Campbell are shown here
during such a ceremony.

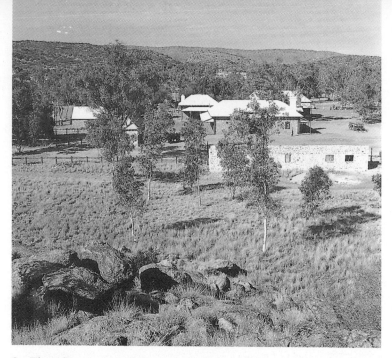

2 The Alice Springs Telegraph Station (NT) operated as part of the Overland Telegraph system from 1872 until 1932. After that date the area became an Aboriginal reserve, and the buildings a home and school for part-Aboriginal children, many of whom were forcibly removed from their families. The place has two histories, but since it became a national park, most of the interpretation has focused on the earlier, non-Aboriginal past.

3 The local history museum at Nowra (NSW) is the former police station. Many local societies occupy similar redundant public buildings or former residences in suburbs and country towns. Planning for conservation in these situations requires the manager to have a good knowledge of the local council planning scheme and development regulations affecting the place.

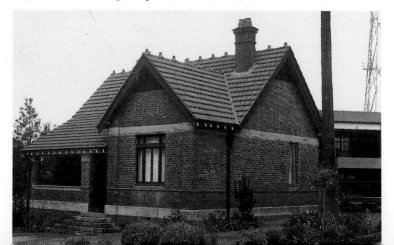

4 An archaeological excavation at a historic site—the Metropolitan Hotel site at Hill End (NSW), an 1870s hotel, the details of which are revealed by excavation of its foundations. Such work can be very productive, but is expensive, and needs to be very carefully planned with clear objectives in mind. 'Treasure hunting' in any guise should not be a part of heritage management.

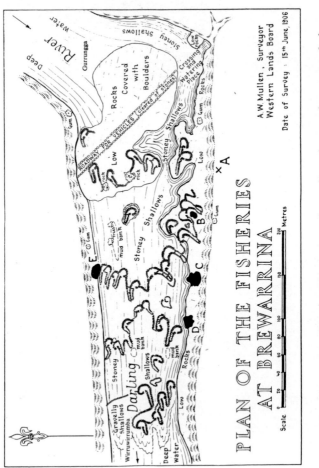

PLAN OF THE FISHERIES
AT BREWARRINA

A.W. Mullen, Surveyor
Western Lands Board

Date of Survey : 15ᵗʰ June, 1906

Scale [0 20 40 60 80 100 200 Metres]

5 One source of valuable information can be earlier plans and surveys of places. Here is a 1906 representation of the fish traps on the Darling River at Brewarrina (NSW), which can be used to show changes to the arrangement of the stone traps since that date.

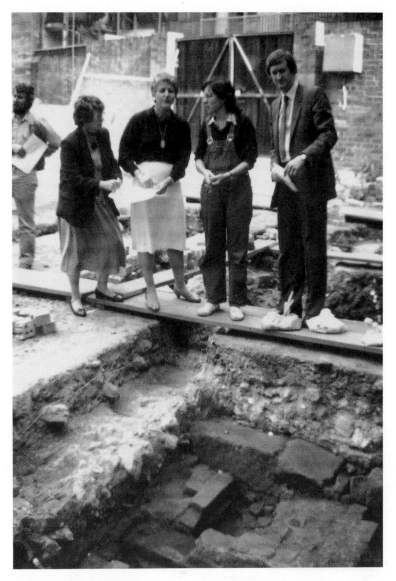

6 The extent of the archaeological remains of the 1788 Government House in Sydney had not been predicted when test excavation started there in the early 1980s. The techniques of archaeology have uncovered the physical record of the growth of the building over nearly sixty years, and revealed a car park to be one of Australia's important historic sites.

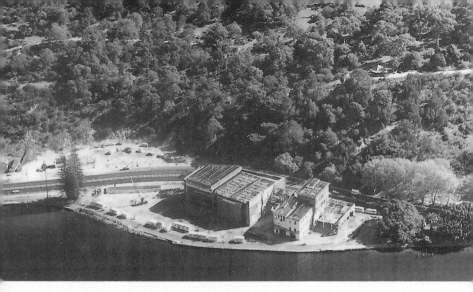

7 The Swan Brewery in Perth (WA) has been assessed as having both great Aboriginal and European historical significance—our methods of comparatively assessing cultural values is as yet only poorly developed, and situations where heritage values actually conflict, as in this case, are difficult to resolve.

8 Managing the surrounds of buildings is as important as managing the buildings themselves. The landscape surrounding the prison buildings on St Helena Island in Moreton Bay (Qld) was historically kept cleared, both for the planting of crops by the convicts and to ensure that the movements of inmates could be observed. An understanding of the historical significance of the landscape is critical in devising a management policy for the place.

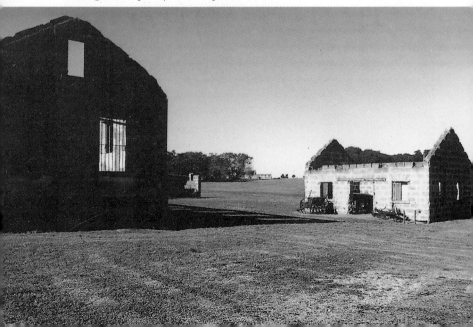

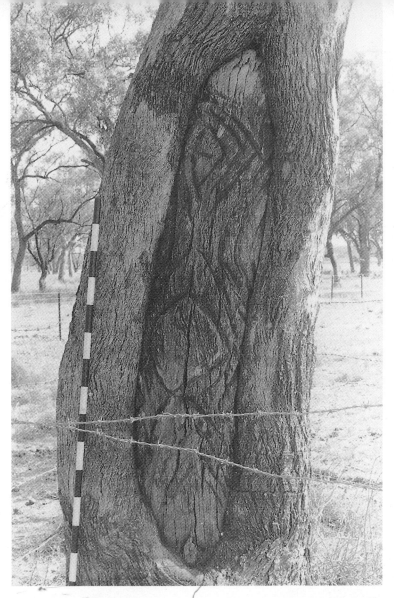

9 A carved tree near Warren (NSW). Such sites have great signifi-
cance to Aboriginal communities, are aesthetically important, and pro-
vide evidence of ceremonial or burial practices. They are of great
interest to visitors, but are very vulnerable to decay, fire and vandalism.
Their assessment and management has to take all of these elements
into account, and give weight appropriately in each circumstance. There
is no 'formula' approach to the assessment and management of such
sites. This tree has been 'managed' by the placement of barbed wire—
neither appropriate nor effective.

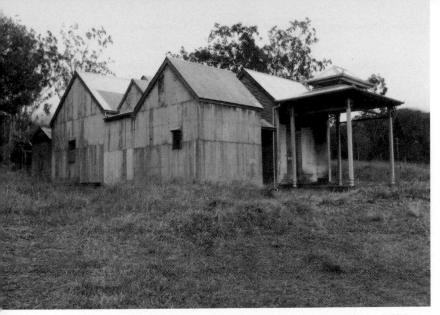

10 Chinese Temple, Atherton (Qld). There are a number of Chinese temples around Australia that are of value to local Chinese communities, but there are many other places associated with Chinese communities that might not be so obvious. Managers should avoid developing stereotyped views of the heritage of other cultures.

11 Ntaria, the former Hermannsburg Mission (NT), was established as a Lutheran mission in 1877, and to a degree provided a refuge where cultural traditions of the Aranda people could survive. It is now owned by the Aboriginal community, and has dual significance in European and Aboriginal history.

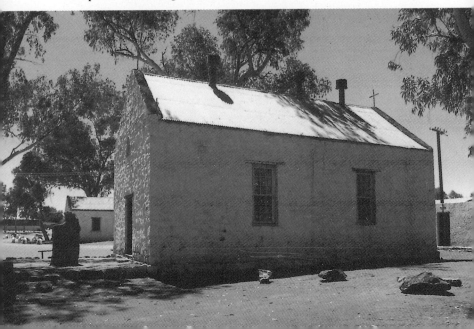

12 A historic landscape: an alluvial goldmining field on the Turon River, near Sofala (NSW), where mining has occurred at various periods from 1851 onwards. Clearly, decisions about land use are critical in ensuring the continued existence of such landscape elements.

13 Post offices, such as this one at Omeo (Vic.), and other public facilities, such as railway stations, are often not designed in a way that allows them to be easily modified to deal with the changing technology of service delivery. Sometimes modification can maintain the significance of both the fabric and the use, but in other situations the building is sold and the use changes. The effect of this on the local community's sense of place is as yet little studied.

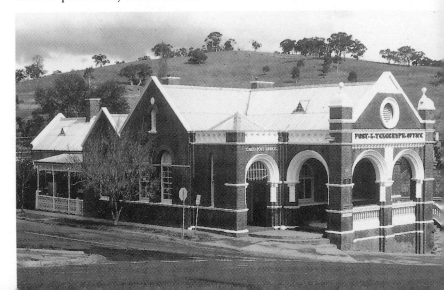

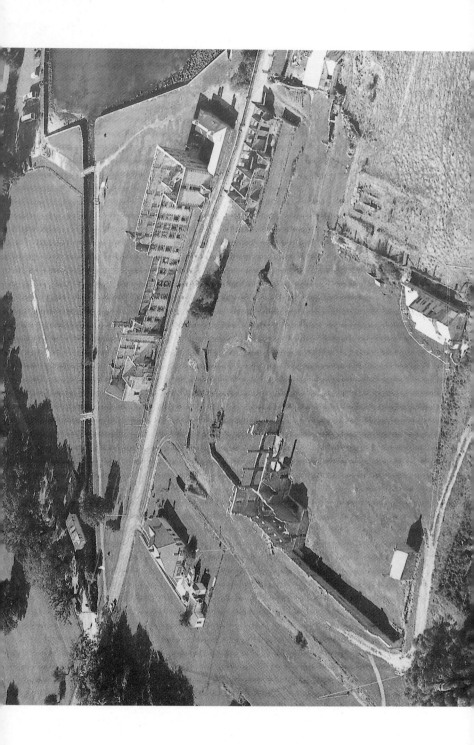

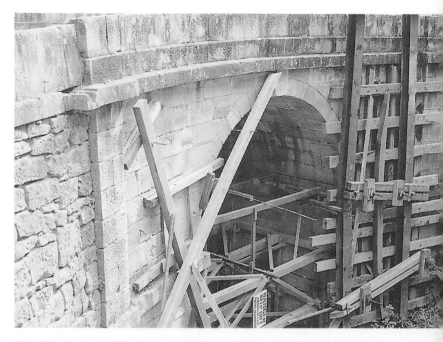

15 Reinforcing of the Lennox Bridge at Lapstone (NSW), in the Blue Mountains, west of Sydney, in the 1970s. The bracing is to hold the stonework together while the fill inside is removed, repair work carried out, and the structure consolidated—a combination of preservation, restoration and reconstruction. Such work is clearly very expensive, and should be based on an understanding of the substantial heritage significance of the place.

14 (*facing page*) Aerial view of part of Port Arthur Historic Site (Tas.). As shown in this view, it is an extensive site with standing buildings, ruins, landscape elements, archaeological sites, and contemporary functions. Each element calls for a different conservation approach, but the whole has to be integrated to retain the heritage significance of the place.

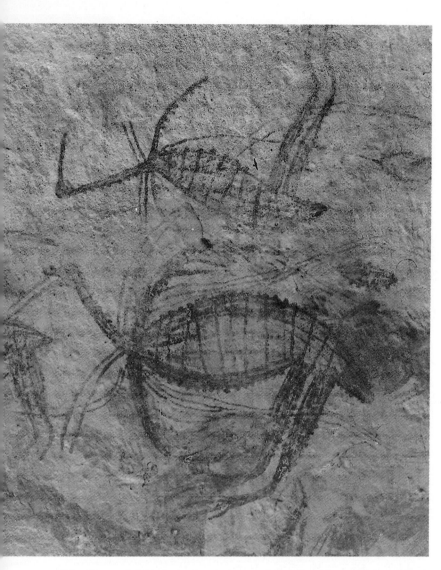

16 'Yam style' birds depicted on a rock face in Kakadu National Park (NT). The management of such sites has to be based on an understanding of and respect for the cultural ownership of the place by the Aboriginal community, and, once that is established, on the particular conservation issues facing the site, assessment of public demand for access and visitor control.

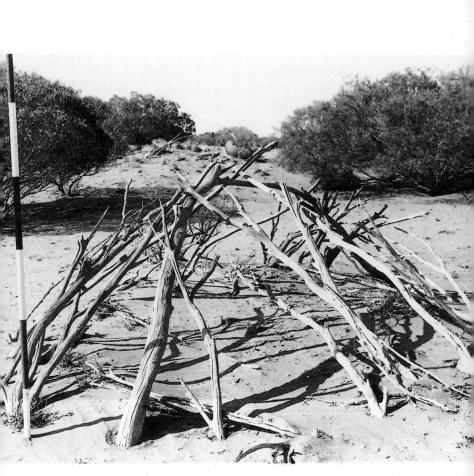

17 Aboriginal bough shelter ('gunyah') in western NSW. Such places
are extremely vulnerable, and extremely rare. It may not be possible
both to conserve them and to allow public access, as they are usually in
very isolated places (hence their survival), are difficult to protect, and
receive minimal day-to-day management.

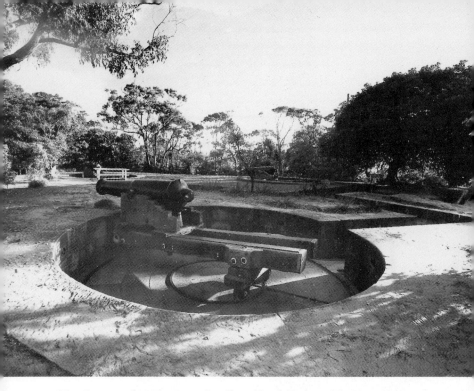

18 Gun emplacements at Bradleys Head, Sydney Harbour National Park. Guns were installed to protect the harbour and the city of Sydney from foreign ships, a defence strategy that relied on having an unobstructed view of the harbour. Today the harbour cannot be seen from the emplacement because of regrowth vegetation. The dilemma for the manager is whether to restore the view by removing bush; and, if so, how much of the surrounding bushland can be removed while preserving its nature-conservation values.

19 (*facing page*) Illustration from the Conservation Plan for Woodlands homestead (Vic.), which exhibits an interesting approach to indicating elements of the place that are of interpretive potential.

What to look for in the house

You have to use your imagination at Woodlands! Unlike Como or Werribee Park, most of the rooms here are not furnished. Almost nothing is known about the furniture at any stage of Woodlands' history. In addition, the original use of some of the rooms is uncertain, and several had different uses over the years. In time, it is hoped to furnish some rooms; others will house displays or reading material.

These notes mostly describe architectural features. Despite the changes made to the house over its 140 year history, many original features can still be seen.

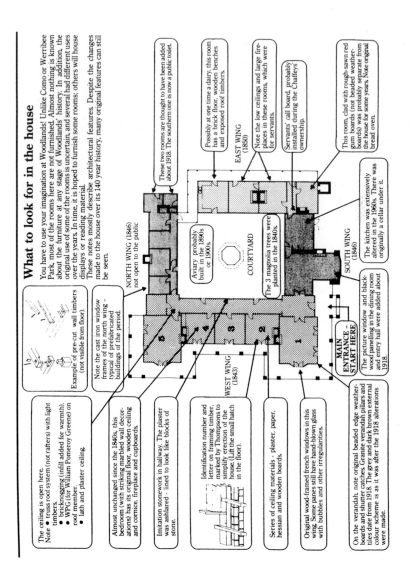

The ceiling is open here.
Note ● truss roof system (not rafters) with light timbers.
● bricknogging (infill added for warmth).
● WPG (for William Pomeroy Greene) on roof member.
● lath and plaster ceiling.

Example of pre-cut wall timbers (not visible from floor).

Note the cast iron window frames of the north wing - typical of prefabricated buildings of the period.

Almost unchanged since the 1840s, this bedroom (with striking marbled wall decorations) has its original floor, wooden ceiling and cornice, fireplace and cupboards.

Imitation stonework in hallway. The plaster was ashlared - lined to look like blocks of stone.

Identification number and letter on framing timber, marked by Thompsons to simplify erection of the house. (Lift the small hatch in the floor).

Series of ceiling materials - plaster, paper, hessian and wooden boards.

Original wood-framed french windows in this wing. Some panes still have hand-blown glass with bubbles and other irregularities.

On the verandah, note original beaded edge weatherboards and shutter catches Granite verandah pillars and tiles date from 1918. The grey and dark brown external colour scheme is as it was after the 1918 alterations were made.

These two rooms are thought to have been added about 1918. The southern one is now a public toilet.

Possibly at one time a dairy, this room has a brick floor, wooden benches and exposed roof timbers.

EAST WING (1850)

Note the low ceilings and large fireplaces in these rooms, which were for servants.

Servants' call board, probably installed during the Chaffeys' ownership.

This room, clad with rough-sawn red gum boards (not beaded weatherboards) was probably separate from the house for some years. Note original bread oven.

NORTH WING (1846) not open to the public

Aviary probably built in the 1890s or 1900s

COURTYARD

The 3 magnolia trees were planted in the 1840s

SOUTH WING (1846)

The kitchen was extensively altered in the 1960s. There was a cellar under it. The house bore original a cellar under it.

WEST WING (1843)

MAIN ENTRANCE - START HERE

The picture window and black-wood wood panelling in the dining room and entry hall were added about 1918.

AWFULISE — AWFULISATION — TO BE AN AWFULISER —

Every night and every day
The awfulisers work away
Awfulising public places,
Favourite things and little graces
Awfulising lovely treasures
Common joys and simple pleasures
Awfulising far and near
The parts of life we held so dear
Democratic, clean and lawful
Awful, awful, awful, awful.

Leunig

20 This cartoon by Michael Leunig expresses the sense of loss and alienation that communities sometimes feel as a result of development and change over which they have no control. The Manager's aim should be to empower the community by involving it in the identification and conservation of its heritage, and not to become another 'awfuliser'.

work reveals clear regional variations within an art corpus that at first glance is homogeneous, evidence of influences from outside the study area, and a close relationship between ethno-graphically-deduced cultural divisions and art sites. In some areas motifs common elsewhere are missing altogether; and techniques and colours vary within the region. The study identifies areas and sites not well sampled, and indicates areas where more detailed study will be promising. It also gives an indication of the art styles now poorly represented because of urban develop-ment. One large and 'important' site, conserved because of its range of motifs and size, appears to be the art site most unlike any others in the area.

This information provides the basis for regional planning for site management. It allows the Service to target key areas of land for acquisition, and to add depth and interest to its interpretation of sites. It forms a basis for planning the opening of further sites to the public. It provides a context for the assessment of signifi-cance and management of particular sites.[3] Another example is the study of goldmining sites in the Castlemaine area in Victoria, aimed at establishing a repeatable set of assessment criteria, and a base study for a whole region using those criteria.[4]

In the absence of this context, detailed management planning becomes more difficult. For example, a manager may need to decide on a management policy for an Aboriginal campsite. If the number of other similar sites in the region and the regional prehistory are known, it is possible to see where this particular place fits in, and to determine its comparative value. It is then possible, for instance, to decide, if necessary, whether a proposed development should be modified to conserve the site. Without this comparative information the manager is really not in a position to make this decision.

The other major elements that the manager needs to consider in devising a management policy are the general management climate, the type and severity of management constraints and the nature of particular management opportunities a place may offer. Once again, the manager can only do this effectively if the state or regional management context is known. That is, the manager needs to know not only the full significance of the place but also the regional management policy relating to such a place. For example, in the case of the Aboriginal place men-tioned above, the manager may need to know not only how

many other such places there are, but what the state or regional policy is about their protection, how many of them are in secure land tenure, how many have been excavated, or interpreted to the public, how many of them are owned by Aborigines, and so on. The manager of a single heritage building needs to know the context of local and regional conservation philosophy, funding assistance, planning schemes, and the range of similar places being conserved, quite apart from understanding the historical and social context of the place.

Ideally, it is also necessary to know the regional land-use policy, planned land use, relevant zoning and other land-use restrictions. This is necessary in order to assess the full range of possible alternatives for the future of the land on which the place is located.

Therefore it is sometimes difficult to devise a conservation or management policy for a particular place in the absence of state or regional heritage planning, because the contextual policy and data is missing. So state and regional planning are very important priorities in heritage conservation. Many states have begun State Heritage Conservation Plans, which are designed along the same lines, with the same general format as that outlined below. Many have not progressed very far. As outlined in Chapter 3, South Australia has come a considerable distance in planning for its historic places. Following a historical overview, regional surveys to locate significant sites have been conducted in about half the state to date. They have been followed by assessment of management options for the range of places, and a statewide interpretation plan, aimed at explicating important themes in South Australian history, through a network of relevant heritage places, is in train.

New South Wales's State Heritage Inventory Program (SHIP) combines a number of elements that contribute towards providing a state and regional context, at least (at this stage) for non-Aboriginal heritage. SHIP incorporates:

- a set of historic themes for the state
- a carefully devised and detailed set of criteria for assessment of heritage value (based on National Estate criteria)
- a programme of regional and local studies, which incorporate regional history and context, and which relate places to the themes and criteria outlined above

- a comprehensive heritage place database (not yet under way)
- a hierarchical set of protection measures, at state or local level, based on a range of legislative and planning provisions.

The approach is now being applied to heritage studies in the state. It provides a context for more detailed heritage studies, and heritage planning within the region.

Regional and local heritage planning is becoming the practice in most states, especially where it is a requirement of environmental planning and assessment legislation. Such planning is in its infancy in Australia, and common problems cited to date include lack of effective and ongoing local involvement, very selective determination of significance, the tendency to 'fossilize' present heritage value, neglect of the Aboriginal heritage, and so on. However, such regional and local plans, regardless of their faults, are invaluable in providing a management context for planning for particular places.

Regional and local land-use planning provides the manager with potentially important tools and goals for heritage place protection. In particular, it is possible in some states to zone land with important heritage value so that this value is recognized and the area is protected from future inappropriate or damaging land use. Hence, an area can be zoned for scenic preservation or historic conservation, and appropriate land-use restrictions applied. It may also be possible, in a local environment plan, to identify areas of potential heritage value (where sufficient survey work has not been done to locate all the Aboriginal sites, for example), and to require further identification work as part of the consideration of any development proposal.

Similarly land-management organizations need an overarching policy and strategy for heritage management. The policy should outline their responsibilities with respect to heritage places, and should identify conservation opportunities and planning needs, and policies and procedures for dealing with specific issues and situations. A forestry authority, for example, is a major land-holder with many Aboriginal sites and historic places within its domain. It carries out many potentially destructive activities (roadmaking, logging, reafforestation, etc.), but also conserves large areas of land (and sites) intact, and offers significant opportunities for recreation and education. Many such authorities (for example, in New South Wales and Tasmania) are

commissioning surveys and management recommendations to guide them in their management of their heritage places. For instance, the New South Wales Forestry Commission has carried out a survey of the types of Aboriginal sites on forest lands, and the Tasmanian Forestry Commission has produced an excellent booklet on Aboriginal site survey and management.[5]

Most national park and other conservation authorities have sets of policies on various relevant issues (see, for instance, New South Wales National Parks and Wildlife Service manual on Aboriginal burials[6]).

Identification of policies, priorities and procedures, and effective land-use planning at a state, regional or organizational level is very important to the local manager for the reasons outlined above. The local manager is not responsible for such planning; but can encourage it, through request and recommendation, especially within the organization, and can take care to note its absence, and the consequences of this, in planning for a particular heritage place.

The management plan

In almost all cases, the following major elements should be included when the manager is preparing a plan for cultural place management. The sequence in which the various elements are presented here differs from that followed by the Burra Charter. This reflects the reality of the management situation in which most heritage place managers find themselves: the management process is based first and foremost on statutory obligation, which may encourage or discourage conservation action. Often the manager's primary task is to find a way to interpret the legislative constraints to allow conservation to occur.

1 Statement of legal responsibility, philosophy and general policy forming the base for the plan

This may be a statutory responsibility at federal, state or local government level, a cabinet directive, or an organizational policy (for example, a local council decision to conserve a pioneer cemetery or a house museum as a council responsibility). Putting the manager's responsibility and general management approach

to heritage places into context provides one baseline for the assessment of the appropriateness and effectiveness of the plan that follows.

2 Description of the heritage place, its assessment and a statement of significance

The necessity for this, and the methodology involved, is described in Chapters 3 and 4. A statement of significance, based on an assessment, is of major importance. If done properly, it will solve some of the decision-making problems commonly encountered in management planning. The actual statement of significance should be comprehensive but succinct—it is not necessary to include all the data that led to the statement, but it must be referred to and be accessible. Indeed, it is counter-productive to produce volumes describing the place. The information should be sufficient to demonstrate the accuracy of the statements of significance, and must be well researched.

The statement of significance as a determining factor
As we have seen, the ideal course of action, based only on the consideration of the significance of the place, is often in conflict with management constraints and limitations. For instance, Cadman's Cottage, the earliest remaining house in inner Sydney, is of undoubted significance, and ideally should be fully restored as a house museum. However, damage to the fabric, because of earlier 'restoration' attempts, and the lack of information required for an authentic house museum, makes such a proposal impossible to fulfil.

Alternatively, assessment of the significance might point to a clear and unequivocal need to conserve the place in a certain way, reducing options for use, interpretation, and other aspects of management. A good example of this is the management-policy decision that the Western Australian Museum recently had to make concerning the Wandjina figures (Aboriginal paintings) in the Kimberley. In their present form these sites have undoubted aesthetic and scientific value, but they also have great significance as part of a living culture. The Aboriginal traditional owners wished to repaint them, to 'freshen them up', as was traditionally done. The Museum is the legal guardian (though not the traditional guardian), and in effect had to decide on

whether this was acceptable management policy. The Museum assessed the situation in detail, and opted for repainting, with safeguards. Their follow-up assessment revealed that the repainting had been well done; but that some of the original art (and hence the previously perceived aesthetic significance) had gone. However, the overriding significance, as an element of a living culture, was conserved.[7] This is an extreme example. In most cases, while management policy may need to limit or restrict some options in line with the statement of significance, ideally it is aimed at the conservation of all elements of significance.

If the heritage place or its significance is incompletely known, additional *survey* and *assessment* will become a major management aim, to be carried out before major management decisions about the resource are put into operation, and the plan must be flexible enough to cope with the future outcome of the assessment of significance. An example of this is the Kosciusko National Park Plan of Management (New South Wales), where procedures were established within the plan for the ongoing identification and assessment of historic places within the park during the life of the plan, and for the application of appropriate zoning and management practices once these places had been assessed as significant.

3 Statement of other values in the management area, and of how the heritage value ranks with them

The importance of the conservation of the heritage place or places compared with other values of the place must be assessed and stated. The need to identify these potentially conflicting values applies as much to individual buildings as it does to large land areas, but we will illustrate the problem as it applies to large areas. Within any large land area the balancing of different values is greatly influenced by the specific purpose for the reservation and management of that area. An example of a water-catchment reserve might illustrate the point. In this management area the primary considerations might be the control and promotion of natural vegetation and the eradication of sources of actual or potential pollution, both of which are designed to conserve water-catchment values. In this context, a nineteenth-century arsenic mine with unstable waste dumps might be in direct conflict with the *primary* management values of the land,

making it very hard to argue for the conservation of the mine and dumps as a historic place. On the other hand, the presence of other historic and Aboriginal places on the same land might not pose a direct threat to the primary objective of management, but their active conservation would probably be given low priority if the management aims for the water-catchment area precluded substantial public visitation and conservation and interpretation-oriented works. However, passive or low-key conservation of heritage places in such circumstances can and should occur.[8]

Managers of large areas of land must guard against becoming too dogmatic in their assessment of the relative value of the land for cultural or natural conservation purposes. In recent years, for example, many national parks managers have reconsidered the old concepts of 'wilderness' and 'natural area' when assessing the zoning of parks, and are now perceiving that many areas previously given these labels in fact have been substantially altered, moulded, or even created by human activity. In this context, to argue for the removal of historic resources, or the non-management of Aboriginal places, on environmental grounds is to ignore the validity of these heritage places in what may be, to a greater or lesser extent, a human-modified environment. It is of far greater benefit to the cause of environmental conservation to explain the relationship of humanity and environment through the balanced conservation of cultural and natural resources than to ignore the cultural, and thereby falsify the interpretation of the natural environment. With the current resurgence of interest in wilderness legislation, it is time for managers, administrators and lawmakers to again address this balancing of perceptions about what is natural and what is cultural in the landscape.

Where heritage place conservation is one of a range of policies being sorted out for an area of land it will be necessary to reflect all the requirements in the final planning scheme. One solution, in this situation, is to allow for different zoning within any given land area, so that heritage places can be zoned for the slightly different management practices necessary to conserve the cultural resource. This might allow for different fire-control measures, variation in the allowable visitor numbers, or different controls over works of all kinds.

However, this balance is sometimes difficult to achieve; and the existence of land-use conflicts is a possible major problem. For instance, the conservation and consequent gentrification of

inner-city terraces, instead of the provision of new, cheaper accommodation or work-generating development, may have significant social consequences. Similarly, a proposal to carry out open-cut coalmining may be of great importance for Australia's balance of payments, but may threaten an important complex of Aboriginal sites.

In these instances, the heritage place manager is usually not the final decision maker, and is certainly not left to come to a considered objective decision via the medium of a management plan. The whole matter (and the manager) is thrust into the social and political arena, and the question of the heritage place's significance and future management becomes only one of a complex of technical economic, social, and political factors. This is part of the process of environmental appraisal, for which, in many states, there are now legislative and administrative frameworks.

Even in these circumstances a thoroughly researched management strategy for the cultural places under dispute, which places their significance and options for their management on record, will be an important first step in achieving the conservation of some or all of the resource.

We discuss such situations in more detail in the next chapter, under the heading Environmental impact procedures and salvage recording.

4 Identification of other requirements, opportunities and constraints placed upon the management of heritage places

The comparison of cultural values with other values for management purposes just discussed can identify one type of constraint upon management in some cases. For example, to say that a polluting mine-waste-dump cannot be tolerated in a water catchment is a serious constraint on conservation and management options for the place. On the other hand, to say that stockmen's huts are a valid part of a 'natural' area because of the role of stock in modifying the environment is to impose a requirement on the manager to fully assess such huts, and not to automatically stipulate their removal. It provides an opportunity for the manager to interpret, say, the interaction of the cultural and natural history of the area to visitors.

Red flaxe!

In many cases a body or organization responsible for the management of the place will have (as pointed out above) certain general objectives of management specified either in legislation or in management or administrative policies. For example, the New South Wales *National Parks and Wildlife Act 1974* specified that in the production of management plans consideration will be given to the 'preservation' of Aboriginal and historic places and relics, and the encouragement and regulation of appropriate use, understanding and enjoyment of the resource (Section 72). The National Parks and Wildlife Service's management policies specify the objective of conserving all significant places as resources for research, vehicles for interpreting history and culture, and as elements in landscapes.

These types of objectives of management clearly identify for the manager the requirements, opportunities and constraints to be addressed and resolved in the management-planning exercise.

Other legislation or government policy can be a constraint or a requirement. For example, the building codes relating to fire protection and health place constraints upon use options for historic buildings. In some states such constraints can be overcome using the powers of the state's heritage Act, or by clever design in the adaptation of a building, but in other instances can be a major constraint on the manager's ability to conserve heritage values.

The legal status of the land may be another limiting factor. In most states one conservation agency is responsible for the management of Aboriginal sites on land of any status, and all such sites are protected legally. However, such authorities usually choose to carry out active conservation work only on land that has secure reserve status, or appropriate zoning, where the long-term survival of the place is guaranteed. Lack of secure tenure is often a constraint, limiting the manager's option for place management. (Methods of securing long-term legal protection are discussed in Chapter 6.)

The needs of the owner, or the managing authority are also important: the manager should 'Investigate needs, aspirations, current proposals, available finances in respect of the place'.[9]

The owner may wish to live in the historic place, and hence it may need some modernization and adaptation. The managing authority—a forestry department, for instance—may need to undertake a logging programme, to provide particular access,

or to meet certain other management needs, which will require adaptation and adjustment to heritage conservation. For example, it may be necessary to complete conservation work within a certain time, or to clearly identify heritage places or to provide special training for forestry workers, so as to avoid damage being done to heritage places in the future.

Financial constraints are also common. There is often simply not enough funding to provide the ideal management solution, and a compromise or an alternative solution has to be found. The adopted policy has to provide long-term as well as short-term solutions to management problems. Hence, ongoing maintenance costs as well as short-term stabilization or restoration must be considered. Lack of assured long-term maintenance funding may be a constraint that renders restoration impractical. However, the inability to commit funds should not be used as excuse not to consider conservation action, as much can be done at little expense, such as identifying and altering potentially damaging uses or maintenance practices. A simple example would be changing the way flower beds around a brick house are watered to reduce splash on walls and relieve a rising-damp problem.

Physical or environmental constraints
Often the place being managed produces its own constraints and requirements because of its physical condition. A significant Aboriginal archaeological deposit being eroded by stream action might require protective works that both alter the natural environment and restrict other management options in fields such as interpretation. In another case, a historic structure might be in such a poor condition that its preservation is technically impossible. Or an Aboriginal art site may be a very important example of its type but may have severe and, with only present technology, irreversible conservation problems, which will mean that it will have a very short life-span as a place that visitors can appreciate. Further, visitors, in fact, may exacerbate the problem.

The setting of the place may also be a constraint. An Aboriginal midden on the headland of a very popular beach or fishing resort will probably be difficult to conserve and interpret, and may be subjected to ongoing unsympathetic treatment if attention is drawn to it. In this case it may be better to stabilize, revegetate and play down its existence; and to find another such

place to interpret to the public. The place may have other management problems, such as extreme isolation, over-use, a high incidence of vandalism, a high fire-risk (for example, a weatherboard building in a forest), or the existence of hostile climatic conditions or other natural threats (for example, beach or river bank erosion near middens). These problems should all be identified, and methods of avoiding or resolving the threat or problem investigated.

Factors such as these will often influence the management or conservation policy. In cases where it is possible to choose (their significance being equal), the place with the least practical and physical problems is clearly the one to select first for active management. Hence, the manager must investigate not only a site's significance, but its long-term manageability and stability.

This is not meant as a recommendation to manage only those sites that are in good condition and have no major management problems. The importance of conserving very significant places, regardless of their condition, has already been mentioned. It might be that a decision has been made to retain examples of a range of sites, and the only example of part of that range under the manager's control is in poor condition or has other problems. The decision to actively conserve the place in question then relates back to its importance in the original conservation sampling strategy. In another case, the very fact that a place is in bad condition (particularly in the case of a ruined building) may be a major factor in its appeal to the public. This might be seen as an opportunity rather than a constraint. In this case it is the selection of the appropriate conservation option, stabilization or preservation as a ruin, that will ensure the retention of the place's public significance.

Appropriate use
Establishing an appropriate use for a heritage place is a critical issue to be resolved during the development of management policy.

Places of cultural significance may be still in use; or they may be reused for their original purpose, or for an adapted purpose. The management policy for the place should determine whether a particular use is compatible, and, if a range of compatible uses exist, decide which uses actively contribute to an understanding of the place's heritage value.

In the case of the Mint and Hyde Park Barracks, both early nineteenth-century buildings in Sydney of great historical value, the uses were determined before the places were properly assessed. It was decided to make the complex a museum for the display of important collections from the Museum of Applied Arts and Sciences. Many now think that the modern museum function is inappropriate to buildings as historically, archaeologically and architecturally significant as these are. The new use necessitated the installation of massive air-conditioning and modern services into what was essentially original early nineteenth-century fabric. In the process the majority of the archaeological resource has been destroyed and the architectural and historical integrity of the places jeopardized. The use of the Hyde Park Barracks has recently been reassessed because of the manifest inappropriateness of the initial decision, resulting in a much more sympathetic interpretation of the place.[10]

On the other hand, the conversion of the old Parliament building in Adelaide into the Constitution Museum is seen by most to be an extremely appropriate use for the building. The adaptation of the place to interpret its earlier significance in the political and constitutional development of the state has been highly successful.

A more prosaic example might be a nineteenth-century slab cottage, which is proposed to be conserved as the headquarters of the local historical society. It may therefore need new kitchen and toilet facilities. This may be acceptable, but if the place's major significance is as a simple nineteenth-century vernacular building, illustrating the early pioneering life style, such adaptation may jeopardize this value. In this case, the provision of new services in a new and separate building might reduce the impact of the adapted use on the old building. If this solution were chosen, of course, care would have to be taken to locate and design any new buildings in a way that did not detract from the slab hut's visual values, or any archaeological remains in the vicinity.

For very many sites the only appropriate use is sympathetic interpretation. Aboriginal sites (art sites or middens, for instance) in south-eastern Australia can rarely be used or adapted except for Aboriginal, or general public, education and enjoyment. In some cases, the actual use will be simply reservation, conserving the sites for the future, with no active present use.

This is appropriate where, for instance, the place is a representative sample of a type of place, with research potential.

The manager should bear in mind that there is a distinction to be made between 'compatible use' and 'most appropriate use'. The compatible use is one that will not damage the place or cultural significance of a place, while a most appropriate use will be one that is not only compatible but will actually reinforce and maximize the understanding of the cultural significance of a place. As an example, a nineteenth-century joinery shop, with intact steam-engine-driven line-shafts and lathes, might be adapted for use as a restaurant. This might be a 'compatible use', as the physical evidence of the joinery machinery could be incorporated into an evocative public area. However, a 'most appropriate use' would be to use it as a timber-craft workshop, making joinery by traditional means. This use would give the machinery an operating use, and visitors would be better able to understand the work practices of the nineteenth-century workshop than would be the case were the machinery simply static in a restaurant.

In some situations the traditional use of a place (which may be a continuous use) may be a major component of the place's significance, and the most appropriate use in such cases is clearly to ensure that the traditional use is revived or is allowed to continue.

In some instances, even though the most appropriate use is clear, the manager will be unable to implement it because the proposed use may not be economically viable. Changing technologies have affected the viability of many traditional uses, so that while continuing that use makes good conservation sense it is not feasible to do so. Such a dilemma has faced managers of places as diverse in use as banks, post offices, and many types of industrial sites. A classic example is given in the case of churches, as this quote shows:

> For many historic churches, new uses must be found to ensure their survival. Financially bereft, the churches nonetheless retain an intense symbolic significance, and the question of an appropriate new use is a vexing one for their owners. Use by another denomination, or for a community purpose such as a library, sports hall, or day-care centre, are generally favoured, although private residence or even commercial purposes are tolerated. The case of Ballarat's Baptist Church

illustrates the problem. Its conversion into a strobe-lit disco,
its sunken baptismal font now a fish tank, stimulated the
suggestion that it might have been better to lose the building
than subject it to such indignity.[11]

The main consideration in the manager's mind when deciding
possible uses for a place is to ensure that the use chosen is
compatible with the significance of the place, that it is the most
appropriate possible use for that place and will be sustainable
economically and able to be managed effectively.

The management climate—community needs and expectations
It is very important for the manager to be aware of local opinion,
and to take local views into account. Research into these views,
and involvement of locals in advice and input, are essential
prerequisites in determining management policy.

At times in the course of the planning process there are issues,
usually concerned with management options, that to a greater
or lesser extent are a matter of public concern .

In some cases it is worthwhile putting different points of view
about management issues into a 'public issues document', which
is circulated widely, or just to special-interest groups, well before
the draft plan is completed. In this way, public response can be
properly assessed before making a final commitment to a man-
agement policy. This process ensures public participation in the
planning exercise and in the policy development, and it can
enable the manager to modify or reassess proposals before
committing them to draft plan stage, thereby simplifying any
amendment process the plan may have to undergo.

Community pressure groups can affect the manager's or the
government's views. At times, public hostility to some manage-
ment objectives or practices will alter the manager's approach.
Indeed, this is the very reason why the public display of draft
statutory plans is so often specified. At other times the 'open'
approach is simply not available to the manager. For example,
some constraints and requirements might not be spelt out in a
management plan for privacy, political or community reasons.
Sometimes an owner's needs or government policy and directive
are not as open as might be wished, and might affect a plan
without being clearly identified. While this is a reality known to
all managers, it should never be used unnecessarily as a smoke
screen to avoid open discussion of a planning process. As we

stressed in the last chapter, the involvement of the local community in the planning process is essential, if the plan is to be a success, and the more open and self-explanatory the planning process is, the easier it is to work through issues and problems.

In some situations joint management between the authority and those traditionally associated with the heritage place is appropriate. Thus Uluru and Kakadu National Parks are owned by local Aboriginal groups, are leased back to the Parks Service, and are run by way of joint management agreement. The NSW National Parks and Wildlife Service leases a historic place to the Tweed Heads Aboriginal Community, who run a visitor's centre and conduct guided tours. If appropriate, such arrangement should be considered as part of the management policy.

Present and projected visitor-use patterns
The place's visitor catchment, visitor-number trends, visitor needs and wishes, and the place's potential tourist market, are important considerations in the preparation of a management policy. It may be that present numbers are unacceptably high, or that the best way of conserving the site is to encourage a certain type of visitation.

Comparative information
In considering management options for a heritage place, information about the conservation or management of similar places is often helpful. The same problems and constraints may have been encountered before, and effective solutions (or mistakes to be avoided) may be documented.

5 Formulation of a conservation or management policy

Once this information has been gathered and assessed, the manager is in a position to formulate a conservation or management policy, or to assess such a policy if it is being formulated by a consultant or specialist. (In some planning processes, the identification of management policy is given other names. It might, for example, be called 'management objectives'.)

Such a policy determines how the cultural significance of the place, identified by the statement of significance, may best be conserved (or if this is not possible, how the impact of damage or destruction might best be mitigated) in the short and long

term, taking into account the particular constraints, problems, opportunities and circumstances relating to the place.

The policy will specify the most appropriate use, compatible with the significance of the place, and identify the best options for physical conservation, interpretation, visitor use, and ongoing management and maintenance, or for mitigation or salvage.

The policy should clearly state the options available and the way in which the implementation of the management policy will or will not
(a) change the place including its setting;
(b) affect its significance;
(c) affect the locality and its amenity;
(d) affect the client owner and user;
(e) affect others involved.[12]

It is easy to blandly describe the requirements for a management or conservation policy. Achieving a successful and workable policy that will effectively maximize the conservation opportunities for the place is often a complex and multifaceted task, requiring technical expertise, sound judgement, practical common sense, lateral thinking and adaptability.

The policy cannot be achieved by a recipe, or simply hiring an appropriate expert. It requires the attention and management skill of the manager and the commitment of the organization or authority responsible for the management of the place.

To fulfil its aim, the policy must, among other things,

- articulate the implications of the statement of significance
- be able to be implemented by the owner/authority who controls the place
- pay due attention to the needs and desires of the community, and especially those with a special interest in the place
- be financially feasible and economically viable
- be technically feasible and appropriate
- provide a long-term management framework
- be sufficiently flexible to allow review, improvement or alteration.

6 Management strategy or implementation plan

The management strategy or implementation plan should put the conservation or management policy into practice by pre-

scribing specific management practices. The strategy may outline personnel, resources, management structure and technical requirements, and may detail the timing and sequence of particular conservation or management actions. Such planning is, of course, essential for management, but the degree to which it is specified will vary with circumstances. The following set of headings gives a range of management practices that might be considered in planning exercises. Not all would necessarily be appropriate for any one heritage place, nor is the list exhaustive. Details of some specific management practices are discussed in the next two chapters. When the manager is actually designing the management practices it is important to strike a balance between too little detail ('Historical features in the park will be protected') and too much ('Every archaeological site in the area will be located and recorded on form 266, by 10 April 1995, by Ranger Jones').

Headings for management practices

1 Recording/assessment/research
In most cases the database is imperfectly known; a continuing data-gathering and assessment programme is required (all the Kosciusko huts have been found, but not all the Aboriginal sites in Kakadu; the historic house may have been assessed by an architect but the garden may not have been studied for its plant species and landscape values). Special provision for a survey of sensitive areas before any proposed modification begins may also be required.

2 Maintenance and updating of records of the resource
This is an associated practice to point 1.

3 Appropriate conservation works
This may be preservation, reconstruction, restoration, adaptation, or it may be (and most often is) a combination of these processes.

4 Physical protection
The necessity and appropriateness of such measures as fences, grids, signs, damaging animal or insect eradication, special fire-control measures, need to be considered.

5 Control of impinging development or potentially conflicting management practices
Control could be achieved by provision of a buffer zone; alteration of normal management practices (for example, rerouting a fire trail, preserving exotic vegetation or animals, or relocating a car park away from sensitive features); special care with possible disturbance of sub-surface deposits.

6 Control of research
Research that physically affects a place can be useful, but it is sometimes inappropriate or poorly designed and/or destructive.

7 Visitor-use/interpretation practices
Appropriate level of visitor use and the main aim of any interpretation programme must be determined, as well as determining the use that will be made of visitors' books, interpretative material, guided tours, restrictions on opening hours, and permit systems, and consideration of facilities and access.

8 Salvage procedures
If removal or destruction of heritage places is to be allowed in some circumstances, these circumstances must be defined, and provision must be made for salvage and recording. This may include detailed recording, excavation, and collection of artefacts.

9 Curation of movable artefacts
Artefacts from the place being managed may need managing *in situ,* or collection or removal for safekeeping or for display or interpretation. Consider standards of curation and documentation.[13]

10 Arrangement of ongoing consultation with, and/or involvement of particular relevant groups
It will usually be necessary, in the case of Aboriginal sites, to consult frequently with the local Aboriginal community concerning management of the sites. Often joint-management agreements are worked out between the manager and the traditional owners; this may be an important factor to be considered. In some situations such arrangements are made with other special-interest groups. The local community is always a relevant group for consultation.

11 Maintenance of the place
Any maintenance, especially of buildings, should be referred to in the plan. Regardless of the conservation strategy applied to a structure, the built fabric will decay over time without regular maintenance. A schedule for maintenance can be the most efficient way of ensuring long-term conservation.

Provision for review

Planning is an iterative process. Management planning is not a one-off exercise. The process producing the actual written plan is, of course, more important than the document itself, as is the follow-up action that actually implements the plan. In this process it will rapidly become apparent that the management prescriptions will require constant review, update and alteration as new information comes to hand, the management climate changes, and new techniques and opportunities arise. It is essential that any planning process has within it the mechanism for ongoing review and improvement. (Such review, as we have seen in Chapter 4 may be as necessary for the assessment of significance as for the prescribed management practices.)

The manager and the plan

Many technically brilliant and meticulously researched plans for physical conservation or ongoing management are never implemented. One important reason is that they are inappropriate for the management environment in which they are supposed to operate. The simplicity and logic of the planning process itself is self-evident. Its only real contribution (and the reason it is so easily adaptable) is usually that it pulls together, strengthens, and adds to present local planning principles and practices. The secret of successful management is to develop a plan that suits the long-term needs and abilities of local management, and responds to the multiple values a place may have.

There is a belief, especially in Western society, that there is a technical solution for every problem, and that the key to management problems is to employ complex new methods and major resource input. In fact, 'high-tech' solutions often do not endure.

Even more noticeable to the objective observer is the fact that they are often not targeted to the most pressing and simplest of problems. The case of Australian rock-art conservation perhaps provides a good example. This body of art is probably the greatest and largest in the world. Many high-tech solutions for its conservation have been proposed. It is certainly true that the art is on an unstable medium and is threatened by natural elements over time. Complete prevention of natural weathering is almost impossible, and many of the proposed solutions are intensive (with a 5–10-year lead time), site specific, and too costly for most conservation authorities. In their effort to discover and document this state of affairs, researchers have proposed extravagant schemes. However, many overlooked another obvious point—most of the damage was occurring, dramatically and irrevocably, as a result of the actions of non-managed or poorly managed visitors. It proved relatively easy, and 'low tech', to study their behaviour and to devise methods (for example, better-defined walking routes and psychological barriers such as rope rails) that resulted in the alteration of their on-site behaviour. Often the simplest and most obvious management techniques are overlooked, although they return the largest conservation bonus, with the simplest solutions and technology.

One of the common problems of managers writing and commissioning plans is their inability to actually complete them. The plan is 'in preparation' or 'in final draft' for years, but never really promulgated and implemented. This is because the manager is faced with a complex and interconnecting jigsaw of problems—some not solvable in the short run, and many for which we cannot presently see the solutions because we must take other preliminary steps first.

A plan, to be successful, needs to move in small, discernible steps from the known to the new—from the present situation to incremental change for the better. Management strategy development is iterative and gradual. Because of this, physical conservation measures and other interventions need to be an integral part of management planning, and will not succeed if they get too far ahead of this process, in terms of available technical or logistical support and follow-through.

It follows from this that a 'perfect' plan, which instantly identifies and solves all the major problems of the site, is unrealistic and unattainable, despite pressure from organizations and other

managers to achieve such an end. The process of planning, and the steps in which it takes place, must be used as a discipline; but, equally, its use and adaptation to fit local outlooks, philosophy and management environment are crucial.

If the plan does not have the commitment or ownership of the manager and the key players in decision making and resource provision for the site, it will not succeed. It therefore follows that the manager must be intimately involved in the processes of managing the development of the plan. Experts to carry out research, to advise on technical matters, etc., are usually essential, but the manager must oversee the planning process, and must play a significant role in decision making at the key points of the plan's development—the manager must understand enough to be convinced by the statement of significance, and must be a prime mover in the shaping of the management policy and strategies. Likewise, for key decision makers—the staff, the regional manager, the local stakeholders, the main local or regional politicians, must all be involved. This can be done in a number of ways, depending on need, resources and time. Ideally a discussion group or workshop(s) can be held to work through key issues. As an example, with the assistance of local staff such a workshop could conduct a 'SWOT analysis' of the site and its management.

A SWOT analysis is an analysis of the strengths and weaknesses, and consequently the opportunities and threats, of the management environment at the place. Manager and workshop could look in some detail at budgets and staffing, visitor numbers and physical problems, local political support and government policy, to establish, in a realistic way, the management situation, and what, in this situation, would be a reasonable and useful plan.

From this, the group will be able to look at significant threats (for example, local levels of pollution) and opportunities (for example, the possibility of a changed pricing policy for visitors). A real advantage of such an exercise is that it brings home to the key people the real situation at the place, and perhaps they can then provide vital support in its improvement. In any case, one outcome should be that the manager has the support of the stakeholders in planning to implement solutions.

Actively involving the stakeholders in a real way in the planning process is often difficult, but it is crucial. It is not good

management to allow unguided group decision making, or unacceptable compromises; but, on the other hand, it is probably more advantageous to achieve an initial workable, if partial, solution to a problem, than to come up with a technically perfect solution that is not supported. This pulling together of the key people is one of the crucial roles of managers; and one in which they should be competent and skilled.

Consultation with the wider community is also a part of this process. As we have already said, sometimes the production of an 'issues document' or similar, or a public display period, is useful. Sometimes a much greater effort than this is needed. A more practical and ongoing set of consultation measures is necessary, especially in dealing with indigenous and minority groups.

Perhaps it will be useful for you to think about what genuine consultation is not:

• Consultation is *not* a formal letter enclosing the draft plan and seeking comment within 30 days.

• Consultation is *not* finding the nearest indigenous or local person who might be associated with the site, and expecting that person to decide its future.

• Consultation is *not* pestering the community until they finally agree with proposals.

• Consultation is *not* sending off an uninterpreted technical or research report and expecting lay people to understand it.

• Consultation is *not* meeting the community only when you want agreement or another favour, and paying no attention to the community's ongoing cultural needs and concerns.

Consultation should be an ongoing process—the establishment of a good working relationship with the community. It should begin as early as possible in any planning exercise, so that the exercise becomes a joint venture, with a real opportunity for the incorporation of indigenous views.

• Consultation must be conducted at the pace of the community, not the researcher. This will cost time and money.

• Consultation is most successful when it is carried out by people from the community. Ongoing effective consultation means the employment and training of members of the community

by the authority concerned, and their appointment to responsible, decision-making positions. Academics and researchers need special skills and training to explain their view of a place's significance, and to appreciate other views and beliefs.

- Consultants must have a commitment to accepting the consequences of consultation even if the community rejects the major thrust of the proposal.

A major problem to be faced every day is that conservation planning never takes place in the ideal situation that allows us to contemplate cultural value divorced from proposed use, or to carry out regional assessment prior to site assessment. In the real world cultural conservation planning is carried out in a crisis situation, relating to visitor pressure, to political agendas, and to ongoing social disruption and disempowerment. The key to operating in this environment is to find the most realistic and authentic solution to a complex and exciting problem.

Some examples of conservation policies

The following policies are extracts from conservation plans.

Gellibrand Hill Park, and Woodlands Homestead, Victoria:

Management Objectives:

Landscape
To restore and manage the landscape of the Park to reflect the landscape as it was in the 1840s at the beginning of European settlement.

Natural flora and fauna values
To protect/reintroduce the native flora and fauna that is believed to have occurred in the open grassy woodland communities around the 1840s.

Historic and cultural values
To protect, maintain and interpret the remnant European and Aboriginal cultural sites in the Park.

Land use
To develop an integrated pattern of uses reflecting the 1840s European pastoral settlement and land use theme, and, where appropriate, the cultural and environmental changes experienced since that period.

Recreation and Interpretation
To provide opportunities for rewarding experiences that make the best use of the attributes of the Park; that is, Woodlands Homestead Complex, the unique woodland setting and the rich cultural and natural history of the Park.

Community Education
To provide opportunities to study a range of environmental and cultural themes in Australian studies which are portrayed by the changes and developments which have taken place within the area included in the Park, since the 1840s.

Management
To effectively manage Gellibrand Hill Park as an entity, consistent with its natural and cultural heritage values and significance.

To develop a unifying identity and concise, integrated image of Gellibrand Hill Park and to successfully promote the Park.

To encourage developments and uses which enhance the financial viability of Gellibrand Hill Park consistent with its theme, unique values and desired visitor experiences.[14]

Admiralty House, Sydney:

A slightly different approach is that taken in the Conservation Policy for Admiralty House in Sydney, reflecting a different management arrangement where conservation was not the principle objective in the management of the property:

1. That the property continue to be used as the official residence in Sydney of the Governor-General of the Commonwealth of Australia.

2. That the statement of significance set out [previously in this Plan] be accepted as one of the bases for future planning.

3. That the future conservation and development of the place be carried out in accordance with the principles of the *Charter for the Conservation of Places of Cultural Significance* (Burra Charter) . . . and that any further revision of the Burra Charter be considered for adoption in place of the 1981 version.

4. That the approach and options recommended for the conservation of specific elements or qualities of the place [outlined elsewhere in this Plan] be endorsed as a guide to future work, the recommendations having been based on the principles of the Burra Charter.

5. That Admiralty House, being a place on the Register of the National Estate, the obligations set out in Section 30 of the Australian Heritage Commission Act, 1975, be complied with by the Department of Housing and Construction on its own behalf as well as on behalf of the Office of the Official Secretary to the Governor-General.

6. That a clear structure showing responsibility for the care of the fabric be set out and made available to all persons involved and that this practice be continued in any future management rearrangement.

7. That every five years this conservation plan be reviewed and, where necessary, amended by the Department of Housing and Construction in consultation with the Office of the Official Secretary to the Governor-General and the Australian Heritage Commission, and that the first review be completed by August 1993.[15]

Laura Aboriginal art and archaeological sites, Queensland:

A plan for a complex of sites of major significance, particularly to the Aboriginal community .

Four long-term objectives are identified:

A. To preserve and care for the land and for the sites in the Laura/Maytown/Musgrave region for our kids and their kids.

B. To control access to sites because they are part of the living Aboriginal culture and religious heritage.

C. To share Aboriginal culture with the wider world to show that we care for the culture and so that other people can learn about Aboriginal culture, and so that visitors can respect and not damage them.

D. To use land and sites for economic and Aboriginal community benefit.[16]

A range of specific strategies to achieve these objectives then follows.

 6

Implementing Heritage Place Management

Conservation Processes and Practices

Once the manager has determined the management policy for a heritage place, it is necessary to devise a strategy for implementing the policy. This strategy makes use of a number of management practices, and requires the resolution of specific management issues and problems, which are the subject of this chapter.

These discussions are not exhaustive. Rather they are intended to indicate the range of matters managers commonly have to deal with in planning for heritage place management, in day-to-day management activities, or in the oversight of consultants' activities, and to indicate where further information can be obtained.

Using legal protection for active conservation

In many, if not most, cases managers will be dealing with a resource that is already protected in some way by legal controls. These legal controls might apply to the land upon which the presence of the place is only incidental, or might apply specifically to the Aboriginal or historic place itself. However, there are many situations where this may not be the case, and where the manager is dealing with freehold land. In these circumstances one way of guarding against possible management problems is

to arrange for secure legal protection for the place. If a decision has been made that a place is important enough to be conserved and managed by an active conservation and/or interpretation programme, it is most important, as a first priority, to provide for its secure legal status to reduce future land-use conflict.

In Chapter 2 we outlined a number of legal and planning mechanisms that might be available to the manager seeking to enhance the legal protection of heritage places.

The suitability of a particular type of legal protection depends on the management proposal. Acquisition by the state allows full control, but clearly has financial and other resource implications. Permanent conservation orders, zoning and covenants confer only limited power to manage and control a site. On the other hand, they can be ideal if the aim is to encourage management by the land owner. Some heritage legislation encourages private ownership and use, with a system of grants and rebates for up-keep, coupled with restraining covenants and agreements. This works especially well for historic places still in their original use, or with an existing use compatible with the place's significance.

An example of a situation in which a manager might seek direct acquisition of a historic place is where the place is directly related to other sites already being managed. If, say, the manager has direct control over a place such as a mine, but the associated processing works is still in private hands, the full conservation and interpretation of the significance of the mine may only be achieved if the associated processing works is also conserved. This could be achieved by acquisition and adding the works area to the land management unit; in some states the same result could be achieved by covenant, agreement or conservation order, often applied under a different piece of legislation than the one under which the manager operates. In many cases this will require close liaison with the body actually protecting the new site to ensure that compatible management is achieved. In most situations it would also require a close liaison with the landowner to be a successful management solution.

In another example the manager might wish to add a historic place to a management area, partly for heritage conservation reasons but also to solve other management problems. A case in point is the addition of the Great North Road, an 1830s convict-built road north of Sydney, to Dharug National Park. The road was of recognized significance and was being badly damaged by

excessive four-wheel-drive use. As the road formed one boundary of the park, it was also giving access for the same road-users to fragile sections of the park, and was seen by the managers as a major access problem. The gazettal of the road as an extension to the park solved the two problems; by allowing closure of the road to traffic it removed a major threat to the heritage place and ensured its active management, and it also gave the manager direct control over the perceived access problem. Management planning for the heritage place then proceeded, leading towards its conservation with foot access only. Alternative routes were offered to four-wheel drivers.

Physical conservation: some principles and issues

As we discussed in the last chapter, decisions about heritage place management are dependent on a wide range of factors, including the degree of significance, and management opportunities and constraints. One of the management options is physical conservation. Some form of physical intervention or conservation will be appropriate at most significant heritage places of some stage. Most heritage places are subject to decay and ultimately to destruction by the processes of natural weathering or human activity, and so may require stabilization or restoration. In other cases adaptation to new uses or physical protection from overuse may be necessary.

Conservation as destruction

The principles governing the processes of physical intervention are contained in the Burra Charter,[1] sections of which have been quoted throughout this book.

ICOMOS was set up in response to a demonstrated need to define principles and standards for the physical conservation of places. The need for such standards was quite clear. Even in circumstances where the decision had been made to conserve a place, there were numerous examples of well-meant efforts at conservation which, in fact, destroyed the cultural significance of the place being 'conserved'. This arose not only from lack of technical know-how—the application of harmful techniques—but also from a fundamental lack of understanding of the aim of

the exercise. This was often because the cultural significance of a place had not been properly assessed, or because that significance had been ignored by the practitioner who actually carried out the conservation.

One example of this is the Aboriginal rock-engraving site at Bondi, in Sydney, which looks mysteriously fresh, with smooth, bevelled outlines of sharks and other figures. The mystery is explained by the brass plaque in the centre, which explains that it is 'regrooved by Waverly Council'. It could be argued that this is an improvement on the original, but the point is that it no longer is the original, merely a replica on the same site, its cultural significance largely destroyed. This is a case where physical 'conservation' effectively destroyed the site; whereas, if nothing had been done, it would still be there, albeit with the grooves getting a little shallower over time.

There are many other examples of over-enthusiastic conservation measures, whereby the historic fabric is replaced, often unnecessarily, leaving a pretty replica rather than a historic place. Often it is a progressive erosion of the original, rather than a planned blitz. It can start with the replacement of 'rotten' window frames, followed by the removal of the roofing iron to be replaced by 'authentic' shingle, the stripping of old paint to allow repainting in 'original' colours, the installation of 'appropriate' furnishings and interior decoration, and the planting of a cottage garden.

Often the problem might arise out of ignorance, lack of expertise, or poor professional practice. Australia is littered with such examples.

Because physical conservation is often a key management strategy for important sites, and because it is potentially one of the most destructive of management activities, particular care must be taken in its implementation. The conservation plan is specifically designed to ensure that the physical conservation solution for a significant place is appropriate, and professionally and effectively implemented.

Form and fabric

Richard Mackay, a Sydney archaeologist, has made a useful distinction between 'form' and 'fabric' in significance assessment and physical conservation:

In considering the interpretation of significant fabric it is necessary to draw a distinction between significant form and significant fabric. In referring to significant form the example of an historic timber bridge is cited. In the 1980s it may look the same as when it was constructed in the 1880s. However in the meantime traditional maintenance procedures would probably have resulted in the replacement several times over of every single timber member of the bridge fabric. This has major implications for proposed conservation work as it is clearly the conceptualisation and the design of the bridge which must be retained, rather than any particular member.

At the other end of the scale an example such as the cannon from the Sirius which now stands in Macquarie Place, Sydney epitomizes the concept of significant fabric. The cannon which one may go and touch in 1988 is exactly the same fabric which Captain Phillip would have touched in 1788. It therefore has additional and direct historical associations which evoke an intimacy or emotional response from the beholder. A cast replica, no matter how beautifully crafted would not be the same.

In between these two extremes fall the majority of built items of cultural heritage, particularly buildings. In developing conservation policies and interpretive programs it should be stressed that planners must be cognisant of whether it is the form or the fabric which is important as this will be a decisive factor in policies to be adopted (it can of course be both).[2]

This distinction is central to many conservation debates, and should be addressed in the development of the conservation policy, and again be borne in mind when developing the implementation strategy.

A further issue for consideration is the situation where the significance resides neither in the form nor the fabric but in the spirit of the place. That is, it is not its material elements at all that make the place significant, it is the essence or emanation of the place itself. This we understand with respect to some of the Aboriginal sites we have discussed earlier. It is also an issue in managing the places whose cultural origins are different from the comparatively materialistic concerns of our modern Western society.

The Burra Charter lays great stress upon sensitive physical conservation aimed at preserving significant elements that relate

to the place's past. However, this emphasis is not always the automatic outcome of a significance assessment. The process of significance assessment may reveal that the main value of the object is architectural, and that it requires stabilization or restoration, in Burra Charter terms. On the other hand, the main value of the item may be its significance as a living spiritual or symbolic icon, which gains its significance by ongoing use, change and development. C. Wei and A. Aass, speaking of the logical conservation policy for monuments that have such value in China, state:

> Consequently, in the field of the conservation of monuments such as Qufu, the Forbidden City or Cheng De, the allowing of continuous repairs or even rebuilding all respect this concentration on the spirit of the original monument. Although the physical form may change, the spirit and purpose of the original is not only preserved as a continuity, but can be enhanced through the contributions of succeeding generations.[3]

Such a decision will depend very much on the value(s) that the particular society gives to the place, which may, in turn, dictate some unexpected management options, including ongoing traditional use, a change in custodianship, non-intervention, or ongoing renewal and rebuilding. However, here we will address in most detail the situation facing most managers—an endangered and significant fabric.

Conservation principles and the Burra Charter

The principles and processes governing a conservation plan are the same as those for a management plan (previously discussed). In this section, using the Burra Charter, we review those principles with specific relevance to physical conservation, and discuss the appropriateness of various physical conservation options.

The Burra Charter (Article 1.3) defines fabric as 'all the physical material of the place'. It includes, for instance, the actual buildings at historic places, their contents, the associated archaeological deposits, rock shelters and the paintings within them, mine shafts and poppet heads, historic plantings, old fencelines, earthworks, roads, sacred rocks or other landscape elements. In planning for physical conservation, a major consid-

eration is the state of the fabric, its significance, completeness, state of preservation and permanence. Prior to the development of a conservation policy, research must be conducted to determine these factors, and the effect of any proposed physical conservation measures on them.

This seems all rather daunting. How does the manager direct such work? Article 4 of the Burra Charter suggests that

> *Conservation* should make use of all the disciplines which can contribute to the study and safeguarding of a *place*. Techniques employed should be traditional but in some circumstances they may be modern ones for which a firm scientific basis exists and which have been supported by a body of experience.

Conservation techniques should be carefully researched before application. 'Traditional' techniques are appropriate in the restoration or reconstruction of buildings or structures (for example, replacing cedar joinery or carved stone work), but more modern techniques can often be used to advantage, especially to stabilize a site, and when adapting a place for new uses. A good example of a modern technique to conserve building fabric is the use of epoxy resins to reinforce white-ant-eaten timbers, so as to retain the original fabric and form, and not to have to remove fabric to replace rotted members. Erosion control, stone conservation, or insect eradication should be carried out by the most up-to-date and well-tested methods available. The methods must not be experimental, and their application requires the manager to seek relevant professional practitioners. Rock-art conservation makes very common use of modern techniques: the installation of 'drip lines', treatment for salt-weathering, graffiti removal, etc.

As discussed in the previous chapter, the use of the place may have the capacity to affect the cultural significance of the place, either directly or by the physical conservation/alteration measures that it demands. The Burra Charter stresses that any new uses must be compatible, and a measure of compatibility includes assessing what changes a new use will entail, and if that is acceptable.

Physical conservation or alteration of the fabric for an adaptive use is only appropriate where that use and the consequently necessary physical intervention will conserve the cultural significance.

Age means wrinkles and dignity

Article 3 of the Burra Charter states that '*Conservation* is based on a respect for the existing *fabric* and should involve the least possible physical intervention. It should not distort the evidence provided by the *fabric.*'

The original Venice Charter of International ICOMOS points out that 'The valid contributions of all periods to the building of a monument must be respected, since unity of style is not the aim of a restoration'. Additions and alterations to a place are evidence of its history and use, and their removal is a serious matter that can only be justified by the far greater significance of the fabric being revealed by such action.

Often what people value most about a place is its 'oldness' and historical quality—an 'untouched' atmosphere. Often, also, the original fabric and environment is part of the historic or scientific importance of the place. The least possible physical intervention is therefore not only the most elegant and cheapest solution, but the one most likely to preserve the cultural significance. In the case of an Aboriginal art site, simple protective techniques, such as drip-lines and insect control, are better than the erection of a building or other structure to protect the site— if they will do an adequate job. The minimum requirement should always be the preferred option.

The setting is often part of the place, and in such cases should not be altered.

> *Conservation* requires the maintenance of an appropriate visual setting, e.g., form, scale, colour, texture and materials. No new construction, demolition or modification which would adversely affect the settings should be allowed. Environmental intrusions which adversely affect appreciation or enjoyment of the *place* should be excluded. (Burra Charter, Article 8)

This clause may apply to any heritage place, but it is particularly relevant to cultural landscapes, streetscapes and townscapes. The erection of a power line, or a tall, unsympathetic building, may severely affect the cultural significance of the place without physically altering it. In some cases where revegetation has occurred around a place, the traditional setting of which was cleared, careful thought has to be given as to whether reclearing of the vegetation will make the significance of the place more

understandable to visitors. Clearing around gun emplacements in Sydney, Hobart and Adelaide would be examples of this. In some cases vegetation totally obscures the harbour the gun emplacements defended, and hence understanding their significance is difficult. In other situations, such as a very early shale-oil refinery site in Wollomi National Park in New South Wales, the revegetation could be seen as symbolizing the transient nature of the industry, and starkly indicating the environment the refinery displaced. In more recently vacated industrial sites, such as the Tasmanian Railway Workshops in Launceston, the temptation to introduce 'softening' plantings of trees into a stark industrial landscape should be resisted, as general tree-planting would destroy the industrial character of the place.

Aboriginal sites, in particular, are very closely related to the environment in which they exist. This integrity is important for the Aboriginal custodians, since in many cases the site itself is only a marker in a sacred landscape. Even in the case of non-sacred sites, places such as rock shelters where people lived, the setting is crucial in experiencing and understanding the place, and its significance. In some instances the surrounding vegetation and topography is of research significance.

The interconnection of location and the works of humanity
If the setting is important to the place, the physical presence of the human artefacts themselves is even more important. Article 9 of the Burra Charter stresses that 'A building or work should remain in its historical location. The moving of all or part of a building or work is unacceptable unless this is the sole means of ensuring its survival.'

An article on this point in the Venice Charter states that 'a monument is inseparable from the history to which it bears witness and forms the setting in which it occurs'. Rarely will the cultural significance of a site or place survive if it is moved from the setting in which it was created. Cutting out and moving Aboriginal rock engravings, and resetting them, even in land-scaped surroundings, is an absolute last resort, and is not to be recommended. The art is an integral part of the rock outcrop and its setting—its cultural significance is largely destroyed by its removal from this setting.

The explanatory note accompanying the Burra Charter points out that some structures were designed to be readily removable,

or already have a history of previous moves (for example, pre-fabricated dwellings and poppet-heads at mines). Provided that such a structure does not have a strong association with its present site, its removal may be considered. Such action should not be to the detriment of any place of cultural significance, including the place in which the object is relocated.

Another aspect of the physical evidence that constitutes a place is the portable objects associated with it: 'The removal of contents which form part of the *cultural significance* of the *place* is unacceptable unless it is the sole means of ensuring their security and *preservation*. Such contents must be returned should changed circumstances make this practicable.' (Burra Charter, Article 10)

Removal of original furniture, industrial equipment or other contents of a place is undesirable in most circumstances, and detracts from the significance of the place. Managers, through ignorance, sometimes overlook the contents of places. Special security and other measures are at times necessary to ensure the protection of a place's contents. On the other hand, in some cases (for example, at archaeological sites) it is necessary to remove contents that form part of the cultural significance for research purposes to determine initially, or in more detail, what the cultural significance is. For instance, in research at Kakadu National Park sites have been excavated to obtain dates and cultural sequences in order to produce a prehistory of the area. (See the section on control of research in this chapter.)

Conservation is for the future, not for the opening day
Often the manager will find a solution to these challenges that looks great in the short term. However, Article 2 of the Charter reminds us that 'The aim of *conservation* is to retain the *cultural significance* of a *place* and must include provision for its security, its *maintenance* and its future.'

A consideration often overlooked is the necessity to provide for the long-term conservation of the place. A once-off restoration may have an effective life-span of five years. Part of the strategy must be to build in requirements and effective management arrangements to provide for the future physical and general care of the place.

A study of Aboriginal carved trees in New South Wales was commissioned by the National Parks and Wildlife Service, with

funding from the Australian Heritage Commission. A conservator inspected and treated all the trees, and initially recommended that a conservator carry out the same work on an annual basis. This was not a management possibility, because of lack of guaranteed funding. However, it was, possible to simplify and rank in order of importance the ongoing treatment required, so that most of it could be carried out by local staff.

Burra principles in summary
A conservation policy should meet the following criteria for conservation action:

• The proposed use should be appropriate to the significance of the place, and should not require physical intervention that would jeopardize that significance.
• Any conservation action should respect the statement of significance, and should aim at retaining or enhancing all the elements of the place's cultural significance.
• The proposed action should deal in a realistic way with the constraints posed by the fabric, by costs, and by technical problems.
• The setting and contents of the place, as well as its fabric, should be assessed, considered, respected and, if appropriate, conserved.
• As a general rule, the least possible physical intervention is the best policy.
• Provision should be made for effective ongoing, long-term management of the place.

Conservation processes

Physical conservation can mean anything from elaborate and expensive work to restore a building, to simple protective measures, such as cutting fire-breaks or stabilizing erosion at archaeological sites or continuing to use and maintain a building. Whatever the extent or method of conservation, the same basic principles apply. It is crucial that the manager is intelligently aware of these principles, and able to apply them when arranging for conservation measures. The Burra Charter distinguishes a range of possible conservation actions:

Conservation means all the processes of looking after a place so as to retain its *cultural significance*. It includes maintenance and may according to circumstances include *preservation, restoration, reconstruction* and *adaptation* and will be commonly a combination of more than one of these. (Article 1.4)

Maintenance means the continuous protective care of the *fabric*, contents and setting of a *place*, and is to be distinguished from repair. Repair involves *restoration* or *reconstruction* and it should be treated accordingly. (Article 1.5)

Preservation means maintaining the *fabric* of a *place* in its existing state and retarding deterioration. (Article 1.6)

Restoration means returning the EXISTING *fabric* of a *place* to a known earlier state by removing accretions or by re-assembling existing components without the introduction of new material. (Article 1.7)

Reconstruction means returning a *place* as nearly as possible to a known earlier state and is distinguished by the introduction of materials (new or old) into the *fabric*. This is not to be confused with either recreation or conjectural reconstruction which are outside the scope of this Charter. (Article 1.8)

Adaptation means modifying a *place* to suit proposed compatible uses. (Article 1.9)

Compatible use means a use which involves no change to the culturally significant *fabric*, changes which are substantially reversible, or changes which require a minimal impact. (Article 1.10)

These clauses outline the options open to the specialist or manager in conserving a place. Which one, or which mixture, will be appropriate in order to maintain the cultural significance will depend on the circumstances.

These definitions are explained further in an explanatory note to the Charter. If we take the example of roof gutters, the distinction would be:

Maintenance—regular inspection and cleaning of gutters.

Preservation—continued maintenance in existing form, and treatment to stabilize the gutter in that form.

Restoration—returning of dislodged gutters to their place.

Reconstruction—replacing decayed gutters with the same form of gutter.

Adaptation—replacing decayed or missing gutters with modern gutter forms in keeping with a new compatible use.

In the case of an Aboriginal rock painting, the distinction would be:

Maintenance—regular inspection of painting and brushing away of dust.

Preservation—continued maintenance in existing form and treatment to stabilize the painting in that form, perhaps by diverting water away from it by means of an adjacent drip-line.

Restoration—returning of paint and rock fragments to their place on the painting (not a very practical or possible action at present).

Reconstruction—repainting or respraying the painting with the same type of ochre, and the same brush technique to repaint the same picture as the original.

Adaptation—replacing, or painting over the art, with another type of paint, to produce a different figure (determined by the traditional owner) or placement of walkways, signs, for public use.

In the case of Aboriginal site conservation, reconstruction and adaptation are appropriate choices for managers only in special circumstances.

Before discussing these options in more detail, we should make two general points. In many cases, conservation of any one place will require a mixture of some or all of these processes. Any one place may have some elements preserved, some restored and some reconstructed. It is also clear that people often confuse this terminology—hence the frequent broad use of the term 'restoration'—and that some of these processes would be most inappropriate at some heritage places. The Burra Charter suggests some guidelines for selecting an appropriate mixture of processes.

Maintenance, as defined above, is a benign, non-invasive continuous protective care. It means sweeping and dusting, cleaning and oiling, polishing and gardening. Though, in the long run, the fabric will be affected by maintenance (water will wear away a stone), maintenance essentially means caring for the place, to maintain it, without altering it by preservation techniques, restoration or reconstruction.

Preservation

Preservation is aimed, essentially, at maintaining a place as it now is. We might take as examples the ruins of a nineteenth-century mining town, or a weathered Aboriginal rock engraving or carved tree. In the case of the ruins of a mining town, preservation is to take steps to prevent further deterioration, but not rebuilding the buildings; in the case of an art site it is to take steps to prevent the art fading further, but not repainting or touching it up, or trying to reconstruct the original surroundings. Preservation simply means taking steps to maintain the status quo.

It is appropriate where the cultural significance would be diminished by any higher degree of intervention, where the present state of the site is itself significant, where there is insufficient information or resources to restore or reconstruct the place, or where sufficient well-restored examples already exist.

In many cases the cultural significance of a place would be diminished by restoration or reconstruction. A major cultural value of an archaeological deposit is its research potential. The attempt to restore elements of such a site to their former positions, or to reconstruct them, would often harm this significance by destroying other valuable evidence. For instance, replacing scattered stone artefacts, which have dislodged from an occupation deposit in a cave and fallen down the slope, would confuse the stratigraphy now existing and may damage the research potential. Reconstruction of such a site, even if we have enough information to undertake it, would do more damage. Ruins of buildings may themselves have acquired the patina of age and character that contribute to their cultural significance and popular appeal. The ruins at Port Arthur (Tasmania) are felt by many to have a value in their present state that restoration would spoil.

Ancient places are widely considered to represent a way of life that is 'past' and 'other'. There is an excitement about seeing the original, even if it is faded or eroded, which restoration or reconstruction would spoil. There is also the feeling that Europeans have no right to 'restore' Aboriginal places. In any case there is often insufficient information about the original site—rock art, for instance—to allow for restoration or reconstruction.

At the 'roasting pits' at Hill End Historic Site (NSW) the details of construction and function of the oldest gold-crusher in Australia are not known; so the existing ruins are stabilized. There is no attempt to restore or reconstruct them, because it is not known how they were. (See D. J. Mulvaney[4] for a discussion of the valuing of ruins, and L. Maynard[5] on the ethics of restoring rock art.) On the other hand, a different argument may prevail where the place is still part of a living culture (see below for a discussion on this point).

Similarly, for reasons discussed in Chapter 4, because of its research value the preservation of ancient Aboriginal skeletal material could in some cases be viewed as an artificial intervention, and as one that was contrary to the wishes of those originally associated with the person, and possibly offensive to present-day Aborigines.

Preservation may be appropriate when another example of a similar site has been restored or reconstructed. Many colonial homesteads have been restored or reconstructed—preservation of other examples allows the display of the evolution of such a building, in contrast to an often-idealized view of nineteenth-century grand living presented by restorations or reconstructions.

In our culture it is difficult to envisage a situation where maintenance or preservation is inappropriate or would diminish the cultural significance of a place. A possible example might be the artificial maintenance of a place whose cultural significance rested in its gradual decay. In Aboriginal society sometimes the gunyah and possessions of a dead person are left to decay, and are considered too dangerous to enter or use. Maintenance or preservation of such a place, say as a living museum, might be offensive to the Aboriginal group who knew of its origins.

The belief in the value of original fabric, the need for maintenance, and a perception of the potential damage done by over-zealous 'restoration' is not new. One of the influential voices speaking out against the excesses of the Gothic revival in the Victorian era was John Ruskin. In his *Seven Lamps of Architecture* (published in 1849) Ruskin attacks restoration. In Burra Charter terms we would read restoration, reconstruction, and adaptation for Ruskin's 'restoration'. He wrote:

> Neither by the public, nor by those who have the care of public monuments, is the true meaning of the word restoration understood. It means the most total destruction

which a building can suffer: a destruction out of which no remnants can be gathered; a destruction accompanied with false description of the things destroyed . . . And as for direct and simple copying, it is palpably impossible. What copying can there be of surfaces that have been worn half an inch down? The whole finish of the work was in the half inch that is gone; if you attempt to restore that finish, you do it conjecturally; if you copy what is left, granting fidelity to be possible (and what care, or watchfulness, or cost can secure it?), how is the new work better than the old? There was yet in the old some life, some mysterious suggestion of what it had been, and of what it had lost; some sweetness in the gentle lines which rain and sun had wrought. There can be none in the brute hardness of the new carving . . .

But, it is said, there may come a necessity for restoration! Granted. Look the necessity full in the face, and understand it on its own terms. It is a necessity for destruction . . . And look that necessity in the face before it comes, and you may prevent it . . . Take proper care of your monuments, and you will not need to restore them. A few sheets of lead put in time upon the roof, a few dead leaves and sticks swept in time out of a water course, will save both roof and walls from ruin. Watch an old building with an anxious care; guard it as best you may, and at any cost from every influence of dilapidation. Count its stones as you would jewels of a crown; set watches about it as if at the gates of a besieged city; bind it together with iron where it loosens; stay it with timber where it declines; do not care about the unsightliness of the aid; better a crutch than a lost limb; and do this tenderly, and reverently, and continually, and many a generation will still be born and pass away beneath its shadow.[6]

Restoration

Restoration is appropriate only if there is sufficient evidence of an earlier state of the fabric, and only if returning the fabric to that state reveals the cultural significance of the place (Burra Charter, Article 13). It should reveal anew culturally significant aspects of the place. It is based on respect for all the physical, documentary and other evidence, and stops at the point where conjecture begins (Article 14). Restoration is limited to the reassembling of displaced components or removal of accretions (Article 15).

Restoration is narrowly defined in the Burra Charter. It means only the process of putting back parts of the fabric that without the use of new material have been displaced or removing additions not judged to be significant. The examples given earlier make the distinction clear. If applied literally in fact there would be very few cases of restoration of places in Australia—all involve an element of reconstruction in terms of these guidelines. Even using new nails to put the guttering back would be reconstruction in Burra terms rather than restoration. Most practitioners use a more liberal definition of restoration that allows the introduction of some new material (for example, repainting a building in its original colour). Restoration is often taken to mean returning a place to some prior state where this does not necessitate major alteration of the fabric.

In terms of the ICOMOS definitions, most places that are not just preserved have elements of both restoration and reconstruction.

It may be inappropriate to restore a site or place if evidence of cultural importance is removed to do so. For instance at Throsby Park, a nineteenth-century homestead complex in New South Wales, it has been decided not to remove the 'accretion' of later additions to the original house, because it is considered that the history of growth of the house as a family home is itself significant, and would be destroyed by the restoration. In other words, it would jeopardize the cultural significance of the site. It may also be inappropriate to remove the most recent part of an Aboriginal occupation deposit to expose and interpret an earlier section (technically 'restoring' the earlier period): this would depend on the assessment of significance.

Reconstruction

Reconstruction is appropriate only where a place is incomplete through damage or alteration, and where it is necessary for its survival or where it reveals the cultural significance of the place as a whole (Burra Charter, Article 17). Reconstruction is limited to the completion of a depleted entity, and should not constitute the majority of the fabric of a place (Article 18). It is limited to the reproduction of fabric the form of which is known from physical and/or documentary evidence. It should be identifiable on close inspection as being new work (Article 19).

Reconstruction is what has occurred at most conservation projects on historic buildings to date, together with varying degrees of adaptation. In most cases of building conservation it may be necessary to replace guttering, roofing, structural members, plumbing, and so on.

Reconstruction of historic buildings brings the conservation architect into full flower, and care must be taken to ensure that, while sufficient work is done to reveal the significance of the building, the architect does not become so creative as to have the architectural bad manners to attempt to improve on the original. The question is, as ever, whether the proposed action will conserve or reveal the cultural significance of the place, or whether it will simply create an architectural gem. It is easy, in these circumstances, to swamp historic or social significance completely so that it is the 'restoration' that people come to view, the modern architect's creation, rather than to understand and appreciate the place itself.

While there are cases where reconstruction is considered inappropriate, it is often appropriate for purposes of interpretation or conservation of the place. This will depend on the nature of the cultural significance. It is very important to note that this definition does not cover conjectural reconstruction, which is rarely appropriate. By conjectural reconstruction we mean reconstruction based on guesswork with little or no evidence—for example, rebuilding a building when only its foundations remain, in what is believed to have been the style of the time. This gives a misleading impression, and usually destroys the cultural significance of the place. Often, education of the public about the incomplete existing and preserved cultural remains is more appropriate than reconstruction, and is also cheaper.

After the footings of the first Government House were found in Sydney, an early proposal was to 'restore' (that is, reconstruct) a replica on the original site, using the excavated footings, and historical drawings as evidence. This would have been unacceptable, not only because it was conjectural but also because it would destroy the value and significance of the remaining original fabric. The footings and exterior views of the building gave no indication of the details of construction, internal layout, detailing or finishes. All would have been educated guesses.

If there is a strong community wish for reconstruction, but also a danger of its inappropriateness destroying the cultural

significance of existing remains, another alternative is to reconstruct the work elsewhere—that is, not on the original site. The cave paintings in France are duplicated for visitors, and so is Old Sydney Town, and the gold fields of Victoria (Sovereign Hill).

As already mentioned, there is ample evidence that Aborigines repainted art sites, and regrooved rock engraving in the past, and in some areas this 'reconstruction' is still a living tradition. In this case, repainting of a site by Aborigines may conflict with the value placed upon the present fabric by researchers and the general public. Here, as in other such situations, a policy based on the assessment of the various significant values of the place will dictate the appropriate course of action.[7]

Adaptation

Adaptation is acceptable where the conservation of the place cannot otherwise be achieved, and where the adaptation does not substantially detract from its cultural significance (Burra Charter, Article 20). Adaptation must be limited to that which is essential to establishing a compatible use for the place (Articles 6, 7, 21). Fabric of cultural significance unavoidably removed in the process of adaptation must be kept safely to enable its future reinstatement (Article 22).

Adaptation is the process of modifying a place to allow for its renewed use, either as originally planned, or for a new, compatible use. This is often the only way the conservation of a place can be achieved. A historic inn may be best used as an inn, even if this means some alterations to bring it up to acceptable modern standards—it may be that this will best preserve its cultural significance. In this case and others (for example, post offices) the historical use may be a major part of the place's cultural significance. It may be appropriate in such cases to allow minor modifications that permit continued traditional use, even if an alternative new use might mean less modification. It comes down again to what is significant about the place. Similarly, if a new use can be found for a place that is currently vacant—as a museum, craft centre or study centre, for example—there are clear advantages, provided that such use does not detract from the cultural significance (see above, the example of the initial adaptation of the Hyde Park Barracks Building). To be pragmatic, it is not possible to simply conserve all historic sites without

finding a continued or new use, and many of them can best be conserved by such use. Examples of adaptation are the installation of new plumbing, electricity, amenities or interpretive facilities. Many Aboriginal places are adapted for visitor use. Originally perhaps dwelling places or manufacturing sites, they are now stabilized, protected, signposted and advertised as places where visitors can be educated and informed. In other cases (for example, with sacred sites) this would be totally inappropriate. The central issue to address in considering adaptation is whether it is the best option for the conservation of the cultural significance of the place.

Preservation, restoration, reconstruction and adaptation can all be valid conservation methods, taking account of the problems outlined above. While the conservation strategy for a particular place will involve elements of more than one, one of these approaches will often be the dominant, overall aim that can summarize the conservation policy of the place.

Conservation practices

Knowing what you have

> Work on a place must be preceded by professionally prepared studies of the physical, documentary and other evidence, and the existing fabric recorded before any disturbance of the place. (Burra Charter, Article 23)

This principle is most important. It is crucial to fully record a site or place before any work begins on it. The recording of such information is essential to establishing the cultural significance of the place and acts as a 'before intervention' database against which future works can be monitored. It is a safeguard against mistakes, and an aid to later study and interpretation. For instance, it is good practice to carry out detailed recordings of Aboriginal art sites before European graffiti is removed. The graffiti may itself be of later interest; the recording will also serve as a check on the work, and as a monitor of the future state of the site. Similarly, detailed recordings of archaeological sites and 'as found' drawings of buildings are good conservation practice.

Physical intervention at a place is covered by Article 25, which states that study of a place by any intervention in the fabric or by archaeological excavation should be undertaken where necessary to provide data essential for decisions on the conservation of the place and/or to secure evidence about to be lost or made inaccessible through necessary conservation or other unavoidable action. Investigation of a place for any other reason that requires physical disturbance, and adds substantially to a scientific body of knowledge, may be permitted, provided that it is consistent with the conservation policy for the place.

We have previously discussed the necessity, in some cases, for physical disturbance (for instance, excavation) in order to determine the significance of archaeological sites. Vaucluse House in Sydney is an example of where investigation of the fabric may be necessary in order to decide or implement the conservation policy; a policy of restoration/reconstruction has necessitated excavation of the grounds, to determine the original location of paths and plantings. Paint scraping is often necessary to determine the sequence of colour and type of paint applied to a building. Adaptive use of historic buildings often necessitates connection of services, which will probably require archaeological investigation to ensure that important underground features or artefacts will not be damaged by service installation. On the other hand, destructive research is not appropriate if it endangers the cultural significance of the place. (See Control of research, below, for a fuller discussion of this.)

Involvement of experts

Article 23 of the Burra Charter states that a conservation policy must be professionally prepared.

It is important that a written statement is prepared, so that it can be assessed and used as a reference point. The Burra Charter states that conservation plans should be prepared by experts appropriately trained. Ideally, as we discussed in Chapter 5, for some projects this will require a team of experts who together encompass the range of skills required. For others it is satisfactory to employ some consultants for the specialized work, and to do the rest in-house. In general, the greater the level of proposed intervention, the more checks and balances are required, and the more professional expertise will be needed.

Though consultants may be used, it is essential that the manager plays a major role in this process, to ensure that the proposed active conservation measures meets requirements and are in line with good conservation practice. The Burra Charter needs intelligent interpretation: it is not possible to apply its principles by rote—they need tailoring to particular circumstances.

Building conservation

Almost inevitably the manager of heritage places at some time will become involved with the conservation of a building, these being among the most numerous of heritage places. Building conservation has long been the province of the architect, who has built up a vast body of knowledge about conservation technique. However, architects are often not fully versed in the intricacies of significance assessment or management, and the manager must not be overawed by technical knowledge. The establishment of the cultural significance of a place, and the development of a conservation policy based on it, form the 'strategy' for a building's conservation, while the building conservation practices are the 'tactics' for fulfilling that strategy. The manager should attempt (with appropriate professional assistance) to be the strategist, and leave the tactics to the architectural experts.

A series of points indicating standard practice that managers, and the specialists they employ, should bear in mind is given below. Not every point is appropriate to the conservation of every building, nor are the directives they give unchangeable dogma. However, to act in a way opposite to standard practice the manager must be certain that there is a very good reason for so doing, that the best advice has been sought on the problem, and that no alternative exists that is less damaging to the fabric of the building or to its cultural significance.

Simple dos and don'ts
In all of the procedures listed here, it should be possible to see one or more of the principles of the Burra Charter put into practice.

It is essential to resist the temptation to do too much too soon without adequate assessment, planning, expert advice and funding. Good intentions without a logical process of investigation

and planning lead to institutionalized vandalism. The minimalist conservation approach dictates the repairing of deteriorated building material wherever possible, rather than replacing it with new material, and stabilizing and preserving fabric where repair is not necessary. This includes retaining details such as doors, windows, etc., even if in the short term they have to be replaced temporarily with modern fittings for security or use. Avoid using unsympathetic materials such as aluminium windows and doors, gutters and roofing materials or long-sheet steel roofing simply because they are convenient, cheap or available. The manager is managing a heritage place, not just renovating an old building. Similarly avoid 'cute' but out-of-character 'period' details such as twelve-pane windows, carved barge-boards or chintzy print decoration schemes if they are not appropriate to the conservation of that particular building.

As part of this process, and to retain evidence for future reference, it is necessary to retain and store details and fittings removed from a building, and to keep samples of building materials that have had to be replaced. In many cases these will be needed once the building is conserved, or retained as evidence for some future alteration in the conservation process applied to the building. For example, a building adapted for commercial use might, in five year's time, be re-adapted for interpretive purposes, and the stored details and fittings will be necessary for restoration/reconstruction associated with that process.

In all conservation work it is necessary consciously to avoid inappropriate conservation actions and techniques. For example, avoid removing paint layers or wall finishes to expose traditionally covered wall materials such as stone, brick or timber, and similarly avoid covering with new finishes wall materials that were designed to be uncovered. An all-too-common and disastrous example of this is the use of cement render to solve rising-damp problems. It does not solve the problem in the long term, but it does irreparable damage to the walls. The use of cement and concrete generally should be avoided when treating old buildings. Mortars for repointing masonry should be matched to the existing mixture (usually a soft lime mortar), again to avoid future damage to the walls. Concrete slab floors for additions to a building often create new damp problems in the adjacent original walls, and may have to be removed. Professional advice is needed in such circumstances.

As already suggested, a new use for a building may prove to be a necessary part of its conservation. It is essential to make every effort to provide a compatible use for the place that requires minimal alteration of the building structure, site or surrounding environment. Where new additions or alterations are necessary to adapt a building for a new use, ensure that they are designed in a modern but sympathetic style that does not compete visually with, or overwhelm, the original significant fabric of the building. Where possible, such new construction should be designed to allow its removal at a later date without damage to the original fabric. In adaptation of buildings, avoid changes to the pattern and rhythm of door and window openings, and other elements that make up the visual character of the place. Where possible, retain the basic floor plan of the building, room sizes and finishes. Any temporary or permanent new structures should be located away from the building being conserved, and from other significant features such as archaeological sites, and gardens, and avoid making the new structures part of significant views of or from the place.

In planning adaptation works it is necessary to consider the impact of new uses for old buildings, both in the conservation stage and in the subsequent use of the place. For example, the impact of TV aerials, parked cars, garages, carports, washing lines, screen doors and windows, fences, garden sheds, bush houses, plantings, septic tanks, sewerage lines and other services, especially power lines (above ground, visually intrusive; below ground, disturbing to archaeological fabric), air-conditioners, advertising and signs, all have to be considered in view of their impact on the fabric and on the maintenance of the cultural significance of the place.

Compliance with relevant safety and health codes in various legislation is necessary. However, the impact of compliance on the building conservation can be modified by decisions regarding use, and investigation of the various exemptions from the codes sometimes existing for historic buildings. Thus, use of a building for public purposes may require safety features (such as fire protection and escapes) that may be unacceptable given the significance of the building. These safety codes may be modified by special exemptions, or the use of the building could be rethought, say to residential use, which might require less modification to comply with these codes. At the same time, the

building may require fire protection as part of its conservation, and a sympathetic design and installation of such services has to be carefully planned.

The manager has to guard against the temptation to 'tidy up' a building and its grounds before proper physical investigation has taken place. Often, in making a place tidy and clean, vital information about the place is swept away, or material is collected and stored without reference to its original context, or moved about a site, creating real problems for those subsequently trying to make sense of the physical evidence for conservation purposes. Always get the physical investigation carried out before even superficial cleaning-up of a place occurs.

Steps have to be taken to ensure the protection of all elements of a place during and after conservation works on buildings. Sometimes the absorbing nature of works on a building lead managers and practitioners to ignore the necessary protection of other elements, such as outbuildings, gardens, trees, earthworks of various kinds, and other cultural features that might be important in understanding the history and development of the place. The study of these features should occur at the same time as the study of buildings, and their conservation should occur when the building is conserved. This should include the protection of archaeological deposits, and, in fact, all ground surfaces around a building, from damage and disturbance as far as possible. This requires the control of machinery and equipment (especially earth movers) in the works phase, and careful design of services, outbuildings and the use of grounds associated with the building.

Prior to disturbance, known archaeological deposits, or ground where information about a place may be recovered through archaeology (which includes any ground around an old building), should be assessed by, and if necessary salvaged by, a trained archaeologist. The involvement of an archaeologist in the design and installation of underground services, insertion of new footings, underpinning of walls, and other tasks that disturb the ground, will maximize the preservation of significant fabric and the retrieval of useful information, and will avoid embarrassing delays in the undertaking of the work due to the accidental uncovering of 'unforeseen' remains.

Finally, it is essential to establish a maintenance programme. No matter what conservation process is applied to a building,

that building will require maintenance to ensure that its conservation is effective. In Australia at present maintenance is often carried out on a crisis basis—that is, when something falls off, cracks or collapses. Several heritage conservation agencies overseas are developing special scheduling procedures to ensure a simple and regular maintenance inspection of buildings to identify maintenance problems at an early stage, and thus save the money that the 'crisis' approach involves. Managers with buildings to maintain should study the literature available on maintenance scheduling, and attempt to adopt or adapt a system suitable to their situation and needs.[8] Most government public works or building management authorities should be able to supply managers with up-to-date information on maintenance scheduling.

A growing number of publications on specific building conservation problems and solutions to them are now available in Australia. These include advice on the standards of conservation practice that should be applied to specific problems. The Australian Council of National Trusts' publications in this field are readily available, and are listed in the bibliography, together with other useful sources.[9]

Conservation of works other than buildings

Many of the same practices applying to building, or at least the principles behind them, also apply to, say, engineering structures such as bridges, roads, railways, mine poppet-heads, and the like. The respect for original material in the fabric of the place, for conservation controls and the need for control of the use of the place, all apply. The Institution of Engineers, Australia, has outlined the conservation planning process and Burra Charter principles for engineers interested in engineering heritage.[10]

Some discussion of broad conservation options for engineering features has appeared. It has been pointed out that, because of the high maintenance costs of many engineering features, it is often best to make every effort to retain existing active uses for them. Thus, to encourage the continued use of a historic bridge, or the incorporation of a historic mine headframe within surviving mining operations, might be the best way of ensuring conservation if the managing body is convinced of the values attached to the place and is prepared to expend money on their

maintenance. In the case of the Lennox bridge at Lapstone (NSW), modern traffic proved to be a major factor in the decay of the engineering work built to support only foot, horse and wagon traffic. Therefore, the only responsible conservation option was to stop vehicle access. On the other hand, another Lennox bridge at Lansdown (NSW) still carries a major road artery of Sydney, apparently without ill effect.

Another prominent element of the built environment requiring conservation and management are monuments and memorials and their settings. Cemetery conservation and the conservation of war memorials have been the subject of several recent booklets and articles.[11] These stress the need to respect the original intention of the memorial (or gravestone), to appreciate all of the factors giving the memorial and its surrounds significance, and to carry out the physical conservation of the memorials with the aim in mind of also conserving significance and setting.

Site conservation

The significance of many heritage places resides not in buildings, but in elements more closely integrated with the land itself.

The separation of sites in this way from the buildings that may stand on them is a totally artificial one, made necessary by the need to distinguish different conservation practices for various parts of a place. Clearly, the manager of a historic place containing a building cannot totally divorce the management of the site from the management of the building, but the manager should be able to distinguish different conservation practices for different part of the area being managed.

Many heritage places, of course, have no buildings, and never have had. If, for the purposes of this argument, we ignore buildings, then heritage sites can take four basic forms:

1 Sites containing no cultural remains at all, but having cultural significance through connection with explorers, proclamation of colonies, or other documented historic event, or through traditional associations (for example, an Aboriginal sacred site).

2 Sites containing above-ground remains of former land uses, including building remains, fences, mine workings, dumps,

land modifications, Aboriginal fish-traps, rubbing grooves, quarries, etc.

3 Sites containing landscapes with a cultural origin, such as former gardens, intentional landscaping, and accidentally modified landscapes.

4 Sites containing archaeological deposits with evidence of human habitation or use. These might include Aboriginal shell middens or deposits in rock shelters, and early European settlement sites.

Landscape/vegetation management

In each of the cases just outlined, different conservation practices might be appropriate. For example, careful control of vegetation and selective culling of native plant regeneration to encourage the regeneration of exotic plant species may be an appropriate conservation practice for former gardens, but it is hardly likely to give good results on a mining site or an explorer's campsite. At some Aboriginal sites the natural vegetation might be an important aspect of the site's significance.

Hence, just as all building conservation practices are not applicable to all buildings, so different types of sites require different conservation practices. Some heritage-site conservation practices include maintaining appropriate landscape/environmental surroundings. The events and land uses that created the sites took place in a certain physical environment. The event or land use may in itself have modified that environment, or the environment may have changed in the period since. The investigation of the history of the site, the assessment of its significance and an overview of subsequent events may enable the manager to decide what course of action to take with the landscape surrounding a site. An avenue of trees leading up to a nineteenth-century homestead building or site might be considered significant and conserved accordingly, while dense thickets of self-seeded hawthorn might be culled to regain an appropriate landscape setting for the same homestead. In some cases, the evidence of natural regeneration might be maintained as an interpretive device and for practical purposes such as erosion control. One such case (referred to previously) is the Newnes kerosene-shale refinery and mine in Wollemi National Park (NSW). The largest Australian industrial site of its time, Newnes

was cleared of vegetation to reduce the fire hazard. Since the abandonment of the works in the 1930s, the site has revegetated. The revegetated site can be presented to the visitor in such a way that the nature and scale of the original effort in clearing and developing this site is made abundantly clear, while at the same time showing the ephemeral nature of much of our industrial use of the natural environment.

While the Newnes remains still make sense in their bush environment, the fortifications at Sydney Harbour National Park (NSW) (also referred to previously) are difficult to understand and interpret to the public because of the local regeneration of bush. The area in front of all the fortifications was originally cleared and landscaped to allow an uninterrupted arc of fire out into the harbour. The regrowth now hides the complexity of the fortifications and separates them from the harbour, the protection of which was their reason for being. It is also prone to cause damage to the fortifications. In this case, selective clearing of vegetation is called for to restore the setting and context of the historic remains.

A third example is at Hill End Historic Site (NSW) where extensive alluvial mining has created an eroded landscape around the village. Here a balance has had to be achieved between conservation of a significant and evocative landscape, and the continuing erosion that the mining scars are causing. Selective planting to try to stop the erosion while retaining the landscape has been undertaken, but the results will not be clear for some years. There will be similar examples in every state, such as the quandary in Queenstown (Tasmania) as to whether natural revegetation of its smelter-blasted landscape (a major tourist attraction) should be allowed to proceed, or the problem facing the managers of goldfields sites in Queensland, where the introduced tree-of-heaven is becoming a pest species.

At Aboriginal sites conservation of natural vegetation is often a major aim; but there are exceptions. Revegetation of sandstone rock surfaces obscures and damages engravings, rubbing grooves or seed-grinding patches. Spinifex growing too close to an engraved rock surface can be a fire hazard, burning at a high temperature when ignited, and fracturing both rock and engravings. Occupation deposits, middens, etc., in thick coastal rainforest need to be kept free of tree regrowth, since it may damage the deposit and disturb the stratigraphy. Aboriginal campsites,

consisting of scatters of stone artefacts, and hearths and extensive stone arrangements have been revealed at Pindera Downs in western New South Wales. Stock were disturbing the sites, and they have now been fenced out. However, as a result, revegetation is obscuring the sites, and may eventually harm it.[12]

On some sites the conservation of gardens is a major aim. The significance may lie in the garden design itself, but more often in the context provided by the association of the domestic residence and its garden. Victoria has led the way in the recognition, assessment and conservation of historic gardens, but the growth of the Australian Garden History Society points to a nationwide recognition of the significance of gardens. Guidelines for the conservation planning and practices for gardens have been published by the Society, by the National Trust of Australia (Victoria) and by the Australian Heritage Commission.[13]

Appropriate land use

Sometimes the maintenance or restoration of an appropriate setting for a historic place is beyond the control of the manager. Such is often the case when the boundaries of the area being managed do not extend to include the 'visual catchment' (the view) of the place. The most common problem is when an existing landscape that is appropriate to a place has its land use changed. Thus forest can become grazing land, pastoral landscapes can be subdivided for urban development, or any landscape turned into an open-cut mine, sand pit or quarry. In negotiating with government departments and local government, managers can make their interests clear, but it is usually very difficult to have management control over land that the manager is not responsible for. In some cases this conservation/management problem can be traced back to inadequate consideration of proper boundaries for the heritage place when it was reserved.

Another aspect of site conservation is the maintenance or development of an appropriate land use and the prevention of inappropriate use. This is often closely related to the last issue. The maintenance of a historic or traditional land use, such as grazing, agriculture or an industrial/craft process, in some management situations may be possible, and can be a very effective way of perpetuating the significance of a site. In Kakadu National Park members of the Gagadu Association pursue a partly hunting/gathering, partly consumer lifestyle. They collect vegetable

food and hunt and fish, and 'clear up' the country every early dry season with a series of fires. In other situations, the leasing of farming or grazing lands, with adequate protective clauses in the lease, can remove many of the demands from the manager for site maintenance, security and control. Just as appropriate use can be an aid in building conservation, so it can for site conservation.

However, in many situations the legal framework and the nature of the reservation in which the manager must act precludes this sort of perpetuation of traditional land use. As has been pointed out throughout this book, the land is often reserved primarily for other values, which are at odds with the traditional uses. If this is the case, the manager must analyse what it is about the site that is significant, and devise management practices that achieve the conservation of that significance. This might exclude or modify some management practices normally part of the management of an area, such as fire-hazard reduction (the manager being quicker with the match than the visitor or nature), the eradication of exotic plant species, and 'rubbish' removal, or modify plans for car parks, management structures or roads. In extreme cases, the significance of a landscape created by a particular land use may lead the manager to recommend re-gazettal of the land to a category that will allow reintroduction of the traditional land use.

The removal or modification of land uses posing a physical threat to heritage places can be a difficult task. Good planning of compatible uses within an area can avoid this problem from the start. However, the manager is often acting in a situation where little or no planning has yet been done. Parts of an area being managed may be leased out for commercial use, or for quarrying or mining, and these activities can directly threaten Aboriginal and historic places. Where major conflicting land use is concerned, the manager may only be able to reduce the effects of the impact, and not remove its cause. In some cases, the manager can argue for the termination or non-renewal of the lease, or for the insertion of strict conditions to protect the heritage place.

While conflicting land use is a common management problem, the desire to reinstate a defunct land use can also be a problem. For example, the manager must guard against the all-too-common pressures to re-create the buildings once associated

with a site. Such reconstruction is almost invariably highly con-
jectural, expensive, and cannot be undertaken without in some
way detracting from, if not destroying, the cultural significance
of the place. Similarly, the removal of buildings from their
original locations and their reconstruction on significant sites
can normally not be accepted as a conservation option.

Rock-art conservation
Australian Aboriginal rock art, consisting of paintings, drawings
and engravings, is an outstandingly beautiful and significant
cultural heritage. Australia is probably the most outstanding
rock-art province in the world.

Rock art is widespread, and presents a difficult conservation
problem. Much of the art is very ancient, and is on unstable
materials. Much of it was not designed to last, or was previously
repainted or re-engraved by the traditional owners, who in vast
areas are now no longer able to do this.

Rock-art conservation is a very specialized area, in which
expertise is essential. The complex micro-environment of any
site makes it unique and makes diagnosis and physical inter-
vention particularly complex and risky. To date there are no
long-term solutions for the process of inevitable weathering and
decay. Successful conservation measures are aimed at slowing
down weathering processes, preventing or lessening attack by
insects or animals, or controlling or minimizing the effects of
human misuse or overuse.

Nicolas Stanley Price[14] has discussed appropriate conservation
methodology in a recent paper. Stanley Price suggests the pro-
cess outlined in Figure 6.1. He further suggests three principles:
the principle of minimum intervention—as little alteration as
possible to the original material; the principle of reversibility—
any conservation process should ideally be reversible without
damaging original material; the principle of compatibility of
materials—the composite formed by the original materials and
the modern ones should perform favourably in the expected
environmental conditions.

Quite a number of simple techniques to achieve these aims
have been evolved by Australian workers during the last twenty
years. These methods are designed to be relatively cost effective,
reversible, and simple to implement. However, they do require
considerable expertise and skill. It cannot be too strongly

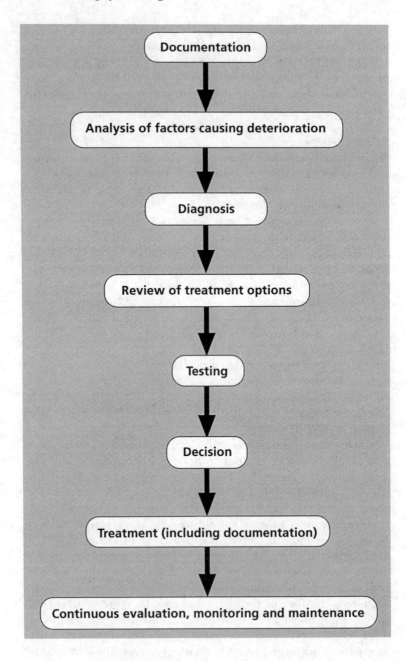

Figure 6.1 A proposed methodology for conservation treatment

emphasized that rock-art conservation is not for amateurs. It is strongly suggested that managers do not undertake even simple physical conservation measures without expert advice.

A manual by Dave Lambert[15] details some of the simple techniques so far devised. What follows is a brief summary of rock-art conservation problems and treatment from this manual.

The most important first step is the monitoring and preliminary diagnosis of conservation problems. Is the art noticeably and measurably decaying or fading? Does it have discernible insect or animal attack, or human intervention (graffiti, etc.)? The manager can institute a simple monitoring programme at important sites by photographing from the same spot at regular intervals, and can keep a careful recording of the site, documenting and describing possible problems, for further analysis if necessary. Lambert also details more sophisticated long-term monitoring techniques.

Pigment instability is a problem requiring expert diagnosis and treatment (if any is available). Pigment instability results from ineffective binding of the pigment to the rock surface. It is often initially diagnosed as 'fading', whereas what is actually happening is that microscopic pigment fragments are falling off.

Weathering can occur by direct or indirect weather action. It may be discernible by direct pigment removal from paintings, or by indirect action such as salt weathering, or silica accumulation through slower seepage and mineral build-up. Simple techniques for combating it include the installation of silica drip-lines, water diversion, around or away from the site, and, in some cases, water flushing to reduce mineral build-up.

Engravings and paintings in rock shelters can become covered by soil, and hence be subject to accelerated chemical weathering; though in some cases, if the soil cover has been long term, the soil may be acting as protection for decaying rock. Expertise is required to determine particular cases: once again, careful documentation is the first step.

Vegetation may be harming a site, by direct rubbing of art surfaces or by creating an undesirable change in the microclimate. In some cases vegetation (for instance, spinifex near rock engravings) can be a severe fire risk, with resultant damage to the art. Trees and shrubs can attack the parent rock, causing cracking or fissuring, and forming water channels or splash areas.

In many cases, the actual or potential damage will be readily apparent to the manager.

Vegetation can be used in some cases to protect sites, serving as effective wind-breaks. Vegetation may also be an integral part of the site and part of its cultural significance. Trees or plants may be derived from food gathered by Aborigines and brought to the site. Lambert suggests that prior to any vegetation removal, the manager should assess damage, consequences of removal, aesthetics, and, of course, cultural significance.

Micro-flora (lichen, etc.) is very common at art sites. In some cases it can be clearly seen to be attacking the art. Experts can simply remove micro-flora from the art by brushing or washing. Insect and animal attacks are also diagnosed readily. Mud, insects' and birds' nests, and termite tracks, can be simply removed using Lambert's methods, though often the art underneath them has deteriorated. Animals, especially goats, buffaloes and cattle, can do great damage to the art by rubbing and licking the painted surfaces. Stock removal or fencing of the site are obvious and simple solutions.

Humans can cause extreme damage to rock art: by touching it and causing micro-erosion and the imposition of grease and dirt, by walking on it, by raising dust that obscures it and by defacing it with graffiti. The next chapter discusses visitor management in more detail. Methods available to the manager include access restriction, the construction of weld-mesh grids, walkways, and psychological barriers, and the provision of on-site interpretation, visitors' books, or guided tours.

Repairing the damage previously done by visitors is also important, since any graffiti will be mimicked by others. Graffiti removal is not simple, but it can be surprisingly effective, as outlined by Lambert. Perhaps the most crucial question about graffiti removal is what to remove, and what to leave. In any case, a meticulous recording is required, prior to graffiti removal.

Intervention at art sites and cultural attitudes

D. Lewis and D. Rose provide an interesting case study and discussion concerning Aboriginal attitudes to rock-art conservation. They worked in the Victoria River area of the Northern Territory, an area rich in rock art, with a traditional Aboriginal community with direct and recent cultural associations with the

sites. Their argument, in brief, is that in this case the beliefs of the traditional owners should dictate the degree of intervention.

In the belief system of the Victoria River people the oldest, most knowledgeable people are at the interface between the past and the present—the Dreaming and the now. The past has little depth and certainty in European terms, and is actively interpreted by the oral traditions of the elders. What they say about time past is the past for the present people. The art, which is rich and varied, is seen as one manifestation at one point in time, of the Dreaming creation ancestors, who shape-shift in the landscape. The art therefore can change its meaning: or rather, its meaning is subject to the authority of the elders. The art is also seen as being self-sustaining and as renewing itself.

Writing down the meaning is hence a meaningless exercise, and its fossilization in this way destroys the elders' authority and the fluidity of the significance. Conventional physical intervention —the imposition of conservation techniques to the art— implies lack of faith in the regenerative powers of the Dreaming, and also implies that the care of the elders is defective in some way. Essentially the paintings are not seen as inanimate objects: and what the European sees in looking at or researching the art, without intimate inside knowledge of its cultural context, is a very distorted single aspect of a complex mystery. The Aborigines say of such people that 'They come up here blind and bump into things'.

Aboriginal beliefs and attitudes must be at the core of any conservation or site-management work, and these beliefs and attitudes are quite foreign to the Western view of art. It can be insulting, in this situation, to suggest conventional conservation and management-intervention techniques.

Lewis and Rose discuss this in the context of the Burra Charter, and conclude that at this time the cultural significance of the sites would be gravely impinged on by any physical conservation. The Aboriginal view is that the appropriate protection technique is to provide vehicles and assistance to allow the traditional knowledge and care of the sites to continue.

Physical protection—maintenance and prevention of threats
Most of the day-to-day work that managers carry out at heritage places is aimed at preserving or maintaining them. It includes

rather mundane stabilization work, maintenance, and other physical protection works such as prevention of soil erosion and the erection of fences and signs. In some cases, especially where large or scattered heritage resources are being managed, staff and funding constraints dictate that physical protection work to halt or slow the rate of decay, or to remove specific threats to a place, is the only management practice that can be applied.

It is essential, therefore, that the manager first identifies the extent of the cultural place or places being managed and assesses them (see Chapters 3 and 4), and identifies and analyses the threats affecting or that might affect the resource. Threats can be divided into natural processes and human activities, and can include:

Natural processes: decay of fabric
 erosion of fabric and site
 animal and plant activity
 fire

Human activities: management uses and activities
 visitor impact
 vandalism
 inappropriate use.

A range of management practices can be applied to reduce or remove these threats. In the case of protection against the threats from natural processes, these practices include the inspection, identification and treatment or replacement of decayed elements of a place, and the removal or reduction of factors leading to that decay. A living Aboriginal-carved tree, for instance, might be threatened by tree diseases, insect attack or rot, all of which might be solved by treatment by a tree surgeon. In the case of a timber building, the removal of termites, or the replacement or patching of affected timber fabric, will slow the decay of the place as a whole, and the identification of the cause of the decay (such as a leaking roof, seepage of groundwater, or termite infestation) might enable the manager to remove the cause, and thus further reduce the risk of future decay.

Erosion control
The carrying out of erosion control works is often essential. Soil erosion can affect both Aboriginal and historic places. The

identification of sheet erosion, gully erosion, creek bank or foreshore erosion is the first step, then solutions to the problem should be sought.[16] Some problems will be easier to solve than others. The redirection of creeks or the erection of diversion walls on sites might solve a small-scale erosion problem at an Aboriginal or mining site, but the problems facing an Aboriginal midden or European wharf structure through massive coastal erosion may ultimately be unsolvable, and salvage might be the only solution (see below).

The manager, in this as in all other protection and conservation works, must ensure that the treatment is not more destructive of the cultural resource and its assessed significance than the threat that is being treated. The example of gully erosion control in a gullied mining landscape at Hill End has been used earlier in this chapter. In that case there is a fine line between achieving physical protection (both of the cultural resource and of other values for which the area is managed) and the destruction of the meaning of the cultural resource.

Animals and plants as threats

Of equal importance is the control of animals and plants. This can also be a delicate balance between protection and destruction of the resource, depending on the methods employed to control the pest species. Earlier in this chapter we looked at various examples where tree regeneration could add to or detract from the cultural significance of a place, and it can be seen from these examples that the assessment of significance and conservation implications of actions are prerequisites for arriving at an appropriate response to plant invasion. Root penetration in masonry walls (and other structures and some ground surfaces) is a major problem in some places. In seeking a solution to this damage, the manager must weigh up the longer-term implications of action or inaction: Will the roots grow any more or are they stable? If the tree is cut down or poisoned for later removal, can it be removed without destroying parts of the place in its falling? Can the roots be removed without major damage to the fabric of the place? If the roots are not removed, will their eventual decay cause major subsidence or movement in the fabric of the place? It can be seen that prompt but ill-considered action might be regretted at the manager's leisure for a long time to come.

Another example is where the threat posed by a plant species must be balanced with consideration of the benefits it might have in protecting the place. In many historic places, and especially old mining areas, blackberry infestation is seen as a problem, and the manager or outside agencies might attempt to remove it as a noxious weed. However, blackberry thickets are a very effective protection when they grow over or around historic remains, and in the case of open mine-shafts can provide a degree of visitor safety. When managers do not have the resources to carry out active protection works at a place, it might be in their own interests (and those of the visitors) to delay blackberry eradication, and allow the weed to do some of the protection.

In the case of archaeological deposits, vegetation growth can have a disastrous effect on the place. The New Zealand Historic Places Trust has published a manual on vegetation management that outlines principles and practice in this situation.[17] Some points brought out in this manual are that:

- The manager must gain a working knowledge of the local vegetation and the way it behaves.

- Deep root-penetration must be prevented.

- Vegetation control must go hand in hand with erosion control.

- The form of vegetation control employed must be ecologically acceptable to adjacent landowners (and compatible with other management values).

- If visitor-use of the area occurs, then care has to be taken with the herbicides used and landscape modifications undertaken, to guarantee the safety of visitors.

Animal control usually takes the form of fencing or gridding to keep animals away from fragile elements of a site. At neglected buildings, verandah posts, doorways and corners make very effective rubbing-posts for animals. Until an anti-itch formula is developed that can be sprayed over the fauna, the only answer is to build a barrier between the animal and the place being conserved. This implies regular maintenance inspections to mend the fence or grid, and to mow grass or remove plants regenerating in the absence of grazing animals. All damaging species must be identified and protected against; for example, a fence that will keep out cattle might not keep out wombats and

rabbits who are busily burrowing into the archaeological deposit or undermining the stockman's hut.

As with all of these management practices, the significance of the place must be taken into account. In the case of Hill End mining village (New South Wales), for example, the managers (the National Parks and Wildlife Service) assessed the significance to include the need to retain the existing rural-village character of the place. A major element in this character was the presence of roaming stock occupying the large common and the village itself. The management practice in this case is to monitor the impact of stock, repair damaged verandah posts and the like, but only to exclude stock from particularly fragile areas within the historic site. At Norfolk Island the opposite policy was implemented, and stock are excluded from the area of the primary convict ruins. This meant an increased management obligation for mowing in this area.

Fire hazard reduction

The manager must address the reduction of the risk of fire. Fire can be a natural or a humanly induced problem, but the protection of sites from fire is the same in both cases. The two main management practices with respect to fire are to remove or reduce the risk of fire occurring, and to provide facilities to fight fires when they do occur.

For Aboriginal or historic places located within a natural environment, the simplest risk-reduction practice is to remove fuel from close proximity to the place being conserved. The removal of nearby trees and accumulated litter will help. Particular management practices for fire-hazard reduction by controlled burning-off on the lands adjacent to the place may have to be modified to reduce the risk of accidentally burning the place. This can be a key element of special zoning requirements in a management plan for a larger area (see management planning sections in Chapter 5). The management plan should also identify the location of historic and Aboriginal places so that they can be incorporated in fire-control maps and avoided when emergency fire-trails or fire-breaks are created in the course of firefighting.

Some facilities for firefighting can and should be installed at all historic buildings, fire extinguishers, knapsack sprays, fire hoses and bags being the simplest. In many cases integrated fire-

sprinkler or alarm systems would not be appropriate or practical. In situations where a reticulated water supply is available, a regular maintenance inspection of hydrants, hoses and sprinklers must be carried out to ensure their effective operation when required.

Human threat

Management practices appropriate to coping with threats caused by human activity include the proper planning of the location of management-related activity, and their relocation if the original decision proves to be inappropriate. The wrong decision about the location of roads, car parks, works depots, picnic areas, toilets or other visitor facilities, can be damaging or completely destructive to heritage places. If the place is identified in the course of works, and a change in plans is required to conserve it, the situation can be acutely embarrassing to the manager.

Not only the actual physical impact of such developments on physical places should be considered but also the side-effects like increased access, impact on erosion and the creation of other threats, or the creation of positive benefits for other heritage places located nearby.

Visitor use, and management decisions aimed at better interpreting places to visitors, are major sources of threats to the long-term conservation of heritage places. This aspect of policy implementation deserves a section on its own, and is dealt with in Chapter 7.

Control of research

Most states have some regulations to control research on heritage places. This control is necessary for two reasons. Firstly, since the resource is scarce and valuable, destructive research must be controlled to preserve it. Secondly, the manager has the responsibility of preserving a viable sample of heritage places. In order to do this, managers need information derived from research. Many state authorities therefore control research to the extent of requiring information to be provided on the results of research, such as surveys to locate sites, to add information to the state's databanks.

The appropriateness of research depends on many factors, including the situation in which it is carried out, and the status

of the sites under consideration. It may be appropriate to allow extensive excavations in an area threatened by long-term unsympathetic land use but to refuse a similar programme on an area set aside for conservation, with the aim of reserving a sample of sites for future reference. Heritage place managers often have to decide such questions.

We stressed earlier that research is an essential part of the process of determining the significance of a place, and that one reason for conserving sites is as a resource for future research. Research that does not affect the fabric of the place is here termed non-destructive. Such research may be, for instance, an archival study of the past use of a place, an oral history programme aimed at getting useful information from local residents, a programme to record and photograph sites, or replication experiments to rediscover old craftsman skills.

There are other areas of research, however, which to some degree affect the place or the fabric. Clearly, archaeology is one such area of research. Once an archaeological deposit is excavated, it essentially no longer exists as a deposit—that part of the deposit cannot be re-excavated, and the material excavated has only as much value as the researcher's aims, experience and methods will allow. If mistakes are made, or the work poorly done, it is not possible to look again at the evidence in context. Even if the excavation is a superb piece of research work, which adds greatly to our knowledge, it can only be done with presently available technology, and can only answer the questions we presently perceive to be important. For instance, one cannot re-excavate deposits dug in the 1940s, before the invention of radio-carbon dating, in order to now date them, because the site has been excavated and the deposit no longer exists, except in so far as only a sample was dug (see below).

The investigation of the fabric of a building by architects, archaeologists or managers may be destructive research, in that bits of the fabric are often removed to gain access to wall-frames, roof spaces, underfloor areas or former surfaces. The destructive element of this research should be limited to the extent that is absolutely necessary for information-gathering or conservation works.

Other forms of research can be destructive too, to a lesser degree. Research into rock-art deterioration often requires the removal or testing of parts of the fabric, so does research into

some historic place conservation. Study of artefacts from a site may necessitate their temporary removal at least.

For all these reasons, applications for research should not be accepted uncritically by managers. All proposals should be considered carefully, with the aim of preventing any unnecessary or inappropriate destruction, and of maximizing the contribution of the research to an understanding of the place. The most useful word in the manager's vocabulary, when dealing with experts recommending interference with the fabric, is 'Why?'

Management requirements for research approval

Non-destructive research, if it is truly such and does not include undesirable side-effects (for example, increased publicity and visitor-pressure), does not need such stringent controls as destructive research. The following is a set of criteria for use in assessing a potentially destructive research project. Many of the states have permit application forms, which ask applicants to provide information along these lines and enable the manager to judge the project accordingly. Often the manager, in addition, will need to seek expert advice on the professional value and suitability of the project.

The project should have a clear research design outlining the specific aims of the project. It is unacceptable to carry out destructive testing or investigation with no specific aim or research strategy. A research aim may vary from a very broad aim to a very precise search for specific information. For instance, if no prehistoric sites in a particular area have ever been excavated, it may be justifiable to excavate with the simple aim of finding out basic information about the prehistoric occupation of the region. When this is known, however, one would expect future research to concentrate on answering more refined questions about occupation of the area.

An example of a precise aim would be research into the nature of the place, with the aim of restoring its fabric. This may require the removal and detailed analysis of paint scrapings, with the specific purpose of identifying the paint and stabilizing it or perhaps reconstructing it.

Acceptable aims for a research project vary with circumstances. In general, it is important to ask if the damage done to the place and its significance is justifiable in terms of the gain in knowledge or conservation-related information. For example, the provision

of significant new information in a relevant area, the testing of a major hypothesis, adding substantially to information about the site, or providing information necessary for the interpretation and conservation of a site, might all be acceptable aims, in the appropriate context.

The necessity for the research should be clearly demonstrated. All other avenues of research and information should have been pursued, prior to the carrying out of destructive research. For example, excavation of a historic site should not be undertaken before the appropriate archival and other research has been undertaken and the need to excavate proven.

A research design that seems promising may not be appropriate, none the less, at a particular site. The site may be fragile, unstable, or otherwise unsuitable. It may be a site reserved for future reference, and it may be possible to carry out the same piece of research at a site not so reserved, or, even better, at one threatened by destruction due to other circumstances. If the site has scientific or research significance (see Chapter 3), then the research design should be compatible with the degree of significance. For example, if a site is important because it is one of only a few sites known to contain certain information, then excavation of it for any purpose that did not seek to gain this information would be unacceptable. Many management policies do not allow archaeological research in areas set aside specifically to conserve heritage places, because it is destructive, and can usually be done elsewhere. In any case the research should not conflict with the cultural significance of the site or with the management or conservation plan for the area.

Only the minimum amount of disturbance necessary for the research should be allowed. A good percentage of the fabric of the site or place should be left undisturbed to allow for further work and checking of results. There are exceptions to this rule, but they are rare.

The professional competence and experience of the researcher should be established, as should the adequacy of the researcher's resources, professional back-up and proposed time-scale for the project.

Plans for publication should be realistic, clearly outlined and funded. The project will be of little use if the results are not available in some readily accessible form to fellow-colleagues, to the manager, and, if desirable, to the general public.

Provision should also be made for the safe keeping of any recovered artefacts and associated documentation. This sometimes poses difficulties, since in most states historical artefacts recovered from freehold land are the property of the owner, and may be sold or disposed of as the owner wishes. Therefore agreements, prior to the research, are often necessary.

Consultation with other appropriate authorities should be clearly indicated on the application. Excavation of Aboriginal sites should be preceded by consultation with their Aboriginal owners; other community members with a special interest should also be consulted. Care should also be taken to avoid or cater for undesirable or unexpected side-effects of the research, which make the work more difficult and which may threaten the place. Undue or unwanted publicity, for instance, may lead to unauthorized copy-cat excavation, or souveniring.

Sometimes research can be destructive to local traditions, or socially inappropriate even if it does not harm the fabric of the place. For instance, the publication of a learned book on Central Australian Aboriginal art may offend the custodians of the art to whom it is secret and sacred, and may be viewed as dangerous for others in the community.

Deciding on whether research should be allowed is a difficult job requiring expert advice. The manager often has to make this decision; but should do so by relying on the advice of two groups of people. The peers of the researcher should be able to advise on the researcher's competence and on the validity of the research: those closely associated with the place—traditional custodians, curators, or concerned and informed locals—should be able to advise on the suitability and relevance of the project to the enhancement of the place's cultural significance, or its conservation.

The manager must also be satisfied that all permits required by other statutory authorities, such as the state Aboriginal or historic site protection bodies, are obtained by the researcher.

Environmental impact procedures and salvage recording

Chapter 4 discusses methods of assessment of heritage places to enable proper decisions about their importance to be made.

Chapter 5 outlines planning procedures aimed at minimizing land-use conflict, and hence the unnecessary destruction or damage of heritage places. However, because of their widespread occurrence, and because of the pace of development and land-use change in Australia, it is inevitable that many heritage places will be destroyed, regardless of the procedures in place. The aim of this section is to describe procedures that minimize unnecessary or inadvertent damage or destruction of significant places, and to provide effective mitigation procedures in situations where destruction or damage of significant heritage places is inevitable. Probably, to be strictly organized, part of this section should be in Chapter 5 (planning) and part here. However, it seems to us to be potentially more useful treated as a separate unit; since this is the way most managers will have to tackle it.

The manager does not have to be an expert in site assessment or in salvage recording. The manager's role is to ensure that appropriate policies and procedures are in place for emergency survey and salvage, to assess the quality of environmental appraisals relating to heritage places, and, if necessary, to supervise the conditions under which heritage places are destroyed or damaged by development or changing land use.

There are two usual reasons for the planned destruction of or damage to significant places. The first is when damage to a site is necessary to obtain important information through research (see research control). The second is when the proposed land use that will destroy a place is judged to be more important to society than the conservation of the place. The conflicting land use is usually a development that is justified on economic terms. Decisions about the relative value of, say, the archaeological site of the first Government House, as against the returns to the New South Wales government (and hence the taxpayer) on the multistorey building planned for erection on the site, are not easy to make; and in the final analysis are usually not made solely by the place manager, because the considerations are so complex, with environmental, social, political and economic parameters. It is because this is such a potentially contentious and difficult area that, in most states, processes generally called environmental assessment procedures have been developed to deal with them.

Environmental impact appraisal procedures vary from state to state. Some states have well-developed environmental impact

procedures, others have almost none laid down by law, except for very major projects, usually those carried out by transnational companies. In a state without effective environmental impact legislation many problems arise. In a state with environmental planning legislation the manager should be generally familiar with the procedures and with the manager's role. In New South Wales, for instance, National Parks and Wildlife Service rangers advise, initially, on whether surveys for Aboriginal sites are necessary, and give similar advice and assistance to local councils and developers.

The procedures have the great advantage of forcing the proponents to justify their proposal, and give the community a chance to become involved in the decision to a greater or lesser degree. They often have the disadvantage of becoming either quite cynically superficial or, alternatively, so legalistic and formalized that their real purpose appears to be to contribute to the barristers' retirement fund. A major drawback is that the environmental impact statement is almost always a document funded by and designed by the proponent of the potentially damaging development proposal. The following notes do not attempt in any way to exhaustively cover this complex field, but simply to provide some general guidance for heritage place managers. Perhaps the most important point to make is that all the elements of place management described in this book to date are relevant to the process, including competent survey procedures, effective and detailed assessment of significance, and the development of a management policy.

The manager's role will vary. The manager may be an assessor who advises on the adequacy of procedures and the appropriateness of a proposed course of action. In most states the managers of cultural conservation agencies have this role. In Victoria, for instance, the Victoria Archaeological Survey (or its successors) advises on when an archaeological survey is necessary, on the adequacy of the findings, and on any salvage recording or excavation required. Such staff may assess ten or twenty environmental impact surveys per week, and are constantly advising, negotiating and consulting with experts and proponents. Proposals range from subdivisions on the outskirts of Melbourne to major irrigation schemes, open-cut mining, or hundreds of miles of electricity transmission lines. When the scale of environmental impact survey work is considered, the

importance of good regional and local planning becomes apparent.

The staff of the Heritage Branch in the state Department of Planning, or similar, perform similar work for the whole range of historic places on an ongoing basis.

At a local level, the managers often have to assess the effects of proposals on the land that they manage. A proposal by the water authority to raise a reservoir's capacity, or by a local council to put in a local road, or to take the shortest route (through the park) for the sewerage outlet, may impact on heritage places.

Alternatively, the manager, or land-use authority itself, may wish to take action that will affect heritage places—for instance, putting in a new fire-trail or picnic area in a park, or approving a new development in a local government area.

Whether there is a legal framework or not, land managers are responsible for the effect of their own proposals, or the proposals of other authorities on the land they manage. Proposed development should therefore be preceded by an assessment of significance of places and an appraisal of impact upon them, regardless of the requirements of the legislation. If the manager is a proponent, preparation of this document is a responsibility, as is objective assessment of it. In these circumstances, the document may also be assessed by an outside authority or group—the relevant statutory authority, or a conservation group.

If the manager is in the position of having to deal with a proposal, generated externally, that affects the heritage place or places being managed, the role will be as an assessor. This will require that the manager have a knowledge of the value of the place, of the proceedings, and the necessary management experience to deal with the situation.

The manager may also be a supervisor who oversees necessary procedures for the protection or salvage of heritage places during development.

Expertise will be required in many situations. The manager must know when to commission an archaeological survey or an architectural recording, and should resist the temptation to act 'as judge and jury' unaided by such necessary expertise.

The most crucial requirement, however, and one that will answer questions such as appropriate use of expertise, is a set of principles and practices that assist the manager in deciding the appropriate course of action. These policies and procedures

should be contained in the management plan for the area. That document should state what will or will not be permissible activity, how this will be assessed, and under what circumstances (if any) places can be damaged or destroyed. Assessment of the resource, usually by experts, is a necessary prerequisite for any decision to affect any place. If such an assessment has not been carried out, the planning document should state this, and make it a mandatory precursor to any consideration of cultural place impact.

In practical terms, what is needed for effective day-to-day management is an automatic triggering system for development proposals, whether they emanate from the land-management authority, or outside it, and whether or not they are required by law. Any application for development should be accompanied by at least an initial assessment of impact on places, and should not be considered by the management authority without this assessment. For instance, many local councils require such a form (often called a review of environmental factors) with development applications. This is equally important where the proponent is also the determining authority, that is, when the development is proposed by the land-use authority. The pit toilets dotting Aboriginal middens in our east-coast national parks are mute testimony to the need for park authorities to impose this discipline on themselves.

As a general rule deliberate destruction of sites within an area of land reserved in perpetuity for conservation purposes is not an acceptable practice. Such sites, whether in a national park, nature reserve or historic area, represent a permanent sample of sites. No long-term protection of sites can be guaranteed to be as effective outside such areas, and therefore protection of this sample should be given a very high priority.

Appraising an environmental impact statement for heritage places—Should there be a section on heritage places?

When dealing with a full environmental impact statements, the first thing to determine is whether a section on heritage places has been included. If it has, proceed to the next step. If it has not, consider whether there is adequate justification, within the statement, for this omission. There should always be some stated explanation for failure to consider heritage places.

A detailed survey and/or assessment may not be necessary if:

- a previous survey has been conducted, or the resources of the area may be well known for some other reason

- there is good reason to believe that no important heritage places will be affected. This may be, for instance, because the area has already been totally developed, and it seems that no evidence of previous human occupation is likely to remain, or, in the case of European places, perhaps because the area has never been settled by Europeans

- the development will not harm any places directly or indirectly, because of its nature.

A survey and assessment is necessary when no previous survey has been conducted, and there is reason to believe from local or comparative evidence that the area may contain heritage places. Information and expertise is therefore required to determine the adequacy of statements about lack of survey and assessment procedures for heritage places.

Here are two examples of justification for lack of further consideration of cultural resources. Are you convinced?

> The company surveyor, an experienced bushman, was asked to keep a lookout for relics, and found none. It is therefore not considered that the area would contain any . . .

> ∼

> The records of the Victoria Archaeological Survey were inspected, no sites were recorded, and the area was the subject of a complete on-the-ground survey in 1978, by an archaeologist. Witter located no sites, and commented in his summation that sub-surface occupation deposit was unlikely to exist. Witter also reported in detail on contact with local Aborigines, who also knew of no sites in the area.

The first example is not convincing. A surveyor cannot necessarily recognize or evaluate Aboriginal sites or even some types of historic place. No reasoned justification is given for the statement that the area contains no relics. There is no evidence of consultation with

Aborigines, or use of existing records. The second example is a reasonably thorough account of previous satisfactory work, which can be checked further by reference to the original report.

These are good, simple rules. However, as more regional surveys of, and plans for, heritage places are done, the situation is changing. Often we can predict from these regional surveys what will be the likelihood of the occurrence of heritage places and what type they will be. This is especially the case with Aboriginal sites, which relate so closely to the landscape and vegetation. Further, it may be that a representative sample of such places has already been conserved in a national park or some other secure reserve. In these circumstances, experts may advise, for instance, that only a sample survey is necessary to check earlier results, prior to development.[18]

The quality of the survey and statement

A survey and/or assessment should be conducted by suitably qualified person or persons, depending on the nature of the cultural resources and the survey method—for example, full survey, random sample, stratified sample, literature survey—should be stated and described, and be justified and justifiable.

Often a professional is needed to assess whether the work has been properly done, but there are sometimes rather obvious problems, which any intelligent reader can spot: 'Because ground visibility was poor, the area was surveyed by four-wheel-drive', or 'This area was not accessible by four-wheel-drive, being too rough, but it was thoroughly examined with binoculars', or 'The survey method was to conduct aimless transects'.

There should be a clear description of the heritage place or places located, such that it is possible for the assessor to comprehend the significance. The significance of the heritage place or places should be thoroughly researched and described. The regional and thematic context of significance is particularly important in cases where the place may be threatened by destruction.

There is sometimes a temptation to overstate the significance of a place, in an attempt to ensure its conservation or to add weight to other conservation or social arguments being put to oppose the development. For instance, those interested in the

nature conservation values of an area (forests, wetlands, etc.) will often seek the help of archaeologists or anthropologists in the hope of locating heritage places to bolster their argument. There is nothing wrong with this, it is clearly desirable that such places be located, and often a case for the multifaceted significance can be a very powerful and valid argument in itself, but in such instances over-enthusiastic descriptions and assessments sometimes occur.

An objective and balanced assessment of heritage places is very important. Overstating or exaggerating the case is to be discouraged. In the short term it is unlikely that such overstatement will be convincing, or that it will stand up to judicial inquiry. In the long term, 'crying wolf' does a disservice to the cause of heritage conservation by bringing significance assessment procedures into disrepute.

A statement of impact, clearly detailing primary and secondary impacts of the proposed development, should be included. Often secondary impact is not considered, although it can be as damaging as direct impact. For instance, subsidence caused by underground mining is often a threat to sites above, but this is rarely considered. Likewise support facilities, road, depots, etc., are often ignored.

The result of a survey and assessment will be, broadly:

- no places or areas of cultural significance located

 or

- places of some cultural significance located, necessitating minor changes to the proposed development, and/or salvage work on sites to record their information before they are affected

 or

- places or areas of great importance/significance located, necessitating consideration of the worth of the whole project compared to the sites, and possibly resulting in abandonment of the project.

Ideally, the document itself should assess the value of the heritage place versus the development, but in reality this is often not done. The assessor can consider this, however, if it is a comprehensive document. If there is a land-use conflict, the final decision will be made by the government or the courts—

not by the manager—though it is the manager's professional role to supply competent advice. If the matter raises sufficient public controversy, a public inquiry might air these questions.

If it is proposed that some places should be destroyed or damaged by the development, the proposal should contain recommended mitigation procedures, aimed at minimizing the damage and salvaging as much information or data as is useful from the site or sites.

In many cases, there is no chance of a real assessment, and the only concession that is made is that salvage is allowed while the development proceeds—that is, a decision has been made by the government before the environmental impact statement is undertaken that the development will go ahead. Even in this case, however, a statement of the value of the cultural resource can lead to mitigation of the impact, and variation in the development to allow for the protection of some places, or perhaps their incorporation in the project.

In recent times, there has been an increasing tendency for environmental and conservation issues to be much more seriously considered as constraints to development than previously. The decisions covering the Franklin Dam, the First Government House site, and Kakadu Stage II, all indicate that there is a real chance of environmental assessment procedures working effectively. This makes it increasingly important to ensure that good-quality, comprehensive and objective information is available.

Mitigation procedures

If a place is to be destroyed, it is the manager's duty to ensure that as much of its value as possible is salvaged. Ideally the manager should lay down conditions that mitigate the effect of destruction in this way. Determining appropriate procedures depends on the value of the site.

If the site has research value, part of the mitigation should be the recovery of as much of this value as possible. The information that the site holds should be recorded for future use. This might mean employment of experts to undertake detailed recording of and photogrammetry of buildings and Aboriginal art sites, excavation of all or part of an occupation deposit, or collection of artefacts and other movable relics at a site.

All of these techniques are straightforward, and common sense would suggest them. There is a growing feeling, however, that mindless data collection, with no real research objective, is not a very profitable or stimulating exercise. Recently, more emphasis has been put on research-oriented work that utilizes doomed sites to solve current major research problems. This is not to say that a minimum level of recording and excavation is no longer necessary—it would be irresponsible to neglect this—but that more detailed mitigation should be aimed at specific ends.

A good example is the Mangrove Creek Dam Salvage Project (NSW). This project was to salvage about twenty Aboriginal sites in a valley in the northern Hawkesbury area. The whole valley was to be flooded and all the sites destroyed. All sites were recorded, and test excavations carried out in all occupation deposits. Further research work concentrated on answering specific questions about Aboriginal occupation of this environment—to create a culture history for the valley. This meant that some data was not collected—for instance, not all sites were fully excavated—but the data that was recovered was used successfully for the research proposal outlined above.[19]

Another ancillary aim was the use of some of the sites for experimental purposes to provide specific data that would assist in the conservation of rock art in the Sydney basin.

Analysis of the material recovered should always be part of the mitigation procedures. Collection or excavation of artefacts, and storage for future analysis, is not very satisfactory. Long experience in the United States and here shows that such collections, because they have no aim, are often not very useful and, in fact, are rarely used by later researchers. The information is, to all intents and purposes, irretrievable.

If the site has public significance, the value should be reflected in the procedures. The developer should be asked to acknowledge or commemorate the site in some way, with, say, a small museum or interpretive display, relevant to the sites, a plaque or explanatory sign, incorporation of the site or part of it in the development design, or provision of funding to preserve or refurbish a similar, unthreatened site.

Sometimes actual moving of elements of the place (for example, a building or rock engraving) is undertaken. This can be better than the alternative; but invariably such items lose a part of their original significance and integrity. This is often a costly

process, and the funding could perhaps be better spent in some other form of mitigation, or on the active conservation of similar, but more secure, places elsewhere.

Social value is usually very difficult to salvage. There is a general feeling that compensation for loss of such values should be attempted. Payment of royalties of some sort to traditional owners and involvement of affected groups in the project have been tried, but, in fact, if a major site is destroyed against the will of its creators there is no truly just compensation available.

What level of costs is it fair to ask the developer to contribute? Many schemes—a percentage of total cost of development, for instance—have been advanced, but none are totally satisfactory. Costing should be based on what is genuinely required to salvage information and provide commemoration in such a way as to truly preserve or express some of the place's significant values. This may be sometimes very costly, sometimes quite cheap. In an ideal situation, funding for proper salvage procedures would be taken into account in the costing of the project, and the assessment of its viability. If the manager is in a position to insist on appropriate salvage, then it may be that this cost may make it cheaper for the developer to select an alternate area or method of development.[20]

Artefact curation

Most historic and Aboriginal places have artefacts associated with them, be they in the form of archaeological remains either still on-site or in deposits, or as excavated or collected artefacts, domestic implements and furniture that are the contents of buildings, equipment or machinery that are associated with an industrial site, or specially acquired collections used in a museum or visitor-centre display. These artefacts are part of the heritage place, and as such demand curation.

The basic principles of an artefact curation policy that should be developed for each place should include the following:

- Burra Charter principles should apply to artefacts traditionally or intrinsically associated with places. They should not be removed except for safe keeping, and should not leave the area, or be sold or otherwise disposed of, if they contribute to the cultural significance of the place.

- Tight control must be imposed to guide the removal of artefacts from their original location, the acquisition, storage and display conditions, physical conservation, and disposal of all artefacts.

- Acquisition policy should define conditions for purchase (what to buy), gifts (what to accept, and what conditions will be accepted), and loans and transferrals (procedures for keeping track of loans and transferrals, and sets of standard conditions).

- Most Aboriginal and historic places are not primarily museums, therefore acquisition of artefacts should be aimed at well-defined aims and objectives, and not the haphazard collection of 'old things'. Other historic sites should not be pillaged to provide furnishings.

- Care must be taken that artefacts acquired to be used in the interpretation of a place do not distort the perception of a place's significance. For example, furnishings for a house must not be finer or grander than would have been used by the inhabitants in the period being interpreted.

- Although it is often difficult to achieve, the storage and (where appropriate to the significance of the place) display areas for artefacts should be designed to fulfil current museum standards of temperature and humidity levels, and should minimize the problems of dust, insect and light damage. Regular inspection by a trained conservator should be aimed at. If the nature of the place is such that the introduction of temperature and humidity control would entail damaging alterations, a different sort of presentation not requiring such upgrading should be implemented.

- Artefact cataloguing and numbering procedures should be established, if possible, on an organization-wide basis. Without effective cataloguing, the collection will never be a tool to be used by the manager, but rather a weight around the manager's neck. Cataloguing is also essential for insurance and stocktaking purposes.

- Disposal procedures should be established that allow the identification of artefacts superfluous to the research and interpretive needs of the place. Procedures should include ascertaining whether or not the artefact concerned is required at another place being managed by the organization, in which

case transferral is desirable. If possible, the disposal procedure should allow funds gained from the sale of artefacts to be retained by the place for the acquisition of further artefacts that are relevant to the collection. (Note that the consideration of disposal should apply in most situations only to artefacts that are not part of the cultural significance of the place.)

• Conditions should be established to ensure the conservation of artefacts associated with a place that is leased to another person or body, or where a new use is not automatically appropriate to the conservation of the contents of the place.

There are some very useful guides for the management and conservation of objects in small museums,[21] and the Museums Association of Australia, through several of its state member bodies, holds workshops for museum managers.

See Appendix 5 for a list of names and addresses of useful organizations to contact.

 7

Visitor Management and Interpretation

Introduction

This chapter is a brief discussion of visitor management and interpretation. It is a general introduction for the practitioner, and provides some basic principles and procedures for consideration. It cannot hope to cover the topic in detail, or to provide sufficient examples or discussion to satisfy all readers' needs. There is, however, a growing body of literature on the topic, to which you will be referred throughout the chapter.[1]

The aim of visitor management is to enable visitors to maximize their appreciation and enjoyment of the heritage place, while minimizing the risk of damage to the place by attrition, direct or indirect damage, or diminution of the experience of the place for other visitors.

Visitor management incorporates a range of techniques, skills and tools, ranging from very simple measures, such as psychological barriers, signs and staff presence to protect places, to the provision of interpretation programmes (planned approaches to the presentation of interpretive material and activities), guides and elaborate visitor-facilities to enhance understanding of places.

Interpretation and visitor management are very closely linked. Interpretation is at once an aim in itself, and an important

component or tool of visitor management. Visitor management, in turn, is part of the place's management context, in which the interpretation programme operates.

A prime aim of visitor management should be to give the visitor the best possible on-site experience. It is not just the place itself, or the standard of the interpretation programme that is important for this: it is a whole range of site-management factors. The friendliness of the staff, the standard of facilities, the availability and quality of souvenirs or parking, the standard of site care, and the range and suitability of activities may all contribute to the visitors' enjoyment and hence their capacity to appreciate the heritage place, to learn from it, and to retain a favourable impression of their visit and of the worth of such places generally. Good visitor management can have very positive effects.

It remains a truism, however, that all visitor use will have some unavoidable impacts on places. Good visitor management aims to minimize this impact. The impact may be simply attrition—the gradual wearing away of the place's fabric or setting by constant visitor use. People's feet will eventually wear away floorboards and stone steps, they will erode land surfaces and rock engravings on flat surfaces. In contrast to the long-term diminution of the resource is the often more immediately noticeable and dramatic damage. This may be indirect—dust rising from people's feet may quite quickly coat rock paintings, for instance—or more direct—vandalism or theft. In a more subtle way, visitors can ruin the ambience, feeling or significance of a site by their behaviour or by inappropriate activities or numbers.

Most of these problems arise from overuse or inappropriate use of the site, or from ignorance, over-enthusiasm or disaffection on the part of the visitors. Ultimately they arise from poor management practices. A whole range of techniques is available to assist in effective management, and the skill of the manager is in selecting the right techniques for the visitors and the heritage place.

Effective visitor management is becoming increasingly important as the heritage industry grows along with the booming tourism industry, and yet to date heritage managers have often tended to ignore or discourage tourism. Previously it was possible for heritage managers to adopt a 'go away' approach in the case of historic properties ('Open to visitors every third Thursday at 9 p.m. on request'), and a 'Let's pretend they're not here'

approach in the case of Aboriginal sites. In some instances this may, in fact, be a legitimate management approach where places are not yet adequately protected, or where funding does not allow active interpretation and visitor management, or where the significance of the place itself places limits on visitor activities.

However, the people, who pay for heritage management, increasingly want to see the results, and far-sighted managers can see that there will usually be definite advantages in visitor use. There is no doubt that the most effective way of selling the conservation message is to give people an enjoyable experience, which they will recall with pleasure and relate to the heritage conservation movement. The survival of these places and the continued support of society for them will depend to quite an extent on the heritage manager's ability to use the tourism bonanza.

A manager able to take advantage of increasing opportunities for tourism activity by good management practices, and effective marketing to channel and control visitors, can maximize advantages while minimizing deleterious effects. Intelligent and positive responses by the manager to such opportunities can mean more conservation funds, more employment, better place conservation and a more sympathetic community.

Place selection

For managers of a large area with a number of heritage places, choosing the heritage place for public use is a crucial first step. Of course, the managers of individual places may not have the luxury of this choice. It is very important to have a regional profile in order to select places to present to the public when a wide range of options presents itself. We need to know what other places are open to the public, what the likely visitor levels will be, what visitors in general want in the way of facilities and experiences. If we know this, we can position the place we wish to open in a niche that will ensure that we get the results we want, then provide appropriate visitor-management strategies for it. Once we have a regional profile, we can proceed to select a place for visitor use, on a number of criteria.

In this situation the quality of the place to be displayed is very important. Managers sometimes choose second-best, or medio-cre, examples, especially if they fear that visitor activity will

damage the place. However, this has a number of disadvantages. People appear to react well to quality. Places of outstanding value, if well interpreted, will be more appreciated and less damaged than mediocre examples. Additionally, the visitors will be more impressed by the experience and will take in more of the message the manager wishes to impart. Of course, in some instances the best place may be too fragile, or require too much conservation work for current resources, and should not be opened to public access.

The level of visitor use and the planned management strategy should not be in conflict with the statement of significance of the place, or the conservation plan, which ideally should incorporate visitor management and interpretation planning. Any place chosen for visitation should be robust enough to withstand it, and should not have significant values that would be jeopardized by visitor use. For instance, opening a very important scientific area to indiscriminate visitation would jeopardize its major value. Levels of visitation and of control will relate closely to the physical fragility of the site. A coalmine is probably much less fragile than an Aboriginal cave painting. It can probably take more visitors, unsupervised, with less threat of damage or destruction. In some cases the place, though extremely interesting and significant, is simply too fragile to allow visitors, given the resources available for protection. It is always necessary to balance the need to present a place to visitors with the need to conserve the heritage place.

Site manageability is another major factor for consideration. A heritage place may need good access, room for facilities, a buffer zone around the actual site, etc., to enable successful management.

Of course, the manager rarely, if ever, has the luxury of choosing the best, most appropriate place to interpret. Probably the place has been chosen, or is already being visited, or indeed over-visited, and what is required is remedial action. In cases where the place in question is being degraded by the existing visitor activities, the only strategy may be to alter visitor behaviour through management to protect the site, or to stop access the site. In some cases, for instance with Aboriginal sites, numerous places in an area are visited without any formal interpretation, supervision or management, and all are suffering. In this case opening one place for formal management with facilities and

interpretation, while promoting a superior visitor experience, may allow the others to be closed as visitor attractions.

Clearly any visitor use and management proposals should be the subject of an assessment of impacts, prior to a final decision being made.

Researching visitor behaviour

The good news about visitor management studies is that it is possible, demonstrably, to alter people's behaviour by a range of techniques. Professor Fay Gale, working in the Northern Territory, found that it was possible to dramatically reduce levels of vandalism at unsupervised Aboriginal rock art sites by the placement of notices and barriers, and by other associated fairly simple techniques.[2] Visitor management can be spectacularly successful, but it does require a carefully considered, researched, and individually designed approach for each heritage place or area.

Professor Gale's important studies have general application. They demonstrate how relatively simple techniques can assist in visitor control, but also illustrate the necessity for careful consideration and research prior to the application of visitor-management techniques. Though they refer to rock-art sites, described here, clearly the methodology and the findings have relevance to heritage places generally.

Gale has now conducted surveys of visitor behaviour at art sites in many parts of Australia. She has used questionnaires, interviews, and concealed observation techniques. Her survey techniques are designed to obtain the following sorts of information: the number of visitors at a particular site or complex of sites; the characteristics of the visitor population (for example, age, gender, place of residence, etc.); the behaviour of visitors at sites (for example, what they did, movement, comments, etc.); the attitudes of visitors to the sites visited. She found that some techniques are better suited to providing certain types of information than others: counts of visitor numbers, which provide levels of use of sites; observation of visitors to sites, which can provide basic data on the observable characteristics of the visitor population, as well as extensive data on the behaviour of visitors while at a site; interviews with visitors to provide in-depth information on the characteristics of the visitor population, as well as their attitudes and opinions.

The survey procedure was as follows:

- Determine the information to be sought.
- Inspect the site.
- Decide what survey techniques are to be used.
- Select or devise a computer program.
- Design the survey schedules to suit computerization.
- Test the schedules in a pilot study.
- Amend the survey techniques according to the finding of the pilot study.
- Train a survey team.
- Organize the logistics of the survey—timing, transport, equipment, printing of schedules, etc.
- Undertake the survey.
- Analyse the data.
- Prepare a report on the findings.

She also experimented with different approaches at sites—for example, moving signs, changing their language, providing visible guardians, providing written information, etc.

Gale used teams of students or volunteers. Perhaps the most interesting element of her work was the use of concealed observation to learn of visitor behaviour. Gale found a difference between visitor behaviour and comments on site as observed by her team and as afterwards stated by visitors, and found that there were very definite advantages in concealed observation. This method also allowed for monitoring of guides, talks, responses to questions, etc. She also used standard techniques such as visitor counters, questionnaires (self-administered and formally administered, with interviews).

Findings

Variations in visitor numbers to sites

These were is linked to distances to walk, signposting, and distance off main driving routes. Seasonal changes were also very important. Some sites 'peaked' at weekends; others, more remote, didn't. Periods of peak visitation during the day were also measurable, with mid-morning and late afternoon being the busiest periods.

Characteristics of visitor population

Gale found that the visitor population varied significantly, as did its behaviour. For instance, locals tended to behave in a more destructive and less-responsive manner than tourists. Private and tour groups also behaved differently, and put different pressure on sites.

Assessing visitor behaviour

Gale found that three groups put art most at risk (by touching, scratching, etc.): children, especially in large groups, rather than small parties; organized tours, which tended to be large, uncontrolled, and encouraged to behave inappropriately; local visitors, who tended to act as though they owned the site and were exempt from rules for tourists.

Gale noted that there was also a marked difference in the vulnerability of different sites from these groups.

Assessment of visitor views

Of the Kakadu visitors interviewed 90 per cent found the art 'better than expected', but most did not come specifically to see the art. Most expressed disappointment with its interpretation, and wanted to see more Aboriginal involvement.

On-site behaviour indicated that the visitors were often not interested. Many, judging from their comments, saw the art as primitive or juvenile. The level of speculation about meaning, age and authenticity was high.

Often ridiculous or fanciful meanings were ascribed to the art. Visitors did recognize and pick out particular motifs, and were especially interested to know the age of the art. Inspection of uninterpreted sites by visitors tended to reinforce simplistic or patronizing attitudes to Aborigines.

The art of Kakadu was better received than that at Uluru, possibly because it is more accessible (more readily comprehensible)—'figurative' as opposed to 'abstract'. The information for tour guides was often very poor and racist, and tended to reinforce present attitudes.

Site damage

In general terms, Gale found negative correlation between the number of people at a site and the direct damage (vandalism)

done to it. There seemed to be two elements at work here. If a site was well interpreted (say, by guided tour), then the visitor was well informed, comprehended the importance of the place, and had little urge to damage it. The visitor was also aware of being watched. This effect seems also to occur at places that are not permanently guarded (or guided) but frequently visited. Gale found at her visitor-survey work at West Head in Sydney that the most-visited rock-engraving sites (none were supervised) were least damaged, presumably because the visitor sensed the imminent presence of others.

Managers can commission such surveys or can carry out a lot of the observations, visitor surveys, etc., themselves. For an example of a very simple visitor-observation/survey project and its results see *Grotto Sites in China*.[3]

On-site management

Visitors' attitudes to the heritage place are undoubtedly coloured by the level and type of attention they receive. A pleasant, helpful reception is a good insurance against direct damage. Providing people with things they can take away—good quality souvenirs, books, etc.—adds to their experience, satisfies many people's needs, and will help prevent unwanted souveniring behaviour.

On the other hand, Aboriginal places and rural historic places (mining ruins and deserted towns, etc.) with no permanent custodial presence are particularly vulnerable to vandalism and antisocial behaviour. One way of dealing with this, at least in part, is to make the visitor feel appreciated and welcomed by a well-maintained area, good facilities, a good interpretive programme and a place (a visitors' book) where the visitors can leave their mark.

Visitors' books certainly help at remote sites. They give people somewhere to put their graffiti, they give the appearance that the site is cared for, they record visitor numbers and attitudes, and warn of changes in them. They should contain high-quality site information, as well as a telephone number for more interested visitors to contact.

At such sites barriers of various sorts are often used to keep the visitors at a certain distance. These work well when the

barriers are unobtrusive, they allow the visitors a good view, and are a psychological barrier rather than an actually impenetrable wall or fence.[4] A simple rope barrier or sign, or a formal walkway (also useful for keeping dust down), have been shown to be effective.

In some cases, especially where the place is remote and fragile and has a history of vandalism, weld-mesh grids have been erected over the front of rock shelters containing Aboriginal art. This process has its supporters and detractors. It certainly detracts dramatically from the aesthetic appearance of the place, and from the visitors' experience of its remote, undisturbed nature. On the other hand, when no softer management option is available, it preserves the place until better times. At Mt Grenfell, in western New South Wales, important art sites were fitted with grids in the early 1970s. The sympathetic property-owners, who lived 5 km from the paintings, kept the keys to the gates in the grids, as well as selling tea, scones and souvenirs. They issued a key to visitors after the visitors had signed the visitors' book and provided their car registration number. These tough protection measures, indicating the importance of the paintings, combined with the feeling of privilege visitors obviously experienced at being issued with a key, paid off as a strategy. The paintings were not vandalized, and not even one set of keys was lost.

Signs are a very common visitor-management technique. They are used for information, interpretation and direction. They are most common and necessary in the absence of guides and attendants, and careful consideration of their wording and placement are crucial. Fay Gale's work indicates that official, indeed officious, signs and signs that warn of penalties are effective; but they are most effective when combined with 'softer' interpretive signs.

It is important to let the visitor know quite clearly that particular activities (such as touching rock art or antique furniture), which they might not normally consider to be unacceptable, are not allowed. It is always important, in these instances, to explain the reasons for the prohibition. Often signs are quite inappropriate. They interfere with the visitors' experience. In this instance, other clear means of giving information (brochures, etc.) must be found.

Acts of vandalism, of course, might occur on any heritage place, no matter how well managed and interpreted. The man-

ager must be able to weigh the chances of further vandalism, and its causes, and not react in a knee-jerk way by immediately introducing heavy-handed and inappropriate anti-vandalism devices, or by severely restricting visitor access. Over-reaction to isolated problems may well undo an already effective interpretive programme compatible with the conservation of the place.

The placement and type of ancillary facilities is also important. Picnic areas, restaurants, kiosks or shops, depending on circumstances, can enhance the experience of the visitor, or add to management problems. Encouraging picnicking and camping near an unsupervised place—a ruin or an Aboriginal site, for instance—can add to damage by unsupervised, bored children, rubbish-dumping, and poor sanitary practices, etc. On the other hand, the provision of generally good facilities, and the presentation of neat, well-cared-for heritage places will always be beneficial. In some cases it is most appropriate and useful to arrange for facilities to be provided off-site by a private agent. Within the site, detailed planning and use zoning are often important.

Controlling numbers of people on-site can be done in a number of ways. Limiting group size and duration of stay, limiting facilities (for example, camping spaces or numbers allowed in at any one time), arranging a pre-booking system, and selective marketing of the place, have all been used effectively. A good information system and links with the local tourism authority are very important for the success of such a programme.

Marketing heritage places

Effective marketing of heritage places is a conservation technique often overlooked by managers.

Marketing of heritage places does not necessarily mean increasing visitor numbers through advertising. It really means that the manager has the opportunity to target consumers, and to regulate and control their visits to spread the visitor-pressure on places more evenly, while marketing and improving interpretive and presentation and conservation standards. In many cases the effort put into fending off visitors can much more effectively and more profitably be put into good marketing.

The Historic Houses Trust in New South Wales has carried out an effective marketing exercise, such that its houses are used to full sustainable capacity, an excellent interpretive programme is run, and because of a well-targeted campaign over-use does not occur. The manager, in order to carry out such a programme effectively, does need professional help. Three elements are crucial: a good marketing survey, which indicates the range and type of the market and fits it to the product, and identifies a niche for the product; a good quality product; and an ongoing effective marketing strategy, which might be as simple as ensuring that the right information is supplied at the right place and the right time.[5]

Education and visitor management

Education is a crucial tool in visitor management. Interpretive programmes, signs and guides should all be giving a consistent message. So should tourism operators, such as coach drivers. Yet frequently this is neglected. Gale found that tour operators at Uluru were giving guided tours of art sites, during which they went to places that were off-limits, scratched the art, and gave racist and simplistic explanations.[6] Encouraging all tour operators to be trained in appropriate behaviour and to give accurate information is an important management tool.

At St Helena Island in Moreton Bay, the Queensland National Parks and Wildlife Service has established a licensing system for self-employed guides, who are trained by the Service in the history and conservation of the historic places on the island. The Service then insists that all tour boats visiting the island employ such a guide to interpret the place to the visitors. Parks earn income from the tour operations, and do not have to pay for a large interpretation staff.

The locals, too, should not be neglected. Often (as at Mootwingee Historic Site in western New South Wales) locals feel that they have a particular claim to a heritage place. This sometimes means, in fact, that they treat it casually, allow themselves all sorts of privileges, and are responsible for a high percentage of the damage. Selling the importance of the place locally is quite important.

The manager will use a whole range of techniques in visitor management, and certainly each place will require a different mix for a solution.

At the end of this chapter you will find a list of common techniques for interpretation and visitor management, with some comments and references to examples where these are available.

Interpretation is part of visitor management, but is also often the method whereby the significance of the place is revealed. The next section discusses some facets of interpretation.

The purposes of interpretation

> Interpretation is a communication process, using a variety of approaches and techniques, designed to reveal meanings and relationships of our cultural and natural heritage to the public through first hand experience with an object, artefact, landscape or site.[7]

On-site interpretation may include a guided tour, a leaflet, a furnished room, a sign, a display of historic crafts, a 'living history' re-enactment, an audiovisual, a display at a visitors' centre, a reconstruction or model, a self-guided walk or drive, information obtained from an attendant or custodian, do-it-yourself activity programmes, hands-on computer programs, and personal audio or video cassettes. Interpretation may be part of the fabric—a room restored in a certain way, with written or related information about the furniture or the restoration, for example—or may be separate from it but relate to it—an explanation of the heritage place on a display board or in a leaflet, or a model or map in a visitors' centre.

On-site interpretation may be elaborate or simple, static or interactive, specifically targeted or generalized. It may relate to the whole place, or to selected aspects or themes within it.

The manager needs, or wishes, to interpret places because their meaning and significance are often difficult to grasp without such interpretation. Hence, the manager uses interpretation to enhance the visitors' understanding and appreciation of the place and the experience of visiting it. This may range from a simple explanation—a site map of a wool scour, for instance, showing features and explaining their functions and

origins—to a complex interpretation of the place—the history of the wool scour, the social setting of the operations, the role of wool in the Australian economy, changing technology, modern methods, the archaeology of the place, and its history as a heritage place.

The manager may also consciously wish to use the place to convey a certain message, or a lesson that does not relate simply to the physical attributes of the place, or to its significance. (The manager, as we shall see below, will very probably convey such a message in any case, unintentionally or unconsciously.) Such a message is usually didactic and aimed at changing visitors' views or values. For example, an Aboriginal site may be used as part of a school course aimed at teaching children about the richness and variety of Aboriginal culture and, ultimately, at changing attitudes towards Aborigines today.

Sometimes the argument is put by managers that 'a place speaks for itself' and needs no interpretation. This is, in fact, rarely the case. A place may speak to the *cognoscenti*, but it will say different things to different visitors, depending on their individual background. Few of the things 'read into' the place without interpretation will increase or alter the visitors' understanding of the place or its associated messages, and indeed inaccurate, and even negative, perceptions may be reinforced by going unchallenged.

Interpretation in Australia

The United States, Canada and many European countries have long had active and wide-ranging interpretation programmes. Since the 1930s the Parks Service in the United States has run a nationwide heritage interpretation programme, with visitors' centres, guided tours, and living-history programmes. These have been developed according to a thematic list, which identifies the major themes in US history to be interpreted by heritage places.

By contrast, Australia's efforts in this field have generally been sparse, disorganized, and concentrated on a very narrow range of places.[8] A short, and often undervalued, European history, and a little-understood or dismissed Aboriginal one, coupled with a sparseness of population, has meant that little or no

interpretation has occurred at many heritage places, for the basic reason that until recently few of them were actually valued or conserved.

Until the 1970s the places that were interpreted tended to be National Trust properties, which often reflected the finest colonial (British) traditions, and which were lovingly furnished with the finest furniture available—interpreted, in fact as splendid antique shops, with only the price-tags missing. (Visitors, none the less, have been known to make an offer.) Thankfully, the last decade has witnessed a significant change in emphasis in most parts of Australia.

Except in so far as the refurbishment of fine colonial houses could in itself be called a theme (the posthumous gentrification of our ancestors?), interpretation has also been disorganized, with no regional or state overview plan, or thematic approach, and with each separate authority (National Trust, Historic Houses Trust, local historical society, etc.) pursuing its own interpretative plan with no regard for duplication, or gaps in particular areas of presentation.

Meredith Walker has pointed out that, in fact, presently there is no way of determining at a national level what the stock of overall interpreted heritage places is, and therefore what picture is being portrayed, what is missing from this picture, or what our future interpretation dollars should be spent on.[9] Additionally, in this field, like the field of conservation, until recent times there has been a marked lack of involvement by professional historians, who have not generally contributed to the interpretation of heritage places and, through them, to the education process. Popular history and interpretation—practised at the grass roots by local historical societies—have become divorced from academic rigour and from regional and thematic history. This has become more marked as the popular heritage movement has developed.[10]

Aboriginal places have also been neglected. Though they represent at minimum 60 000 years of Aboriginal history, and are, in that sense, of much greater significance than European sites in Australia, the attention they attract within the heritage movement is almost in inverse proportion to this significance. White society has assumed custodianship of such places, but has marginalized their significance. Their interpretation is often non-existent, or when it exists it relates purely to archaeological

elements, or is patronizing and simplistic. Some sites—for instance, massacre sites—have been ignored, or in some cases destroyed, in a deliberate attempt to make the memory of the event 'disappear'. Others have been interpreted without consultation, and against the wishes of their Aboriginal custodians.

Recently, things have changed. The increase in interest in the heritage movement, and the tourism boom, has led to a great increase in interpretive progress at all levels across Australia. At the same time, the growth of heritage authorities, and of professional organizations such as Australia ICOMOS, has meant that the interpretation process is being more professionally planned, and that its tenets and practices are being more rigorously examined. Though there is as yet no 'Burra Charter' for interpreters, it is possible to perceive the growth of a number of agreed-upon principles and practices (co-ordinated by bodies such as the Australian Museums Association), which an increasing number of managers and interpreters would endorse.

Ideology and interpretation

There is a growing realization that interpretation practices have often been biased and simplistic. The properties interpreted to date have tended to mythologize and gentrify the past and our ancestors. They portray a world in which we could imagine ourselves living in colonial elegance, or as noble pioneers. The nineteenth-century landscape is eerie indeed as it is portrayed in many heritage properties—a fabulously elegant and well-bred upper class, inhabiting colonial palaces, and served, apparently, by an invisible army whose lives are rarely portrayed. So, instead of history we often have a nineteenth-century fantasy.[11]

This arises from the way in which certain properties are interpreted, and from the selectivity of the places chosen for interpretation. These days, heritage managers are looking rather more self-consciously and critically at their aims and methods. They are seeking professional historians' and interpreters' advice and assistance, and are looking more carefully at the message they are attempting to portray. The initial step is the realization that there is no such thing as the 'truth' about the past; only our subjective interpretation, now, about what happened in the past.

We will never have all the evidence to re-create the past, only at best artefacts that give us clues and documents giving us past interpretations of it, which we then reinterpret. Further, our interpretation of this evidence is inescapably ideologically based. It arises out of our perceptions of the world and our value system. An example of this, in Australia, is the very common ideological concept of 'progress' as it is applied in history. The 'progress' of European civilization—the privations of first settlement, the crossing of the Blue Mountains, the spread of the squatters, the discovery of gold, the growth of population, the attainment of nationhood—are seen as important themes in our history that show an inexorably upward 'improving' trend: and our heritage places commemorate and celebrate many of these achievements. Yet we can turn this on its head, if we have another ideology and interpret it as the gradual destruction of a society, and of the last habitable continent to be exploited by the industrial revolution. Note that neither interpretation is 'wrong', but also that neither is 'true'.

> Ideology appears to be real because once people have been socialised to incorporate it in their lives, they use it to define their world according to the givens of everyday life. Ideological constructs include time, history and the idea of knowledge as independent of the society which produced it. Despite the fact that it is widely known that history and historic events are presented through the eyes of the victors, many people simultaneously believe that a completely accurate account of the past can in fact exist. [12]

This has clear implications for interpreters. It is crucial, on the one hand, that they accept that they are prisoners of ideology, and that they self-consciously, deliberately and critically examine their work in this area. It is also crucial that they convey their message in such a way as to make the visitor aware that what they are seeing is an interpretation, rather than 'the truth'.

This is not to say that it is wrong to be didactic, or to use places to provide a learning experience, or one that is aimed at changing values. An American programme developed in Annapolis in the 1980s takes interpretation to its logical end—the programme is designed to demonstrate to visitors the various possible interpretations of the past, and the fact that any interpretation is an ideological construct.[13]

Interpreting the place in context

At present, many historic places open to the public are cut off from much of the intellectual and cultural background of which they are, in fact, a product. In this respect there are some similarities between the processes of management of historic places and those for Aboriginal sacred sites or sites of significance. European managers, often with the best intentions, have acted to conserve individual Aboriginal places, without recognition of the fact that the sites are merely pinpoints or markers in a sacred or significant landscape, and derive their significance from it. In the same way, historic sites, cut off from their cultural landscape—the local, regional and wider history and its ongoing study—lose a great deal of their significance, richness and depth of meaning.

One way of dealing with this is to ensure that the place is interpreted in its regional historic context, and that it is related to other similar sites and places. This will usually require the services of a professional historian or archaeologist, who can place the site in its cultural context.

In some areas (South Australia, for example) use is being made of regional and state-wide themes for the interpretation of historic places, as described in Chapter 4.[14] By this process regional histories are developed, and from them a series of themes, which covers the major significant area of the state's or region's history. Following this, a number of places are selected and consciously interpreted to explicate one of these themes, or part of it. Thus, for instance, a place that demonstrates women's life on the frontier in the nineteenth-century, or the history of goldmining in the arid zone, might be chosen, and so interpreted.

Such thematic treatment can be conceptually and practically useful if not taken too seriously or adhered to too rigidly. It can provide a coherent story, and ensure that all significant areas are covered, and it can prevent unbalanced concentration or duplication and endless 'antique collecting'.[15]

Thematic lists, as such, have limitations, however. Obviously the thematic process does not automatically guard against bias. It is by nature selective, and such a selection is inescapably based on ideological principles: 'I'll give you an example of the ideological nature of themes. In NSW you could call the same historic

process you wanted to outline in the period 1788 to 1850 "The Spread of Settlement" or "Guerilla Warfare on the Frontier".'[16] And what are we to say of the US Parks Service thematic treatment of native American people today, which it titled 'Living remnants'?

Rigid application of the thematic principle can also lead to loss of opportunity and spontaneity at the grass-roots level, and sometimes to the inertia of a bureaucratized system. It may also take on a life of its own, with heritage places selectively interpreted or with one of their elements overstressed, to fit a regional or thematic mould with a consequent diminution of other significant elements of the place in the interpretation process.

Some historic themes are not very well interpreted by places, or at least may be better interpreted by some other means. In some cases no places exist that are relevant to particular themes, and an element of artificiality or irrelevance results in attempts to too-rigidly adhere to a thematic framework.

Interpreting the market

It is also clear that the use of the historic themes to provide a full heritage experience is not enough, since it is a one-dimensional approach to a multifaceted problem. People not only want to learn about a range of things, they want a range of experiences and a range of locales, and they are a segmented not a homogeneous group. What is required is an approach, at a state or regional level, similar to the recreational opportunity spectrum approach used in recreation planning. Hence, at a regional level, in order to properly plan a successful heritage interpretation programme that is comprehensive, integrated, accessible at a number of levels, cost effective and with measurable success, we need access to a matrix of factors. We need information on the historic/heritage themes we wish to interpret, the properties available for interpretation and those already being interpreted (the gaps and opportunities), and on customers—who they are, what they want, how far they will travel, what their idea of a heritage experience is. If we have this information, we can plan for interpretation at a regional level, in the case of an administrator, or, in the case of a heritage place manager, we can fit our heritage place into this spectrum, and provide an

experience lacking elsewhere, which our customers will appreciate and use. We might even make some money.

Doing such an analysis does not mean that the manager is bound to provide the interpretive theme most favoured by popular opinion. As we discuss below, the interpreter may have a particular theme for the site, dictated by its significance, which might also dictate the limits of interpretation. However, a cardinal rule of interpretation is the necessity to move from the known to the unknown. An interpretation that does not somehow relate to the needs of the visitor will not succeed. With these needs as a starting point, the interpreter can market the message accordingly. In fact, since what we want to give people is often not what they want (in the sense that it is presently beyond their knowledge and experience or, in fact, may be opposed to their present value system), it is essential to anchor it in the familiar and current, and work outwards from there.

Pitching the message at the right level is very important. It has been pointed out that most people do not go to heritage sites or national parks to learn things or to change their value systems: they go to recreate, to re-establish links with their families, to pass the time, or because there are no other recreational options. Hooking into their needs is a complex process, and one requiring careful consideration and research.

Interpretation and cultural significance

The significance of the heritage place is as central in interpretation as it is in conservation. In many cases, interpretation planning is part of the conservation plan: the place is often being conserved for interpretation, or display, and the effect of interpretation will be one of the considerations of heritage planning. In any case, it is now recognized that interpretation should be preceded by significance assessment and conservation analysis and planning. This is to ensure that interpretation does not jeopardize the significance of the place, but rather articulates it and makes it more explicit.

Interpretation can jeopardize the place's cultural significance in a number of ways. It may cause physical damage by encouraging over-use or the conservation of only particular elements. A definition of the limits of acceptable change to the place, along

with an analysis of the effect of visitor-use, should be a pre-requisite of any interpretation programme. If the interpretation is going to damage the place, its atmosphere or its setting in such a way as to diminish its significance, then clearly it should not proceed.

The interpretation approach may distract from the place's significance by calling attention to minor elements at the expense of this significance. For instance, a historic house may be very lovingly restored with the very best period furniture available, which is interpreted in detail by enthusiastic guides, but this may detract from its real significance—for example, its role as a relatively simple family home—and give visitors a false impression of nineteenth-century life. Additionally, the kitchen or out-buildings, settings or garden may be ignored.

Good interpretive practice dictates that all significant elements of the place are available and perceptible to visitors. This does not mean that it is necessary to stress all elements equally, but it does mean that a balance must be struck between, for instance, the use of historic themes on a regional basis and the particular significance of the place. As we have seen, both are necessary, and information about both is a prerequisite for an effective interpretation programme. Interpretation of the place in its cultural landscape and context is the ultimate aim, and a prerequisite for any ancillary messages—for example, the value of conservation generally (the commercial message from the sponsor).

Aboriginal place interpretation

Aboriginal heritage places do not immediately relate to most visitors' own cultural experience and background. Revealing their significance is a particular challenge. A nineteenth-century white settler's cottage is much easier to understand than a rock shelter with a floor of grey coloured sand, referred to as an 'occupation site'. Often Aboriginal places are not even perceptible as such until located and explicated by a specialist such as an archaeologist, or by the local Aboriginal community. When they are identified for visitors they are often visually disappointing, and difficult to understand. A scatter of stone artefacts, in a featureless landscape often looking to the lay person like any

other stony patch of ground, is not, of itself, stimulating or exciting. Interpretation of many Aboriginal places is for this reason probably more necessary than it is for European historic places, and is certainly more of a challenge.

In these circumstances, it is often a temptation to 'tart up' a place. However, the subtle and unobtrusive nature of places means that sensitive and low-key interpretations will be most suitable. It is fatally easy to drown the site in its interpretive facilities. In terms of conservation practice, 'restoration' or 'adaptive use' of Aboriginal places is usually inappropriate, although interpretation for visitors in itself may be an adaptive use.[17] It would clearly be spurious to reconstruct an Aboriginal campsite from a scatter of stone tools, or a fully-prepared ceremonial ground from the remains of an earth ring. In Burra Charter parlance, and in accordance with its principles, preservation or stabilization is usually the appropriate conservation technique for an Aboriginal site. This, in turn, has implications for interpretation, which must be imaginative enough to bring the place to life, but not so inventive or speculative as to be untrue or misleading. It is understandable that Aboriginal sites would not be as comprehensible or as emotionally significant to non-Aboriginal Australians as places relating to their own history in Australia. Making such places, and the culture they represent, relevant and significant in mainstream Australia is one of the challenges of Aboriginal site interpretation.

Commonly these days Aboriginal cultural centres—a combination of a visitor centre/museum and a place for cultural activities—are set up in association with Aboriginal places, and run by the Aboriginal community. Such centres have the advantage of ensuring Aboriginal interpretation of the places, and of allowing the visitor to appreciate the integration of the place with other aspects of Aboriginal culture.

Interpretive techniques

Over-interpretation can swamp any site. The high-tech visitors' centre, with computerized information and other gimmicks, may detract from the real experience; in fact, may make people feel that they do not need to visit it.[18] In the same way, 'designer' interpretation may produce visitor 'oohs' and 'aahs' for reasons

more related to technology and aesthetics than to heritage interpretation.

Some places may need no interpretation. The 'as found' experience may be the most valuable a visitor could have, jeopardized even as it may be by signs and explanatory boards. There are occasions when people feel the need to discover things for themselves, and feel perhaps that they are discovering or seeing something not usually on display, something that is 'their find'. Such approaches, however, are usually based on the assumption that visitors have sufficient knowledge or established cultural context to be able to recognize and understand what they are seeing. In many areas this knowledge is given off-site at a generalized, non-site specific level by the manager, for example as part of a familiarization display at a visitors' centre at a park entrance.[19]

Many places require quite detailed research to provide the information necessary to interpret them. Archaeological sites relating to European history, and prehistoric Aboriginal sites, about which there is no living Aboriginal tradition, rely on archaeological investigation to explicate them. Without this, often we can say very little about them. So scientific investigation (following Aboriginal consultation where appropriate) is commonly a prerequisite for interpretation of such sites. The findings, while exciting to the specialist, can be dry, impersonal, or too technical for general consumption. They are often hedged with so many uncertainties as to be almost meaningless. The interpreter has the difficult and delicate job of translating these findings into comprehensible or interesting information, while not oversimplifying or overstating the evidence.

In some cases, large amounts of information are missing. At historic places it may be that most of the original furniture or fittings have disappeared, or that parts of its history are quite unknown. Once again, there is a fine line between giving the visitors a glimpse of the imagined past by replacement or restoration and hoodwinking them into believing that they are looking at the real thing. This is a matter that is receiving increasing attention. One experiment has been the introduction of grey 'ghost' furniture and other items into houses where the original furniture and information about it is missing. This is to indicate the use and manner of use of the room, while at the same time clearly drawing a distinction between the real and the imagined.[20]

In the same house, the methods of conservation itself are revealed by leaving squares of preserved material and doing an interpretive presentation about original versus restored or re-constructed fabric.

There is, of course, a limit as to how much purism and critical conservation evaluation the general public is interested in, understands, or is prepared to take. Once again, intellectual rigour must be balanced by common sense, and the common touch.

> On the opening day of Dundullimal a few weeks ago, for example, I was busy examining albums of historic photographs in the main sitting room when a visitor entered, explaining to her rather numerous progeny that the furniture may be grey because Dubbo was a long way from Sydney and they didn't have very many colours available in the old days.[21]

This is not to say that it is never right to re-create a scene or a room for the visitors, or that 'original' and authentic material is always necessary. This depends on where the significance resides. Richard Mackay's useful distinction between form and fabric, which has relevance for both conservation and interpretation of places, is quoted in Chapter 6. He points out that in making decisions about the interpretation of a place it is necessary to decide whether its significance resides in the form, or the fabric, or both.

Often a whole historic town or village, or indeed a district, is 'interpreted' as part of the local authority's tourism marketing. This can have the effect of conserving key elements of heritage—streetscapes, nineteenth-century industrial sites, etc.—but can also lead to oversimplification of the listing of a locality, or worse can turn it into a 'toy village' without authentic life, and which is effectively lost to its inhabitants who often are made to feel like part of the display. For interpretation, as for other facets of management, the locals' involvement, and indeed active participation, is advantageous.

It is important to reiterate that the interpretation of heritage places does not have to be complex or costly. In many instances simple, cheap approaches are all that are required, work very effectively, have least impact, and do not need a lot of professional expertise or input. Simple demonstrations, self-guiding

walk and leaflets, interpretative signage or a visitors' book with explanatory material may be all that is required. All managers have basic interpretive skills and many have very developed skills, in this area.

On the other hand, consultants, historians, prehistorians, interpreters, designers and marketing people can all be useful on occasion, and are sometimes necessary. There are a few rules for the use of such consultants.

Use of consultants

It is important that the manager stays in control of the process. The manager must have a good idea of the aim of the interpretive approach, its scope and cost, design a tight brief, and oversee the programme closely. The manager, informed and assisted by appropriate expertise, will have to make the crucial decisions as the design develops. None of the consultants are managers and know the place's management needs—this is the one crucial skill that will make the programme work, and which the place manager must supply. It is important also to know what consultants can and can't do. Historians, prehistorians and archaeologists can provide information on which the interpretation is based. They will not necessarily be able to put it in digestible form or to display it effectively. This is the job of the interpreter and/or the designer. They, in turn, cannot be relied upon to get the facts right, and their work must be back-checked at all stages with the technical experts. The marketing consultants can tell you what will work in terms of attracting visitors, and can also tell you how to attract or cater for various segments of the market, but what they advise will not necessarily be appropriate, manageable, or in keeping with the place's significance.

Summary advice

Heritage place interpretation should be preceded by, and should not conflict with, significance assessment and conservation planning.

Heritage place interpretation should interpret the place in its cultural and regional context, and should complement the interpretation of other places within the region.

The significance of the heritage place should be a major consideration in its interpretation.

The interpretive programme should not jeopardize the significance of the place, and should articulate and explicate that significance.

All heritage place interpretation should be preceded by an assessment of its potential impacts on the place and its significance.

The interpreter should clearly state the aims of the interpretation programme, and should be aware of the subjectivity of the process.

An interpretation programme should provoke questions and interest, as well as simply supplying answers.

Local people, and especially those with custodial or traditional rights and interests, should be consulted about the interpretation process, and should be involved in it if they so wish.

The interpretation must be based on factual, specific information about the place. It must identify speculative elements, and distinguish between original elements and replacements or mock-ups.

The interpretive programme must relate to something within the personality or experience of the visitor, and must fulfil the visitor's needs at some level.

The interpretation should complement and add to the visitors' experience of the site—not distract from it, or drown it out. It should be pitched at the appropriate level, usually the simpler the better.

Appropriate professional assistance will be required for some interpretive approaches.

A marketing strategy should be an integral part of the interpretation programme.

Planning for interpretation and visitor management

1 Prepare a preliminary statement of interpretive aims.

2 Gather information about the significance and conservation policy of the place; its regional significance and cultural context; the type and thematic scope of interpreted properties in the region; the existence and interest of special-

interest groups, descendants, custodians and locals; the needs of visitors or potential visitors—number range, group size, type, interest, geographic spread, mobility, mode of access, etc.

3 Determine the funding and resources (personnel, etc.) likely to be available for the programme.

4 Collate and consider the information gathered to refine the aim and scope of the programme, so that it is well defined, appropriate and practical.

5 Prepare a brief or prospectus that outlines the aims of the interpretation. It should define the theme(s) and intent of the interpretation (what is the proposed message?); the proposed level(s) of communication and their intended audience(s); the intended outcome; anticipated effects on site management.

6 Consider some alternative media for transmitting the message, in accordance with the budget; for example, visitor centre—self-guided walk; pamphlets—a guide programme; furnishing as a house museum; display excavation; display of traditional crafts; special marketing.

7 Consider the requirements of place management and visitor management when the interpretation programme is installed, and plan some alternative management techniques to deal with potential problems resulting from the programme; for example, zoning, tracks, signs, maintenance requirements, etc.

8 Carry out an impact assessment of the proposed interpretive medium and management strategy to establish short- and long-term impacts on the heritage place.

9 Review long-term costs and benefits of the interpretive programme.

10 Establish personnel and resources requirements.

11 Review your programme in the light of points 8, 9 and 10, and finalize planning and design for the programme.

12 Design and implement a monitoring programme.

All or part of this approach may require specialist assistance. Consultants can lock in at any stage of this process or can be given the whole brief.

It is also clear that the aims of the interpretation programme may need refining and varying as the planning proceeds. However, the manager should take care to keep control of the project and its planning. The manager should clearly define the interpretation programme's aims as an initial step, as they are perceived at the beginning of the process; be closely involved in supervising the brief, and in the process by which the aims are refined and finalized; and be aware of the management implications of the implementation of the proposed interpretation programme.

Some techniques for visitor management and heritage place interpretation

- Visitor assessment

 This is an ongoing requirement of visitor management. Information on the number, expectations, and behaviour patterns of visitors is vital. It can be a commissioned survey, an in-house survey, or information gathered from a visitors' book. Proposed and new measures of visitor management should be tested with visitor surveys and observations.[22]

- Monitoring

 Heritage places should be monitored regularly for evidence of attrition and damage, so that use patterns and visitor numbers can be altered or other remedial measures taken.[23]

Physical restrictions/protective measures

- Indicative barriers

 Low fences, roped-off areas, handrails, clearly marked paths, etc., if well designed and placed deter a large percentage of visitors from leaving defined paths. They do not work well if they are too numerous, or prevent people from seeing something clearly or getting relatively close to it. Often used with signs.[24]

- Person-proof barriers

 Weld-mesh grids over rock shelters, high fences, locked gates, mesh or perspex barriers across doorways in buildings, etc.,

are used to protect places where surveillance is usually not possible. Key features include provision for access or removal of the barrier when necessary, for maintenance, viewing, care of archaeological deposits, etc. They should be accompanied by good interpretive signs explaining the place, and the reason for the grid or fence. They are a last resort for aesthetic and other reasons,[25] but have been successful in some instances.[26]

- Walkways and pathways

 These can be used to guide and direct visitors, to protect fragile surfaces (for example, rock engravings), to prevent erosion and dust problems, or to avoid traffic over dangerously uneven surfaces, or to give access to areas not readily seen from ground-level. There is a potential problem with their visual impact on some places. They are usually used at Aboriginal sites, but have also been used, for example, in the penitentiary ruins at Port Arthur (Tas.). Care must be taken in their installation. They must be removable, and designed with aesthetic sensitivity. They should allow for larger grouping areas at key spots where visitors will congregate.[27]

- Visitors' books

 These are very useful at remote spots where they are the only contact with the visitor. They can serve as interpretive devices, as outlets for visitors' feelings, and as a check on numbers.[28]

Use management

- Pricing regulation policy
- Limiting group size
- Limiting facilities
- Limiting accommodation type and accommodation availability
- Booking procedures
- Selective marketing or advertising

 All of the above methods (and more) can be used to control the number and type of visitors, the duration of their stay and to even out peaks and troughs in visitor numbers.[29]

- Siting of facilities
- Zoning of areas within the site
- Control of access points

 These methods can be used to control and regulate use within the place to enhance visitors' experience, and to minimize damage.

Information, interpretation, motivation, direction

- Attendants and guides

One of the best methods of protecting a heritage place is to employ well-trained, well-motivated staff.

- Demonstrations:
 - craft
 - living history, conservation in action

 These are used extensively in the United States and can be effective if not overdone.

- Visitors' centres

 These should be simple, and should direct visitors to the heritage place, rather than becoming an end in themselves. They can be used to manage visitor movement, etc., by direction, and must be effectively sited to catch visitors, and not to impinge on heritage places.

- Interactive programmes

 Re-enactment, exploration exercises, etc., are used extensively in some children's programmes.[30]

- Self-guided walks, drives, etc.

 These should be well sign posted and should include good quality information available en route and specific to the particular point of interest (brochure, interpretive signs,) etc.

- Signs—informational, interpretive, or directional

 These must be carefully chosen, designed and placed. They are often used with other measures.[31]

- Static displays, re-creations, restorations, including
 - re-creations of settings (furnished houses, etc.)
 - displays of original conserved fabric (often excavation, original house furniture, etc.)
 - displays of associated artefacts (excavated finds, or historic persons possessions, etc.)
 - displays of conservation/exploration processes (how the site was excavated, or conserved)

 These are the most common forms of interpretive display, almost always at heritage places with curators or staff. They are often included with living history, craft displays, etc.

- Sales outlets: food, souvenirs, crafts, associated literature, material related to other local attractions or to the authority or organization running the place

 These can be run by the authority or by concessions. They should enhance the visitors' experience and the place's interpretive aims, rather than distracting from them.

- Marketing/advertising

 Effective marketing can control numbers, type, duration, the interest of visitors, and can allow more effective planning and targeting.[32]

 8

Some Current Issues and Future Concerns

The structure of this book has followed the outline of the processes of the Burra Charter. This has distinct advantages for the users, especially if they wish to use this book in their planning processes. This is what it is primarily intended for. However, one result of this is that there is an inevitable streamlining or 'idealization' of the processes of heritage conservation, and perhaps an over-simplification of some of the issues. In fact, the heritage conservation movement today is complex and multifaceted and developing rapidly, and part of it comprises a vigorous and ongoing debate about the profession and a constant reappraisal of issues of theory and practice.

During the last decade, much has changed in the field of heritage conservation. The movement has grown and strengthened, with the introduction of legislation and administrative systems in all states of Australia (except Tasmania), and an exponential expansion in the level of popular interest in cultural heritage conservation issues, especially at the local level. Allied to this has been an increasing recognition of the economic and social value of heritage, along with the growth of sophistication in the academic examination and analysis of the rationale for the practices involved in heritage conservation.

Some of the issues and concerns that have faced conservation practitioners for years are now being also addressed by those

working in other fields, and the cross-fertilization of ideas is one of the most promising prospects for the coming decade. Emerging trends such as these form the basis for the healthy debate and reappraisal now under way. This chapter discusses some of the current issues and future concerns with which practitioners and theorists are presently concerned.

Heritage practitioners and heritage in the community

The heritage movement in Australia focused initially on the conservation of heritage buildings; especially those that related to the origins of European colonization, either by way of commemorating important people, or, more commonly, as architectural gems that characterized colonial adaptations of the English tradition. Hence, we have a strong tradition in the heritage movement of valuing architectural significance (especially grand architecture) and, arising from this, a concentration of effort on the conservation of fabric. Interestingly, this has been the trend not only in the conservation of the European heritage but also in our consideration of the conservation of Aboriginal places. Such a tendency is in line both with the materialist outlook of modern Western society and with our traditional views about the importance of our colonial heritage.

Over the past two decades, however, the understanding of heritage values has matured considerably, and it is still developing. One aspect of that maturing view is the realization that many heritage values are not as fabric-based as was previously thought, and that there are much more subtle ways in which places possess meaning for communities. Fabric has been the focus for the professional conservation specialist, because that has been the basis of the discipline and training. The community, however, might derive meaning and pleasure from the place in a much more multifaceted way. Some of the value will certainly be represented by the fabric in many cases, but it can also be in the spaces between the fabric, or in the traditional use of the place, or in the special and personal associations that reside in the individual's mind and memory and nowhere else. Individuals in our society don't subdivide and analyse why they value a place, they just do; and practitioners have to accept that society's

values system is likely to be a rich, and perhaps chaotic, amalgam of the neatly compartmentalized value types we have described in this book. For the community, 'passion and significance erupt at the intersection of lives and places'[1] rather than coming out of a rigid analytical framework.

Learning about community values calls for different skills. Much work is being done in developing ways of assessing community values,[2] and it is certain that aspects of the approaches outlined in this book will be modified or changed totally by these developments over the next decade.

Ten years ago a heritage survey commonly revealed 'the most important' buildings and precincts—usually on the grounds of their being good examples, in good condition, of a range of architectural types. Today the best heritage studies create, as a result of a partnership of keen experts and locals, a web of history and meaning for a town or suburb, of which fabric is an important component but by no means the only one. Another reason why 'fabric' is not so pre-eminent as it once was is that historians have entered the debate on heritage, and have addressed the question of historic, as opposed to architectural, significance. This has meant that the place and its context, and its role in the local and regional story, have been much more clearly articulated.

Similarly, Aboriginal notions of spirituality, and of the sacredness inherent in the landscape itself have had a significant effect on our heritage practice.

Despite these advances, still inherent in this practice is often an untested assumption of the pre-eminence of fabric as the most important element of our heritage. One way of demonstrating this is to compare the amounts of money still spent on fabric conservation with the amounts spent on identifying and conserving places of social value.

The Burra Charter itself reflects its origins (the Venice Charter) in this regard. In its newest incarnation (*The Illustrated Burra Charter*) it is a most helpful and user-friendly document. Its statements about significance assessment clearly draw our attention to a variety of types of significance; but the descriptions of conservation practice that follow are still rather fabric-bound. They do not fully explore the issues discussed above; nor do they provide sufficient detail on conservation practice of values not essentially tied to fabric conservation.

This is not to say that the manager should put aside conscious considerations about appropriate fabric conservation; or that the difficult question of an appropriate level of restoration should be abandoned. An understanding of and respect for the processes of the Burra Charter are still an essential starting point; and it is easy to 'throw the baby out with the bath water' (or the significant elements of fabric out along with the insignificant) by disregarding or playing down significant fabric with the poorly-researched or ill-considered excuse that it is, in fact, not significant.

Another problem with the Burra Charter, as it stands, is that it does not fully address the issue of conflicting values. The Charter states that all the cultural values of a place should be taken into account in the provision of a management solution; but this is sometimes not possible.

A good example of this is the case of the Swan Brewery in Perth. The Brewery is an early European building of some distinction, with significant connections with the growth of Perth and its industry. It is also, indisputably, an Aboriginal sacred site, first documented by Europeans in 1838, and still of importance to a group of local Aborigines (for a description of both values, see Stapleton[3] and Vinnicombe[4]). For many Aborigines the only way to conserve (or restore) the significance of the site is to demolish the buildings. Yet for both the past and present WA governments, as representatives of the modern Perth constituency, restoration of the building is the most appropriate way to conserve its major significance. This is not a view shared by many of their constituents, who clearly see the incongruity, irony and unsatisfactoriness of the solution.

Here there is a direct clash between aspects of significance and their management. This is an unusual case, but it points up the growing technical and political complexity of heritage assessment and management brought about by the claims of an ever-widening diversity of groups in our society, seeking recognition of their heritage, and appropriate management of it.

Practitioners need awareness and guidance (rather than rules and lists) to venture into this territory. With these issues in mind, Australia ICOMOS has been commissioned by the Australian Heritage Commission to hold discussions with its members, and to come up with suggestions for dealing with aspects of multiple values at heritage places, especially when there is a potential for their management to be in conflict.

Our cultural heritage empires also set up conflict and tension between the centre and the edges—between the heritage bureaucrat and the ordinary person, and between the expert and the ordinary person. Increasingly, tension between bureaucratic methods of making conservation decisions, and the feelings within the community about it, are becoming clear, and are leading to a reappraisal of work methods. There is, increasingly, a feeling of resentment at the 'edges' relating to the centre— the ordinary members of the community are inclined to feel alienated from decisions about their heritage made at another level, often without consultation, and often unintentionally excluding local input.

The idea of carrying out regional assessments of values has steadily been gaining ground over the last ten years. Heritage studies addressing this have now been undertaken, and, as described earlier, the Australian Heritage Commission has now embarked on the assessment of National Estate values at a regional level. This combines an assessment of natural and scientific values with aesthetic historic and social values, and leads to an integrated view of all the conservation values of a locality or region, in large part through consultation with the local people.

Academics and heritage

Academic developments in a number of fields (history, archaeology and cultural theory, for example), as well as specific courses in heritage studies, all have important implications for the heritage practitioner. In particular, cultural theory has a lot to say about the phenomenon of the heritage conservation movement, its origins, foundations and rationale. This often takes the form of a critique of current methodology and the assumptions underpinning it. The direction this might take the heritage assessment process is to make it look more at the world of symbolism and meaning, and to rely less on the traditional assessment of morphological, stylistic or technological attributes of the fabric.

Similarly, historians have had much to say lately about the relationship of history to heritage studies, and the necessity of adopting an historical outlook in grappling with the significance of a particular place.

These contributions have enriched and given depth to cultural place assessment in a number of ways, as illustrated in the articles in the *Public History Review,* volumes 1 and 2, and in John Rickard and Peter Spearitt's *Packaging the Past.*[5]

On the other hand, it is clear that there is a sometimes worrying gap between the academic and the popular heritage movement. Neither has the 'truth' or the answer, but the problem seems to be that, while the expert increasingly strives for methodological purity, popular culture moves towards the emotion and the mythology of heritage.

There is a tendency for academic articles, and indeed for displays and restorations to illustrate the esotericism and correctness of professional practice—the exercise is sometimes aimed not at the community but at the academics' or practitioners' peers: 'Heritage practitioners became the gate keepers of "public" history, privileging histories that have been produced within the discourse, marginalising those which have not'.[6]

There is a need for more dialogue, and more exchange between academic and manager, in the field of heritage conservation to ensure good practice and to strengthen the link between the intellectual cultural critique and the actual cultural landscape—what we could term the self-conscious and the unconscious elements of cultural heritage.

Immigrant, ethnic, Aboriginal, woman—the minority heritage

Of course these groups do not comprise a minority; they make up the majority of our population. However, it is a commonplace that their history is under-represented and over-simplified in heritage conservation practice.

The issue that has been concerning a number of heritage authorities is how to expand the concepts and practices of the established heritage industry to accommodate the heritage of an increasingly multicultural society. Heritage value to the large number of cultural groups now comprising a substantial percentage of the Australian population is often not associated with buildings and places but with cultural tradition, and with the

retention of a knowledge of why they came here and what they left behind. This urge to retain traditional culture is the same as that which stimulated many Anglo-Saxon immigrants over the last 200 years to create images of Britain in Australia, to introduce new plants and animals, and to retain antipodean versions of 'old country' traditions and practices. Many of us, as descendants of those earlier settlers, have a different perspective on those efforts, but still see them as being part of our heritage—just as succeeding generations of other groups of immigrants will presumably have a different view of their forebears' heritage in time to come. The melding of individual cultural tradition and heritage into the heritage of the combined population, or conversely the retention of a pluralist heritage of Australia, is one area where there will be much thought and debate over the next decade.

The fact that the more recently arrived cultural groups have not yet created (and indeed may never create) many buildings and places that they will regard as being their heritage, makes it difficult for the heritage establishment to incorporate their heritage into the standard approach to 'mainstream' heritage place conservation. What is called for is a more integrated approach in co-operation with ethnic communities, their support organizations, museums and others to find new ways of recognizing the heritage of different cultural groups, and assisting them to celebrate, enshrine, mourn or enjoy that heritage as they best see fit. Some pioneering work has been started in this field, such as the programme of support and assistance undertaken by the Immigration Museum in South Australia, which set aside space where immigrant groups could present and commemorate their own history of becoming Australian.

Women's history has been, and continues to be, hidden and marginalized. Margaret Anderson discusses this issue in a recent article. She points up the still very apparent problem of 'the missing woman'—missing in the interpretation of heritage places generally, and missing in the sense that no real effort has been made to identify places with women's contribution to society, or the history of women's emancipation, as primary value. We must tell the story of women in all the places where they were, and integrate women's presence and women's contribution into the history of Australia.[7]

Heritage—who benefits, who pays

We generally consider that the community has a right to heritage conservation, and the laws and administrative arrangements we make are to protect elements of heritage from individual or group destruction. In this sense, we believe that heritage belongs to the community. Yet individual heritage places also often belong to private owners who live in them, invest in them, or in some other way use them to make a living.

With increased regulations aimed at protecting heritage places (national, state and local provisions in many instances) some private owners are becoming uneasy about the effects of such regulations on their rights and on their income. Often, in fact, heritage classification can increase the value of property. On the other hand, there is no doubt that on occasion heritage protection regulations can cause owners to incur expensive restoration costs, or can prevent development or certain types of reuse. Additionally, in many cases there are actual disincentives to heritage conservation—for example, difficulties in insurance, lack of tax deductibility for conservation work that does not have a revenue outcome, etc.

Each time a state develops heritage legislation the same battle is fought: on the one side, those who believe that legislative heritage protection imposes intolerable restraint on the individual rights of owners to enjoy unimpeded use of their property, and, on the other, those who believe that places with heritage value are of value to the community, and that most owners can use such property profitably and still protect their heritage values. The advocates of private rights argue that any owner of property subjected to constraint through heritage laws should be financially compensated; the advocates of private responsibility to comply with the needs of the community argue that such automatic compensation in effect would cripple any heritage law, as no government would implement a law with a substantial bill for compensation attached to it every time it was used.

The compromise that has been incorporated into a number of Acts is to enable an owner to seek (or demand in some cases) acquisition of the property by the state if it can be shown that the heritage requirements makes the property incapable of providing a reasonable level of economic return. Clauses in some Acts allow developers to claim compensation for money actually

spent in preparing for a development if a subsequent heritage order rules out that development. The balancing act between ensuring social justice on the one hand, and deciding the degree to which the rights of the individual override the rights of the community on the other, is one that largely takes place in the political arena, and ultimately in the courts. When compromise clauses or wording have been forced into Acts by political pressure, they almost invariably adversely affect court decisions on heritage matters. This is, however, an increasingly strong debate, with a tendency for owners of buildings to take legal action (by way of challenging criteria, etc.) to prevent listing on federal or state lists, or to allow demolition or unsympathetic alteration.

Recently the Australian government has moved to introduce taxation incentives for conservation work on private property; initially the sum is very limited—about $20 million worth of work is allowed for—but it is a step in the right direction, one the conservation movement has long lobbied for. However, this does not satisfy many of the concerns of the owners, and there continues to be a serious problem in this area, especially since the tax deduction scheme assists the well off more than low-income earners—and those not working benefit not at all.

In general we can detect, along with a growing public interest in heritage, a backlash against the increasing climate of regulation. One way of helping to solve this problem is to strengthen the processes for local involvement and consultation. Certainly, though it has been demonstrated that heritage conservation has a general economic benefit for the community,[8] this is not presently recognized in the levels of funding available for its identification and conservation; and certainly not compared with the funding available, say, for Greening Australia, or for Landcare.

Natural and cultural heritage conservation

It is pleasing to see that natural and cultural heritage conservation are moving closer together. Over all, people do not distinguish between natural and cultural heritage in their identification of these values, or in their wish to see them conserved, but there are presently some potential conflicts—proposals to

restore traditional tracks or a nineteenth-century hut in a wilderness area being good examples of some of the current areas of discussion.

The idea of wilderness itself is sometimes simplistically put forward as meaning a pristine area, 'untouched by humans'. This is, of course, a very Eurocentric view of wilderness. Seen from other perspectives, wilderness is rich in meaning and in cultural history to its original human inhabitants. In fact, the more the natural environment is impacted by Europeans the more of a wilderness it becomes in the eyes of traditional Aboriginals. This is how Rhys Jones described the way Frank Gurrumanamana, a traditional member of the Gidjengali group of Arnhem Land, saw the Canberra countryside:

> Here was a land empty of religious affiliation; there were not wells, no names of the totemic ancestors, no immutable links between land, people and the rest of the natural and supernatural worlds. Here was just a vast *tabula rasa*, cauterised of meaning. Discussing the history of this place and being shown archaeological sites and nineteenth-century pictures of old Aborigines of the region, Gurrumanamana said that once, long ago, Aborigines had lived here and that they would have known these attributes of the land which still existed somewhere, but that now, in his own words 'this country bin lose 'im Dreaming'. He was disturbed by this . . .
>
> This land and its people therefore were analogous to the state of all of the world once in some time before the Dreaming, before the great totemic Ancestral Beings strode across it, naming the places and giving it meaning. Viewed from this perspective, the Canberra of the geometric streets, and the paddocks of the six-wire fences were places not of domesticated order, but rather a wilderness of primordial chaos.[9]

In a more limited, but essentially true way, most Australian natural environments have evidence of European cultural remains, or stories associated with them. National park managers are becoming more sensitive at recognizing and managing for all the values they are responsible for, but there is still a need for vigilance and care to ensure that this tendency continues. This is especially crucial since many types of European and Aboriginal heritage places in the main will only be conserved in parks and forests as development increasingly encroaches on our Aboriginal and nineteenth-century heritage.

Conservation of urban districts

Increasingly, there is a recognition in the heritage movement, the broader community, and the bureaucracy that conservation of the essential character of suburbs and districts is the only way to conserve the cultural heritage in its context. Hence, we have an increasing tendency to zone districts as heritage areas, and to regulate or restrict new development accordingly. This, however, often has the unintended consequence of 'gentrification' as the conservation precinct becomes more valuable, prices rise, and the original inhabitants can no longer afford to live there. This is an area that has not been given sufficient attention in Australia—and it is beyond the scope of this book. However, it certainly needs attention, as James Marston Fitch, writing of America, has pointed out:

> This internal migration, popularly termed 'gentrification', has a number of unfortunate consequences. It alienates the displaced population even farther from its urban base, transposing the slum and ghetto instead of eliminating it. It has the effect of pushing a wide range of small stores, workshops, and ateliers either into bankruptcy (because they cannot survive forced transplantation) or out of the central city altogether. Thus, while the physical fabric of the heritage may be preserved and enhanced, the lifestyles it has generated and supported may be impoverished.
>
> Minimizing or preventing these disruptive effects of retrieval and recycling of historic districts clearly calls for new levels of sociocultural engineering—levels which in the United States we are only beginning to explore. In a number of European cities, where experience is more extensive (Paris, Bologna) or legal and financial resources greater (Prague, Split), the process of preserving *both* the historic district *and* the traditional population is well under way. These cities merit the attention of Americans as prototypical examples of how this can be achieved.[10]

Conservation in the late twentieth century

To date, much heritage conservation rhetoric, as it appears in popular debate, has a negative tendency. It is about destruction, loss or damage; it is about prescriptions for use and prohibition

of development. It is also characterized by politically motivated or legalistic debates about degrees of historic significance, and hence worthiness for conservation.

In our somewhat oppositional public life, such an emphasis on rules and prescriptions has been an inevitable stage in the development of the debate. However, this emphasis needs to change. Very good argument can be made for the economic and social values of heritage, in our current society.[11] In particular, heritage conservation has a direct contribution to make to ecologically sustainable development, and to providing a sense of identity and community to create a stable, happy and creative community. These broader issues are now being explored by the community, especially those whose identity and way of life are threatened. Coastal villages threatened with being engulfed by 'international resorts', small country centres losing their traditional services (post, rail, bank, hospital) and hence their viability, urban districts losing their corner shops and main streets to mega-malls—all of the people in these communities are suddenly aware of the importance of their traditional way of life and of the fabric of their past.

Heritage conservation is viewed as an important and valuable part of that struggle; and of regaining or retaining 'a sense of place'. This means, in turn, that the heritage conservation movement cannot operate on a narrow, prescriptive agenda. Saving specific places of particular significance is important, but these places will become scattered and meaningless remains in an amorphous and characterless landscape unless we become part of a broad agenda, aimed at assisting the community to conserve its sense of identity. This sense of identity is not static. Its strengthening will mean change as well as conservation, it will mean the integration of the best of modern technology and development into the existing cultural landscape, in such a way as to be able to blend the two:

> . . . the fabric of each city, town or cultural landscape creates a document, which is legible and which describes the economic and social history of its people . . .
>
> The question is this. As we edit that urban text—adding, erasing and reshaping our built environment—will we write it in our own dynamic dialect or in an ill-studied universal language, an Esperanto of building?

. . . the contradiction is resolved by the modernisation of tradition itself through a simultaneous process of rejection of the moribund . . . and assimilation of its live, vital and relevant elements . . . The modern does not generate in a vacuum; it grows in the womb of tradition. It does not replace it; it transforms it . . . [as] a new wave in the ocean of time.[12]

 Appendix 1

The Burra Charter

The Australia ICOMOS Charter for the Conservation of Places of Cultural Significance

Preamble

Having regard to the International Charter for the Conservation and Restoration of Monuments and Sites (Venice 1966), and the Resolutions of the 5th General Assembly of the International Council on Monuments and Sites (ICOMOS) (Moscow 1978), the following Charter was adopted by Australia ICOMOS on 19th August 1979 at Burra Burra. Revisions were adopted on 23rd February 1981 and on 23 April 1988.

Definitions

ARTICLE 1. For the purpose of this Charter:

1.1 *Place* means site, area, building or other work, group of buildings or other works together with associated contents and surrounds.

1.2 *Cultural significance* means aesthetic, historic, scientific or social value for past, present or future generations.

1.3 *Fabric* means all the physical material of the *place*.

1.4 *Conservation* means all the processes of looking after a place so as to retain its *cultural significance*. It includes maintenance and may according to circumstance include *preservation, restoration, reconstruction* and *adaptation* and will be commonly a combination of more than one of these.

1.5 *Maintenance* means the continuous protective care of the *fabric*, contents and setting of a *place*, and is to be distinguished from repair. Repair involves *restoration* or *reconstruction* and it should be treated accordingly.

1.6 *Preservation* means maintaining the *fabric* of a *place* in its existing state and retarding deterioration.

1.7 *Restoration* means returning the EXISTING *fabric* of a *place* to a known earlier state by removing accretions or by reassembling existing components without the introduction of new material.

1.8 ***Reconstruction*** means returning a *place* as nearly as possible to a known earlier state and is distinguished by the introduction of materials (new or old) into the *fabric*. This is not to be confused with either recreation or conjectural reconstruction which are outside the scope of this Charter.

1.9 ***Adaptation*** means modifying a *place* to suit proposed compatible uses.

1.10 ***Compatible use*** means a use which involves no change to the culturally significant fabric, changes which are substantially reversible, or changes which require a minimal impact.

Conservation Principles

ARTICLE 2. The aim of *conservation* is to retain the *cultural significance* of a *place* and must include provision for its security, its *maintenance* and its future.

ARTICLE 3. *Conservation* is based on a respect for the existing *fabric* and should involve the least possible physical intervention. It should not distort the evidence provided by the *fabric*.

ARTICLE 4. *Conservation* should make use of all the disciplines which can contribute to the study and safeguarding of a *place*. Techniques employed should be traditional but in some circumstances they may be modern ones for which a firm scientific basis exists and which have been supported by a body of experience.

ARTICLE 5. *Conservation* of a *place* should take into consideration all aspects of its *cultural significance* without unwarranted emphasis on any one aspect at the expense of others.

ARTICLE 6. The conservation policy appropriate to a *place* must first be determined by an understanding of its *cultural significance*.

ARTICLE 7. The conservation policy will determine which uses are compatible.

ARTICLE 8. *Conservation* requires the maintenance of an appropriate visual setting: e.g., form, scale, colour, texture and materials. No new construction, demolition or modification which would adversely affect the setting should be allowed. Environmental intrusions which adversely affect appreciation or enjoyment of the *place* should be excluded.

ARTICLE 9. A building or work should remain in its historical location. The moving of all or part of a building or work is unacceptable unless this is the sole means of ensuring its survival.

ARTICLE 10. The removal of contents which form part of the *cultural significance* of the *place* is unacceptable unless it is the sole means of ensuring their security and *preservation*. Such contents must be returned should changed circumstances make this practicable.

Conservation Processes

Preservation

ARTICLE 11. *Preservation* is appropriate where the existing state of the *fabric* itself constitutes evidence of specific *cultural significance*, or where insufficient evidence is available to allow other conservation processes to be carried out.

ARTICLE 12. *Preservation* is limited to the protection, *maintenance* and, where necessary, the stabilisation of the existing *fabric* but without the distortion of its *cultural significance*.

Restoration

ARTICLE 13. *Restoration* is appropriate only if there is sufficient evidence of an earlier state of the *fabric* and only if returning the *fabric* to that state reveals the *cultural significance* of the *place*.

ARTICLE 14. *Restoration* should reveal anew culturally significant aspects of the *place*. It is based on respect for all the physical, documentary and other evidence and stops at the point where conjecture begins.

ARTICLE 15. *Restoration* is limited to the reassembling of displaced components or removal of accretions in accordance with Article 16.

ARTICLE 16. The contributions of all periods to the place must be respected. If a *place* includes the *fabric* of different periods, revealing the *fabric* of one period at the expense of another can only be justified when what is removed is of slight *cultural significance* and the *fabric* which is to be revealed is of much greater *cultural significance*.

Reconstruction

ARTICLE 17. *Reconstruction* is appropriate only where a *place* is incomplete through damage or alteration and where it is necessary for its survival, or where it reveals the *cultural significance* of the *place* as a whole.

ARTICLE 18. *Reconstruction* is limited to the completion of a depleted entity and should not constitute the majority of the *fabric* of the *place*.

ARTICLE 19. *Reconstruction* is limited to the reproduction of *fabric*, the form of which is known from physical and/or documentary evidence. It should be identifiable on close inspection as being new work.

Adaptation

ARTICLE 20. *Adaptation* is acceptable where the *conservation* of the *place* cannot otherwise be achieved, and where the *adaptation* does not substantially detract from its *cultural significance*.

ARTICLE 21. *Adaptation* must be limited to that which is essential to a use for the *place* determined in accordance with Articles 6 and 7.

ARTICLE 22. *Fabric* of *cultural significance* unavoidably removed in the process of *adaptation* must be kept safely to enable its future reinstatement.

Conservation Practice

ARTICLE 23. Work on a *place* must be preceded by professionally prepared studies of the physical, documentary and other evidence, and the existing *fabric* recorded before any intervention in the *place*.

ARTICLE 24. Study of a *place* by any disturbance of the *fabric* or by archaeological excavation should be undertaken where necessary to provide data essential for decisions on the *conservation* of the *place* and/or to secure evidence about to be lost or made inaccessible through necessary *conservation* or other unavoidable action. Investigation of a *place* for any other reason which requires physical disturbance and which adds substantially to a scientific body of knowledge may be permitted, provided that it is consistent with the conservation policy for the *place*.

ARTICLE 25. A written statement of conservation policy must be professionally prepared setting out the *cultural significance* and proposed *conservation* procedure together with justification and supporting evidence, including photographs, drawings and all appropriate samples.

ARTICLE 26. The organisation and individuals responsible for policy decisions must be named and specific responsibility taken for each such decision.

ARTICLE 27. Appropriate professional direction and supervision must be maintained at all stages of the work and a log kept of new evidence and additional decisions recorded as in Article 25 above.

ARTICLE 28. The records required by Articles 23, 25, 26, and 27 should be placed in a permanent archive and made publicly available.

ARTICLE 29. The items referred to in Articles 10 and 22 should be professionally catalogued and protected.

Words in italics are defined in Article 1.

 Appendix 2

Code of Ethics of the Australian Archaeological Association

Members' obligations to Australian Aboriginal and Torres Strait Islander people

Australian archaeologists work in many different situations where they need to interact appropriately with the indigenous people (eg Cyprus, Jordan, Papua New Guinea, Thailand, Vanuatu). The Australian Archaeological Association believes that these principles and rules should apply in all such situations just as much as they do within Australia.

Principles to Abide by:

Members agree that they have obligations to indigenous peoples and that they shall abide by the following principles:

1. To acknowledge the importance of indigenous cultural heritage, including sites, places, objects, artefacts, human remains, to the survival of indigenous cultures.

2. To acknowledge the importance of protecting indigenous cultural heritage to the well-being of indigenous people.

3. To acknowledge the special importance of indigenous ancestral human remains, and sites containing and/or associated with such remains, to the indigenous people.

4. To acknowledge that the important relationship between indigenous peoples and their cultural heritage exists irrespective of legal ownership.

5. To acknowledge that the indigenous cultural heritage rightfully belongs to the indigenous descendants of that heritage except items given or sold without force to non-indigenous people or institutions by the appropriate indigenous people.

6. To acknowledge and recognise indigenous methodologies for interpreting, curating, managing and protecting indigenous cultural heritage.

7. To establish contractual arrangements between archaeologists . . . and representatives authorised by indigenous communities whose cultural heritage is being investigated.

8. To see, at all times, representation of indigenous people in agencies funding or authorising research to be certain their view is considered as critically important in setting research standards, questions, priorities and goals.

Rules to Adhere to:

Members agree that they will adhere to the following rules prior to, during and after their investigations:

1. Prior to conducting any investigation and/or examination, members shall define . . . the indigenous peoples whose cultural heritage is the subject of investigation . . . We do no recognise that there are any circumstances where there is no community of concern.

2. Members shall negotiate with and obtain the informed consent of representatives authorised by . . . the indigenous people whose cultural heritage is the subject of investigation.

3. Members shall ensure that the authorised representatives of . . . the indigenous peoples whose culture is being investigated are kept informed during all stages of the investigation and are able to renegotiate or terminate the archaeological work being conducted at that site.

4. Members shall ensure that all published materials resulting from their work are presented and handed over for ownership to the representatives of . . . the identified indigenous peoples.

5. Members shall not interfere with and/or remove human remains of indigenous peoples without the written consent of representatives authorised by the indigenous people whose cultural heritage is the object of investigation.

6. Members shall not interfere with and/or remove artefacts or objects of any cultural significance, as defined by all associated indigenous peoples whose cultural heritage is the object of investigation without the written consent of their authorised representatives.

7. Members shall employ and train indigenous peoples in proper technique as part of their projects, and involve indigenous peoples in monitoring the projects.

8. All research shall result in written reports produced in simple legible English and where possible in language for those particular communities.

9. In joining the Australian Archaeological Association members agree to accept these principles and rules . . .

 Appendix 3

Thematic List

*Draft list of themes developed by the Centre for
Western Australian History for the Australian
Heritage Commission 1994**

1) Tracing the evolution of a continent's special environments

[*Although the environment exists apart from human consciousness, identifying
parts of the environment for special consideration as 'heritage' is very much a
human activity. The human factor is recognised in the way this theme and its
sub-themes are stated. This approach also recognises that science is constantly
expanding our appreciation of the environment.*]

Tracing climatic and topographical change

Tracing the emergence of and development of Australian plants and
animals

Appreciating the natural wonders of Australia

[There are many features of the environment that are low in scientific
interest but high in human interest, blow holes and natural bridges,
for example.]

2) Peopling the continent

[*Categories previously used to cover this aspect of heritage, such as settlement,
fail to recognise the pre-colonial achievements of Aboriginal people. They also
divert attention from more recent movements of immigration.*]

Recovering the experience of Australia's earliest inhabitants

Appreciating how Aboriginal people adapted themselves to diverse
regions before regular contact with other parts of the world

* N. Etherington, P. Brock, T. Stannage, J. Gregory and J. Lennon, *Principal
Australian Themes Project—Stage 1 Draft report for Circulation and Discussion—
Uses and Identification of Principal Historic Themes*, vol. 1, Report of Findings,
Centre for Western Australian History for the Australian Heritage Commis-
sion, 1994.

Coming to Australia as a punishment

Migrating

 Migrating to save or preserve a way of life

 Migrating to seek opportunity

 Migrating to escape oppression

 Migrating systematically through organised colonisation

Promoting settlement on the land through selection and group settlement

Fighting for the land

Resisting the advent of Europeans and their animals

Displacing Aboriginal people

3) Developing an Australian economy linked to world markets

[*Geoffrey Blainey conceived Australian history as dominated by the 'tyranny of distance'. It could with equal justice be summed up as the conquest of distance. If new developments in technology had not made it possible to link the continent to distant marketplaces, the Aboriginal economy might have been left undisturbed. The first European 'explorers' were not motivated by idle curiosity. Seeking valuable resources was the root cause of almost every expedition.*

 It is astonishing to realise how much of what we regard as heritage is the result of activity undertaken for economic gain. The project team made a few efforts to divide activities linked to the world marketplace from activities concentrated on local marketplaces. All of these failed, because the linkages between local and international markets are so strong.]

Inspecting the coastline

Surveying the continent and assessing its potential

 Looking for inland seas and waterways

 Looking for overland stock routes

 Prospecting for precious metals

 Looking for land with agricultural potential

Exploiting natural resources

 Hunting

 Fishing and whaling

 Mining

 Making forests into a saleable resource

 Tapping natural energy sources

Developing sheep and cattle industries

Recruiting labour

Establishing lines and networks of communication
 Establishing postal services
 Developing electronic means of communication
Moving goods and people
 Shipping to and from Australian ports
 Safeguarding Australian products for long journeys
 Developing harbour facilities
 Making economic use of inland waterways
 Moving goods and people on land
 Building and maintaining railways
 Building and maintaining roads
 Getting fuel to engines
 Moving goods and people by air
Farming for export under Australian conditions
Integrating Aboriginal people into the cash economy
Altering the environment for economic development
 Damming waterways
 Irrigating land
 Clearing vegetation
Feeding Australians
 Using indigenous foodstuffs
 Developing sources of fresh local produce
 Importing foodstuffs
 Preserving food and beverages
 Retailing foods and beverages
Developing an Australian manufacturing capacity
Developing an Australian engineering and construction industry
 Building to suit Australian conditions
 Using Australian materials in construction
Developing economic links to Asia
Struggling with remoteness, hardship and failure
 Gambling on uncertain climatic conditions and soils
 Going bush
 Dealing with hazards and disasters
Inventing devices to cope with special Australian problems
Financing Australia
 Raising capital
 Banking and lending
 Insuring against risk

Marketing in Australia

Informing Australians
 Making, printing and distributing newspapers
 Broadcasting

Entertaining Australians for profit

Catering for tourists

Selling companionship and sexual services

Adorning Australians
 Dressing up Australians
 Caring for hair, nails, and shapes

Treating what ails Australians
 Providing medical and dental services
 Providing hospital services
 Developing alternative approaches to good health

4) Building Australian towns and cities

[*Although many people came to Australia in search of personal gain, they realised the need to cooperate in the building of safe, pleasant urban environments. Australian urbanisation and suburbanisation have special characteristics which set them apart from similar phenomena elsewhere in the world.*]

Planning urban settlement
 Selecting township sites
 Making suburbs
 Learning to live with property booms and busts

Developing local government authorities

Supplying urban services (power, transport, fire prevention, roads, water, light & sewerage)

Developing urban institutions

Living with slums, outcasts and homelessness

Making towns to serve rural Australia

5) Working in Australia

[*Although a lot of what we call work is related to the economy, most of it is not undertaken for profit. A great deal of the work done in the home is neither paid nor counted as part of the national economy. Some of the most interesting recent social history written about Australia concerns work and workplaces. For all those reasons, working deserves recognition as a separate theme.*]

Working in harsh conditions
 Coping with unemployment
 Coping with dangerous jobs and workplaces
Organising workers and work places
 Structuring relations between managers and workers
Caring for workers' dependent children
Working in offices
Trying to make crime pay
Working in the home
Surviving as Aboriginal people in a white-dominated economy

6) Educating Australians

[*Every society educates its young. There was education in Australia before the coming of Europeans. While European education places a great emphasis on schooling, it encompasses much more than formal progression through grades one to twelve. Government has come to play a big role in education, but Australia places more education in private hands than most OECD countries.*]

Forming associations, libraries and institutes for self-education
Establishing schools
Training people for workplace skills
Building a system of higher education
Educating people in remote places
Educating Aboriginal people in two cultures

7) Governing Australia

[*This theme is as much about self-government as it is about being governed. It includes all the business of politics, including hostility to acts of government.*]

Governing Australia as a province of the British Empire
Developing institutions of self-government and democracy
 Protesting
 Struggling for inclusion in the political process
 Working to promote civil liberties
 Forming political associations
Federating Australia
Governing Australia's colonial possessions
Developing administrative structures and authorities

Providing for the common defence
 Preparing to face invasion
 Going to war
Policing Australia
Dispensing justice
Incarcerating the accused and convicted
Providing services and welfare
Enforcing discriminatory legislation
Administering Aboriginal Affairs
Conserving Australian resources
 Conserving fragile environments
 Conserving economically valuable resources
 Conserving Australia's heritage

8) Developing Australian cultural institutions and ways of life

[*Australians are more likely to express their sense of identity in terms of a way of life rather than allegiance to an abstract patriotic ideal. One of the achievements of this society has been the creation of a rich existence away from the work place. While some of the activities encompassed in this theme are pursued for profit—horse racing and cinema, for instance—their reason for being is the sheer enjoyment of spectators. While many people could not purse careers in art, literature, science, entertainment or the church without being paid, those activities do not fit easily into the categories of economy or workplace.*]

Organising recreation
 Playing and watching organised sports
 Betting
 Developing public parks and gardens
Going to the beach
Going on holiday
Eating and drinking
Forming associations
 Associating to preserve traditions and group memories
 Associating to help other people
 Worshipping together
 Maintaining religious traditions and ceremonies
 Founding Australian religious institutions
 Making places for worship

Evangelising
 Running city missions
 Founding and maintaining missions to Australia's indigenous
 people
Associating to pursue common leisure interests
Honouring achievement
Remembering the fallen
Commemorating significant events
Pursuing excellence in the arts and sciences
 Making music
 Creating visual arts
 Creating literature
 Designing and building fine buildings
 Advancing knowledge in science and technology
Making Australian folklore
 Celebrating folk heroes
 Myth making and story-telling
Living in Australian homes

9) Marking phases in the Australian life cycle

[*When asked to name neglected themes, many of the people who responded to our
questionnaire cited themes concerned with stages in life. Although much of the
experience of growing up and growing old does not readily relate to particular
heritage sites, there are places that can illustrate this important theme.*]

Bringing babies into the world
 Providing maternity clinics and hospitals
 Promoting mothers' and babies' health
Bringing up children
Discovering youth culture
 Courting
 Joining youth organisations
 Being teenagers
Forming families and partnerships
Retiring
Looking after the infirm and the aged
Mourning the dead
Disposing of dead bodies

 Appendix 4

Heritage Study Model Brief*

_____ Heritage Study

Brief

1. *Background*

This study is funded by

_____.

> **Explanatory notes**
>
> *These notes do not form part of the brief.*
>
> Insert name(s) of funding agencies.
>
> For projects with National Estate funding this should read:
>
>> This study is Project No. ___ of the National Estate Grants Program 19__ and is funded by the Victoria National Estate Committee and _____.

2. *Study area and budget*

The study area is _____.

The total budget is $____.

> Insert name of municipality or study area, and budget.

* Department of Planning and Housing, *Local Government Heritage Guidelines*, Department of Planning and Housing, Victoria, Melbourne, 1991.

3. *Purpose of the study*

3.1 The purpose of the study is to:

- identify, evaluate and document post-contact places of cultural significance in the study area;
- to make recommendations for the conservation and management of identified places of cultural significance.

> Post-contact: the period since first contact was established between Aboriginal and non-Aboriginal people.
>
> Place: means site, area, building or other works together with associated contents and surrounding. Place includes structures, ruins, archaeological sites and landscapes modified by human activity.
>
> Cultural significance: means aesthetic, historic, scientific or social value for past, present or future generations.

4. *Management of the study*

4.1 Steering committee

The consultant will report to a steering committee consisting of:

(a) Representatives of the _____.

(b) Representatives of the Heritage Branch of the Department of Planning and Housing.

> (a) Insert name of municipality.
>
> For projects with National Estate funding, Section 4.1 should also specify a representative of the Victoria National Estate Committee.
>
> It is desirable that steering committees include representation from other sections of the community. This should be spelt out in Section 4.1.

4.2 Appointment of the consultant

The appointment of the consultant shall be upon the recommendation of the steering committee and shall be in two stages:

Stage 1: The selected consultant shall be initially appointed to conduct a preliminary survey of the study area (see Section 7) to establish the scope of the study that is possible within the budget and to set time allocations to each task as outlined in Section 8 of this brief. The consultant will be entitled to a payment equal to 10% of the total budget upon completion of the preliminary survey which will be submitted to the steering committee for approval within a mutually agreed time.

The preliminary survey shall establish the parameters of the study and shall form the agreement between the consultant and the employer.

Stage 2: Upon conclusion and approval of the preliminary survey the consultant shall be appointed to undertake the major portion of the study as outlined in Section 8.

Should the steering committee fail to agree to the proposed study as per the preliminary survey, it reserves the right to seek other tenders on the basis of the preliminary survey.

4.3 Payments

Upon appointment to stage 2 (Section 8), the consultant shall be entitled to:

(a) A starting allowance equivalent to 10% of the total budget

(b) Progress payments as agreed upon by the committee as per the preliminary survey less 15% to be withheld until the final approval of the completed document.

Should the consultant not meet the agreed submission dates for each section (as per the preliminary survey) and, unless approval has been granted by the steering committee to extend those dates, the committee shall reserve the right to withdraw from the relevant progress payment an amount equivalent to 1% per week that the submission is overdue.

4.4 Dismissal

Should the progress of the study be unsatisfactory the steering committee may recommend the dismissal of the consultant and the appointment of a further consultant to complete the work.

The grounds for dismissal shall only be:

(a) Repeated and deliberate failure to meet agreed submission dates (or as reasonably extended) provided that such failure not be the fault of the steering committee.

(b) Deliberate failure to undertake the work (or portions of it) as agreed to upon appointment to stage 2 (Section 8).

5. *Presentation and format*

5.1 The study shall be arranged in such a way as to provide:

(a) a clear, concise and integrated document suitable for use in an educational and interpretative manner.

(b) a technical document suitable for use in the production of a planning scheme and the management of that scheme.

5.2 The written report shall use an A4 format.

5.3 Written material shall be typed at one and a half spacing. Comparative diagrams shall have a consistent format.

5.4 Photographs shall be black and white and of suitable quality to enable reproduction. All photographs and maps shall be fully captioned including the source.

5.5 Drawings shall conform to accepted standards of drafting and shall be capable of reduction to A4 size. The final document shall include a summary, index page and bibliography.

5.6 In all cases, sources of information shall be fully documented. Terminology shall be consistent with the Australia ICOMOS Guidelines for the Conservation of Places of Cultural Significance ('Burra Charter').

6. *Ownership and distribution*

6.1 Ownership

Ownership of the report shall remain with the _____.

The right to use any of the material from the study shall remain with the author and the _____.

The completed study shall be a public document.

Insert name of municipality.

For projects with National Estate funding, ownership of the report shall remain with the municipality and the Australian Heritage Commission. The right to use any material from the study shall remain with the author, the municipality, the Government of Victoria and the Commonwealth of Australia.

6.2 Distribution

The consultant shall provide the master copy of the report together with photographs (including negatives) and artwork to the municipality together with three copies of the completed document.

Where the study is funded through the National Estate Grants Program, the municipality shall arrange for:

- five copies to meet the requirements of the Commonwealth;
- three copies to be forwarded to the Department of Planning and Housing;
- one copy for the Australian National Library;
- one copy for the State Library of Victoria; and
- one copy for the National Trust of Australia (Victoria).

7. *Stage 1: Preliminary survey*

The preliminary survey shall:

- review the existing available sources of information and prepare a brief bibliography;
- demonstrate an understanding of the major historic themes that constitute the significance of the study area;
- explain the criteria and methodology to be used in the identification and assessment of places of cultural significance;
- provide a brief list and firm estimate of the number of places that will require detailed investigation;
- indicate the time, budget and personnel allocations for each task and the production of the final document and suggest dates for completion of tasks and progress payments; and
- having considered the scope and extent of all other work prescribed in the stage 2 task specifications, suggest any necessary changes to the task specifications or brief. Any perceived deficiencies in the brief must be highlighted at this stage.

8. *Task specifications*

The philosophical basis for the study will be the Australia ICOMOS Charter for the Conservation of Places of Cultural Significance (the Burra Charter) and its guidelines.

The following tasks shall be undertaken in the order that they appear below:

A. The environmental history of post-contact* settlement and development.

B. The identification and evaluation of post-contact* places of cultural significance.

C. A heritage conservation program for the study area.

The specifications for each task are as follows:

Task A
The environmental history of post-contact settlement and development*

This aspect of the study shall address itself to the history of the physical development of the study area since post-contact occupation and shall isolate and explain those themes that are crucial to understanding the area and the historic physical fabric as it exists today.

The environmental history will be concise (between 3,000–8,000 words) and analytical. It will clearly define the themes that will provide an historical explanation of the existing physical fabric and land use patterns of the study area. These themes will then be applied in the identification and evaluation of individual components of the study area's heritage as part of Task B. It must not be a comprehensive chronological history. It will, as far as possible, make good use of illustrative material including copies of original maps and photographs.

Task B
The identification, evaluation and documentation of post-contact places of cultural significance

This aspect of the study shall address itself to the identification, evaluation and documentation of post-contact places within the study area that are significant in explaining for present and future generations those aspects of the area's environmental heritage identified in Task A.

1.1 Identification

The consultant will be required to undertake a comprehensive field survey of the development of the study area identifying potential items of cultural significance by:

• examining and reviewing previously identified heritage items (e.g. AHC, HBC, LCC, National Trust);

* The period since first contact was established between Aboriginal and non-Aboriginal people.

- using as a guide the environmental History undertaken for a Task A, investigating the study area for other potential places of cultural significance;
- identifying other potential places in the field (NB. for some places physical evidence may be minimal or non-existent).

1.2 Assessment/evaluation

The consultant shall evaluate the cultural significance of places identified in 1.1 above, with reference to the Burra Charter and the Guidelines to the Burra Charter: Cultural Significance.

1.3 Documentation

(a) **Mapping**

All identified places of cultural significance must be marked on a base map(s) to be bound into the report.

(b) **Standard form**

A standard form must be completed for all identified places of cultural significance (see attachment 1).

As a minimum, each documentation form must address the following:

- location of place (address and/or title details);
- photograph (as per presentation and format);
- historical theme which the place reflects;
- brief description of the physical characteristics of the place (NB. for some places physical evidence may be minimal or non-existent);
- brief history of the place;
- where appropriate (e.g. for large areas or complex places) a sketch map locating individual elements of the place;
- statement of cultural significance clearly indicating the reasons for the identification of the place (this should be prepared in accordance with the Guidelines to the Burra Charter: Cultural significance 3.4);
- sources of information.

Task C
A heritage conservation program for the study area

The consultant will examine existing planning controls, local council policies and development pressures which may impact on the conservation of places identified in Task B, and develop a comprehensive program of non-statutory and statutory measures to assist in the conservation of the heritage of the study area.

Statutory recommendations

The consultant must compile a schedule of:

- places recommended for nomination to the Register of the National Estate;
- places recommended for nomination to the Register of Historic Buildings;
- places for declaration as an archaeological area under the Archaeological and Aboriginal Relics Preservation act; and
- places for protection within the local section of the planning scheme.

Having prepared schedules the consultant shall recommend ways in which the planning scheme can be used to conserve identified places. Recommendations shall include:

- proposed controls to conserve places identified to be of cultural significance; and
- amendments to other parts of the planning scheme which are necessary to achieve the effective conservation of identified places.

In developing statutory recommendations, the consultant shall confer with:

(a) The Heritage Branch of the Department of Planning and Housing.

(b) Victoria Archaeological Survey

(c) The municipal planning department

(d) Any regional authority with jurisdiction over the area.

Non-statutory recommendations

The consultant must recommend non-statutory measures for conservation of the heritage of the municipality. Non-statutory measures may include but need not be limited to:

- policies for the development of public understanding and appreciation of the cultural heritage of the study area;
- policies which would complement statutory measures to conserve the cultural heritage of the study area such as a local heritage committee, a heritage advisory service, financial incentives for conservation (e.g. a restoration fund, rate relief programs etc.)

 Appendix 5

Useful Contacts

For assistance and further information, consult the following list for an appropriate organization or department to contact.

Archives And Libraries

Australian Capital Territory

Australian Archives
PO Box 34
DICKSON ACT 2602

Australian Archives
Australian Capital Territory
Regional Office
PO Box 92
MITCHELL ACT 2911

National Library of Australia
PO Box E333
Queen Victoria Terrace
CANBERRA ACT 2600

New South Wales

Archives Office of New South
Wales
2 Globe Street
THE ROCKS NSW 2000

Australian Archives
New South Wales Regional Office
PO Locked Bag 4
HAYMARKET NSW 2000

State Library of New South Wales
Macquarie Street
SYDNEY NSW 2000

Northern Territory

Australian Archives
Northern Territory Regional
Office
PO Box 293
DARWIN NT 0801

State Reference Library
PO Box 42
DARWIN NT 0801

Queensland

Australian Archives
Queensland Regional Office
GPO Box 888
BRISBANE QLD 4001

Queensland State Archives
PO Box 1397
SUNNYBANK HILLS QLD 4109

South Australia

Australian Archives
South Australia Regional Office
PO Box 119
WALKERVILLE SA 5081

State Library of South Australia
Archives Section
GPO Box 419
ADELAIDE SA 5001

Tasmania

Archives Office of Tasmania
91 Murray Street
HOBART TAS 7000

Australian Archives
Tasmanian Regional Office
4 Rosny Hill Road
ROSNY PARK TAS 7018

State Library of Tasmania
91 Murray Street
HOBART TAS 7000

Victoria

Australian Archives
Victorian Regional Office
PO Box 4325PP
MELBOURNE VIC 3001

State Library of Victoria
328 Swanston Street
MELBOURNE VIC 3000

Public Records Office
Arts Victoria
3rd Floor
176 Wellington Parade
EAST MELBOURNE VIC 3002

Western Australia

Australian Archives
Western Australia Regional Office
PO Box 1144
EAST VICTORIA PARK WA 6101

Battye Library of Western
Australia History
Alexander Library Building
Perth Cultural Centre
PERTH WA 6000

Associations and Societies

Australia ICOMOS
PO Box 77
Grosvenor Street
SYDNEY NSW 2000

Australian Association of
Consulting Archaeologists
Box 214, Holme Building
University of Sydney
SYDNEY NSW 2006

Australian Garden History Society
PO Box 570
WODEN ACT 2606

Australasian Society for Historical
Archaeology
Box 220, Holme Building
University of Sydney
SYDNEY NSW 2006

Engineering Heritage Committee
Institution of Engineers, Australia
PO Box 138
MILSONS POINT NSW 2061

Museums Association of Australia
659 Harris Street
ULTIMO NSW 2007

Oral History Association of
Australia
(New South Wales Branch)
State Library of New South Wales
Macquarie Street
SYDNEY NSW 2000

Society of Australian Genealogists
120 Kent Street
SYDNEY NSW 2000

Government Authorities

National

Australian Council of National
Trusts
PO Box 1002
CIVIC SQUARE ACT 2608

Australian Cultural Development
Office
Department of Administrative
Services
GPO Box 1920
CANBERRA ACT 2601

Australian Heritage Commission
1st Floor, MTA House
39 Brisbane Avenue
BARTON ACT 2600

Australian Nature Conservation
Agency
GPO Box 636
CANBERRA ACT 2601

Department of the Environment,
Sport & Territories
GPO Box 787
CANBERRA ACT 2601

Australian Capital Territory

ACT Heritage Unit
PO Box 1119
TUGGERANONG ACT 2901

New South Wales

Heritage Council of New South
wales
GPO Box 3427
SYDNEY NSW 2001
Historic Houses Trust
61 Darghan Street
GLEBE NSW 2037

National Parks and Wildlife
Service
PO Box 1967
HURSTVILLE NSW 2220

Northern Territory

Aboriginal Areas Protection
Authority
GPO Box 1890
DARWIN NT 0801

Conservation Commission of the
Northern Territory
PO Box 496
PALMERSTON NT 0831

Heritage Council
Conservation Commission of the
Northern Territory
PO Box 496
PALMERSTON NT 0831

Museums and Art Galleries Board
of the Northern Territory
GPO Box 4646
DARWIN NT 0801

Queensland

Department of Environment and
Conservation
PO Box 155
NORTH QUAY QLD 4002

Department of Family Service and
Aboriginal and Islander Affairs
GPO Box 806
BRISBANE QLD 4001

Queensland National Parks and
Wildlife Service
PO Box 155
NORTH QUAY QLD 4002

South Australia

Aboriginal Heritage Branch
Department of Environment and
Planning
55 Grenfell Street
ADELAIDE SA 5000

National Parks and Wildlife
Service
55 Grenfell Street
ADELAIDE SA 5000

South Australian Heritage
Committee
GPO Box 667
ADELAIDE SA 5001

Tasmania

Department of Environment and
Land Management
GPO Box 44A
HOBART TAS 7001

Department of Environment and
Land Management
Wildlife Branch
134 Macquarie Street
HOBART TAS 7000

Victoria

Historic Buildings Council
477 Collins Street
MELBOURNE VIC 3000

Historic Places Section
Department of Conservation and
Natural Resources
PO Box 41
EAST MELBOURNE VIC 3002

Planning Division
Department of Planning and
Development
5th Floor
477 Collins Street
MELBOURNE VIC 3001

Western Australia

Department of Environment
PO Box 301
WEST PERTH WA 6872

Deptartment of Planning and
Urban Development
State Planning Commission
Albert Facey House
469 Wellington Street
PERTH WA 6000

Heritage Council of Western
Australia
292 Hay Street
EAST PERTH WA 6004
Western Australian Museum
Francis Street
PERTH WA 6000

National Trusts

National Trust of Australia (ACT)
PO Box 173
MANUKA ACT 2603

National Trust of Australia
(NSW)
Observatory Hill
SYDNEY NSW 2000

National Trust of Australia
(Northern Territory)
PO Box 3250
DARWIN NT 0801

National Trust of Queensland
GPO Box 9843
BRISBANE QLD 4001

National Trust of Australia
(South Australia)
452 Pulteney Street
ADELAIDE SA 5000

National Trust of Australia
(Tasmania)
Brisbane Street
HOBART TAS 7000

National Trust of Australia
(Victoria)
Tasma Terrace
Parliament House
MELBOURNE VIC 3002

National Trust of Australia
(Western Australia)
The Old Observatory
4 Havelock Street
WEST PERTH WA 6005

State Historical Societies

Royal Australian Historical
Society
133 Macquarie Street
SYDNEY NSW 2000

Royal Western Australian
Historical Society Inc.
49 Broadway
NEDLANDS WA 6009

Royal Historical Society of
Victoria Inc.
280 William Street
MELBOURNE VIC 3000

Notes

1 Looking After the Past

[1] See, for instance, M. Anderson, 'In search of women's public history: Heritage and gender'.

[2] See, for instance, S. Sullivan, 'The custodianship of Aboriginal sites in southeastern Australia', 'Cultural values and cultural imperialism' and 'Conservation policy delivery'; M. Pearson, 'Cultural resources and academic study' and 'Is saving face everything? Facadism and the National Estate'.

[3] A number of specialist bibliographies cover the heritage field. Perhaps the most useful is the series of bibliographies published from time to time by the Australian Heritage Commission, and which are created from their HERA Bibliography system. One of particular relevance is Australian Heritage Commission, *Cultural Resource Management*, Australian Heritage Commission Bibliography Series no. 3.

[4] M. B. Schiffer and C. J. Gumerman, *Conservation Archaeology*, gives a view from the archaeological profession, and J. M. Fitch, *Historic Preservation: Curatorial Management of the Built World*, gives a view from the conservation specialist perspective.

[5] S. J. Hallam, *Fire and Hearth*.

[6] D. J. Mulvaney, *The Prehistory of Australia*, p. 257.

[7] Australia ICOMOS, *The Illustrated Burra Charter*.

[8] For a more detailed discussion of this point see D. Lowenthal, *The Past Is a Foreign Country*.

[9] W. Gungwu, 'Loving the ancient in China'.

[10] S. Bowdler, *Aboriginal Sites on the Crown-timber lands of New South Wales*, p. 9.

[11] Committee of Inquiry into the National Estate, *Report of the National Estate*, p. 25.

[12] D. G. Yencken, *Australia's National Estate: The Role of the Commonwealth*, pp. 17–18.

13 Fitch, *Historic Preservation*, p. 32.
14 Committee of Enquiry into the National Estate, *Report of the National Estate*, p. 27.
15 H. Tanner and P. Cox, *Restoring Old Australian Houses and Buildings*, p. 12.
16 J. Steinbeck, *The Grapes of Wrath*, p. 79.
17 Mulvaney, *The Prehistory of Australia*, p. 261.
18 H. Proudfoot, quoted in S. Sullivan, 'Cultural resource management and historical studies', p. 13.
19 See an interesting range of such places in D. J. Mulvaney, *Encounters in Place*.
20 H. Creamer, 'The Aboriginal heritage in New South Wales and the role of the NSW Aboriginal Sites Survey Team'; R. Kelly, 'A revival of Aboriginal culture', p. 79.
21 H. Proudfoot, 'The First Government House, Sydney'; H. Proudfoot et al., *Australia's First Government House*.
22 An interesting description of the range of places is also given in J. Lennon, *Our Inheritance: Historic Places on Public Land in Victoria*.
23 R. Irving (ed.), *The History and Design of the Australian House*, p. 7.
24 P. Dargin, *Aboriginal Fisheries of the Darling–Barwon Rivers*, p. 16.
25 J. Birmingham, I. Jack, and D. Jeans, *Industrial Archaeology in Australia: Rural Industry*, p. 23.
26 Mulvaney, *The Prehistory of Australia*, p. 260.
27 C. Crisp, 'A brief report on the history, construction and restoration of Tathra Wharf, NSW'.
28 G. Henderson, *Maritime Archaeology in Australia*, pp. 19–24.
29 M. Staniforth, 'The casks from the wreck of the *William Salthouse*'.

2 The Legislative and Administrative Framework

1 D. Yencken, *Australia's National Estate: The Role of the Commonwealth*, pp. 211–19.
2 See also P. C. James, A guide to the Legal Protection of the National Estate in Australia, pp. 88–94.
3 Yencken, *Australia's National Estate*, pp. 211–19.
4 See Australia ICOMOS, *The Illustrated Burra Charter*.
5 Australian Heritage Commission, *Criteria for the Register of the National Estate: Application Guidelines*.
6 Australian Heritage Commission, *The Heritage of Australia: The Illustrated Register of the National Estate*; state editions: *The Heritage of Tasmania*, 1983; *The Heritage of South Australia and the Northern Territory*, 1985; *The Heritage of Victoria*,1985; *The Heritage of Western Australia*, 1989.
7 R. J. Langford, 'Our heritage, your playground'.

8 D. J. Mulvaney, 'The Australian Aborigines 1606–1929: Opinion and fieldwork', p. 297.

9 G. K. Ward, 'The federal Aboriginal Heritage Act and archaeology', p. 50.

10 See G. M. Bates, *Environmental Law in Australia*, pp. 92–5.

11 For further details see Bates, *Environmental Law in Australia*, and James, *A Guide to the Legal Protection of the National Estate*. The state agency responsible for administering each piece of legislation usually has information brochures on the Acts.

12 H. Temple, 'The listing and control of archaeological sites under the NSW Heritage Act'; Department of Planning, NSW, *15 Suggestions on How Local Councils Can Promote Heritage Conservation*.

13 M. Pearson, 'The acquisition and preservation of historic sites', and 'The National Parks and Wildlife Service's approach to the acquisition and interpretation of historic sites in New South Wales'.

14 James, *A Guide to the Legal Protection of the National Estate*, p. 193.

15 Ward, 'Archaeology and legislation in Australia', p. 21.

16 James, *A Guide to the Legal Protection of the National Estate*, p. 121.

17 James, *A Guide to the Legal Protection of the National Estate*, p. 170.

18 G. K. Ward, 'Archaeology and legislation in Australia'.

3 Documenting the Resource

1 S. Bowdler, 'Unconsidered trifles? Cultural resource management, environmental impact statements and archaeological research in NSW'.

2 S. Blair and A. Claoué-Long, 'A landscape of captive labour: Evidence of the convict era in the Lanyon landscape', pp. 81–2.

3 R. Jones, 'Submission to the Senate Committee on South West Tasmania'.

4 H. Proudfoot et al., *Australia's First Government House*.

5 S. Bowdler, *Aboriginal Sites on the Crown-timber Lands of New South Wales*; A. McConnell, *Forest Archaeology Manual*.

6 For example, see Department of Planning and Housing, Victoria, *Local Government Heritage Guidelines*; Department of Planning, NSW, *Environmental Planning in NSW*.

7 See, for instance, S. Sullivan, 'Making a discovery: The finding and reporting of Aboriginal sites'; J. Birmingham, 'Recording to some purpose'; I. McBryde, 'Place recording: Some basic guidelines'; J. Flood, 'Identification and recording at historic sites'; J. Flood, I. Johnson and S. Sullivan, *Sites and Bytes: Recording Aboriginal Places in Australia*; M. Walker, 'Inventories and their role in managing railway heritage'. A good example of the application of survey and recording techniques is V. Attenbrow, 'Port Jackson archaeological project: A study of the prehistory of the Port Jackson Catchment, New South Wales. Stage 1—Site recording and site assessment'.

8 W. K. Hancock, *Discovering Monaro: A Study of Man's Impact on his Environment*; B. Hardy, *West of the Darling*.

9 B. Meehan, *Shell Bed to Shell Midden*.

10 As an example see C. Eslick, J. Hughes and R. I. Jack, *Bibliography of NSW Local History and NSW Directories 1828–1950*.

11 For useful references for historical sources, and research techniques see D. Barwick, M. Mace and T. Stannage, *Handbook for Aboriginal and Islanders History*; R. I. Jack, 'Sources for industrial archaeologists'; P. White, A. M. Schwirtlich and J. Nash, *Our Heritage: A Directory to Archives and Manuscript Repositories in Australia*; M. Davis and H. Boyce, *Directory of Australian Pictorial Resources*; D. Saunders (ed.), *A Manual of Architectural History Sources in Australia*; Eslick, Hughes and Jack, *Bibliography of NSW Local History and NSW Directories*; J. Hibbins, C. Fahey and M. Askew, *Local History: A Handbook for Enthusiasts*; G. Davison and C. McConville (eds), *A Heritage Handbook*; M. Lewis, *Physical Investigation of a Building: An Approach to the Archaeology of Standing Structures*; C. Sagazio (ed.), *The National Trust Research Manual*.

12 K. Hueneke, *Huts of the High Country*; M. Higgins, '"That's buggered the Cotter" or European heritage in Namadgi'.

13 See H. Creamer, 'Contacting Aboriginal Communities'.

14 For an example of some of the variety of approaches available see Flood, Johnson, and Sullivan, *Sites and Bytes*.

15 ERIN is the Environmental Research Information Network, established by the Commonwealth government to co-ordinate and act as an entry point to a range of continental databases on environmental information. It is intended to give seamless access to geographical information system data compiled by various Commonwealth agencies, and by state and academic bodies, and to provide a series of search and research tools to manipulate and utilize that data.

16 A good example of the use of such an approach on a small-scale urban planning exercise is R. Mackay, 'Statutory protection and predictive plans—Archaeological heritage management in Sydney'.

17 A. Bickford, *Boydtown: The Archaeological Investigation of Boydtown, Twofold Bay, NSW*.

18 For information on predictive modelling see B. J. Egloff, 'Sampling the Five Forests'; and D. Byrne, 'A survey strategy for a coastal forest'.

19 S. Marsden, *Historical Guidelines: South Australian State Historic Preservation Plan*; J. Dallwitz and S. Marsden, *Heritage of the River Murray*, and *Heritage Survey of the Lower North*; Danvers Architects, *Heritage of the South East*.

20 Examples include M. Pearson, 'Historic sites: themes and variations'; Flood, 'Identification and recording at historic sites'; Marsden, *Historical Guidelines*.

[21] D. N. Jeans and P. Spearritt, *The Open Air Museum*; Department of Planning, NSW, *The State Heritage Inventory Project (SHIP)*.

[22] G. Connah (ed.) *Australian Archaeology: A Guide to Field Techniques*; P. J. F. Coutts and D. Witter, *A Guide to Recording Archaeological Sites in Victoria*; P. Coutts, 'Old buildings tell tales'; M. Davies, 'The archaeology of standing structures', and 'Recording, analysing and interpreting timber structures'; Davison and McConville (eds), *A Heritage Handbook*; M. Davies and K. Buckley, *Archaeological Procedures Manual: Port Arthur Conservation and Development Project*.

[23] ibid.

[24] For further information on photogrammetry see L. Rivett, 'Photogrammetric recording of rock art in the Kakadu National Park', *The Application of Photogrammetry to the recording of Monuments and Sites in Australia*, and 'Photogrammetry—its potential application to problems in Australian archaeology'; C. Ogleby and L. J. Rivett, *Handbook of Heritage Photogrammetry*; J. M. Beaton, 'Terrestrial photogrammetry in Australian archaeology'.

[25] Department of Environment, South Australia, *Bridgewater Mill*, and *The Second Company's Bridge*; C. St Clair-Johnson, 'The Australian Heritage Engineering Record and the recording of bridges'.

[26] See, for example, A. J. Koppi, B. G. Davey and J. M. Birmingham, 'The soils in the old vineyard at Camden Park Estate, Camden, New South Wales'.

[27] J. Ramsay, *Parks, Gardens and Special Trees: A Classification and Assessment Method for the Register of the National Estate*, and *How to Record the National Estate Values of Gardens*.

[28] J. Clegg, 'Recording prehistoric art'.

[29] J. Clegg, 'Style and tradition at Sturt's Meadows', and 'The evaluation of archaeological significance: Prehistoric pictures and/or rock art'; P. Stanbury and J. Clegg, *A Field Guide to Aboriginal Rock Engravings*.

4 Assessing the Value of Heritage Places

[1] J. S. Kerr, *The Conservation Plan*; Australia ICOMOS, *The Illustrated Burra Charter*.

[2] Australia ICOMOS, *The Illustrated Burra Charter*, p. 73.

[3] ibid.

[4] Kerr, *The Conservation Plan*, p. 11.

[5] See a stimulating discussion of this issue in D. Lowenthal, *The Past Is a Foreign Country*. See also D. J. Mulvaney, 'The heritage value of historic relics: A plea for romantic intellectualism' and 'Future pleasure from the past?'; A. Bickford, 'The patina of nostalgia'.

[6] Australian Heritage Commission, A Preliminary Proposal for Assessment of Aesthetic Values for Regional Assessment.

7 R. Apperly, R. Irving and P. Reynolds, *A Pictorial Guide to Identifying Australian architecture: Styles and Themes from 1788 to the Present*; P. Bell, *Timber and Iron: Houses in North Queensland Mining Settlements, 1861–1920*; R. Moore, S. Burke and R. Joyce, *Australian Cottages*; J. S. Kerr, *Design for Convicts: An Account of Design for Convict Establishments in the Australian Colonies during the Transportation Era*; P. Hiscock and S. Mitchell, *Stone Artefact Quarries and Reduction Sites in Australia.*

8 Australia ICOMOS, *The Illustrated Burra Charter*, p. 73.

9 Graeme Davison, 'What makes a building historic?', in G. Davison and C. McConville (eds), *A Heritage Handbook*, pp. 65–76.

10 See M. Lewis, 'The ugly historian', and 'Conserving the purpose of conservation planning'; C. McConville, 'History and conservation', and '"In trust"?: Heritage and history'; P. Donovan, 'How historians keep architects honest'.

11 Davison, 'What makes a building historic?', in Davison and McConville, *A Heritage Handbook*, pp. 66–7.

12 Helen Proudfoot, quoted in S. Sullivan, 'Cultural resource management and historical studies', p. 13.

13 Eileen Power (1937), quoted in D. J. Mulvaney, 'The heritage value of historic relics: A plea for romantic intellectualism', p. 4.

14 M. Pearson, 'Historic sites: Themes and variations'; A. Bickford, 'The patina of nostalgia'.

15 D. B. Rose and D. Lewis, 'A bridge and a pinch', pp. 30–1.

16 Australia ICOMOS, *The Illustrated Burra Charter*, p. 73.

17 M. B. Schiffer and C. J. Gumerman, *Conservation Archaeology*, pp. 211–12.

18 R. Jones, 'Submission to the Senate Committee on South West Tasmania'; and 'Ice age hunters of the Tasmanian wilderness'; J. Flood, *The Riches of Ancient Australia*, pp. 327–30.

19 D. J. Mulvaney, 'An archaeological treasure trove may drown'.

20 J. Birmingham, '"The archaeological contribution to nineteenth-century history—some Australian case studies'.

21 B. Rogers, 'Innovation in the manufacture of salt in eastern Australia: The thorn graduation process', 'Derivation of technologies employed in some pre-1900 salt works in eastern Australia', and 'Interpretation of an 1830s salt works site on the Little Swanport River, Tasmania'.

22 S. Bowdler, 'Unconsidered trifles? Cultural resource management, environmental impact statements and archaeological research in NSW'; A. Bickford and S. Sullivan, 'Assessing the research significance of historic sites'; M. Pearson, 'Assessing the significance of historical archaeological resources'.

23 P. J. F. Coutts and D. Witter, *A Guide to Recording Archaeological Sites in Victoria*; P. J. F. Coutts (ed.), *Cultural Resource Management in Victoria 1979–81*.

24 Bickford and Sullivan, 'Assessing the research significance of historic sites', pp. 23–4.
25 Bowdler, 'Unconsidered trifles?'
26 J. M. Adouasio and R. C. Carlisle, 'Some thoughts on cultural resource management archaeology in the United States', p. 234.
27 Australia ICOMOS, *The Illustrated Burra Charter*, p. 73.
28 B. Harrison, 'The Myall Creek massacre'.
29 M. Pearson, *Mawson's Huts Historic Site Conservation Plan*.
30 C. Johnston, *What Is Social Value?*
31 M. Walker, *What's Important about Queanbeyan? A Case Study in the Community Identification of the National Estate.*
32 M. J. Moratto, quoted in Schiffer and Gumerman, *Conservation Archaeology*, p. 244.
33 Schiffer and Gumerman, *Conservation Archaeology*, pp. 244–5.
34 R. Ellis, 'The Aboriginal heritage: Sacred and significant sites'.
35 S. Bowdler, 'Repainting Australian rock art'; D. Mowaljarlai and C. Peck, 'Ngarinyin cultural continuity: A project to teach the young people the culture including the repainting of Wandjina rock art sites'.
36 F. Gale, The Role of Tour Operators in Educating Visitors to Enjoy and Respect Aboriginal Art in Kakadu National Park.
37 Badger Bates, 'Mootwingee National Park: A case study'.
38 C. Pardoe, 'Cross-cultural attitudes to skeletal research in the Murray–Darling region'.
39 B. J. Egloff, *Mumbulla Mountain: An Anthropological and Archaeological Investigation.*
40 J. A. Tainter and G. J. Lucas, 'Epistemology of the significance concept', p. 714.
41 A. Blake, 'Aspects of significance'.
42 D. Bell, Aboriginal Carved Tees in New South Wales: A Survey Report; G. Reid, *From Dusk Till Dawn: A History of Australian Lighthouses*; D. Nash, Report on Historical Classifications of Lighthouses; J. Winston-Gregson, Australian Lighthouses Type-profile.
43 S. Blair and A. Claoué-Long, 'A landscape of captive labour: Evidence of the convict era in the Lanyon landscape', pp. 81–2.
44 P. J. F. Coutts (ed.), *Cultural Resource Management in Victoria 1979–81*; S. Bowdler, 'Archaeological significance as a mutable quality'; Tainter and Lucas, 'Epistemology of the significance concept', p. 714.
45 Australia ICOMOS, *The Illustrated Burra Charter*.
46 ibid., p. 73.
47 Kerr, *The Conservation Plan*.
48 J. S. Kerr, *Cockatoo Island: Penal and Institutional Remains, Goat Island: An Analysis of Documentary and Physical Evidence and an Assessment of Significance, Admiralty House: A Conservation Plan Prepared for the*

Department of Housing and Construction, *Elephant Castle: An Investigation of the Significance of the Head Office Building of the Commonwealth Banking Corporation of Australia, Sydney, Sydney Observatory: A Conservation Plan for the Site and its Structures, Yungaba Immigration Depot: A Plan for its Conservation.*

49 J. McIlroy, 'Bathers Bay whaling station, Fremantle, Western Australia'.

50 Kerr, *The Conservation Plan*, p. 7.

51 Australia ICOMOS, *The Illustrated Burra Charter*, p. 74.

52 C. O'Connor, *How to Look at Bridges: A Guide to the Study of Australian Historic Bridges, Register of Australian Historic Bridges, Spanning Two Centuries: Historic Bridges of Australia.*

53 Kerr, *Design for Convicts.*

54 J. McDonald, *Sydney Basin Aboriginal Heritage Study: Shelter Art Sites: Stage 2, Sydney Basin Aboriginal Heritage Study: Rock Engravings and Shelter Art Sites: Stage 1,* and 'Sydney Basin Aboriginal heritage study: Rock engravings, painting and drawing sites: Stage 1'.

55 Kerr, *The Conservation Plan*, pp. 8–10.

56 ibid., pp. 12–13.

57 [J. Lennon], *Red Gums and Riders: A History of Gellibrand Hill Park*, p. 71. Slightly different wording is used in National Parks Service and Port Phillip Area, Department of Conservation and Natural Resources, Victoria, *Gellibrand Hill Park Proposed Woodlands Historic Park Draft Management Plan*, p. 1.

58 K. Sullivan, *Managing the Art and Archaeological Resources of an Area Near Laura, North Queensland, Inscribed as Part of the National Estate*, pp. 5–6.

5 Planning for Heritage Place Management

1 Australia ICOMOS, *The Illustrated Burra Charter.*

2 ibid.; J. S. Kerr, *The Conservation Plan.*

3 J. McDonald, 'Sydney Basin Aboriginal heritage study: rock engravings, painting and drawing sites: Stage 1'.

4 D. Bannear and R. Annear, *Assessment of Historic Mining Sites in the Castlemaine–Chewton Area: A Pilot Study.*

5 See S. Bowdler, *Aboriginal Sites on the Crown-timber lands of New South Wales*; A. McConnell, *A Forest Archaeology Manual.*

6 A. Thorne and A. Ross, *The Skeleton Manual: A Handbook for the Identification of Aboriginal Skeletal Remains.*

7 S. Bowdler, 'Repainting Australian rock art'; D. Mowaljarlai et al., 'Repainting of images on rock in Australia and the maintenance of Aboriginal culture'; D. Mowaljarlai and C. Peck, 'Ngarinyin cultural continuity: A project to teach the young people the culture including the repainting of Wandjina rock art sites'.

8 See discussion of Aboriginal Sites management in protected areas in S. Sullivan, 'Aboriginal site management in national parks and protected areas', and other articles in J. Birkhead, T. de Lacy and L. Smith (eds), *Aboriginal Involvement in Parks and Protected Areas.*

9 Australia ICOMOS, *The Illustrated Burra Charter.*

10 P. Emmett, 'Convictism: Hyde Park Barracks and the antipodean gulag'.

11 D. Moloney, 'Use—a heritage issue?'

12 Australia ICOMOS, *The Illustrated Burra Charter*, p. 78.

13 See, for example, the discussion in D. Godden, 'Policy for the in-situ conservation of railway items'.

14 National Parks Service and Port Phillip Area, Department of Conservation and Natural Resources, Victoria, *Gellibrand Hill Park Proposed Woodlands Historic Park Draft Management Plan*, p. 7.

15 J. S. Kerr, *Admiralty House: A Conservation Plan Prepared for the Department of Housing and Construction*, p. 56.

16 K. Sullivan, *Managing the Art and Archaeological Resources of an Area Near Laura, North Queensland, Inscribed as Part of the National Estate*, p. 61.

6 Implementing Heritage Place Management

1 Australia ICOMOS, *The Illustrated Burra Charter.*

2 R. Mackay, Built Environment Conservation: Concentrating on the Fabric, pp. 3–4.

3 C. Wei and A. Aass, 'Heritage conservation East and West'.

4 D. J. Mulvaney, 'The heritage value of historic relics: A plea for romantic intellectualism'.

5 L. Maynard, 'Restoration of Aboriginal rock art—the moral problem'.

6 J. Ruskin, *The Seven Lamps of Architecture*, Ch VI (18019).

7 For a discussion of a case of repainting see D. Mowaljarlai and C. Peck, 'Ngarinyin Cultural Continuity: A project to teach the young people the culture including the repainting of Wandjina rock art sites'; S. Bowdler, 'Repainting Australian rock art'.

8 H. Chambers, *Cyclical Maintenance of Historic Buildings.*

9 The Australian Council of National Trusts, the National Trust of Australia (Victoria), and National Trust of Australia (NSW) have published a series of booklets on aspects of conservation work: G. S. Gibbons (ed.), *Maintaining and Restoring Masonry Walls*; P. Jones, *Planting c. 1850–1900: A Guide to the Restoration, Conservation and Rehabilitation of Early Style Australian Gardens and Man-made Landscapes*; M. Lewis, *Physical Investigation of a Building; An Approach to the Archaeology of Standing Structures*; M. Lewis and A. Blake, *Exterior Paint Colours*; C. Lucas, *Conservation and Restoration of Buildings:*

Preservation of Masonry Walls, and *Preservation of Roofs*; A. H. Spry, *Principles of Cleaning Masonry Buildings*; G. Tibbits, *Lettering and Signs on Buildings c. 1850–1900*.

The Heritage Council of New South Wales has a series on conservation practice: E. Balint, *Maintaining an Old House*; K. Gehrig, *A Guide to Traditional Painting Techniques*; G. S. Gibbons, *Masonry Renovation*; J. L. Heiman, *Rising Damp and its Treatment*; Heritage Council of New South Wales, *Infill: Guidelines for the Design of Infill Buildings*.

Other useful references are: Australian Garden History Society, *Historic Gardens in Australia: Guidelines for the Preparation of Conservation Plans*; I. Evans, *Restoring Old Houses: A Guide to Authentic Restoration*; H. Lardner, *Caring for Historic Buildings: Guidelines for Alterations and Additions to Historic Buildings*; J. McKay and R. Allom, *Lest We Forget: A Guide to the Conservation of War Memorials*; I. Stapleton, *How to Restore the Old Aussie House*.

10 Institution of Engineers, Australia, *Heritage for Engineers: Position Paper*.

11 J. McKay and R. Allom, *Lest We Forget*; L. P. Planning Consultants, *Cemeteries of Victoria: Guidelines for Management, Maintenance and Conservation*.

12 G. Hamel and K. Jones, *Manual of Vegetation Management on New Zealand Archaeological Sites*.

13 Australian Garden History Society, *Historic Gardens in Australia*; Australian Heritage Commission, *Australia's Historic Gardens, Parks and Trees*; C. Johnston, 'Assessing gardens: review and recommendations on methods of assessing the cultural significance of gardens'; J. Ramsay, *How to Record the National Estate Values of Gardens*, and *Parks, Gardens and Special Trees: A Classification and Assessment Method for the Register of the National Estate*.

14 N. Stanley Price, 'What makes a conservation treatment acceptable or not?'

15 D. Lambert, *Conserving Australian Rock Art: A Manual for Site Managers*.

16 W. J. Snelson, M. E. Sullivan and N. D. Preece, 'Nundera Point: An experiment in stabilising a foredune shell midden'.

17 Hamel and Jones, *Manual of Vegetation Management on New Zealand Archaeological Sites*.

18 See, for example, B. J. Egloff, 'Sampling the Five Forests', and D. Byrne, 'A survey strategy for a coastal forest'.

19 See V. Attenbrow, Mangrove Creek Dam salvage excavation project; and V. Attenbrow, 'The archaeology of the upper Mangrove Creek catchment: Research in progress'.

20 See M. B. Schiffer and C. J. Gumerman, *Conservation Archaeology*.

21 For example see P. E. Guldbeck, *The Care of Historical Collections*; Western Australian Museum, *Conservation and Restoration for Small Museums*.

7 Visitor Management and Interpretation

1 For general coverage of a range of relevant issues see D. Lowenthal, 'Heritage and its interpreters'; ICOMOS, International Specialised Committee on Tourism, *Cultural Tourism: Tourism at World Heritage Cultural Sites: The Site Manager's Handbook*; *Historic Environment*, Cultural Heritage and Tourism edition, vol. 7, nos 3 & 4, 1990; H. Sullivan (ed.), *Visitors to Aboriginal Sites: Access, Control and Management*; F. Gale and J. Jacobs, *Tourists and the National Estate: Procedures to Protect Australia's Heritage*; G. Schoer, *Heritage Conservation in Action: An Education Kit for NSW High School Students*; Australian Heritage Commission, *The National Estate for Primary Schools*.

2 Gale and Jacobs, *Tourists and the National Estate*.

3 S. Sullivan, *Grotto Sites in China*.

4 F. Gale, 'The protection of Aboriginal rock art from tourists at Ubirr, Kakadu National Park', p. 37.

5 See M. Zweck, 'Heritage and tourism'; P. Watts, 'Museum houses: Costs and benefits'.

6 F. Gale, The role of tour operators in educating visitors to enjoy and respect Aboriginal art in Kakadu National Park.

7 Province of British Columbia, Vancouver Island Regional Interpretation and Information Plan, 1979, quoted in C. A. Evans, 'Heritage interpretation: Philosophy and approach', p. 3.

8 For a recent overview of visitor management and interpretation in New Zealand and Australia see Hall and McArthur, *Heritage Management in New Zealand and Australia*.

9 M. Walker, 'Interpretation and small museums'.

10 S. Sullivan, 'Cultural resource management and historical studies'.

11 See, for example, A. Bickford, 'The patina of nostalgia'; S. Sullivan, 'Cultural resource management and historical studies'; K. Daniels, 'Cults of nature, cults of history'.

12 C. Hoepfner, M. P. Leone and P. B. Potter, 'The preserved is political: A critical theory', pp. 10–11.

13 ibid.

14 J. McCarthy, 'Historic sites: What future?'

15 See also M. Pearson, 'Historic sites: Themes and variations'.

16 A. Bickford, 'The patina of nostalgia', p. 2.

17 But see L. Maynard, 'Restoration of Aboriginal rock art—the moral problem'; S. Bowdler, 'Repainting Australian rock art'.

18 C. Evans, 'Interpretative development: The politics of aesthetics'.

19 C. A. Evans, 'Heritage interpretation: Philosophy and approach'.

20 R. Mackay, 'Built Environment Conservation: Concentrating on the Fabric'.

21 ibid., p. 14.

22 See F. Gale, and J. Jacobs, 'Identifying high-risk visitors at Aboriginal art sites in Australia', for a good example of a visitor study.

23 For a description of a monitoring program see F. Gale, 'Monitoring visitor behavior at rock art sites'.

24 See F. Gale, 'The protection of Aboriginal rock art from tourists at Ubirr, Kakadu National Park', and Gale and Jacobs, *Tourists and the National Estate.*

25 Gale, 'The protection of Aboriginal rock art from tourists at Ubirr, Kakadu National Park'.

26 S. Feary, 'Aboriginal sites as a tourist attraction in New South Wales'.

27 See G. L. Walsh, 'Archaeological site management in Carnarvon National Park: A case study in the dilemma of presentation or preservation'; Gale and Jacobs, *Tourists and the National Estate.*

28 See K. M. Sullivan, 'Monitoring visitor use and site management at three art sites: An experiment with visitors' books', for design and use.

29 F. Gale, 'Aboriginal sites and visitors'.

30 P. Boyer, 'The interpretation of Port Arthur'.

31 Gale and Jacobs, *Tourists and the National Estate.*

32 M. Zweck, 'Heritage and tourism'.

8 Some Current Issues and Future Concerns

1 D. B. Rose and D. Lewis, 'A bridge and a pinch'.

2 See C. Johnston, *What Is Social Value?*; M. Walker, What's important about Queanbeyan? A case study in the community identification of the National Estate; S. Blair (ed.), *People's Places: Identifying and Assessing Social Value for Communities—A Social Value Workshop.*

3 I. Stapleton, 'Assessing the European cultural significance of the Swan Brewery Site, Perth, W.A.'

4 P. Vinnicombe, 'An Aboriginal site complex at the foot of Mt Eliza which includes the old Swan Brewery'.

5 J. Rickard and P. Spearitt (eds), *Packaging the Past?: Public History.*

6 I. McShane, 'Order in the house'.

7 For an interesting recent article on this issue see M. Anderson, 'In search of women's public history: Heritage and gender'.

8 See, for example, J. M. Fitch, *Historic Preservation: Curatorial Management of the Built World.*

9 R. Jones, 'Ordering the landscape'.

10 Fitch, *Historic Preservation*, pp. 40–1.

11 See, for example, Fitch, *Historic Preservation.*

12 J. and S. Domicelj, *A Sense of Place: A Conversation in Three Cultures*, pp. vii–x.

Bibliography

Adouasio, J. M. and Carlisle R. C. 'Some thoughts on cultural resource management archaeology in the United States', *Antiquity*, vol. 62, 1988, p. 234.

Anderson, M. 'In search of women's public history: Heritage and gender', *Public History Review*, vol. 2, 1993, pp. 1–18.

Apperly, R., Irving, R. and Reynolds, P. *A Pictorial Guide to Identifying Australian Architecture: Styles and Themes from 1788 to the Present.* Angus & Robertson, Sydney, 1989.

Attenbrow, V. 'The archaeology of the upper Mangrove Creek catchment: Research in progress', in S. Bowdler (ed.), *Coastal Archaeology in Eastern Australia: Proceedings of the 1980 Valla Conference on Australian Prehistory.* Department of Prehistory, Australian National University, Canberra, 1982, pp. 67–78.

——. Mangrove Creek Dam Salvage Excavation Project. Unpublished report for NSW National Parks and Wildlife Service, Sydney, 1981.

——. 'Port Jackson archaeological project: A study of the prehistory of the Port Jackson Catchment, New South Wales. Stage 1—Site recording and site assessment', *Australian Aboriginal Studies*, no. 2, 1991, pp. 40–55.

Australia ICOMOS. *The Illustrated Burra Charter,* ed. by Peter Marquis-Kyle and Meredith Walker. Australia ICOMOS, Sydney, 1992.

——. *The Tide of Australian Settlement: Conservation of the Physical Evidence,* Proceedings of the Beechworth Conference. Australia ICOMOS, Sydney, 1978.

Australian Garden History Society. *Historic Gardens in Australia: Guidelines for the Preparation of Conservation Plans.* Garden History Society, Sydney, 1983.

Australian Heritage Commission. *Australia's Historic Gardens, Parks and Trees,* Australian Heritage Commission Bibliography Series no. 4. Australian Heritage Commission, Canberra, 1991.

——. *Criteria for the Register of the National Estate: Application Guidelines.* Australian Heritage Commission, Canberra, 1990.

——. *Cultural Resource Management,* Australian Heritage Commission Bibliography Series no. 3. Australian Heritage Commission, Canberra, 1990.

——. *The Heritage of Australia: The Illustrated Register of the National Estate.* Macmillan, Melbourne, 1981.

——. *The Heritage of South Australia, and the Northern Territory: The Illustrated Register of the National Estate.* Macmillan, Melbourne, 1985.

——. *The Heritage of Tasmania: The Illustrated Register of the National Estate.* Macmillan, Melbourne, 1983.

——. *The Heritage of Victoria: The Illustrated Register of the National Estate.* Macmillan, Melbourne, 1985.

——. *The Heritage of Western Australia: The Illustrated Register of the National Estate.* Macmillan, Melbourne, 1989.

——. *The National Estate for Primary Schools.* Australian Heritage Commission, Canberra, 1993.

——. A Preliminary Proposal for Assessment of Aesthetic Values for Regional Assessment. Unpublished working paper, Australian Heritage Commission, Canberra, 1993.

Balint, E. *Maintaining an Old House,* Department of Planning (NSW), Technical Information Sheet 4. Sydney, 1989.

Bannear, D. and Annear, R. *Assessment of Historic Mining Sites in the Castlemaine–Chewton Area—A Pilot Study,* Report for the Historic Mining Sites Assessment Committee. Victorian Department of Mineral Resources and Deptartment of Conservation and Environment, Melbourne, 1990.

Barwick, D., Mace, M. and Stannage, T. *Handbook for Aboriginal and Islanders History.* Special edition of *Aboriginal History,* Canberra, 1979.

Bates, B. 'Mootwingee National Park: A case study', *Historic Environment,* vol. 10, nos 2 and 3, 1993, pp. 63–6.

Bates, G. M. *Environmental Law in Australia.* Butterworths, Sydney, 1983.

Beaton, J. M. 'Terrestrial photogrammetry in Australian archaeology', in G. Connah (ed.), *Australian Archaeology: A Guide to Field Techniques,* Australian Institute of Aboriginal Studies, Canberra, 1983, pp. 64–6.

Bell, D. Aboriginal Carved Trees in New South Wales: A Survey Report. Unpublished report for NSW National Parks and Wildlife Service, Sydney, 1979.

Bell, P. *Timber and Iron: Houses in North Queensland Mining Settlements, 1861–1920.* University of Queensland Press, St Lucia, Qld, 1984.

Bell, R. E. and Gettys, M. (eds). A Consideration of the Archaeological and Historical Resources Involved in the Mid-Ark Project. Unpublished manuscript, Arkansas Archaeological Survey, University of Arkansas, n.d.

Bickford, A. Boydtown: The Archaeological Investigation of Boydtown, Twofold Bay, NSW. Unpublished report for Heritage Council of NSW, Sydney, 1980.

——. 'The patina of nostalgia', *Australian Archaeology*, vol. 13, 1981, pp. 1–7.

——, and Sullivan, S. 'Assessing the research significance of historic sites', in S. Sullivan and S. Bowdler (eds), *Site Survey and Significance Assessment in Australian Archaeology*, Department of Prehistory, Research School of Pacific Studies, Australian National University, 1984, pp. 19–26.

Birkhead, J., de Lacy, T. and Smith, L. (eds). *Aboriginal Involvement in Parks and Protected Areas*, Australian Institute of Aboriginal and Torres Strait Islander Studies Report Series. Australian Institute of Aboriginal and Torres Strait Islander Studies, Canberra, 1992.

Birmingham, J. 'Recording to some purpose', in P. Stanbury (ed.), *10,000 Years of Sydney Life*. Macleay Museum, University of Sydney, 1979, pp. 74–81.

——. 'The archaeological contribution to nineteenth-century history—some Australian case studies', *World Archaeology*, vol. 7, no. 3, 1976, pp. 306–17.

——, Jack, I. and Jeans, D. *Industrial Archaeology in Australia: Rural Industry*. Heinemann, Richmond, Vic., 1983.

Blair, S. (ed.). *People's Places: Identifying and Assessing Social Value for Communities—A Social Value Workshop*. Australian Heritage Commission, Technical Workshop Series, Canberra, 1994.

—— and Claoué-Long, A. 'A landscape of captive labour: Evidence of the convict era in the Lanyon landscape', *Public History Review*, vol. 2, 1993, pp. 81–98.

Blake, A. 'Aspects of significance', in S. Sullivan (ed.), *Cultural Conservation: Towards a National Approach*. Australian Heritage Commission, Canberra, in press.

Bowdler, S. *Aboriginal Sites on the Crown-timber lands of New South Wales*. Forestry Commission of New South Wales, Sydney, 1983.

——. 'Archaeological significance as a mutable quality', in S. Sullivan and S. Bowdler (eds), *Site Surveys and Significance Assessment in Australian Archaeology*. Research School of Pacific Studies, Australian National University, 1984, pp. 1–9.

—— (ed.). *Coastal Archaeology in Eastern Australia: Proceedings of the 1980 Valla Conference on Australian Prehistory*. Department of Prehistory, Australian National University, Canberra, 1982.

——. 'Repainting Australian rock art', *Antiquity*, vol. 62, 1988, pp. 517–23.

——. 'Unconsidered trifles? Cultural resource management, environmental impact statements and archaeological research in NSW', *Australian Archaeology*, vol. 12, 1981, pp. 123–33.

Boyer, P. 'The interpretation of Port Arthur', in S. Sullivan (ed.), *Cultural Conservation: Towards a National Approach.* Australian Heritage Commission, Canberra, in press.

Byrne, D. *The Mountains Call Me Back*, Occasional Paper no. 5. New South Wales Ministry of Aboriginal Affairs, Sydney, 1984.

——. 'A survey strategy for a coastal forest', in S. Sullivan and S. Bowdler (eds), *Site Surveys and Significance Assessment in Australian Archaeology.* Research School of Pacific Studies, Australian National University, Canberra, 1984, pp. 61–70.

Chambers, H. *Cyclical Maintenance of Historic Buildings.* US Department of the Interior, Washington, DC, 1976.

Clegg, J. 'The evaluation of archaeological significance: Prehistoric pictures and/or rock art', in S. Sullivan and S. Bowdler (eds), *Site Surveys and Significance Assessment in Australian Archaeology.* Research School of Pacific Studies, Australian National University, Canberra, 1984, pp. 10–18.

——. 'A 'metaphysical' approach to the study of Aboriginal rock paintings', *Mankind*, vol. 8, 1971, pp. 37–44.

——. 'Recording prehistoric art', in G. Connah (ed.), *Australian Archaeology: A Guide to Field Techniques.* Australian Institute of Aboriginal Studies, Canberra, 1983, pp. 87–108.

——. 'Style and tradition at Sturt's Meadows', *World Archaeology*, vol. 19, no. 2, 1987, pp. 236–55.

Committee of Inquiry into the National Estate. *Report of the National Estate.* Australian Government Publishing Service, Canberra, 1974.

Connah, G. (ed.). *Australian Archaeology: A Guide to Field Techniques.* Australian Institute of Aboriginal Studies, Canberra, 1983.

Coutts, P. J. F. (ed.). *Cultural Resource Management in Victoria 1979–81*, Records of the Victoria Archaeological Survey No. 13. Ministry for Conservation, Melbourne, 1982.

Coutts, P. [J. F.] 'Old buildings tell tales', *World Archaeology*, vol. 9, no. 2, 1977, pp. 200–19.

—— and Witter, D. *A Guide to Recording Archaeological Sites in Victoria,* Records of the Victorian Archaeological Survey No. 3. Ministry for Conservation, Melbourne, 1977.

Creamer, H. 'The Aboriginal heritage in New South Wales and the role of the NSW Aboriginal Sites Survey Team', in C. Haigh and W. Goldstein (eds), *The Aborigines of New South Wales.* NSW National Parks and Wildlife Service, Sydney, 1980, pp. 88–93.

——. 'Contacting Aboriginal communities', in G. Connah (ed.), *Australian Archaeology: A Guide to Field Techniques.* Australian Institute of Aboriginal Studies, Canberra, 1983, pp. 10–17.

Crisp, C. 'A brief report on the history, construction and restoration of Tathra Wharf, NSW', in National Trust of Australia (NSW), *Industrial and Historical Archaeology.* National Trust of Australia (NSW), Sydney, 1981, pp. 58–9.

Dallwitz, J. and Marsden, S. *Heritage of the River Murray.* South Australian Department of Environment and Planning, Adelaide, 1985.

—— and ——. *Heritage Survey of the Lower North.* South Australian Department of Environment and Planning, Adelaide, 1983.

Daniels, K. 'Cults of nature, cults of history', *Island Magazine,* vol. 16, 1883, pp. 3–8.

Danvers Architects. *Heritage of the South East.* South Australian Department of Environment and Planning, Adelaide, 1984.

Dargin, P. *Aboriginal Fisheries of the Darling–Barwon Rivers.* Brewarrina Historical Society, NSW, 1976.

Davies, M. 'The archaeology of standing structures', *Australian Journal of Historical Archaeology* vol. 5, 1987, pp. 54–64.

——. 'Recording, analysing and interpreting timber structures', *Historic Environment,* vol. 6, nos 2–3, 1988, pp. 60–3.

—— and Buckley, K. *Archaeological Procedures Manual: Port Arthur Conservation and Development Project,* Occasional Paper no. 13. Department of Lands, Parks and Wildlife, Hobart, 1987.

Davis, M. and Boyce, H. *Directory of Australian Pictorial Resources.* Centre for Environmental Studies, University of Melbourne, 1981.

Davison, G. and McConville, C. (eds). *A Heritage Handbook.* Allen & Unwin, Sydney, 1991.

Department of Environment, South Australia. *Bridgewater Mill,* Australian Heritage Engineering Record SA6. Department of Environment, Adelaide, 1980.

——. *The Second Company's Bridge,* Australian Heritage Engineering Record SA8. Department of Environment, Adelaide, 1980.

Department of Planning, NSW. *Environmental Planning in NSW.* Leaflet, Department of Planning, NSW, Sydney, n.d.

——. *15 Suggestions on How Local Councils Can Promote Heritage Conservation.* Department of Planning, NSW, Sydney, n.d.

——. *The State Heritage Inventory Project (SHIP),* Information Sheet H91/12 No. 11. Department of Planning, NSW, Sydney, 1991.

Department of Planning and Housing, Victoria. *Local Government Heritage Guidelines.* Department of Planning and Housing, Victoria, Melbourne, 1991.

Domicelj, J. & S. *A Sense of Place: A Conversation in Three Cultures.* Australian Heritage Commission, Canberra, 1990.

Donovan, P. 'How historians keep architects honest', *Historic Environment,* vol. 5, no. 4, 1987, pp. 8–14.

——. 'Regional heritage surveys: the South Australian case', in S. Sullivan (ed.), *Cultural Conservation: Towards a National Approach.* Australian Heritage Commission, Canberra, in press.

Egloff, B. J. *Mumbulla Mountain: An Anthropological and Archaeological Investigation,* Occasional Paper No. 4. NSW National Parks and Wildlife Service, Sydney, 1981.

——. 'Sampling the Five Forests', in S. Sullivan and S. Bowdler (eds), *Site Surveys and Significance Assessment in Australian Archaeology*. Research School of Pacific Studies, Australian National University, Canberra, 1984, pp. 71–8.

Ellis, R. 'The Aboriginal heritage: sacred and significant sites', in S. Sullivan (ed.), *Cultural Conservation: Towards a National Approach*. Australian Heritage Commission, Canberra, in press.

Emmett, P. 'Convictism: Hyde Park Barracks and the antipodean gulag', *Historic Environment*, vol. 10, nos 2 and 3, 1993, pp. 26–30.

Eslick, C., Hughes, J. and Jack, R. I. *Bibliography of NSW Local History and NSW Directories 1828–1950*. NSW University Press, Sydney, 1987.

Etherington, N., Brock, P., Stannage, T., Gregory J. and Lennon, J. *Principal Australian Themes Project: Stage 1 Draft Report for Circulation and Discussion—Uses and Identification of Principle Historic Themes*, vol. 1, Report of Findings. Centre for Western Australian History for the Australian Heritage Commission, Canberra, 1994.

Evans, C. A. 'Heritage interpretation: philosophy and approach', in ACT Heritage Committee, *ACT Heritage Seminars*, vol. 3. ACT Heritage Committee, Canberra, 1985, pp 1–10.

Evans, C. [A.]. 'Interpretative development: The politics of aesthetics', in S. Sullivan (ed.), *Cultural Conservation: Towards a National Approach*. Australian Heritage Commission, Canberra, in press.

Evans, I. *Restoring Old Houses: A Guide to Authentic Restoration*. Sun Books, Melbourne, 1983.

Feary, S. 'Aboriginal sites as a tourist attraction in New South Wales', *Australian Parks and Recreation*, vol. 24, no. 3, 1988, pp. 20–3.

Fitch, J. M. *Historic Preservation: Curatorial Management of the Built World*. University Press of Virginia, Charlottesville, VA, 1990.

Flood, J. 'Identification and recording at historic sites', in National Trust of Australia (NSW), *Industrial and Historical Archaeology*, National Trust of Australia (NSW), SyDNey, 1981, pp. 29–36.

——. *The Riches of Ancient Australia*. University of Queensland Press, St Lucia, Qld, 1990.

——, Johnson, I. and Sullivan, S. *Sites and Bytes: Recording Aboriginal Places in Australia*, Proceedings of 1988 Workshop, Australian Heritage Commission. Australian Government Publishing Service, Canberra, 1989.

Gale, F. 'Aboriginal sites and visitors', in S. Sullivan (ed.), *Cultural Conservation: Towards a National Approach*. Australian Heritage Commission, Canberra, in press.

——. 'Monitoring visitor behavior at rock art sites', *Rock Art Research*, vol. 2, no. 2, 1985, pp. 112–18.

——. 'The protection of Aboriginal rock art from tourists at Ubirr, Kakadu National Park', in H. Sullivan (ed.), *Visitors to Aboriginal Sites: Access, Control and Management*, Proceedings of the 1983

Kakadu Workshop. Australian National Parks and Wildlife Service, Canberra, 1984, pp. 32–40.

——. The Role of Tour Operators in Educating Visitors to Enjoy and Respect Aboriginal Art in Kakadu National Park. Unpublished typescript, Australian Heritage Commission Library, Canberra, 1984.

—— and Jacobs, J. 'Identifying high-risk visitors at Aboriginal art sites in Australia', *Rock Art Research*, vol. 3, no. 1, 1986, pp. 3–19.

—— and ——. *Tourists and the National Estate: Procedures to Protect Australia's Heritage.* Australian Heritage Commission, Canberra, 1987.

Gehrig, K. *A Guide to Traditional Painting Techniques.* Heritage Council of New South Wales, Research Study no. 9, Sydney, 1985.

Gibbons, G. S. (ed.). *Maintaining and Restoring Masonry Walls.* National Trust of Australia (NSW), Sydney, 1978.

——. *Masonry Renovation,* Heritage Council of New South Wales, Technical Information Sheet 2. Sydney, 1982.

Godden, D. 'Policy for the in-situ conservation of railway items', *Historic Environment,* vol. 10, no. 1, 1993, pp. 41–8.

Guldbeck, P. E. *The Care of Historical Collections.* American Association for State and Local History, Nashville, TN, 1972.

Gungwu, W. 'Loving the ancient in China', in I. McBryde (ed.), *Who Owns the Past?* Oxford University Press, Melbourne, 1985, pp. 175–95.

Haigh, C. and Goldstein, W. (eds). *The Aborigines of New South Wales.* NSW National Parks and Wildlife Service, Sydney, 1980.

Hall, C. M. and McArthur, S. (eds). *Heritage Management in New Zealand and Australia: Visitor Management, Interpretation and Marketing,* Oxford University Press, Auckland, 1993.

Hallam, S. J. *Fire and Hearth,* Australian Aboriginal Studies no. 58. Australian Institute of Aboriginal Studies, Canberra, 1975.

Hamel, G. and Jones, K. *Manual of Vegetation Management on New Zealand Archaeological Sites.* New Zealand Historic Places Trust, Wellington, 1982.

Hancock, W. K. *Discovering Monaro: A Study of Man's Impact on His Environment.* Cambridge University Press, Cambridge, 1972.

Hardy, B. *West of the Darling.* Rigby, Sydney, 1969.

Harrison, B. 'The Myall Creek massacre', in I. McBryde (ed.), *Records of Times Past: Ethnographic Essays on the Culture and Ecology of the New England Tribes.* Australian Institute of Aboriginal Studies, Canberra, 1978, pp. 17–51.

Heiman, J. L. *Rising Damp and its Treatment.* Heritage Council of New South Wales, Technical Information Sheet 1. Sydney, 1982.

Henderson, G. *Maritime Archaeology in Australia.* University of Western Australia Press, Nedlands, WA, 1986.

Heritage Council of New South Wales. *Infill: Guidelines for the Design of Infill Buildings.* Heritage Council of New South Wales and Royal Institute of Architects (NSW Chapter), Sydney, 1988.

Hibbins, J., Fahey, C. and Askew, M. *Local History: A Handbook for Enthusiasts.* Allen & Unwin, Sydney, 1985.

Higgins, M. '"That's buggered the Cotter" or European Heritage in Namadgi', in B. Scougall (ed.), *Cultural Heritage of the Australian Alps,* Proceedings of a symposium. Australian Alps Liaison Committee, Canberra, 1992, pp. 165–78.

Hiscock, P. and Mitchell, S. *Stone Artefact Quarries and Reduction Sites in Australia.* Australian Heritage Commission, Canberra, 1993.

Historic Environment, Cultural Heritage and Tourism edition, vol. 7, nos 3 and 4, 1990.

Hoepfner, C., Leone, M. P. and Potter, P. B. 'The preserved is political: A critical theory', *ICOMOS Information,* vol. 3, 1987, pp. 10–16.

Hueneke, K. *Huts of the High Country.* ANU Press, Canberra, 1983.

ICOMOS, International Specialised Committee on Tourism. *Cultural Tourism: Tourism at World Heritage Cultural Sites: The Site Manager's Handbook.* ICOMOS, Paris, 1993.

Institution of Engineers, Australia. *Heritage for Engineers: Position Paper.* Institution of Engineers, Australia, Brisbane, 1990.

Irving, R. (ed.). *The History and Design of the Australian House.* Oxford University Press, Melbourne, 1985.

Jack, R. I. 'Sources for industrial Aarchaeologists', in J. Birmingham, I. Jack, and D. Jeans (eds), *Industrial Archaeology in Australia: Rural Industry.* Heinemann, Richmond, Vic., 1983.

Jacobs, J. M. and Gale, F. *Sydney/Hawkesbury Aboriginal Rock Art: Visitor Pressure Assessment,* final report to NSW National Parks and Wildlife Service. University of Adelaide, Department of Geography, Adelaide, 1987.

James, P. C. A guide to the Legal Protection of the National Estate in Australia. Unpublished report, Australian Heritage Commission, Canberra, 1993.

Jeans, D. N. and Spearritt, P. *The Open Air Museum.* George Allen & Unwin, Sydney, 1980.

Johnston, C. 'Assessing gardens: Review and recommendations on methods of assessing the cultural significance of gardens', *Conservation Bulletin,* vol. 1, no. 1, National Trust of Australia (Vic.), Melbourne, 1987.

——. *What Is Social Value?* Australian Heritage Commission, Canberra, 1992.

Jones, P. *Planting c. 1850–1900: A Guide to the Restoration, Conservation and Rehabilitation of Early Style Australian Gardens and Man-made Landscapes,* Australian Council of National Trusts and National Trust of Australia (Vic.), Technical Bulletin Series 4.1. Melbourne, 1982.

Jones, R. 'Ice age hunters of the Tasmanian wildernesss', *Australian Geographic*, vol. 8, 1987, pp. 26–45.

———. 'Ordering the landscape', in I. Donaldson and T. Donaldson (eds), *Seeing the First Australians*. George Allen & Unwin, Sydney, 1985, pp. 181–209.

———. 'Submission to the Senate Committee on South West Tasmania', *Australian Archaeology*, vol. 14, 1982, pp. 96–106.

Kelly, R. 'A revival of Aboriginal Culture', in C. Haigh and W. Goldstein (eds), *The Aborigines of New South Wales*. NSW National Parks and Wildlife Service, Sydney, 1980, pp. 79–80.

Kerr, J. S. *Admiralty House: A Conservation Plan Prepared for the Department of Housing and Construction*. National Trust of Australia (NSW), Sydney, 1987.

———. *Cockatoo Island: Penal and Institutional Remains*. National Trust of Australia (NSW), Sydney, 1984.

———. *The Conservation Plan: A Guide to the Preparation of Conservation Plans for Places of European Cultural Significance*. National Trust of Australia (NSW), Sydney, 1985.

———. *Design for Convicts: An Account of Design for Convict Establishments in the Australian Colonies During the Transportation Era*. Library of Australian History, Sydney, 1984.

———. *Elephant Castle: An Investigation of the Significance of the Head Office Building of the Commonwealth Banking Corporation of Australia, Sydney*. National Trust of Australia (NSW), Sydney, 1989.

———. *Goat Island: An Analysis of Documentary and Physical Evidence and an Assessment of Significance*. Maritime Services Board of New South Wales, Sydney, 1985.

———. *Sydney Observatory: A Conservation Plan for the Ste and its Structures*. Museum of Applied Arts and Sciences, Sydney, 1991.

———. *Yungaba Immigration Depot: A Plan for its Conservation*. Q-Build Project Services, Administrative Services Department, Brisbane, 1992.

Koppi, A. J., Davey, B. G. and Birmingham, J. M. 'The soils in the old vineyard at Camden Park Estate, Camden, New South Wales', *Australian Journal of Historical Archaeology*, vol. 3, 1985, pp. 24–30.

Lambert, D. *Conserving Australian Rock Art: A Manual for Site Managers*. Aboriginal Studies Press, Canberra, 1989.

Langford, R. J. 'Our heritage, your playground', *Australian Archaeology*, vol. 16, 1983, pp. 1–6.

Lardner, H. *Caring for Historic Buildings: Guidelines for Alterations and Additions to Historic Buildings*. Historic Buildings Council, Victoria, Melbourne, 1993.

Lennon, J. *Our Inheritance: Historic Places on Public Land in Victoria*. Department of Conservation and Environment, Melbourne, 1992.

[Lennon, J.]. *Red Gums and Riders: A History of Gellibrand Hill Park*. Department of Conservation and Natural Resources, Victoria, Melbourne, 1993.

Lewis, D. and Rose, D. *The Shape of the Dreaming*. Aboriginal Studies Press, Canberra, 1988.

Lewis, M. 'Conserving the purpose of conservation planning', in B. Logan (ed.), *Planning for the Past*, proceedings of a seminar, ANZAAS. Monash University, Melbourne, 1985, pp. 27–32.

——. *Physical Investigation of a Building: An Approach to the Archaeology of Sanding Structures*, Australian Council of National Trusts and National Trust of Australia (Vic.), Technical Bulletin Series 9.1. Melbourne, 1989.

——. 'The ugly historian', *Historic Environment*, vol. 5, no. 4, 1986, pp. 4–7.

—— and Blake, A. *Exterior Paint Colours*. National Trust of Australia (Vic.) and Australian Council of National Trusts, Technical Bulletin Series 1.1. Melbourne, 1977.

Lowenthal, D. 'Heritage and its interpreters', *Heritage Australia*, vol. 5, no. 2, 1986, pp. 42–5.

——. *The Past Is a Foreign Country*. Cambridge University Press, Cambridge, 1985.

L. P. Planning Consultants. *Cemeteries of Victoria: Guidelines for Management, Maintenance and Conservation*. National Estate Grants report for Ministry of Planning, Victoria, Melbourne, 1980.

Lucas, C. *Conservation and Restoration of Buildings: Preservation of Masonry Walls*. Australian Council of National Trusts, Sydney, 1977.

——. *Preservation of Roofs*. Australian Council of National Trusts, Sydney, 1979.

McBryde, I. 'Place recording: Some basic guidelines', in National Trust of Australia (NSW), *Industrial and Historical Archaeology*. National Trust of Australia (NSW), Sydney, 1981, pp. 25–8.

——(ed.). *Who Owns the Past?* Oxford University Press, Melbourne, 1985.

McCarthy, J. 'Historic sites: What future?', in S. Sullivan (ed.), *Cultural Conservation: Towards a National Approach*. Australian Heritage Commission, Canberra, in press.

McConnell, A. *Forest Archaeology Manual*. Forestry Commission, Tasmania, Hobart, n.d. [1991].

McConville, C. 'History and conservation', in B. Logan (ed.), *Planning for the Past*, proceedings of a seminar, ANZAAS. Monash University, Melbourne, 1985, pp. 32–5.

——. '"In trust"?: Heritage and history', *Melbourne Historical Journal*, vol. 16, 1984, pp. 66–9.

McDonald, J. *Sydney Basin Aboriginal Heritage Study: Rock Engravings and Shelter Art Sites: Stage 1*, report for NSW National Parks and Wildlife Service, Sydney, 1985.

——. 'Sydney Basin Aboriginal heritage study: Rock engravings, painting and drawing sites: Stage 1', *Rock Art Research*, vol. 2, no. 2, 1985, pp. 158–60.

——. *Sydney Basin Aboriginal Heritage Study: Shelter Art Sites: Stage 2*, report for NSW National Parks and Wildlife Service. Sydney, 1987.

McIlroy, J. 'Bathers Bay whaling station, Fremantle, Western Australia', *Australian Journal of Historical Archaeology*, vol. 4, 1986, pp. 43–50.

McKay, J. and Allom, R. *Lest We Forget: A Guide to the Conservation of War Memorials*. Returned Services League of Australia, Brisbane, 1884.

Mackay, R. Built Environment Conservation: Concentrating on the Fabric. Unpublished paper delivered at ANZAAS Centenary Congress, May 1988.

——. 'Statutory protection and predictive plans—Archaeological heritage management in Sydney', in ICOMOS, *Archaeological Heritage Management*, International Scientific Symposium, ICOMOS 10th General Assembly, Sri Lanka. ICOMOS, Paris, 1993, pp. 65–74.

McShane, I. 'Order in the house', *Public History Review*, vol. 1, 1992, pp. 37–49.

Marsden, S. *Historical Guidelines: South Australian State Historic Preservation Plan*. South Australian Department for the Environment, Adelaide, 1980.

Maynard, L. 'Restoration of Aboriginal rock art—the moral problem', *Australian Archaeology*, vol. 3, 1975, pp. 54–60.

Meehan, B. *Shell Bed to Shell Midden*. Australian Institute of Aboriginal Studies, Canberra, 1982.

Moloney, D. 'Use—a heritage issue?', *Trust News* (National Trust of Australia (Vic.) newsletter), vol. 21, no. 5, April 1993, pp. 18–19.

Moore, R., Burke, S. and Joyce, R. *Australian Cottages*. Hamlyn Australia, Melbourne, 1989.

Mowaljarlai, D. et al. 'Repainting of images on rock in Australia and the maintenance of Aboriginal culture', *Antiquity*, vol. 62, 1988, pp. 690–6.

—— and Peck, C. 'Ngarinyin cultural continuity: A project to teach the young people the culture including the repainting of Wandjina rock art sites', *Australian Aboriginal Studies*, vol. 2, 1987, pp. 71–8.

Mulvaney, D. J. 'An archaeological treasure trove may drown', *Bulletin*, 1 February 1983, pp. 40–2.

——. 'The Australian Aborigines 1606–1929: Opinion and fieldwork', *Historical Studies, Australia and New Zealand*, vol. 8, 1958, pp. 131–51, 297–314.

——. *Encounters in Place: Outsiders and Aboriginal Australians 1606–1985*. University of Queensland Press, St Lucia, Qld, 1989.

——. 'Future pleasure from the past?' in Australia ICOMOS, *The Tide of Australian Settlement: Conservation of the Physical Evidence*, Proceedings of the Beechworth Conference. Australia ICOMOS, Canberra, 1978, pp. 59–67.

——. 'The heritage value of historic relics: A plea for romantic intellectualism', in National Trust of Australia (NSW), *Industrial and Historical Archaeology*, Papers from Goulburn Seminar 1979. National Trust, Sydney, 1981, pp. 3–6.

——. *The Prehistory of Australia.* Pelican, Ringwood, Vic., 1975.

Nash, D. Report on Historical Classifications of Lighthouses. Unpublished report, Department of Transport, Canberra, 1979.

National Parks Service and Port Phillip Area, Department of Conservation and Natural Resources, Victoria. *Gellibrand Hill Park Proposed Woodlands Historic Park Draft Management Plan.* Department of Conservation and Natural Resources, Victoria, Melbourne, 1993.

National Trust of Australia (NSW). *A Guide to the Conservation of Cemeteries.* National Trust of Australia (NSW), Sydney, 1982.

——. *Industrial and Historical Archaeology,* papers from Goulburn Seminar 1979. National Trust of Australia (NSW), Sydney, 1981.

O'Connor, C. *How to Look at Bridges: A Guide to the Study of Australian Historic Bridges.* Institution of Engineers, Australia, Barton, ACT, 1984.

——. *Register of Australian Historic Bridges.* Institution of Engineers, Australia, Barton, ACT, 1984.

——. *Spanning Two Centuries: Historic Bridges of Australia.* University of Queensland Press, St Lucia, Qld, 1985.

Ogleby, C. and Rivett, L. J. *Handbook of Heritage Photogrammetry.* Australian Heritage Commission, Canberra, 1985.

Pardoe, C. 'Arches of radii, corridors of power: Reflections on current archaeological practice', in B. Altwood and J. Arnold (eds), *Power, Knowledge and Aborigines,* a special edition of *Journal of Australian Studies,* Monash University, 1992, pp. 132–41.

——. 'Cross-cultural attitudes to skeletal research in the Murray–Darling Region', *Australian Aboriginal Studies,* vol. 2, 1985, pp. 63–7.

Pearson, C. (ed.). *Conservation of Rock Art.* Institute for the Conservation of Cultural Material, Sydney, 1978.

Pearson, M. ' The acquisition and preservation of historic sites', *Parks and Wildlife,* vol. 2, no. 2, 1978, pp. 42–5.

——. 'Assessing the significance of historical archaeological resources', in S. Sullivan and S. Bowdler (eds), *Site Survey and Significance Assessment in Australian Archaeology,* Department of Prehistory, Research School of Pacific Studies, Australian National University, 1984, pp. 27–33.

——. 'Cultural resources and academic study', in Committee to Review Australian Studies in Tertiary Education, *History and Cultural Resources Project,* part 2, seminar papers. Canberra, 1986, pp. 18–24.

——. 'Historic sites: Themes and variations', in P. Stanbury (ed.), *10,000 years of Sydney Life.* Macleay Museum, University of Sydney, 1979, pp. 96–105.

——. 'The National Parks and Wildlife Service's approach to the acquisition and interpretation of historic sites in NSW', in National Trust of Australia (NSW), *Industrial and Historical Archaeology.* National Trust of Australia (NSW), Sydney, 1981, pp. 9–13.

——. 'Is saving face everything? Facadism and the National Estate', *Heritage Newsletter* (Australian Heritage Commission, Canberra), vol. 11, no. 2, 1988, pp. 4–5.

——. Mawson's Huts Historic Site Conservation Plan. Unpublished report, Australian Heritage Commission and Australian Antarctic Division, Canberra, 1993.

Potter, P. B. (Jr). 'Agenda for public interpretations of monuments and sites', *ICOMOS Information*, vol. 3, 1987, pp. 10–16.

Powell, A. E. (ed.). 'On her own terms', *Historic Preservation—The Magazine of the National Trust for Historic Preservation* (USA), December 1992, p. 28.

Proudfoot, H. 'The First Government House, Sydney', *Heritage Australia*, vol. 2, no. 2, 1983, pp. 21–5.

——, Bickford, A., Egloff, B. and Stocks, R. *Australia's First Government House*. Allen & Unwin, Sydney, 1991.

Ramsay, J. *How to Record the National Estate Values of Gardens*. Australian Heritage Commission, Canberra, 1991.

——. *Parks, Gardens and Special Trees: A Classification and Assessment Method for the Register of the National Estate*. Australian Heritage Commission, AGPS, Canberra, 1991.

Reid, G. *From Dusk Till Dawn: A History of Australian Lighthouses*. Macmillan, Melbourne, 1988.

Rickard, J. and Spearitt, P. (eds). *Packaging the Past? Public Histories*. Melbourne University Press, Australian Historical Studies, Carlton, Vic., 1991.

Rivett, L. *The Application of Photogrammetry to the Recording of Monuments and Sites in Australia*, Bulletin no. 42. Department of Surveying, University of Melbourne, 1977.

——. 'Photogrammetric recording of rock art in the Kakadu National Park', *Australian Archaeology*, vol. 10, 1980, pp. 38–51.

——. 'Photogrammetry—its potential application to problems in Australian archaeology', in C. Pearson (ed.), *Conservation of Rock Art*. Institute for the Conservation of Cultural Material, Sydney, 1978.

Rogers, B. 'Derivation of technologies employed in some pre-1900 salt works in eastern Australia', *Australian Journal of Historical Archaeology*, vol. 8, 1990, pp. 36–43.

——. 'Innovation in the manufacture of salt in eastern Australia: The thorn graduation process', *Australian Journal of Historical Archaeology*, vol. 2, 1984, pp. 59–71.

——. 'Interpretation of an 1830s salt works site on the Little Swanport River, Tasmania', *Australian Journal of Historical Archaeology*, vol. 9, 1991, pp. 49–55.

Rose, D. B. and Lewis, D. 'A bridge and a pinch', *Public History Review*, vol. 1, 1992, pp. 27–8.

Ruskin, J. *The Seven Lamps of Architecture*. Farrar, Straus & Giroux, New York, 1981.

Sagazio, C. (ed.). *The National Trust Research Manual*. Allen & Unwin, Sydney, 1992.

Saunders, D. (ed.). *A Manual of Architectural History Sources in Australia*. University of Adelaide, Adelaide, 1981.

Schiffer, M. B. and Gumerman, C. J. *Conservation Archaeology*. Academic Press, New York, 1977.

Schoer, G. *Heritage Conservation in Action: An Education Kit for NSW High School Students*. Heritage Council of New South Wales, Sydney, 1989.

Scougall, B. (ed.). *Cultural Heritage of the Australian Alps*, proceedings of a symposium. Australian Alps Liaison Committee, Canberra, 1992.

Snelson, W. J., Sullivan, M. E. and Preece, N. D. 'Nundera Point: An experiment in stabilising a foredune shell midden', *Australian Archaeology*, vol. 23, 1986, pp. 25–41.

Spearitt, P. 'Money, taste and industrial heritage', in J. Rickard and P. Spearitt (eds), *Packaging the Past? Public Histories*, Melbourne University Press, Australian Historical Studies, Carlton, Vic., 1991, pp. 33–45.

Spry, A. H. *Principles of Cleaning Masonry Buildings*, Australian Council of National Trusts, Technical Bulletin Series 3.1. Sydney, 1982.

St Clair-Johnson, C. 'The Australian Heritage Engineering Record and the recording of bridges', *Industrial & Historical Archaeology*, National Trust of Australia (NSW), Sydney, 1981, pp. 37–43.

Stanbury P. (ed.). *10,000 Years of Sydney Life*. Macleay Museum, University of Sydney, Sydney, 1979.

Stanbury, P. and Clegg, J. *A Field Guide to Aboriginal Rock Engravings*. Sydney University Press, Sydney, 1990.

Staniforth, M. 'The casks from the wreck of the *William Salthouse*', *Australian Historical Archaeology*, vol. 5, 1987, pp. 21–8.

Stanley Price, N. 'What makes a conservation treatment acceptable or not?', in H. K. Crotty (ed.), *Preserving Our Rock Art Heritage*, Occasional Paper 1. American Rock Art Research Association, San Miguel, 1989, pp. 17–22.

Stapleton, I. 'Assessing the European cultural significance of the Swan Brewery site, Perth, W.A.', *Historic Environment*, vol. 9, nos 1 and 2, 1992, pp. 63–9.

——. *How to Restore the Old Aussie House*. Sydney Morning Herald and National Trust of Australia (NSW), Sydney, 1983.

Steinbeck, J. *The Grapes of Wrath*. Heinemann, London.

Sullivan, H. (ed.). *Visitors to Aboriginal Sites: Access, Control and Management*, Proceedings of the 1983 Kakadu Workshop. Australian National Parks and Widlife Service, Canberra, 1984.

Sullivan, K. [M.]. Managing the Art and Archaeological Resources of an Area Near Laura, North Queensland, Inscribed as Part of the

National Estate. Unpublished report to the Ang-Gnarra Aboriginal Corporation, Laura, and the Queensland Department of Environment and Heritage, Sydney, 1992.

——. 'Monitoring visitor use and site management at three art sites: An experiment with visitors' books', in H. Sullivan (ed.), *Visitors to Aboriginal Sites: Access, Control and Management*, Proceedings of the 1983 Kakadu Workshop. Australian National Parks and Wildlife Service, Canberra, 1984, pp. 43–53.

——. 'Viewing Aboriginal Sites' in P. Stanbury (ed.), *10,000 Years of Sydney Life*. Macleay Museum, University of Sydney, Sydney, 1979, pp. 106–13.

Sullivan, R. 'Trouble in paradigms', *Museum News*, February 1992, pp. 41–4.

Sullivan, S. 'Aboriginal site management in national parks and protected areas', in J. Birkhead, T. de Lacy and L. Smith (eds), *Aboriginal Involvement in Parks and Protected Areas*, Australian Institute of Aboriginal and Torres Strait Islander Studies Report Series. Canberra, 1992, pp. 169–79.

——. 'Aboriginal sites and ICOMOS guidelines', *Historic Environment*, vol. 3, no. 1, 1983, pp. 14–33.

——. 'Conservation policy delivery', in M. G. H. MacLean (ed.), *Cultural Heritage in Asia and the Pacific: Conservation and Policy*. Getty Conservation Foundation, California, 1993, pp. 15–26.

—— (ed.). *Cultural Conservation: Towards a National Approach*. Australian Heritage Commission, Canberra, in press.

——. 'Cultural resource management and historical studies', in Committee to Review Australian Studies in Tertiary Education, *History and Cultural Resources Project, Part 2*. Committee to Review Australian Studies in Tertiary Education, Canberra, 1986, pp. 4–17.

——. 'Cultural values and cultural imperialism', *Historic Environment*, vol. 10, nos 2 and 3, 1993, pp. 54–62.

——. 'The custodianship of Aboriginal sites in southeastern Australia', in I. McBryde (ed.), *Who Owns the Past?* Oxford University Press, Melbourne, 1985, pp. 139–56.

——. *Grotto Sites in China*. Getty Conservation Foundation, California, in press.

——. 'Making a discovery: The finding and reporting of Aboriginal sites', in G. Connah (ed.), *Australian Archaeology: A Guide to Field Techniques*. Australian Institute of Aboriginal Studies, Canberra, 1983, pp. 1–9.

——. 'Mootwingee, conflict and co-operation at an Australian historic site', in *International Perspectives on Cultural Parks: Proceedings of the First World Conference, Mesa Verde National Park, Colorado, 1984*. US National Park Service and Colorado Historical Society, Denver, CO, 1989.

—— and Bowdler, S. (eds). *Site Surveys and Significance Assessment in Australian Archaeology*. Research School of Pacific Studies, Australian National University, Canberra, 1984.

Tainter, J. A. and Lucas, G. J. 'Epistemology of the significance concept', *American Antiquity*, vol. 48, no. 4, 1983, pp. 707–19.

Tanner, H. and Cox, P. *Restoring Old Australian Houses and Buildings: An Architectural Guide*. Macmillan, Sydney, 1975.

Temple, H. 'The listing and control of archaeological sites under the NSW Heritage Act', in National Trust of Australia (NSW), *Industrial and Historical Archaeology*. National Trust of Australia (NSW), Sydney, 1981, pp. 63–5.

Thorne, A. and Ross, A. *The Skeleton Manual: A Handbook for the Identification of Aboriginal Skeletal Remains*. NSW National Parks and Wildlife Service and NSW Police Aboriginal Liaison Unit, Sydney, 1986.

Tibbits, G. *Lettering and Signs on Buildings c. 1850–1900*, Australian Council of National Trusts and National Trust of Australia (Vic.), Technical Bulletin Series 2.2. Melbourne, 1984.

Vinnicombe, P. 'An Aboriginal site complex at the foot of Mt Eliza which includes the old Swan Brewery', *Historic Environment*, vol. 9, nos 1 and 2, 1992, pp. 53–62.

Walker, M. 'Interpretation and small museums', in S. Sullivan (ed.), *Cultural Conservation: Towards a National Approach*, Australian Heritage Commission, Canberra, in press.

——. 'Inventories and their role in managing railway heritage', *Historic Environment*, vol. 10, no. 1, 1993, pp. 32–40.

——. What's Important About Queanbeyan? A Case Study in the Community Identification of the National Estate. Unpublished report, Australian Heritage Commission, Canberra, 1992.

Walsh, G. L. 'Archaeological site management in Carnarvon National Park: A case study in the dilemma of presentation or preservation', in H. Sullivan (ed.), *Visitors to Aboriginal Sites: Access, Control and Management*, Proceedings of the 1983 Kakadu Workshop, Australian National Parks and Widlife Service, Canberra, 1984, pp. 1–14.

Ward, G. K. 'Archaeology and legislation in Australia', in G. Connah (ed.), *Australian Archaeology: A Guide to Field Techniques*, Australian Institute of Aboriginal Studies, Canberra, 1983, pp. 18–42.

——. 'The federal Aboriginal Heritage Act and archaeology', *Australian Aboriginal Studies*, vol. 2, 1985, pp. 47–52.

Watts, P. 'Museum houses: Costs and benefits', in *ACT Heritage Seminars*. ACT Heritage Committee, Canberra, 1985, vol. 3, pp. 25–37.

Wei, C. and Aass, A. 'Heritage conservation East and West', *ICOMOS Information*, vol. 3, 1989.

Western Australian Museum. *Conservation and Restoration for Small Museums*. Department of Material Conservation and Restoration, Western Australian Museum, Perth, 1979.

White, P., Schwirtlich, A. M. and Nash, J. *Our Heritage: A Directory to Archives and Manuscript Repositories in Australia.* Australian Society of Archivists, Sydney, 1983.

Williams, L. R. *Vandalism to Cultural Resources of the Rocky Mountains West*, Cultural Resources Report no. 21. US Department of Agriculture, Forest Service, South West Region, Albuquerque, New Mexico, 1978.

Winston-Gregson, J. Australian Lighthouse Type-Profile. Unpublished report, Australian Heritage Commission, Canberra, 1988.

Womersley, J. 'South Australian state conservation plan', in S. Sullivan (ed.), *Cultural Conservation: Towards a National Approach.* Australian Heritage Commission, Canberra, in press.

Yencken, D. G. *Australia's National Estate: The Role of the Commonwealth.* Australian Government Publishing Service, Canberra, 1985.

Zweck, M. 'Heritage and tourism', in S. Sullivan (ed.), *Cultural Conservation: Towards a National Approach.* Australian Heritage Commission, Canberra, in press.

Index

Aass, A., 225

Aboriginal and Torres Strait Islander Commission, 52

Aboriginal and Torres Strait Islander places, 24–5; burials, 30, 163–4, 198; carved trees, 169, 256; dwellings, 25; interpretation, 51–2, 296–7; legislation and custodianship, 50–5; protection of relics, 60; quarries, 28; shell middens, 102; trading sites, 26; traditional industry, 26; *see also* archaeological sites; conservation; custodianship; objects; rock art

Aboriginal heritage protection agencies: Australian Capital Territory, 56–7; New South Wales, 60–1; Northern Territory, 61–3; Queensland, 64–5; South Australia, 67; Tasmania, 67–9; Victoria, 71–3; Western Australia, 74–6

Aboriginal Land Councils, 63

Aboriginal 'protectorate', 165

Aboriginal significance, 6, 19, 159–65; *see also* archaeological sites; sacred sites; scientific significance; social significance; traditional significance

Aboriginal skeletal material, 53, 68, 73, 163–4, 234

academic contribution to heritage management, 52, 311–12; historians vs architects, 139–40

adaptation, *see* conservation practices

administrative frameworks, *see* government heritage administration; legislation

Admiralty House, NSW: conservation policy, 218–19

aesthetic significance, *see* significance

agricultural places, 27

Alice Springs Telegraph Station, NT, 161, 182

Anderson, Margaret, 313

archaeological site protection: New South Wales, 58, 61; Queensland, 64; South Australia, 67; Victoria, 71

archaeological sites: Aboriginal places, 148–9, 173, 264; assessment, 85, 150–3, 185; European places, 149–50; management, 262–4; *see also* conservation practices; scientific significance; Victorian Archaeological Survey

architectural value, 138–9, 140